crochet stitch dictionary

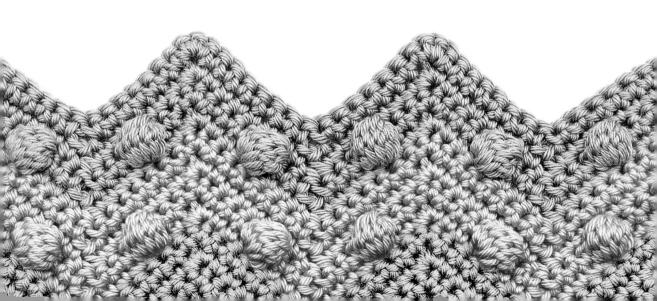

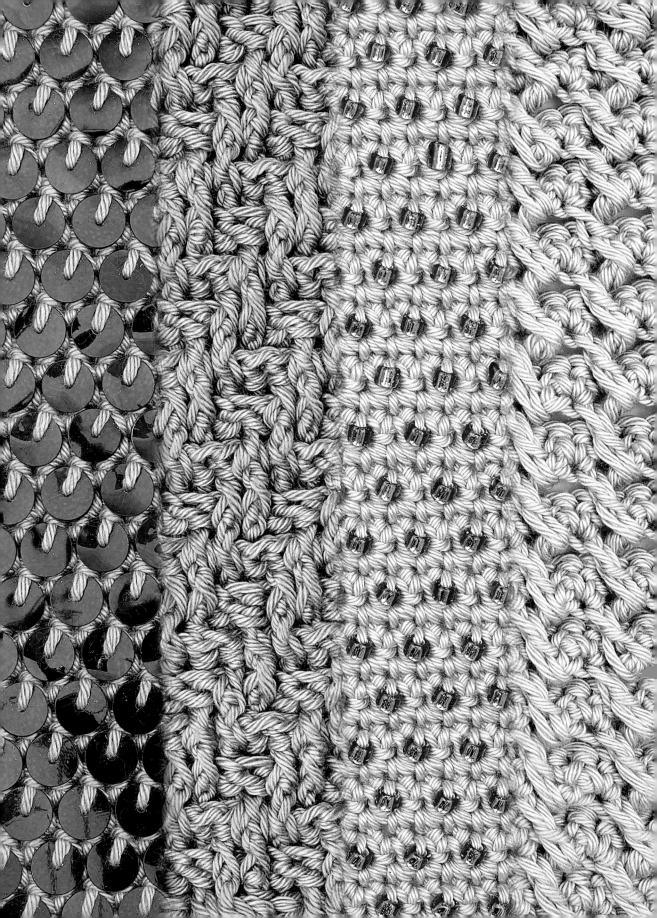

crochet stitch dictionary

200
Essential
Stitches with
Step-by-Step
Photos

Sarah Hazell

A Quarto Book

Interweave
An imprint of Penguin Random House LLC
penguinrandomhouse.com

Copyright © 2013 Quarto Publishing plc

Penguin supports copyright. Copyright fuels creativity, encourages diverse voices, promotes free speech, and creates a vibrant culture. Thank you for buying an authorized edition of this book and for complying with copyright laws by not reproducing, scanning, or distributing any part of it in any form without permission. You are supporting writers and allowing Penguin to continue to publish books for every reader.

Conceived, edited, and designed by
Quarto Publishing plc,
an imprint of the Quarto Group
The Old Brewery
6 Blundell Street
London N7 9BH

QUAR.CRSW

Printed in China

24

ISBN 978-1-62033-129-3

Project Editor: Lily de Gatacre
Art Editor: Emma Clayton
Designer: Julie Francis
Photographer: Phil Wilkins
Proofreader: Diana Craig
Pattern Checker: Rachel Vowles
Illustrator: Kuo Kang Chen
Indexer: Helen Snaith
Art Director: Caroline Guest

Creative Director: Moira Clinch Publisher: Paul Carslake

Foreword About this boo	k			10 10
Equipment and Essential crock Basic stitches Stitch variation	d materials net skills			12 14 17 23 26
Directory Basic Stitches	y of Stite	hes	A ACCULATION OF BASING	32
34 Single Crochet	34 Front Loop Single Crochet	35 Back Loop Single Crochet	35 Front and Back Loop Single Crochet	36 Alternate Single Crochet
36 Half Double	37 Double	37 Treble	38 Paired Single	38 Paired Half
Crochet	Crochet	Crochet		Double

40

Alternate

39

Staggered

Double Crochet Pairs

39

Staggered

Half Double

Pairs

40

Extended

Half Double

41

Up and Down

contents

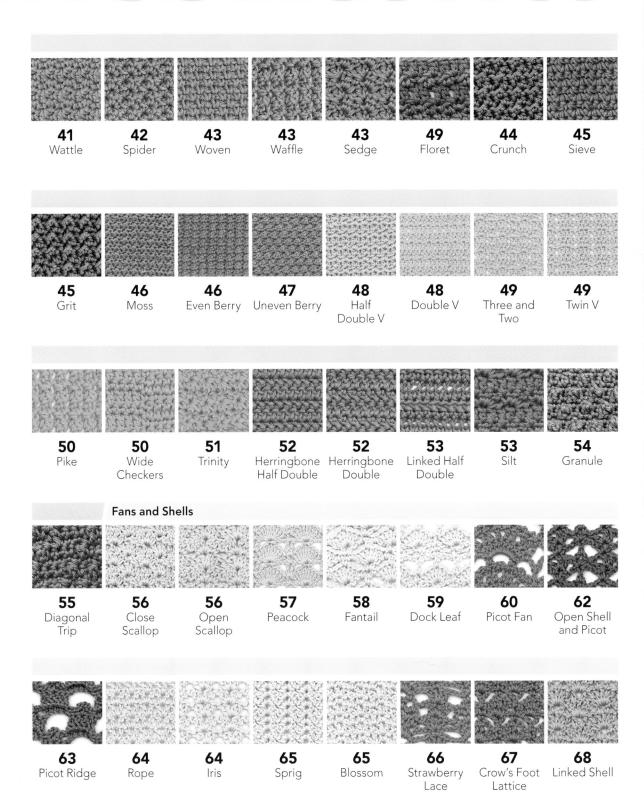

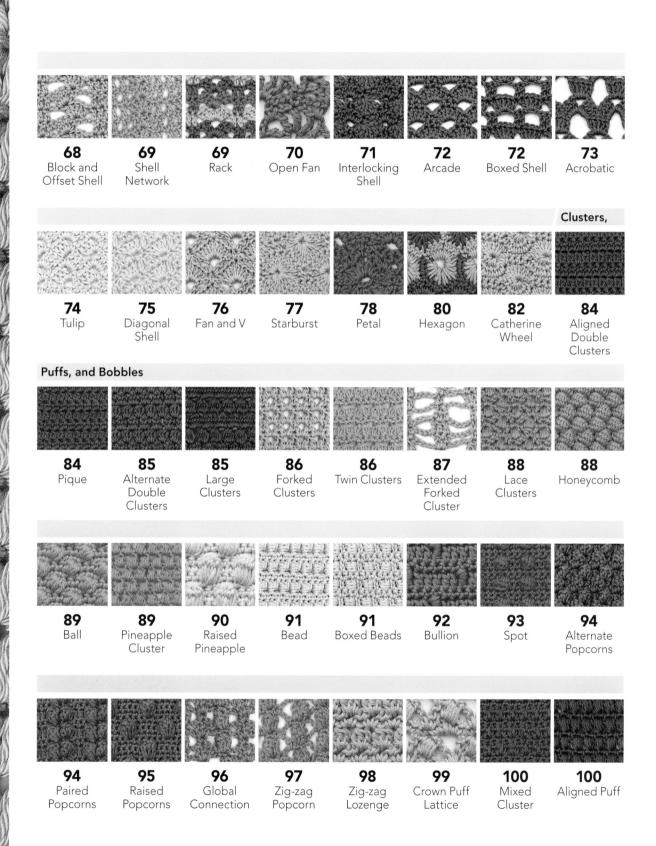

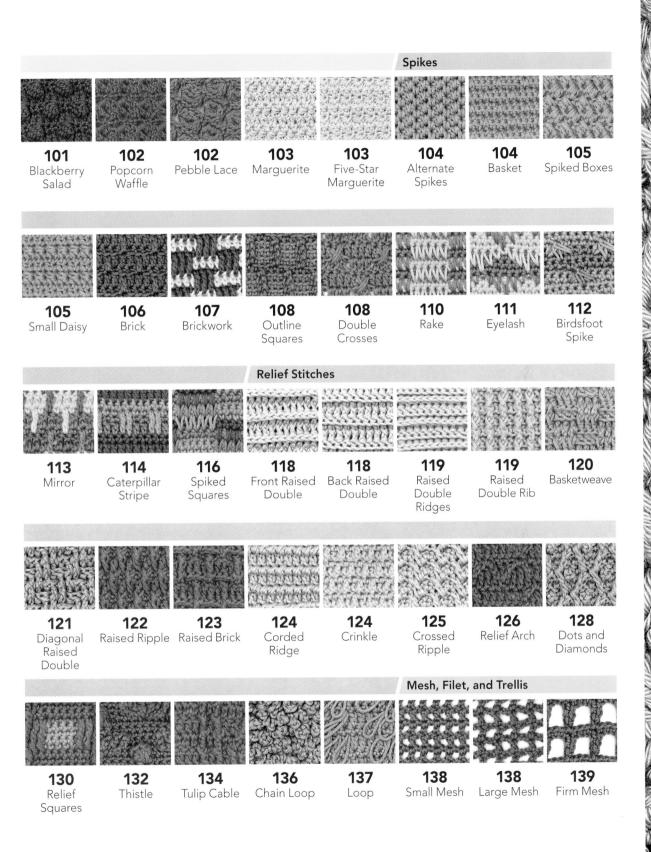

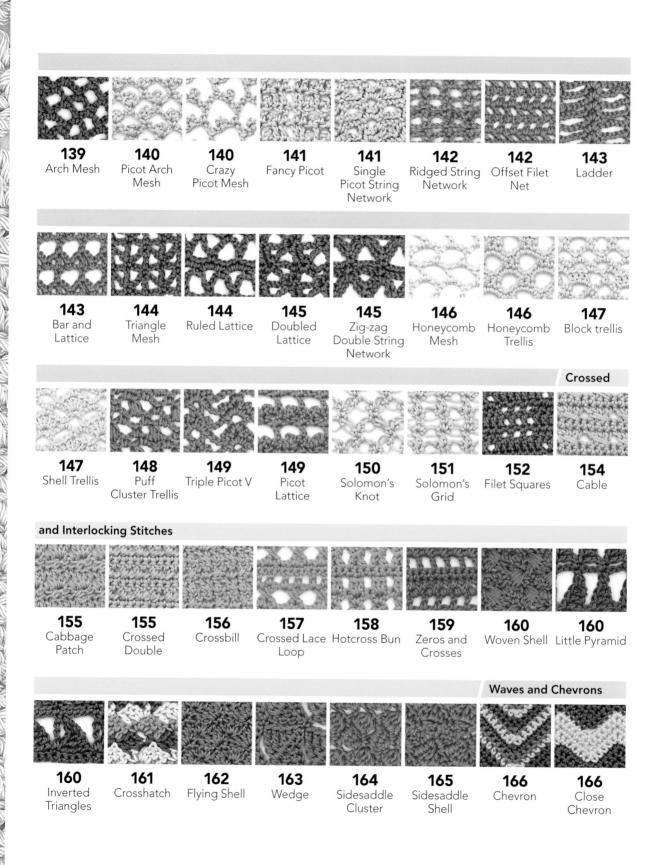

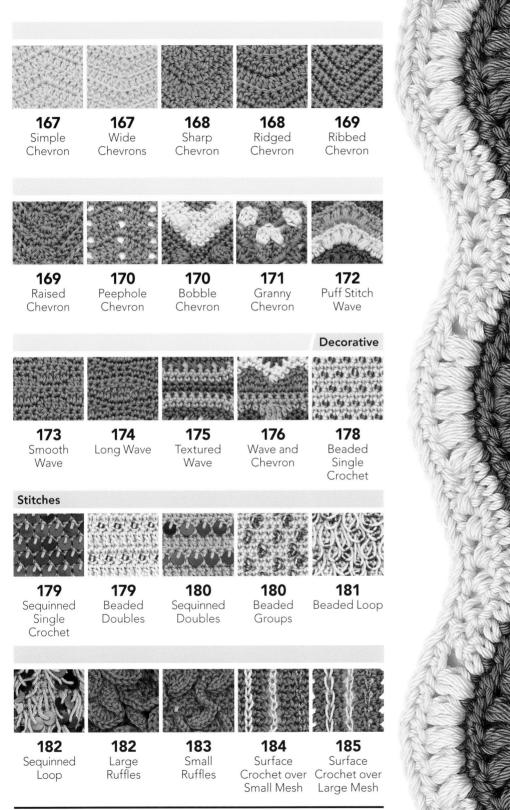

Foreword

As a fanatical knitter, I never thought I would be able to master the craft and skill of crochet. Recognizing my passion for color and varn, a colleague encouraged me to have a go, and I was hooked! While this may be a rather overused pun, it goes some way to convey how addictive crochet can become. The rhythm and repetition of stitches and patterns is not only soothing and relaxing, but encourages you to test out different combinations. After all, if it goes wrong or you don't like something, a row or round is easily pulled out without disturbing all your other hard work.

Crochet is a highly creative process. Stitches can be made taller, shorter, wider, narrower, textured, or smooth using some very simple techniques. Introduce color into the equation and you will soon discover some beautiful, graphic patterns.

The purpose of this book is to make all of these techniques accessible to you. I have taught crochet at workshops for many years and have found that it is useful to have lots of visual references as well as written instructions. I hope that the step-bystep photos and charts will help you to navigate your way through each stitch. The book is divided into different sections, and I have tried to build an element of progression into each section. I have also indicated which yarns and projects may work with certain stitches. These are suggestions only and I hope that you will see the book as a resource for extending your skills and developing your own ideas.

Sarah Hazell

About This Book

The book begins with Getting Started (pages 14–31), a chapter packed with information on crocheting basics, from choosing yarn and holding your hook, to working basic stitches, stitch formations, and measuring gauge. Once you have mastered the basics, it's time to move onto the Directory of Stitches (pages 32–185) and start learning to work a huge variety of crochet stitches.

Different colored yarns are allocated a letter.

- For most of the stitches in this book, the step number is the same as the row number it describes. Where this is not the case (if there is a base row, a step includes instructions for more than one row, or instructions for one row are split over more than one step), the row number(s) will appear in curved brackets after the step number.
- Advanced or specialist stitches are explained with clear written instructions in a Special Stitch section when they are needed.
- Where the stitch is worked from the wrong side, this is indicated at the start of the instructions and by an arrow on the chart.

Guidelines for the length of foundation chain required are listed. See page 18 for more on this.

Curved brackets () are used (RS) within the instructions for explanation or additional information. For example: "1tr in next tr (center of 5)" or "Ch1 (counts as 1dc)".

Two hundred crochet stitches make up the stitch directory with written instructions and charts to help you to master a wide range of crochet skills. Organized into nine families of stitches and clearly numbered, you can dip in and out of the directory or work your way through a particular section to develop your skills in that area.

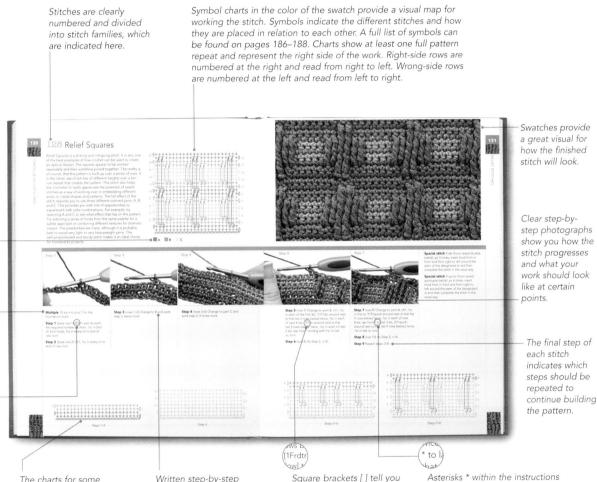

The charts for some stitches are broken down to help you locate the specific part of the chart that relates to the instructions in that step or steps. Previous steps/rows are faintly shown so you can see how the chart and the stitch builds up.

written step-by-step instructions guide you through the creation of the stitch. Make sure that you begin with the correct number of foundation chains and follow the instructions exactly. The terminology of crochet can be confusing at first. A full list of abbreviations is given on pages 186–189 at the back of the book.

Square brackets [] tell you to read the enclosed instructions as a group. For example, "skip [1dc, 1tr]" means that you should skip 1 double crochet and skip 1 treble. Similarly, "[2tr in next tr, ch1] twice" indicates that you should work 2 trebles in the next treble, chain 1, 2 trebles in the following treble, chain 1.

Asterisks * within the instructions indicate a point from which instructions are repeated. For example, "Rep from * to end" means you should repeat the instructions after the * to the end of the row. Where instructions given after the * do not fit exactly or a different stitch is worked at the end of a row, the instruction will reflect this. For example, "*1dc in next dc, 2tr in next dc, rep from * ending 1tr in last dc" means repeat the instructions after the * but at the end of the last repeat, work only 1 treble into the last double crochet.

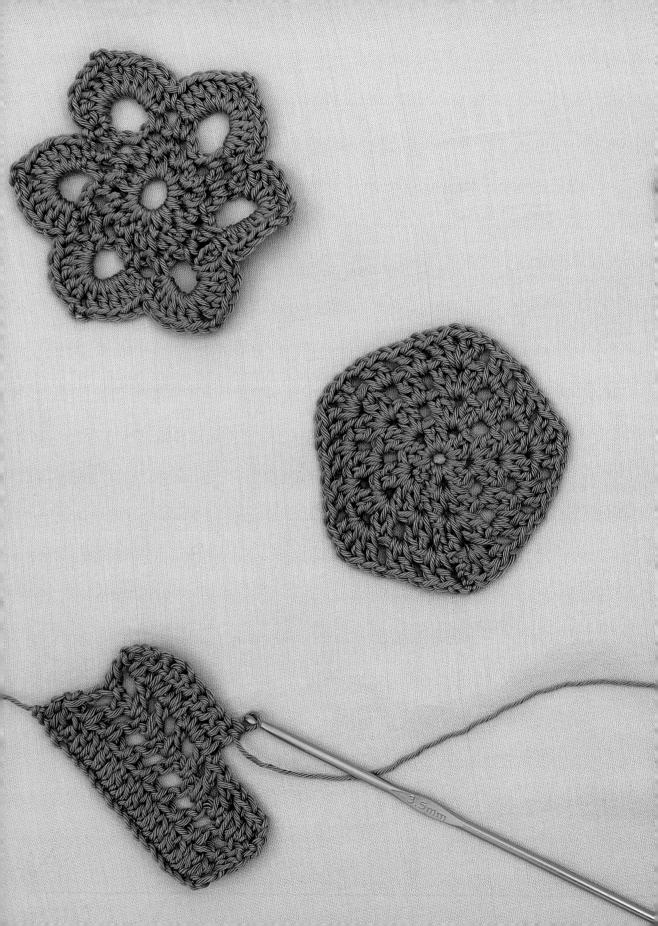

Equipment and Materials

The hooks

Crochet hooks may be made from aluminum, steel, wood, bamboo, or plastic. They are available in a variety of sizes to suit different types of yarn and gauge requirements (see Measuring Gauge, page 22). Sizes range from 0.6 mm (the smallest) up to 15 mm or more, and the hooks are normally between 5 inches (125 mm) and 8 inches (200 mm) long. The shaft behind the hook may be cylindrical, or with a flattened area to help you hold it at the correct angle. Try out the different options to decide which suits you best.

Hook sizes

The internationally used metric system of sizing known as the International Standard Range (ISR) gives the diameter of the hook shaft in millimeters. Before metric sizing, crochet hooks were sized in two ranges: steel hooks (small sizes for fine work) and aluminum or plastic hooks (larger sizes, sometimes called wool hooks). U.S. sizes were used in America and Imperial sizes in the U.K. and Canada, and it is useful to understand these: you may have old hooks in your collection, or wish to follow an old crochet pattern.

You can see from the table at right how hooks labeled under different systems may be confused. Always measure your own gauge.

Approximate equivalent hook sizes

For guidance only, sizes given do not necessarily correspond exactly.

International standard range (ISR)	Imperial steel hooks	Imperial aluminum or plastic hooks	U.S. steel hooks	U.S. aluminum or plastic hooks
0.6 mm	6		14	
0.75 mm	5		13	
1 mm	4		12	
	31/2		11	
1.25 mm	3		10	
			9	
1.5 mm	21/2		8	
			7	
1.75 mm	2		6	
	11/2		5	
2 mm	1	14	4	
			3	
2.25 mm	1/0 or 0	13	2	В
2.5 mm	2/0 or 00	12	1	С
3 mm	3/0 or 000	11	0	D
		10		
3.5 mm		9	00	Е
				F
4 mm		8		
				G
4.5 mm		7		
5 mm		6		Н
5.5 mm		5		1
6 mm		4		J
6.5 mm		3		K
7 mm		2		L
8 mm		1		М
9 mm		0		N
10 mm				
12 mm				. 1
15 mm				0

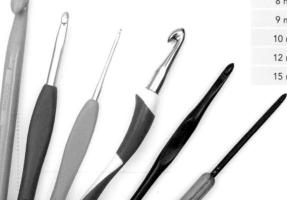

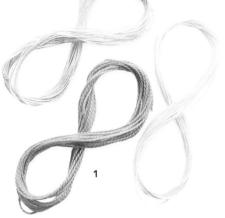

Yarns

Yarns sold specifically for crochet are fine, smooth cottons, usually described by a number ranging from 5 (the coarsest) to 60 (very fine yarn used for traditional crochet). These cotton yarns are often described as "mercerized," which means they have been treated with an alkali to improve their strength and luster. They are ideal for showing off intricate patterns and textures (1).

Fine, natural-linen yarns are also suitable for crochet, and give a crisp finish to the work (2).

Pearl-cotton yarns are sold for use in crochet, knitting and embroidery, and give a softer and less tightly twisted finish than traditional crochet yarns. They are manufactured in a range of thicknesses (3).

Smooth, firm knitting yarns are also suitable for crochet. These are sold in various weights, from 3-ply (the finest) through 4-ply, double knitting and sport weight, to bulky weight. They may be cotton, wool, or synthetic (4).

Special knitting yarns such as silk, glossy viscose and metallic Lurex are equally suitable for crochet. Avoid any that are loosely spun; they may easily catch on the hook (5).

TIPS

- Yarn supplied in hanks must be wound into a ball before you begin to crochet.
- When choosing an unfamiliar yarn, it is a good idea to buy just one ball and experiment with it before purchasing all the yarn for a large project.

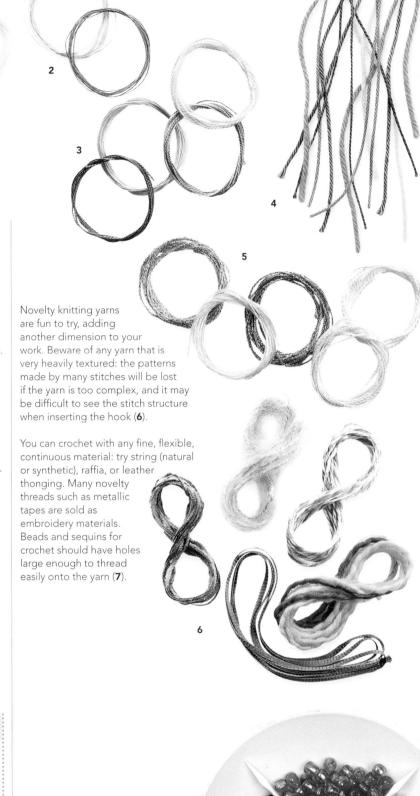

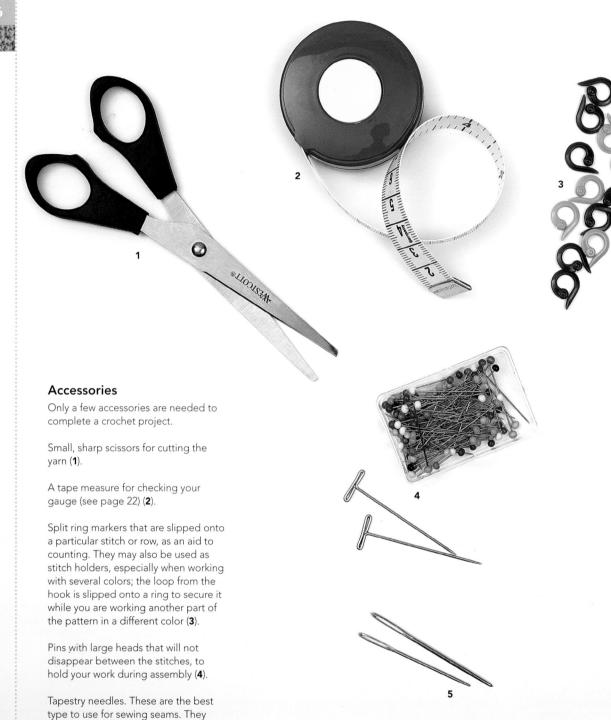

have a large eye and a blunt tip that will not split the yarn, and are available

in a range of sizes (5).

Essential Crochet Skills

Holding the hook

The hook is held in the right hand (if you are right-handed). There is no right or wrong way to hold a hook but most people find it most comfortable to hold the hook either like a pencil (a), with the tips of your right thumb and index finger centered over the flat section of the hook, or by grasping the flat section of the hook between your right thumb and index finger, as if you were holding a knife (b). The hook should face downward.

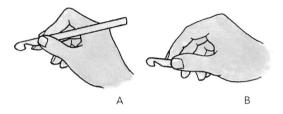

Making a slip knot

Almost every piece of crochet begins with a slip knot.

Step 1

Leaving a tail of about 6 in. (15cm), loop the yarn in the direction shown, insert the hook through the loop to catch the yarn leading to the ball (not the short tail), and pull it through to make a loop.

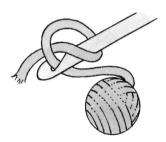

Step 2Pull gently on both yarn ends to tighten the knot against the hook.

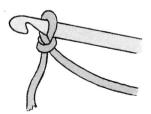

Holding the yarn

The left hand (if you are right-handed) controls the supply of yarn. It is important to maintain an even gauge on the yarn. One method is to wind the yarn around the fingers, as shown below.

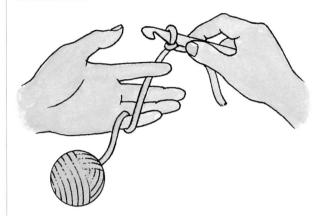

To form a stitch use the first finger to bring the yarn into position so it may be caught by the hook and pulled through to make a new loop. Note the direction of the yarn around the tip of the hook.

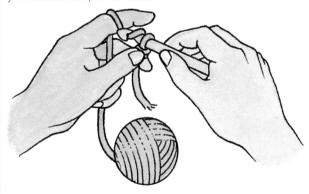

TIP

If you are left-handed, hold the hook in your left hand and the yarn in your right, and look at the reflection of these illustrations in a mirror.

Foundation chains

The foundation chain is the crochet equivalent of casting on in knitting. It is the foundation from which your crochet fabric grows. It is important to make sure that you have made the required number of chain stitches for the pattern you are going to work (instructions for forming chain stitches can be found on page 23). This number will be given as a multiple of a certain number before the instructions for each stitch: for example, "Multiple 3 sts + 2" means any number that divides by 3, with 2 more added, such as 9 + 2 (a total of 11) or 33 + 2 (a total of 35). Extra stitches are sometimes required for the foundation chain: for example, "Multiple 3 sts + 2, plus 2 for the foundation chain means begin with a number of foundation chain stitches that divides by 3, add 2, and then add 2 more, such as 33 + 2 + 2 (a total chain of 37).

The front of the foundation chain looks like a series of "V"s or little hearts, while the back of the chain forms a distinctive bump of yarn behind each "V". Count each V-shaped loop on the front of the chain as one chain stitch, but do not count the slip knot or the loop that is on the hook. You can also turn the chain over and count the stitches on the back if you find that easier.

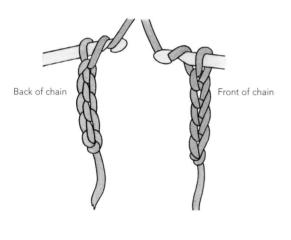

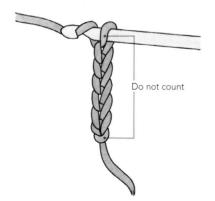

Working in rows

The basic stitches described on the following pages may be repeated in rows to make simple textured fabrics. When you work the first row onto the foundation chain, you begin the first stitch in the second, third, fourth, or fifth chain from the hook, depending on the height of the stitch you are making; the one, two, three, or four chains that you skip stand instead of the first stitch of the first row. Every following row begins with a similar number of chains, called the turning chain(s)—referred to as the tch in the directory. The next examples show rows of double crochet stitches, with three turning chains.

More complicated stitch patterns usually follow the same principle.

Turning the work

Step 1

When the first row is complete, unless otherwise instructed in the steps, turn the work. You can turn it either clockwise or counterclockwise, but a neater edge will result if you are consistent.

At the beginning of the next row, work a number of turning chains to correspond with the stitch in use, as described in the chart at right. These chains will stand for the first stitch of the new row, and are counted as one stitch.

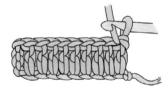

Step 2

Work the appropriate number of chains (three are shown here). Skip the last stitch of the previous row and work into the next stitch. The hook is normally inserted under the top two threads of each stitch, as shown. (When the hook is to be inserted elsewhere, pattern instructions will indicate this.)

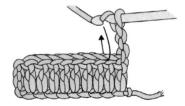

Step 3

At the end of the row, work the last stitch into the top of the chains at the beginning of the previous row. Then repeat Steps 1 through 3.

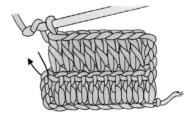

Fastening off and weaving in ends

It is very easy to fasten off yarn when you have finished a piece of crochet, but do not cut the yarn too close to the work because you need enough yarn to weave in the end. It is important to weave in yarn ends securely so they do not ravel. Do this as neatly as possible so that the woven yarn does not show through on the front of the work.

Fastening off

To fasten off the yarn securely, work one chain, then cut the yarn at least 4 inches (10 cm) away from the work, and pull the tail through the loop on the hook, tightening it gently.

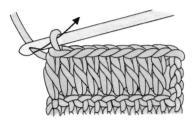

Weaving in yarn

To weave in a yarn end along the top or lower edge of a piece of crochet, start by threading the end into a yarn or tapestry needle. Take the needle through several stitches on the wrong side of the crochet, working stitch by stitch. Trim the remaining yarn.

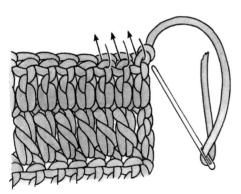

Top edge

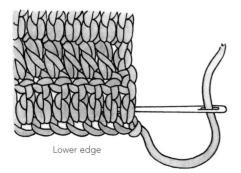

Turning chains

1 chain		
2 chains		
2 chains		
3 chains		
4 chains		
5 chains		

Note: These are the usual numbers of turning chains used for the basic stitches. Sometimes two chains are needed for single crochet, and the requirements of more complicated stitch patterns may vary.

TIPS

- When working in single crochet, extended single crochet, or half doubles, you may find instructions are given to work the first stitch of each row into the last stitch of the previous row. In these cases, the turning chain is not counted as a stitch, and is not worked into at the end of a row. In this book, this method is used only where the construction of a stitch pattern makes it necessary.
- Try to avoid running out of yarn in the middle of a row. When you think you have enough yarn left for two rows, tie a loose overhand knot at the center of the remaining yarn. Work one row. If you need to undo the knot, there is not enough yarn left for another complete row. Fasten off the old ball at the side edge and use a new ball for the next row.

Joining yarn

When working in one color, try to join in a new ball of yarn at the end of the row rather than in the middle to make the join less noticeable. You can do this by making an incomplete stitch and then using the new yarn to finish the stitch. Alternatively, join the new yarn at the beginning of the row you are about to work using the slip stitch method shown below. Many of the stitches detailed in this book look particularly striking when worked in more than one color. When you are working a piece of crochet in more than one color, join the new color of yarn wherever the pattern or chart indicates by leaving the last stitch in the old color incomplete and using the new color to finish the stitch, as shown below.

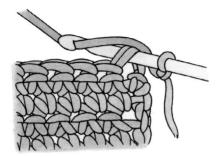

Joining a new yarn using slip stitch

This method can be used when working any stitch. At the beginning of the row, make a slip knot (see page 17) in the new yarn and place it on the hook. Insert the hook into the first stitch on the row and make a slip stitch with the new yarn through both slip stitch and slip knot. Continue along the row using the new yarn.

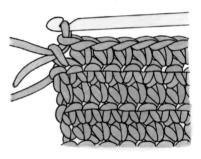

Joining a new yarn in single crochet

Join the new color at the end of the last row worked in the previous color. To work the last stitch, draw a loop of the old yarn through so that there are two loops on the hook. Loop the new yarn over the hook, then pull it through both loops on the hook. Turn and work the next row in the new color.

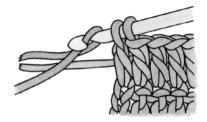

Joining a new yarn in double crochet

Join the new color at the end of the last row worked in the previous color. Leaving the last stage of the final stitch incomplete, loop the new yarn over the hook and pull it through the loops on the hook to complete the stitch. Turn and work the next row in the new color.

Changing color mid row

Use this method for a neat join between colors in the middle of a row. The first ball need not be fastened off: it may be left aside for a few rows or stitches in the course of a multi-colored pattern.

The example shown here is worked in single crochet stitches, but the same principle applies to any stitch. This method is particularly useful when working in striped patterns.

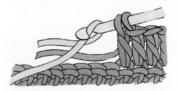

Step 1

Work up to the final "yo, pull through" of the last stitch in the old color and wrap the new color over the hook.

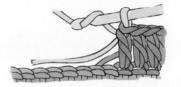

Step 2

Use the new color to complete the stitch.

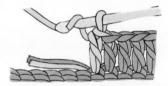

Step 3

Continue in the new color.

Seams

Crochet pieces may be seamed either by sewing them with a tapestry needle or by crocheting them together with a hook. In either case, use the same yarn as used for the main pieces, if possible. If this is too bulky, choose a matching, finer yarn, preferably with the same fiber content to avoid problems when the article is washed.

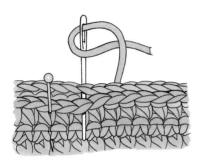

Back stitch seam

This is a firm seam that resists stretching, and is used for hard-wearing garments and articles such as bags, and for areas where firmness is an advantage, such as the shoulder seams of a garment. Hold the pieces with right sides together (pin them if necessary, as shown here), matching the stitches or row ends, and use a tapestry needle and matching yarn to work back stitches, as shown.

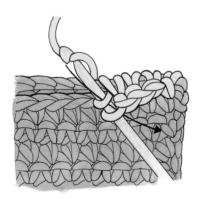

Single crochet seam

Again, this seam may be worked with wrong or right sides together, so that it appears on the inside or outside of the article. Work as for the slip stitch seam (see above), but in single crochet stitches (see page 23).

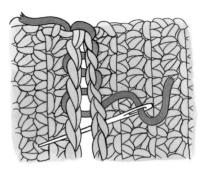

Woven seam

This seam is flexible and flat, making it suitable for fine work and for baby clothes. Lay the pieces with edges touching, wrong sides up, and use a tapestry needle and matching yarn to weave around the centers of the edge stitches, as shown. Do not pull the stitches too tightly: the seam should stretch as much as the work itself. When joining row ends, work in a similar way.

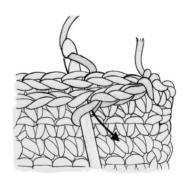

Slip stitch seam

This seam may be worked with right sides together, so that the seam is inside, or with wrong sides together, so that the seam shows as a ridge on the right side of the work. Insert the hook through the corresponding stitches of each edge to work one slip stitch (see page 23) through each pair of stitches along the seam. Fasten off securely (see page 19).

You can insert the hook under two threads of each stitch, as shown here; or, for a less bulky seam, insert the hook under the back loop of the nearer edge and the front loop of the further edge. When working this seam along side edges, match the row ends carefully. Make a suitable number of slip stitches to the side edge of each row so that the seam is not too tight: for example, two or three slip stitches along the side edge of each row of double crochet stitches.

Measuring gauge

Most crochet patterns recommend a "gauge." This is the number of stitches (or pattern repeats) and rows to a given measurement (usually 4 inches or 10 cm). For your work to be the correct size, you must match this gauge as closely as possible. To work out a design of your own, you need to measure your gauge to calculate the stitches and rows required.

The hook size recommended by any pattern or ball band is only a suggestion. Gauge depends not only on the hook and yarn but also on personal technique.

If you have too many stitches (or pattern repeats) or rows to 4 inches (10 cm), your work is too tight; repeat the process described at right with another sample made with a larger hook. If you have too few stitches (or pattern repeats), or rows, your work is too loose; try a smaller hook. It is usually more important to match the number of stitches exactly, rather than the number of rows.

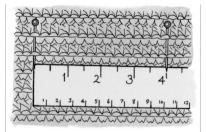

Step 1

Work a piece of crochet about 6 in. (15 cm) square, using the hook, yarn, and stitch pattern required. Press if this is recommended on the ball band. Lay the sample flat and place two pins 4 in. (10 cm) apart along the same row, near the center. Count the stitches (or pattern repeats) between them.

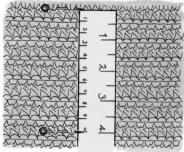

Step 2

Place two pins 4 in. (10 cm) apart on a vertical pattern line near the center, and count the number of rows between them.

Crochet aftercare

It is a good idea to keep a ball band from each project you complete as a reference for washing instructions. Crochet items are best washed gently by hand and dried flat, to keep their shape. Crochet garments should not be hung on coat hangers, but folded and stored flat, away from dust, damp, heat, and sunlight. Clean tissue paper is better than a plastic bag.

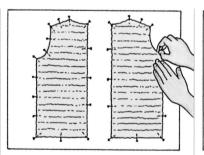

Step 1

Lay each piece right side down on a well-padded surface. With all the rows straight, pin the pieces in place, inserting pins evenly all around at right angles to the edges. If necessary, ease the piece gently to size, checking the measurements. (Matching pieces, such as the two garment fronts shown here, may be pinned out side by side).

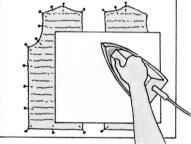

Step 2

Check the yarn band for pressing instructions. For natural fibers, such as wool or cotton, a clean damp cloth and a warm iron are usually suitable. Lift and replace the iron lightly, do not rub. Leave to cool and dry completely before removing the pins. After assembly, press the seams gently.

TIP

Some yarns (such as some synthetics) should not be pressed: pin out the work as above, mist with water, and leave to dry.

Blocking

Crochet often needs to be blocked (see steps above) before assembly, to "set" the stitches and give a professional finish.

Basic Stitches

Chain stitch (ch)

Most pieces of crochet begin with a foundation chain (see page 18) of a certain number of stitches which will be detailed before the step instructions for each stitch. Chains worked at the beginning of a row, or as part of a stitch pattern, are worked in the same way as below.

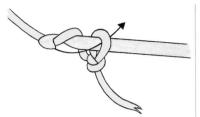

Step 1
Hold the yarn and slip knot as shown on page 17. Wrap the yarn over the hook in the direction shown (or catch it with the hook).

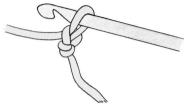

Step 2Pull a new loop through the loop on the hook. One chain (1ch) made.

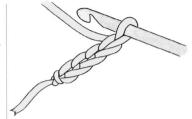

Step 3Repeat Steps 1 and 2 as required, moving your left hand every few stitches to hold the chain just below the hook. Tighten the slip knot by pulling on the short yarn tail.

Single crochet (sc) +

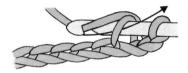

Step 1
Begin with a length of chains. Insert the hook in the second chain from the hook, wrap the yarn over the hook, and pull the new loop through the chain only.

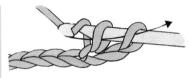

Step 2Wrap the yarn over the hook, and pull a loop through both loops on the hook.

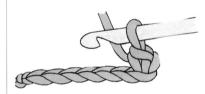

One loop remains on the hook. One single crochet stitch (1sc) made. Repeat Steps 1 and 2 in each chain to the end to complete one row of single crochet stitches.

Slip stitch (sl st)

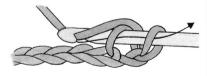

Step 1

Begin with a length of chains. Insert the hook in the second chain from the hook, wrap the yarn over the hook, and pull a new loop through both the work and the loop on the hook. One slip stitch (sl st) made.

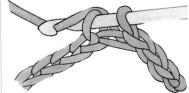

Step 2

Repeat Step 1 in each chain to the end to complete one row of slip stitches.

TIPS

Step 3

- Making the correct number of foundation chains is crucial when working a pattern. Count the chains as you make them, and count them again before continuing. Do not count the slip knot as a chain. See page 18 for more on foundation chains.
- When working into a foundation chain, you can insert the hook under either one or two threads of each chain, but be consistent. For a firm edge, insert under two threads; for a looser edge, insert under one thread.

Extended single crochet (exsc)

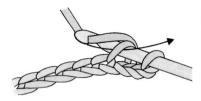

Step 1

Begin with a length of chains. Insert the hook in the third chain from the hook, wrap the yarn over the hook, and pull the new loop through the chain.

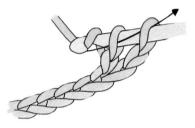

Step 3

You now have two loops on the hook. Wrap the yarn over again, and pull it through both loops.

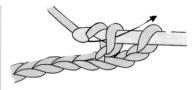

Step 2

Wrap the yarn over the hook, and pull it through the first loop only.

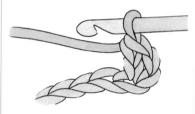

Step 4

One loop remains on the hook. One extended single crochet stitch (1exsc) made. Repeat Steps 1 through 3 in each chain to the end to complete one row of extended single crochet stitches.

Half double crochet (hdc)

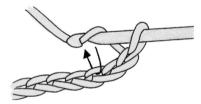

Step 1

Begin with a length of chains. Wrap the yarn over the hook, and insert the hook in the third chain from the hook.

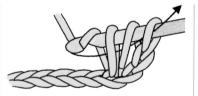

Step 2

Pull a loop through this chain. You now have three loops on the hook. Wrap the yarn over the hook again. Pull through all three loops on the hook.

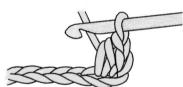

Step 3

One loop remains on the hook. One half double crochet stitch (1hdc) made. Repeat Steps 1 through 3 in each chain to the end to complete one row of half double crochet stitches.

Double crochet (dc)

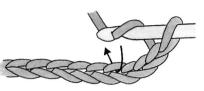

Step 1

Begin with a length of chains. Wrap the yarn over the hook, and insert the hook in the fourth chain from the hook.

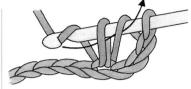

Step 2

Pull a loop through this chain to make three loops on the hook. Wrap the yarn over the hook again. Pull a new loop through the first two loops on the hook. Two loops remain on the hook. Wrap the yarn over the hook again. Pull a new loop through both loops on the hook.

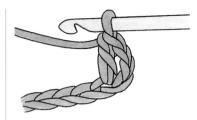

Step 3

One double crochet stitch (1dc) made. Repeat Steps 1 through 3 in each chain to the end to complete one row of double crochet stitches.

Treble (tr)

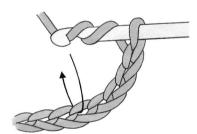

Step 1

Begin with a length of chains. Wrap the yarn twice over the hook, and insert the hook in the fifth chain from the hook.

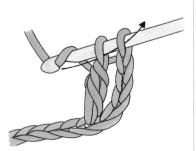

Step 4

Two loops remain on the hook. Wrap the yarn over again and pull through the two remaining loops.

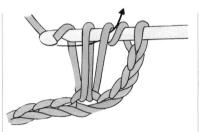

Step 2

Pull a loop through this chain. You now have four loops on the hook. Wrap the yarn over again and pull through the first two loops.

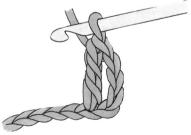

Step 5

One treble (1tr) made. Repeat Steps 1 through 5 in each chain to the end to complete one row of trebles.

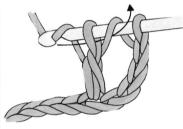

Step 3

Three loops remain on the hook. Wrap the yarn over the hook and pull through the first two loops.

TIPS

- For any stitch, the yarn is always wrapped over the hook in the direction shown, unless specific instructions direct otherwise.
- Make double trebles, triple trebles, or quadruple trebles in a similar way. Wrap the yarn three (or four or five) times over the hook, insert the hook, pull a loop through, then *wrap the yarn over the hook, pull a loop through the first two loops, and repeat from * until one loop remains.

Stitch Variations

Basic stitches may be varied in many ways to achieve different effects. For example, by working several stitches in the same place, by inserting the hook in a different place, by working several stitches together, or by working in the reverse direction you can alter the appearance of basic stitches and create really dazzling crochet designs.

Working into one loop

If the hook is inserted under just one loop at the top of a stitch, the empty loop creates a ridge on either the front or the back of the fabric. Throughout this book, "front loop" means the loop nearest to you, at the top of the stitch, and "back loop" means the farther loop, whether you are working a right-side or a wrong-side row.

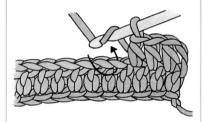

★ T Front loop only

 If the above in its in the second in the

If the hook is inserted under the front loop only, the empty back loop will show as a ridge on the other side of the work.

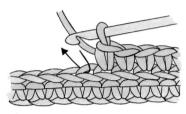

If the hook is inserted under the back loop only, the empty front loop creates a ridge on the side of the work facing you. This example shows single crochet.

Working into a chain space

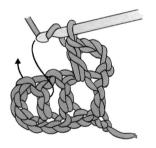

The hook is inserted into the space below one or more chains. Here, a double crochet stitch is being worked into a one chain space (ch-1 sp).

Inserting between stitches

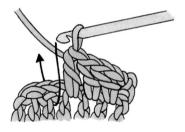

Here, the hook is inserted between the stitches of the previous row, instead of at the top of a stitch.

Spike stitches

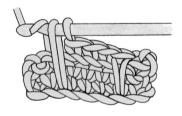

Many pattern variations may be made by inserting the hook one or more rows below the previous row. The insertion may be directly below the next stitch, or one or more stitches to the right or left. See the Spikes section of the directory (pages 104–117) for lots of exciting ways to use this technique.

Insert the hook as directed, wrap the yarn over the hook, and pull the loop through the work, lengthening the loop to the height of the working row. Complete the stitch as instructed. (Single crochet spike shown here.)

Raised stitches

These are created by inserting the hook around the stem of the stitch below, from the front or the back. See pages 118–137 of the directory for the Relief Stitches, which will show you how to use this technique to create a variety of beautiful crochet stitches. The two examples here show raised doubles, but shorter or longer stitches may be worked in a similar way. A "special stitch" note will recap on how to create these stitches when they appear in the directory.

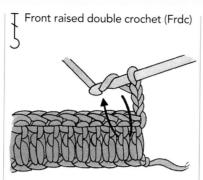

Step 1

Wrap the yarn over the hook, insert the hook from the front to the back at right of the next stitch, and bring it out at left of the same stitch. The hook is now round the stem of the stitch.

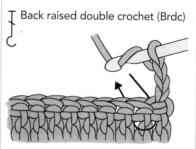

Step 1

Wrap the yarn over the hook, insert the hook from the back through to the front at right of the next stitch, and through to the back again at left of the same stitch.

Step 2

Complete the double in the usual way. A ridge forms on the other side of the work.

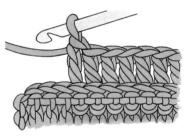

Step 2

Complete the double in the usual way. A ridge forms on the side of the work facing you.

Working several stitches in the same place

This technique is used to increase the total number of stitches when shaping a garment or other item. Increases may be worked at the edges of flat pieces, or at any point along a row.

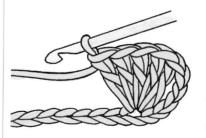

Fans and shells

Two, three, or more stitches may be worked into the same place to make a fan of stitches, often also called a shell. The total number of stitches is increased, so when working a stitch pattern other stitches are worked together or skipped to compensate. See the Fans and Shells section of the directory (pages 56–83) to find many stitches that use this technique.

Here, five double crochet stitches are shown worked into the same foundation chain, making a shell.

Working several stitches together

Two or more stitches may be joined together at the top to decrease the total number of stitches when shaping the work, using the same method as for clusters, see right.

Joining groups of stitches together makes several decorative stitch formations: clusters, puffs, bobbles, and popcorns. These add beautiful features to crochet stitches and feature repeatedly in the directory. Check out the Clusters, Puffs, and Bobbles section (pages 84–103) to really get into using this technique.

Cluster (CI)

A cluster is a group of stitches joined closely together at the top. This can be denoted in the pattern using the abbreviation "tog" along with the type and number of stitches, for example a cluster made from 4 double crochet stitches worked together would be shown as dc4tog. (The term "cluster" is sometimes also used for groups joined at both top and bottom.)

Puff

A puff is normally a group of three or more half double crochet stitches joined at both top and bottom (a three-halfdouble puff [Hdc3tog] is demonstrated below).

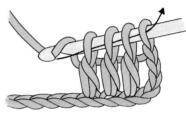

Step 1

Work each of the stitches to be joined up to the last "yo, pull through" that will complete it. One loop from each stitch to be joined should remain on the hook, plus the loop from the previous stitch. Wrap the yarn over the hook once again.

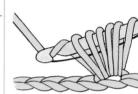

Step 1

*Wrap the yarn over the hook, insert the hook where required, draw through a loop, repeat from * two (or more) times in the same place. You now have seven loops (or more) on the hook. Wrap the yarn over the hook again, and pull through all the loops on the hook.

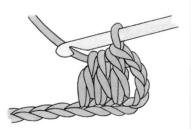

Step 2

Pull a loop through all the loops on the hook. One loop now remains on the hook. Three double crochet stitches are shown here worked together, but any number of any type of stitch may be worked together in a similar way.

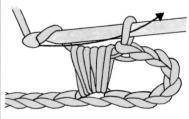

Step 2

Often, one chain is worked in order to close the puff.

Bobble

A bobble is usually a group of several double crochet stitches (or longer stitches) joined at both top and bottom. It is often surrounded by shorter stitches, and worked on a wrong-side row (a three-double crochet bobble is demonstrated here).

Popcorn (Pc)

A popcorn is formed when several complete double crochet stitches (or longer stitches) are worked in the same place, and the top of the first stitch is joined to the last to make a "cup" shape.

A four-double crochet popcorn is shown here.

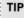

Sometimes the closing stitch of a popcorn is worked through the back loop only of the first stitch of the group and sometimes through the stitch made just before the group.

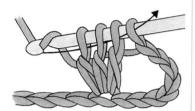

Step 1

*Wrap the yarn over the hook, insert the hook where required, pull a loop through, wrap the yarn over the hook, pull through the first two loops, repeat from * two (or more) times in the same place. Wrap the yarn over the hook, and pull through all loops.

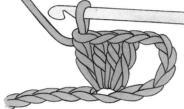

Step 1

Work four doubles (or the number required) in the same place.

Step 3

Pull this loop through to close the top of the popcorn.

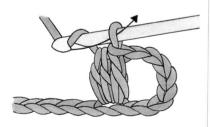

Step 2

Work one chain to close.

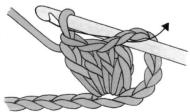

Step 2

Slip the last loop off the hook. Reinsert the hook in the top of the first double of the group, as shown, and catch the empty loop. (On a wrong-side row, reinsert the hook from the back, to push the popcorn to the right side of the work.)

Special formations

Picot

A picot is formed by three or more chains closed into a ring with a slip stitch (or a single crochet stitch).

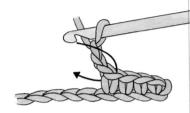

Step 1

Work three chains (or the number required). Insert the hook as instructed. The arrow shows how to insert the hook down through the top of the previous single crochet stitch.

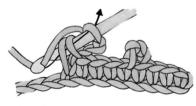

Step 2

Wrap the yarn over the hook and pull through all the loops to close the picot with a slip stitch.

Bullion stitch (Bs)

A bullion stitch is formed by wrapping the yarn several times (normally seven to ten) over the hook, and pulling a loop through.

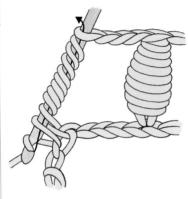

Step 1

Wrap the yarn (not too tightly) as many times as directed over the hook. Insert the hook where required, and pull through a loop. Wrap the yarn over the hook again.

Step 2

Pull through all the loops on the hook. You can ease each loop in turn off the hook, rather than try to pull through all of them at once.

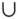

Loop stitch

Sometimes called Fur Stitch, this stitch is normally worked on a wrong-side row, forming a line of loops on the right side of the work.

It may be worked as a single row, to form a fringe, or repeated as on page 137.

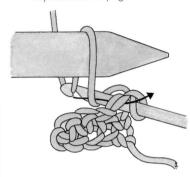

Step 1

Insert the hook in the usual way, wrap the yarn around the left-hand forefinger, or a large rod as shown here, and catch both threads below the finger or rod with the hook to pull them through the work.

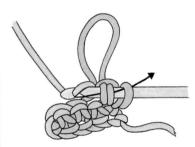

Step 2

Wrap the yarn over the hook again, and pull it through all the loops on the hook.

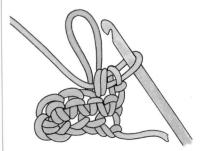

Step 3

The loop is now firmly anchored. Repeat to the left as required.

\int

Solomon's knot (Sk)

A Solomon's knot (see page 150) is simply a lengthened chain stitch, locked in place with a single crochet stitch in the back loop.

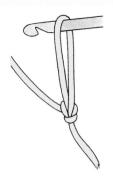

Step 1

Work one chain, and lengthen it as required: normally about $\frac{1}{2}$ to $\frac{1}{2}$ in. (10–15 mm).

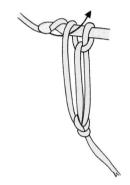

Step 3

Insert the hook under this separate thread, wrap the yarn over the hook, and pull through the first loop.

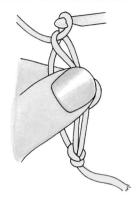

Step 2

Wrap the yarn over the hook and pull through, keeping this loop to a normal size. Hold the lengthened first chain separate from the thread leading to the new loop.

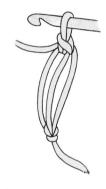

Step 4

Wrap the yarn over the hook again and pull through both loops to complete the knot.

Variation on the foundation chain

Double foundation chain

This foundation chain is more elastic than a single chain, and easier to count.

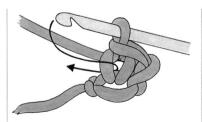

Step 1

Make two chains. Work one single crochet in the first chain made.

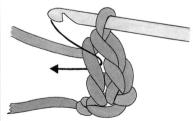

Step 2

Inserting the hook under the left-hand thread of the last single crochet made, work another single crochet. Repeat Step 2 as required.

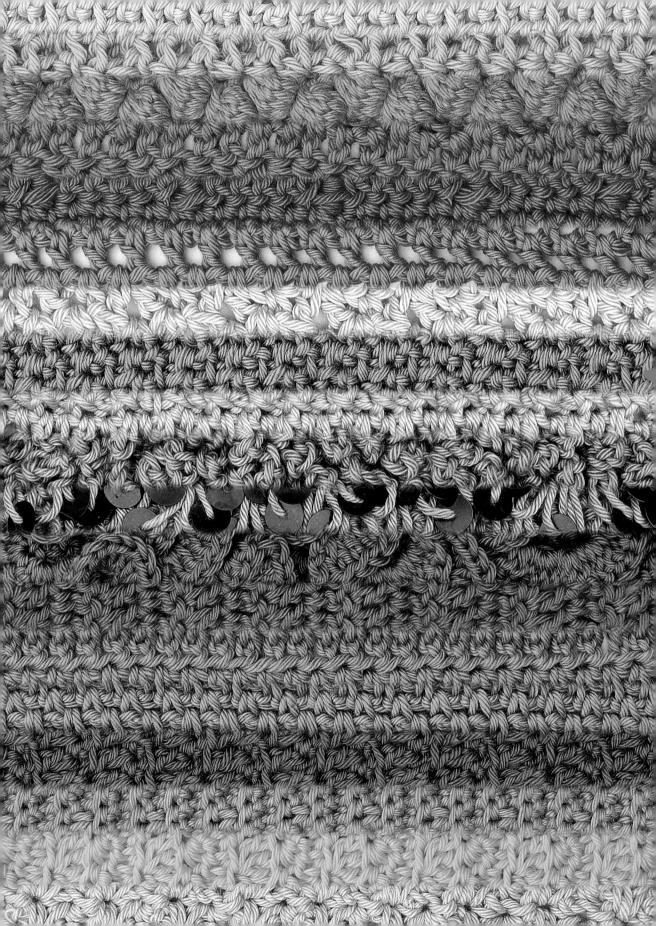

2 Directory of stitches

It's time to dive into the Directory of Stitches and the 200 crochet stiches that you'll find within. Learn how to build a sturdy and hard-wearing fabric from single crochet stitches, create a fun, multi-colored pattern of spikes or chevrons, make a beautiful and delicate filet fabric, or embellish your pieces with bobbles, popcorns, or sequins. The directory is divided into nine families of stitches to help you to easily find the perfect one to suit your peroject. Whether you dip in and out or work your way through a complete section to really master one technique, get ready to create some stunning crochet creations.

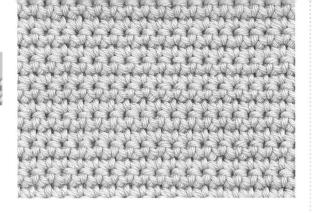

1 Single Crochet

Single crochet is the first stitch to learn. It is the simplest and the shortest stitch after the slip stitch (see page 23). It is easily recognized by its dense pattern and creates a sturdy fabric, making it an ideal choice for bags and pillows.

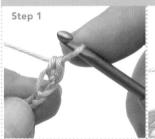

Multiple Any number of sts.

Step 1 (row 1) 1sc in 2nd ch from hook.

Step 2 (row 1 cont.) 1sc in every ch to end, turn.

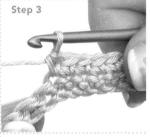

Step 3 (row 2) Ch 1 (does not count as st), 1sc in every sc to end of row, inserting hook from front to back under both loops of each st—this looks like a "V," turn.

Step 4 Repeat Step 3.

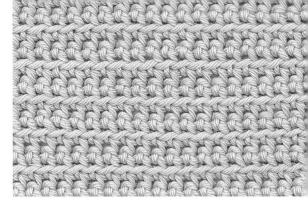

2 Front Loop Single Crochet

Front loop single crochet is a simple variation on the basic single crochet stitch (see stitch 1, left). It will create a slightly more textured fabric and lends itself to being worked in pure cotton yarns. It is easier to recognize the number of rows you have worked in this stitch.

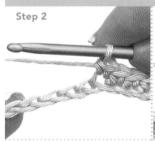

Multiple Any number of sts.

Step 1 (row 1) 1sc in 2nd ch from hook.

Step 2 (row 1 cont.) 1sc in every ch to end, turn.

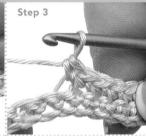

Step 3 (row 2) Ch 1 (does not count as st), 1sc in front loop only of every sc to end of row, turn.

Step 4 Repeat Step 3.

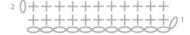

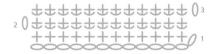

3 Back Loop Single Crochet

Back loop single crochet is a really useful stitch. It can be recognized by the ridges that it produces and looks more difficult to work than it is. The ribbed appearance of the fabric makes it ideal for scarves and pillows. It can be particularly effective when worked in blocks of different colors.

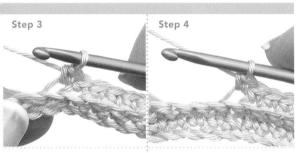

Multiple Any number of sts.

Step 1 (row 1) 1sc in 2nd ch from hook.

Step 2 (row 1 cont.) 1sc in every ch to end, turn.

Step 3 (row 2) Ch1 (does not count as st), 1sc in back loop only of every sc to end of row, turn.

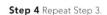

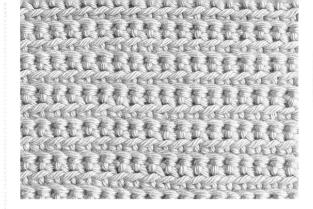

4 Front and Back Loop Single Crochet

This is a stitch that combines the front loop and back loop single crochet techniques. It is not as deeply textured as back loop single crochet (see stitch 3, left), but it still creates a ridged or furrowed fabric. Its effect can be increased by working in stripes of different colors.

Multiple Any number of sts.

Step 1 1sc in 2nd ch from hook, 1sc in every ch to end of row, turn.

Step 2 Ch1 (does not count as st), 1sc in front loop only of every sc to end, turn.

Step 3 Ch1 (does not count as st), 1sc in back loop only of every sc to end of row, turn.

Step 4 Repeat Steps 2 and 3.

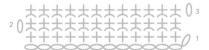

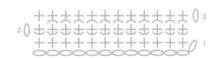

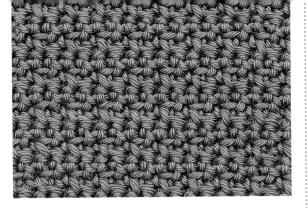

5 Alternate Single Crochet

This stitch combines the techniques of front loop and back loop single crochet stitches (see stitches 2 and 3, pages 34–35) in one row. The alternating of front and back loop single crochet stitches produces a more defined version of basic single crochet. This stitch looks best when worked in smooth cotton yarns.

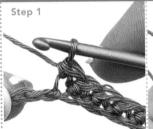

Multiple 2 sts, plus 1 for the foundation chain.

Step 1 1sc in 2nd ch from hook, 1sc in every ch to end of row, turn.

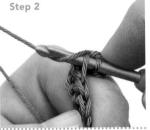

Step 2 Ch1 (does not count as st), *1sc in front loop only of next st, 1sc in back loop only of next st; rep from * to end, turn.

Step 3 Repeat Step 2.

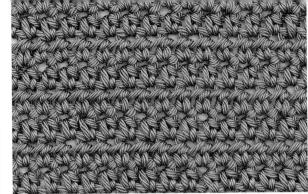

6 Half Double Crochet

Half double crochet is a very pleasing stitch to work. As the name implies, it stands halfway between a single and a double crochet and is often used to bridge the gap between these two stitches. However, it is also a popular choice for creating a solid fabric and has a better drape than single crochet.

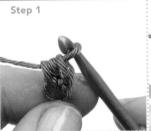

Multiple Any number of sts, plus 1 for the foundation chain.

Step 1 (row 1) 1hdc in 3rd ch from hook.

Step 2 (row 1 cont.) 1hdc in every ch to end of row, turn.

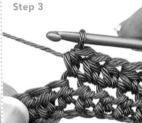

Step 3 (row 2) Ch2 (does not count as st), 1hdc in every hdc to end of row, inserting the hook from front to back under both loops of each st—this looks like a "V," turn.

Step 4 Repeat Step 3.

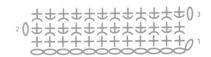

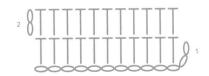

7 Double Crochet

Double crochet is probably the most well known and most commonly used of all the crochet stitches. It does not create such a solid fabric as the single crochet and half double crochet, but it has a really good drape. It is also the stitch that many other techniques, such as clusters, motifs, lace, and filet, are based on.

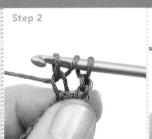

Multiple Any number of sts, plus 2 for the foundation chain.

Step 1 (row 1) 1dc in 4th ch from hook.

Step 2 (row 1 cont.) 1dc in every ch to end of row, turn.

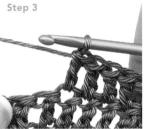

Step 3 (row 2) Ch3 (counts as first st), 1dc in every dc to end of row, inserting the hook from front to back under both loops of each st—this looks like a "V," 1dc in 3rd of ch-3, turn

Step 4 Repeat Step 3.

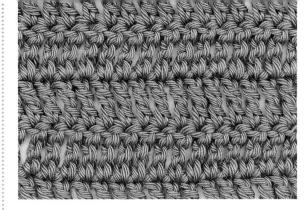

8 Treble Crochet

Treble crochet is the tallest of the most commonly used basic stitches. It is much less stable than the other three and so tends to be used as part of a pattern, supported by other stitches, rather than on its own. It is similar to double crochet since the number of turning chain stitches count as a stitch and so the first st in a row should be skipped and compensated for by working into the turning chain at the end of subsequent rows.

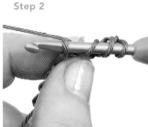

Multiple Any number of sts, plus 3 for the foundation chain.

Step 1 (row 1) 1tr in 5th ch from hook.

Step 2 (row 1 cont.) 1tr in every ch to end of row, turn.

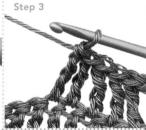

Step 3 (row 2) Ch4 (counts as first st), 1tr in every tr to end of row, inserting the hook from front to back under both loops of each st—this looks like a "V," 1tr in 4th of ch-4, turn.

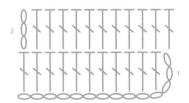

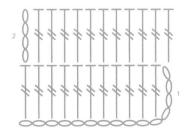

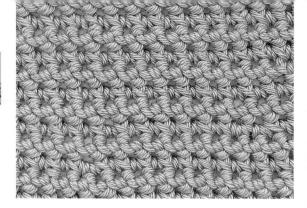

9 Paired Single

This stitch works by joining pairs of single crochet stitches together. The stitch count is maintained by working twice into each stitch along the row to compensate for working two stitches together. It is a much more open stitch than basic single crochet (see stitch 1, page 34) and produces a slightly ridged fabric. Care should be taken to ensure that you work into the turning chain at the end of each row.

Step 3

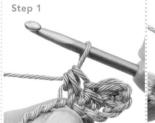

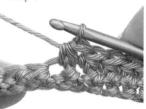

Multiple Any number of sts, plus 1 for the foundation chain.

Step 1 (row 1) Sc2tog over 2nd and 3rd ch from hook.

Step 2 (row 1 cont.) *Sc2tog by inserting hook in same ch as last st, then in next ch; rep from * to end, turn.

Step 3 (row 2) Ch1, sc2tog over first and 2nd sc2tog from previous row, *sc2tog by inserting hook in same place as last st, then in next sc2tog; rep from * to last sc2tog, sc2tog over last sc2tog and ch-1, turn.

Step 4 Repeat Step 3.

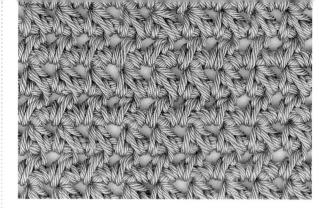

10 Paired Half Double

This stitch works by joining pairs of half double crochet stitches (see stitch 6, page 36) together. The stitch count is maintained by working twice into each stitch along the row to compensate for working two stitches together. The clusters produced by working two stitches together are more pronounced in this version and although the overall structure is less stable, it has excellent drape. Again, care should be taken to ensure that you work into the turning chain at the end of each row.

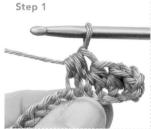

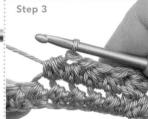

Multiple Any number of sts, plus 2 for the foundation chain.

Step 1 (row 1) Hdc2tog over 3rd and 4th ch from the hook.

Step 2 (row 1 cont.)
*Hdc2tog by inserting hook in same ch as last st, then in next ch; rep from * to end, turn.

Step 3 (row 2) Ch2, hdc2tog over the first and 2nd hdc2tog of previous row, continue to work hdc2tog by inserting hook in st just worked and then in next hdc2tog, working final st in tch, turn.

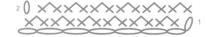

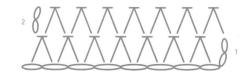

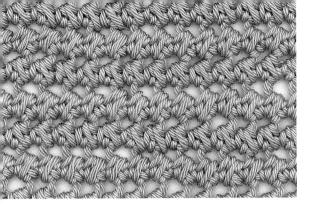

11 Staggered Half Double Pairs

The staggered half double pairs stitch produces a supple and softly textured fabric that would work well on a child's blanket. It follows the same principle of paired single crochet (see stitch 9, left) by working twice into one stitch, but this time you are working into chain spaces and replacing decreased stitches with a chain. This stitch would work well with several yarn weights.

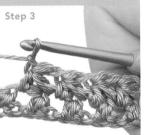

Multiple An even number of sts, plus 1 for the foundation chain.

Step 1 (row 1) Hdc2tog over 3rd and 4th ch from hook.

Step 2 (row 1 cont.) *Ch1, hdc2tog by inserting hook in next 2ch; rep from * to last ch, ch1, 1hdc in last ch, turn. **Step 3** (row 2) Ch2, hdc2tog over first and 2nd ch sp, *ch1, hdc2tog by inserting hook in same ch sp as last st, then in next ch sp; rep from * working 2nd leg of last hdc2tog under tch of previous row, ch1, 1hdc in 2nd ch of tch, turn.

Step 4 Repeat Step 3.

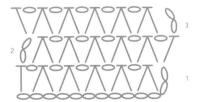

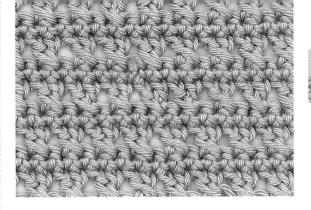

12 Staggered Double Crochet Pairs

Staggered double crochet pairs produces a similarly supple and softly textured fabric to the staggered half double pairs stitch (see stitch 11, left). The increased height of the stitch means that you will create an even more delicate fabric, although some stability is maintained by the "V"-like structure. This stitch would suit all yarn weights and grows very quickly.

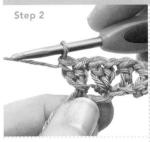

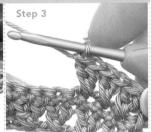

Multiple An even number of sts, plus 2 for the foundation chain.

Step 1 (row 1) Dc2tog over 4th and 5th ch from hook.

Step 2 (row 1 cont.) *Ch1, dc2tog by inserting hook in next 2ch; rep from * to last ch, ch1, 1dc in last ch, turn. **Step 3** (row 2) Ch3, dc2tog over first and 2nd ch sp, *ch1, dc2tog by inserting hook in same ch sp as last st, then in next ch sp; rep from * working 2nd leg of last dc2tog under tch of previous row, ch1, 1dc in 3rd ch of same tch, turn.

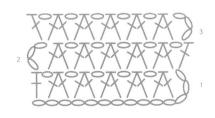

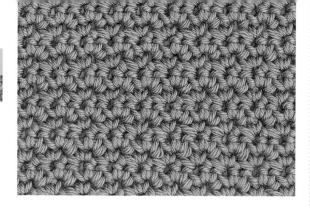

13 Alternate

Alternate stitch is very similar in appearance to basic Single Crochet (see stitch 1, page 34), although it is worked in pairs, rather than single stitches. The result is more defined than the basic version, but just as easy to work. It is important to remember always to work two chains per turning chain at the beginning of each row.

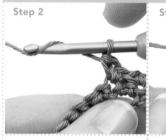

Multiple An odd number of sts.

Step 1 (row 1) 2sc in 3rd ch from hook.

Step 2 (row 1 cont.) *Skip 1ch, 2sc in next ch; rep from * to end, turn.

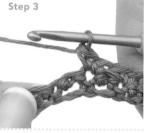

Step 3 (row 2) Ch2, skip first sc, 2sc in next sc, *skip next sc, 2sc in next sc; rep from * to end, turn.

Step 4 Repeat Step 3.

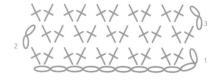

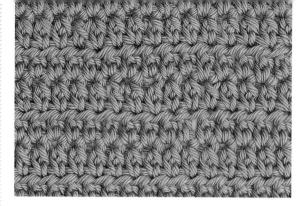

14 Extended Half Double

Extended Half Double crochet is a variation on the basic stitch. It feels very similar to working a Half Double (see stitch 6, page 36) and so care should be taken to remember to pull the yarn through the top of the stitch and then the first loop on the hook, before pulling through all three loops to complete the stitch. The result is a lightweight stitch with lots of drape.

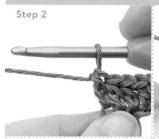

Multiple Any number of sts, plus 2 for the foundation chain.

Step 1 (row 1) 1Exhdc in 4th ch from hook.

Step 2 (row 1 cont.) 1Exhdc in every ch to end of row, turn.

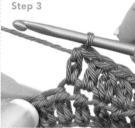

Step 3 (row 2) Ch3 (counts as 1dc), skip first st, 1Exhdc in next and every Exhdc to end of row, 1Exhdc in 3rd of ch-3, turn.

Step 4 Repeat Step 3.

Special stitch EXhdc (Extended half double crochet): yo, insert hook, yo, draw loop through, yo, draw through 1 loop, yo, draw through all 3 loops on hook.

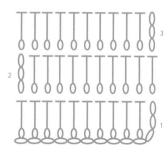

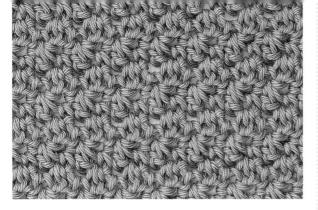

15 Up and Down

Up and Down stitch combines working single and double crochet stitches. Each row of alternating single and doubles is balanced on the following row by working singles into the top of the doubles and doubles into the top of the singles. This is a stitch that benefits from being worked in a pale or neutral color so the subtle texture is not lost.

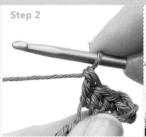

Multiple An even number of sts.

Step 1 (row 1) 1dc in 2nd ch from hook.

Step 2 (row 1 cont.) *1sc in next ch, 1dc in next ch; rep from * to end of row, turn.

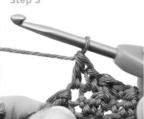

Step 3 (row 2) Ch1, skip first dc, *1dc in next sc, 1sc in next dc; rep from * to end of row, 1dc in tch. turn.

Step 4 Repeat Step 3.

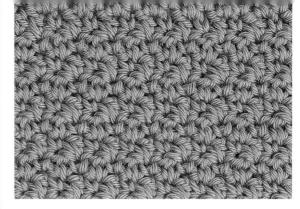

16 Wattle

Wattle stitch is another paired stitch. In this example, a single crochet and a double crochet are linked by a chain. It is quick to work once the foundation row is set up, although it is a good idea to check that you have the correct number of groups of stitches at the end of the row and that you do not miss working into the turning chain.

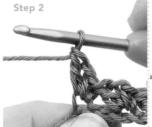

Multiple 3 sts + 2, plus 1 for the foundation chain.

Step 1 (row 1) Skip 2ch (counts as 1sc).

Step 2 (row 1 cont.) *[1sc, ch1, 1dc] in next ch, skip 2ch; rep from * to last ch, 1sc in last ch, turn.

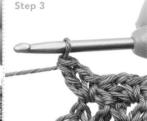

Step 3 (row 2) Ch1 (counts as 1sc) skip first sc and next dc, *[1sc, ch1, 1dc] into next ch sp, skip next sc and next dc; rep from * to last ch sp, [1sc, ch1, 1dc] into last ch sp, skip last sc, 1sc in tch, turn.

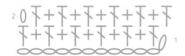

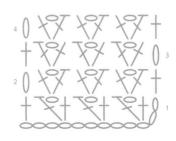

17 Spider

Spider stitch is another stitch that is based on pairing. This time the pairs are split either side of a single chain. It is a good stitch to learn, since the basic structure is common to many other crochet stitches. The result is a very dense pattern that looks best worked in crisp cotton yarns. Stitch definition may be lost on dark colors and so it is best to stick to a paler palette.

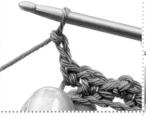

Multiple An odd number of sts, plus 2 for the foundation chain.

Step 1 (row 1) [1sc, ch1, 1sc] in 3rd ch from hook.

Step 2 (row 1 cont.) *Skip 1ch, [1sc, ch1, 1sc] in next sc; rep from * to last 2ch, skip 1ch, 1sc in last ch, turn.

Step 3

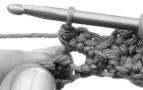

Step 3 (row 2) Ch2, [1sc, ch1, 1sc] in every ch-1 sp; rep from * to end of row, 1sc in tch, turn.

Step 4 Repeat Step 3.

18 Woven

Woven stitch is simple to work, but fairly slow to grow as you are always working into the chain spaces from the row below. It produces a dense, hard-wearing fabric that would be suitable for a range of homeware projects. It lends itself to being worked in a variety of yarn types and weights.

Step 2

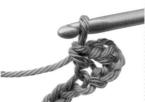

Multiple An even number of sts.

Step 1 (row 1) 1sc in 2nd ch from hook.

Step 2 (row 1 cont.) *Ch1, skip 1ch, 1sc in next ch; rep from * to end, turn.

Step 3

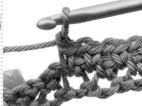

Step 3 (row 2) Ch1, skip first sc, *1sc in ch-1 sp, ch1, skip 1sc; rep from * to end of row, 1sc in ch-1, turn.

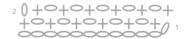

19 Waffle

Waffle stitch is a beautiful stitch. It is deceptively easy to work and produces a lacy, textured fabric that would be ideal for scarves and wraps or larger projects like blankets and throws. It is also suitable for working in a variety of weights of yarn.

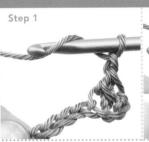

Multiple An odd number of sts, plus 2 for the foundation chain.

Step 1 (row 1) 2 linked exsc in 3rd and 4th ch from hook.

Step 2 (row 1 cont.) *Ch1, 2 linked exsc in each of next 2ch; rep from * to last ch, ch1, 1sc in last ch, turn.

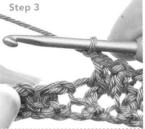

Step 3 (row 2) Ch2, 2 linked exsc in first sc and next ch-sp, *ch1, 2 linked exsc inserting hook to right of next vertical thread (at center of next exsc) and then in next ch-sp; rep from * to last exsc, ch1, 1sc in last exsc, turn.

Step 4 Repeat Step 3.

Special stitch 2 linked exsc (2 linked extended single crochet): Insert hook as instructed, yo, pull through a loop, insert hook in next stitch as instructed, yo, pull through a loop, [yo, pull through 2 loops] twice.

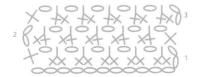

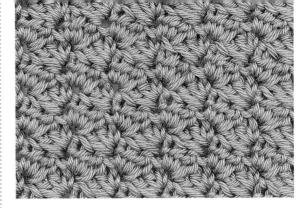

20 Sedge

Sedge stitch is similar to Wattle stitch (see stitch 16, page 41) as it is constructed by off-setting groups of stitches on a row by row basis. It is slightly denser than Wattle stitch though, because no chains are used as part of the group. The result is a strong, durable fabric which is ideal for making bags. This stitch can be varied by replacing the half double with another double. The overall effect of the stitch will be less defined.

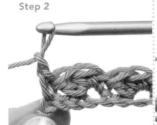

Multiple 3 sts + 1, plus 2 for the foundation chain.

Step 1 (row 1) Skip 2ch (counts as 1sc), [1hdc, 1dc] into next ch.

Step 2 (row 1 cont.) *Skip 2ch, [1sc, 1hdc, 1dc] into next ch; rep from * to last 3ch, skip 2ch, 1sc in last ch, turn.

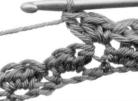

Step 3 (row 2) Ch1 (counts as 1sc), [1hdc, 1dc] into next st, *skip [1dc, 1hdc], work [1sc, 1hdc, 1dc] in next sc; rep from * to last 3 sts, skip [1dc, 1hdc], 1sc in ch-1, turn.

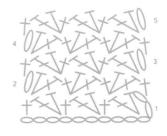

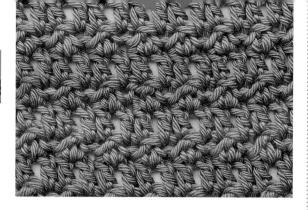

21 Floret

Floret stitch is another stitch that combines different heights of stitch to create an overall pattern. Like Up and Down stitch (see stitch 15, page 41), Floret is worked over two rows. The first row is made by alternating doubles and slip stitches. The second row is worked entirely in doubles. The effect of disrupting the height of the doubles in these rows creates a strongly defined pattern.

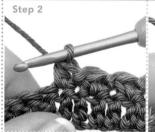

Step 3 Ch3 (counts as 1dc), skip next st, *1dc in next dc,

Multiple 2 sts + 1, plus 2 for the foundation chain.

Step 1 1dc in 4th ch from hook, 1dc in every ch to end of row, turn.

Step 2 Ch1, skip 1 st, *1dc in next st, sl st in next st; rep from * to end, working last sl st in tch, turn.

Step 4 Repeat Steps 2 and 3.

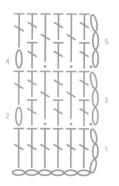

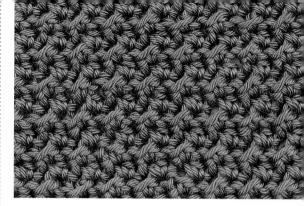

22 Crunch

Crunch stitch is similar to the other stitches that combine different heights of stitch, but unlike the others it is worked over one row only and over an even number of stitches. The first row is made by alternating half doubles and slip stitches. The second row reverses this process by working half doubles into slip stitches and slip stitches into half doubles.

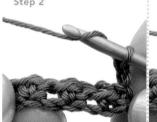

Step 3

Multiple 2 sts, plus 1 for the foundation chain.

Step 1 (row 1) SI st in 3rd ch from hook, (counts as 1hdc).

Step 2 (row 1 cont.) *1hdc in next ch, sl st in next ch; rep from * to last ch, 1 sl st in last ch, turn. **Step 3** (row 2) Ch2, (counts as 1hdc), skip first st, *sl st in next hdc, 1hdc in next sl st; rep from * to end, working last sl st in tch, turn.

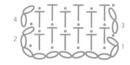

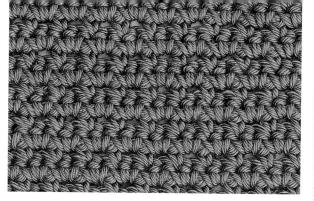

23 Sieve

Sieve stitch is a very finely textured stitch. Its grid-like appearance strongly resembles the square mesh of a household sieve. Unlike some of the other stitches in this section, the pattern is built up over eight rows. This is because rows one through four alternate with rows five through eight.

Step 3

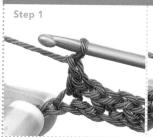

Step 7 (row 6) Ch1, skip first st, 1sc in next st, *ch1, skip next sc, 1sc in next st; rep

Step 1 (base row) 1sc in 2nd ch from hook, *ch1, skip 1ch, 1sc in next ch; rep from * to end, turn.

Multiple 2 sts + 1, plus 1 for

the foundation chain.

Step 2 (row 1) (RS) Ch1, skip first st, *2sc in next ch sp, skip next sc; rep from * to last ch sp, 1sc in last ch sp, 1sc in last sc, turn.

Step 3 (row 2) Ch1, skip first st, 1sc in next st, *ch1, skip next st, 1sc in next sc; rep from * to end, 1sc in tch, turn.

Step 4 (row 3) Ch1, skip first 2 sts, *2sc in next ch sp, skip next sc; rep from * to end, 2sc in tch, turn.

Step 5 (row 4) As Step 3.

Step 6 (row 5) Ch1, 1sc in first st, *skip next sc, 2sc in next ch sp; rep from * to end, working last 2sc in tch, turn.

from * to end, working last sc in tch, turn.

Step 8 (row 7) Ch1, skip first st, 1sc in next ch sp, *skip next sc, 2sc in next st; rep from * ending skip last sc, 1sc in tch, turn.

Step 9 (row 8) Ch1, 1sc in first st, *ch1, skip 1sc, 1sc in next sc; rep from * to end working last sc in tch, turn.

Step 10 Repeat Steps 2-9.

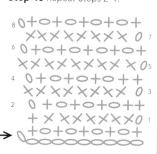

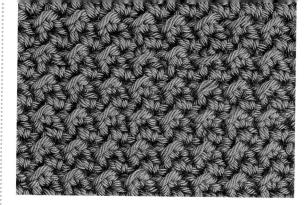

24 Grit

Grit stitch is another softly textured stitch that is based on repeating a one-row pattern. For a smoother version, simply replace each double with a single crochet. This stitch would work well for a variety of different-sized projects and is probably best worked in medium-weight, pale cotton yarn.

Step 2

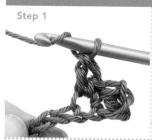

Multiple 2 + 1, plus 2 for the foundation chain.

Step 1 Skip first 2ch (counts as 1sc), 1dc in next ch, *skip next ch, 1sc and 1dc in next ch; rep from * to last 2ch, skip next ch, 1sc in last ch, turn.

Step 2 Ch1 (counts as 1sc) 1dc in first st, *skip next dc, 1sc and 1dc in next sc; rep from * to last 2 sts, skip next dc, 1sc in tch, turn.

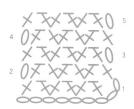

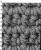

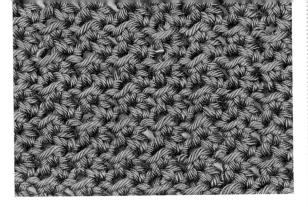

25 Moss

This is a really attractive stitch based on a similar construction to Crunch stitch (see stitch 22, page 44). The difference lies in the number of turning chains worked at the beginning of each row. Only one chain is worked at the beginning of Moss stitch rows which has the effect of creating strong columns of stitches. It is a good idea to check your stitch count regularly.

Step 3

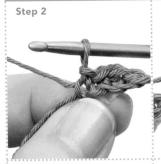

Step 3 (row 2) Ch1, *sl st in next hdc, 1hdc in next sl st; rep from * to end, working last sl st in tch,

turn.

) *1hdc in Step 4 Repeat Step 3. ch; rep

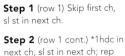

Multiple 2 sts.

from * to end, turn.

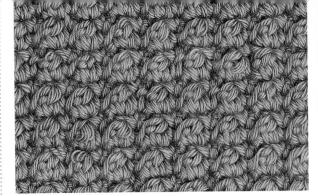

26 Even Berry

Even Berry stitch might be described as an extension of Moss stitch (see stitch 25, left), but with three notable differences. It is built from a foundation row of single crochet, has two pattern rows and the texture is built up from rows and columns of "berries." Each berry is made from a cluster of loops which alternate with slip stitches, giving further definition to the texture of each berry.

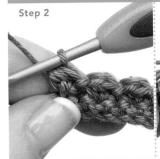

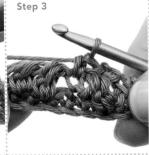

Multiple 2 sts.

Step 1 1sc in 3rd ch from hook, 1sc in each ch to end, turn.

Step 2 Ch1 (counts as first sl st), skip first sc, *1Berry st in next sc, sl st in next sc; rep from * working final sl st in tch, turn.

Step 3 Ch1 (counts as first sc), skip first st, *sl st in top of next Berry st, 1sc in next sl st; rep from * to end, turn.

Step 4 Ch1 (counts as first sl st), *1Berry st in next sl st, sl st in next sc; rep from * to end, turn.

Step 5 Repeat Steps 3 and 4.

Special stitch Berry st: yo, insert in next sc, yo and pull through a loop, yo and insert back in same st, yo and pull through all 5 loops on hook, ch1 to secure.

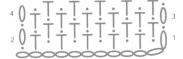

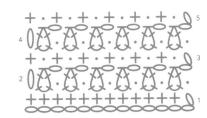

27 Uneven Berry

Jneven Berry stitch is a variation of the previous stitch. It is built from a foundation row of single crochet, but has four pattern rows and this time the berries are offset, creating an even more densely textured pattern. This would be a good stitch to use in homewares projects.

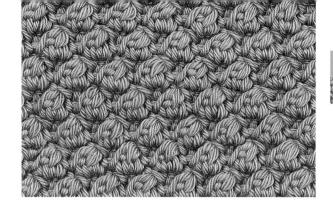

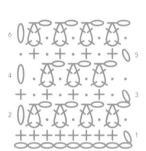

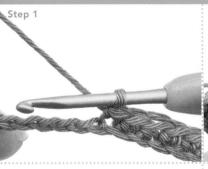

Step 3

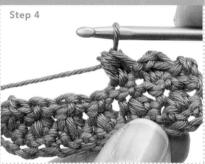

Multiple 2 sts.

Step 1 1sc in 3rd ch from hook, 1sc in each ch to end, turn.

Step 2 Ch1 (counts as first sl st), skip first sc, *1Berry st in next sc, sl st in next sc; rep from * working final sl st in tch, turn.

Step 3 Ch1 (counts as first sc), skip first st, *sl st in top of next Berry st, 1sc in next sl st; rep from * to end, turn.

Step 4 Ch1 (counts as first Berry st), *sl st in next sl st, *1Berry st in next sc, sl st in next sl st; rep from * to last st, sl st in last st, turn.

Step 5 Ch1, skip first st, *1sc in next sl st, sl st in next Berry st; rep from * to end, turn.

Step 6 Repeat Steps 2–5.

Special stitch Berry st: yo and insert hook in next st, yo and draw loop through, yo and draw through first loop on hook, yo and insert hook into same st, yo and draw loop through, yo and draw through all 5 loops, ch1 to secure.

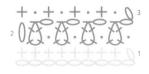

Steps 2–3

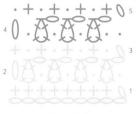

Steps 4–5

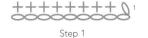

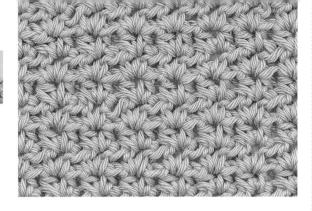

28 Half Double V

Half Double V crochet stitch is similar to Spider stitch (see stitch 17, page 42). However, by using a slightly taller stitch, the resulting fabric is less dense and the overall pattern more clearly defined. It is quicker to work than Spider stitch because the height of the half double makes it easier to work into the chain space.

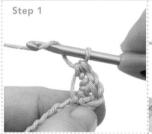

Multiple 2 sts, plus 2 for the foundation chain.

Step 1 [1hdc, ch1, 1hdc] in 4th ch from hook, *skip next ch, [1hdc, ch1, 1hdc] in next ch; rep from * to last 2ch, skip next ch, 1hdc into last ch, turn.

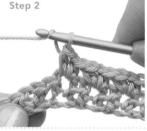

Step 2 Ch 2, *skip next 2 sts, [1hdc, ch1, 1hdc] in next ch sp; rep from * to last hdc, skip next st, 1hdc in tch, turn.

Step 3 Repeat Step 2.

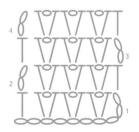

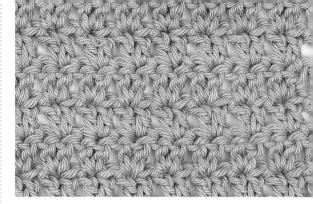

29 Double V

Double V stitch is similar, but not identical to Half Double V stitch (see stitch, 28, left). It is taller and constructed in a slightly different way. In this example, you will be working twice into the space between two stitches to compensate for skipping every alternate stitch, instead of working a chain.

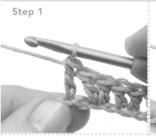

Multiple 2 sts, plus 2 for the foundation chain.

Step 1 2dc in 4th ch from hook, *skip next ch, 2dc in next ch; rep from * to last 2ch, skip next ch, 1dc in last ch, turn.

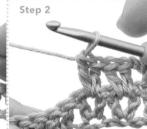

Step 2 Ch3, *skip next 2 sts, 2dc between 2nd skipped st and next st; rep from * to last 2 sts, skip 1 st, 1dc in tch, turn.

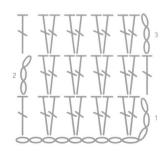

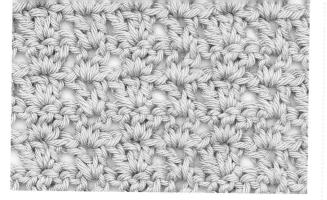

30 Three and Two

Three and Two stitch is an extension of the basic V stitch construction. In this example, the "V" shape is made in one of two ways: either from a group of three doubles or one double, one chain and a double. These groupings are worked alternately across the rows and sit on top of one another in columns. This stitch would suit a variety of yarn weights and depths of color.

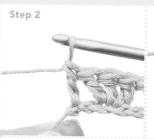

Multiple 6 sts + 2, plus 2 for the foundation chain.

Step 1 V st in 5th ch from hook, *skip 2ch, 3dc in next ch, skip 2ch, V st in next ch; rep from * to last 2ch, skip next ch, 1dc in last ch, turn.

Step 2 Ch3, skip first dc, *3dc into 2nd of next group of 3dc, V st into ch-1 sp of next V st; rep from * to end, 1dc in 3rd of ch-3, turn.

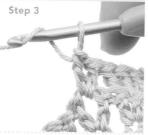

Step 3 Repeat Step 2.

Special stitch V st: [1dc, ch1, 1dc] into next st.

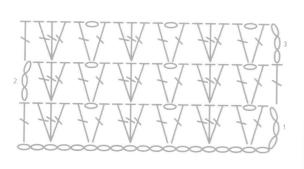

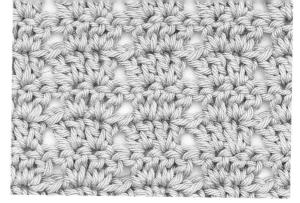

31 Twin V

Twin V stitch might be regarded as an extension of the Double V stitch (see stitch 29, left). While it follows the same basic construction of the Double V, the double pairing of stitches means that the overall appearance of the stitch is much bolder, with defined clusters, rather than a consistently dense patterning.

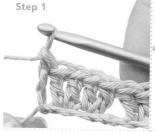

Multiple 4 sts.

Step 1 2dc in 5th ch from hook, 2dc in next ch, *skip next 2ch, 2dc in each of next 2ch; rep from * to last 2ch, skip next ch, 1dc in last ch, turn.

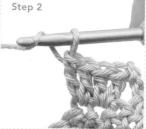

Step 2 Ch3, *skip next 2 sts, 2dc in each of next 2 sts; rep from * to last 2 sts, skip 1 st, 1dc in 3rd of ch-3, turn.

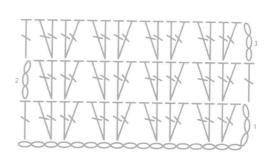

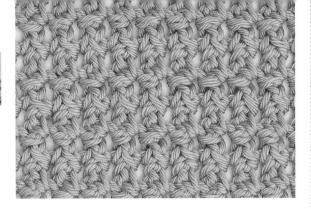

32 Pike

Pike stitch creates a fabric with a very loose structure and excellent drape. This is partly due to the extended method of working a single crochet (see page 24), which makes the stitch taller, and the chains that are worked between the stitches. Its cellular construction would make it an ideal choice for blankets and throws

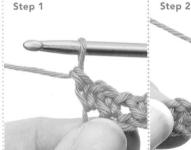

Multiple An even number of sts, plus 2 for the foundation chain.

Step 1 1sc in 2nd ch from hook, *ch1, skip 1ch, 1exsc (see page 24) in next ch; rep from * to end of row, turn.

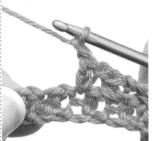

Step 2 Ch3, skip [1exsc, 1ch], *1exsc in next exsc inserting hook to right of single vertical thread, ch1, skip 1ch; rep from * ending 1exsc in 3rd of ch-4, turn.

Step 3 Repeat Step 2 to end of row, ending 1exsc in 2nd of ch-3, turn.

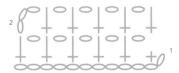

33 Wide Checkers

Wide Checkers is like an extended version of Up and Down stitch (see stitch 15, page 41). In this example, groups of single and double crochet stitches are worked across the rows and then offset on the next row. This is the kind of stitch that is best suited to larger projects in order to appreciate its sense of balance.

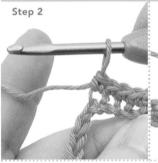

Multiple 10 sts, plus 5 for the foundation chain.

Step 1 1sc in 2nd ch from hook, 1sc in each of next 3ch, *1dc in each of next 5ch, 1sc in each of following 5ch; rep from * to end of row, turn.

Step 2 Ch3, skip first sc, 1dc in each of next 4sc, *1sc in each of next 5dc, 1dc in each of next 5sc; rep from * to end, working last dc in ch-1, turn.

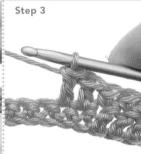

Step 3 Ch1, skip first dc, 1sc in each of next 4dc, *1dc in each of next 5sc, 1sc in each of next 5dc; rep from * to end, working last sc in tch, turn.

Step 4 Repeat Steps 2 and 3.

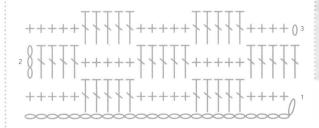

34 Trinity

Trinity stitch has always been an easily recognized and popular crochet stitch. It bears some resemblance to Moss stitch (see stitch 25, page 46), but is created in an entirely different way. Small clusters of stitches are worked closely together, linked by chains. The result looks like a series of small squares, which would work well in a variety of yarns. The stitch can be made more interesting by repeating rows in three different colors.

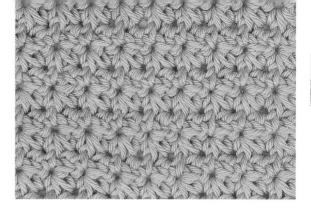

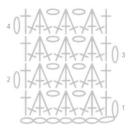

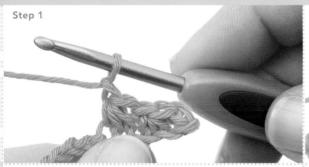

Step 1 1sc in 2nd ch from hook, sc3tog inserting hook in same ch as previous sc and then in next 2ch, *ch1, sc3tog inserting hook in same ch as 3rd leg of previous cl and then in next 2ch; rep from * to last ch, 1sc in same ch as 3rd leg of previous cl, turn.

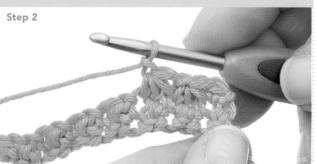

Step 2 Ch1, 1sc in first st, sc3tog inserting hook in same place as previous sc, then in top of next cl and then in next ch sp, *ch1, sc3tog inserting hook in same place as 3rd leg of previous cl, then in top of next cl and then in next ch sp; rep from * to end working 3rd leg of last cl in last sc, 1sc in same place, turn.

Step 3 Repeat Step 2

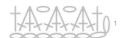

Step 1

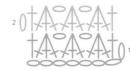

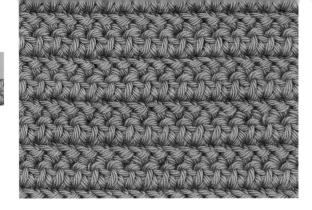

35 Herringbone Half Double

Herringbone patterns are always popular and often used in household items and accessories. This first example provides a firm fabric with a smooth surface that could be accentuated by working in bold stripes of color. It is important to ensure that the final stitch is worked into the top of the turning chain on every row, to maintain a straight edge.

Step 2

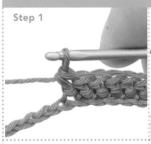

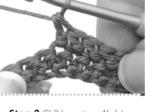

Multiple Any number of sts, plus 1 for the foundation chain.

Step 1 Skip first 2ch, 1Hbhdc in next and every ch to end, turn.

Step 2 Ch2 (counts as 1hdc), skip first st, 1Hbhdc in next and every Hbhdc to end of row, working last Hbhdc in tch, turn.

Step 3 Repeat Step 2.

Special stitch Hbhdc (herringbone half double crochet): yo, insert hook into next ch, yo and pull through the chain and first loop on the hook, yo and draw through both loops on hook.

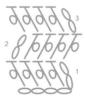

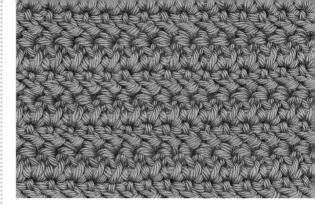

36 Herringbone Double

The Herringbone Double is worked in a similar way to the half double version (see stitch 35, left). The main difference is that by using a slightly taller stitch, the depth of each row is increased and the patterning is more clearly defined. Again, to maintain a straight edge, it is important to ensure that the final stitch is worked into the top of the turning chain on every row.

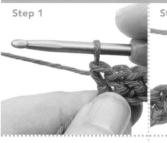

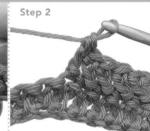

Multiple Any number of sts, plus 2 for the foundation chain.

Step 1 Skip first 3ch, 1Hbdc in next and every ch to end, turn.

Step 2 Ch3 (counts as 1dc), skip first st, 1Hbdc in next and

every Hbdc to end of row, working last Hbdc in tch, turn.

Step 3 Repeat Step 2.

Special stitch Hbdc

(herringbone double crochet): yo, insert hook into next chain, yo and pull through the chain and the first loop on the hook, yo and draw through 1 more loop on the hook, yo and draw through both loops on hook.

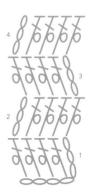

37 Linked Half Double

Linked Half Double is a really pleasing stitch once you have understood the technique. The half double is created by linking back into the base of the stitch that you have just worked. The single vertical thread that is referred to as part of the stitch is the loop that sits at the base of the completed stitch. Take care to ensure that you work into the turning chain on every row as this will count toward the final stitch count.

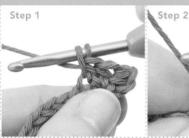

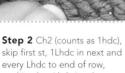

Note To make first Lhdc at beginning of row, treat 2nd ch from hook as the single

Step 1 1Lhdc in 3rd ch from hook (picking up loop through 2nd ch from hook), 1Lhdc in next and every ch to end, turn.

Multiple Any number of sts,

plus 1 for the foundation

chain.

vertical thread.

working last Lhdc in tch, turn.

Step 3 Repeat Step 2.

Special stitch Lhdc (linked half double crochet): insert hook into single diagonal thread at left-hand side of previous st, yo, draw loop through, insert hook into next st, yo, draw loop through st, yo, draw through all 3 loops on hook.

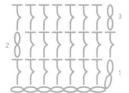

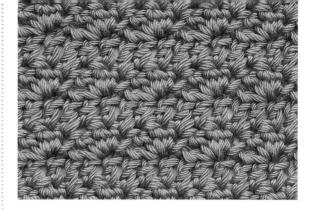

38 Silt

Silt stitch is easy to work and grows quickly. The two-row repeat produces a softly sculpted fabric that is best worked in crisp cotton yarns. This stitch is ideal for larger projects as the subtle patterning would be lost over a small area. Further emphasis could be achieved by working right-side rows in one color and wrong-side rows in another.

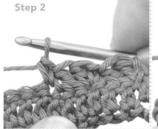

Step 2 (cont.)

Multiple 3 sts + 1, plus 2 for the foundation chain.

Step 1 1dc in 4th ch from hook, 1dc in every ch to end, turn.

Step 2 Ch1 (counts as 1sc), 2dc in first st, *skip 2 sts, [1sc, 2dc] in next st; rep from * to last 3 sts, skip 2 sts, 1sc in tch, turn.

Step 3 Ch3 (counts as 1dc), skip next st, 1dc in every st to end of row, working last dc in tch, turn.

Step 4 Repeat Steps 2 and 3.

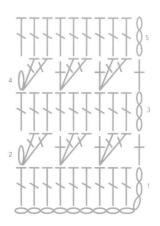

39 Granule

This is a fun and interesting stitch to work and good preparation for understanding how bobbles are constructed later on. The knobbly texture is built up by introducing little picots into the structure. These picots are made by working additional chain as part of a single crochet. Once the stitch is completed, the following single crochet helps to anchor the chain and create a tiny bobble. Once you have mastered the technique, try working the picots in a contrasting yarn to maximize their effect.

Special stitch Psc (picot single crochet): insert hook into designated st, yo, draw loop through, [yo, draw through 1 loop] 3 times to make 3ch, yo, draw through both loops on hook. You will need to draw the picot chain loops to the back, i.e., the RS of the work.

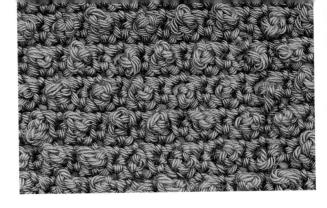

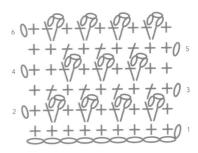

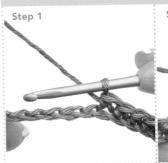

Multiple 4 sts + 1, plus 1 for the foundation chain.

Step 1 1sc in 2nd ch from hook, 1sc in every ch to end of row, turn.

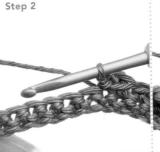

Step 2 Ch1, 1sc in first st, *1Psc in next st, 1sc in next st; rep from * to end of row, turn.

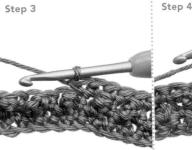

Step 3 Ch1, 1sc in every st to end of row, turn.

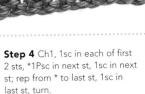

Step 5 Ch1, 1sc in every st to end of row, turn.

Step 6 Repeat Steps 2-5.

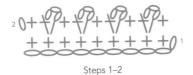

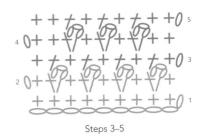

40 Diagonal Trip

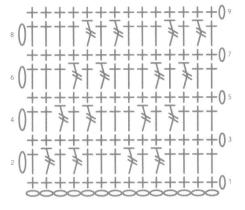

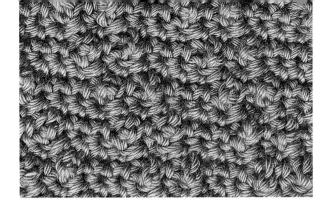

Diagonal Trip stitch is quite a surprising stitch, since it combines one short stitch—single crochet, with one much taller stitch—treble. In the six-stitch sequence there are four single crochet to two trebles. This ratio allows the single crochet to anchor the taller stitches and squash them down to form what appears to be a small bobble or picot. The result is very effective and a really simple way of adding texture to a basic fabric. This stitch is suited to many different yarn weights and would look equally attractive in a crisp, pale cotton or a chunky tweed.

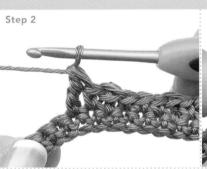

Step 3

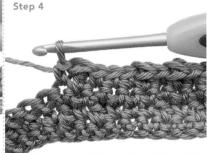

Multiple 6 sts + 2, plus 1 for the foundation chain.

Step 1 (RS) 1sc in 2nd ch from hook, 1sc in every ch to end of row, turn.

Step 2 Ch1, 1sc in first st, *1tr in next st, 1sc in next st, 1tr in next st, 1sc in each of next 3 sts; rep from * to last st, 1sc in last st, turn.

Step 3 Ch1, 1sc in first st, 1sc in every st to end of row, turn.

Step 4 Ch1, 1sc in each of first 2 sts, *1tr in next st, 1sc in next st, 1tr in next st, 1sc in each of next 3 sts; rep from * to end, turn.

Step 5 As Step 3.

Step 6 Ch1, 1sc in each of first 3 sts, *1tr in next st, 1sc in next st, 1tr in next st, 1sc in each of next 3 sts; rep from * to last 5 sts, 1tr in next st, 1sc in next st, 1tr in next st, 1sc in each of next 2 sts, turn.

Step 7 Continue in pattern as set, moving the pairs of tr farther along to the left on every WS row. Continue to work RS rows in sc only.

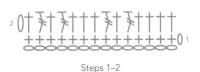

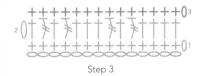

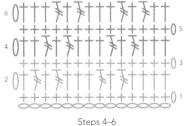

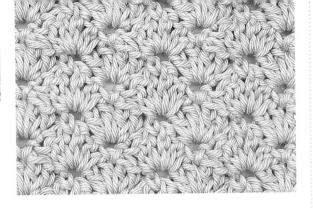

41 Close Scallops

Close Scallops is a very simple stitch, ideal if you are new to this technique. The scallop or fan is made by working four doubles into one stitch, skipping two stitches and then anchoring the scallop with a single crochet. It is a very popular stitch and suitable for all kinds of projects, especially baby clothes and accessories.

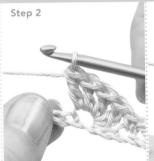

Multiple 6 sts, plus 1 for the foundation chain.

Step 1 (row 1) 2dc in 4th ch from hook, skip 2ch, 1sc in next ch.

Step 2 (row 1 cont.) *Skip 2ch, 4dc in next ch, skip 2ch, 1sc in next ch; rep from * to end, turn.

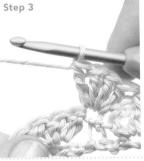

Step 3 (row 2) Ch3, 2dc in first sc, skip 2dc, *1sc between 2nd and 3rd dc of next group, skip 2dc, 4dc in next sc, skip 2dc; rep from * ending 1sc in sp between last dc and ch-3, turn.

Step 4 Repeat Step 3.

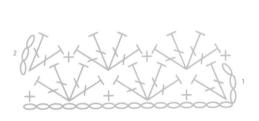

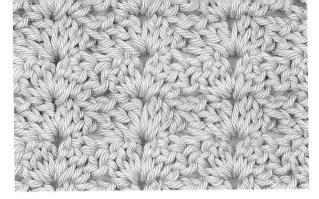

42 Open Scallop

As the name suggests, this is a looser version of the previous stitch. The group of four doubles now has the addition of a chain in the middle of it and the groups are broken up by another grouped stitch. This more open network increases the drape of the fabric and makes it very suitable for shawls, wraps, and scarves.

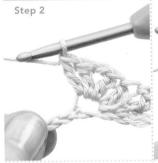

Multiple 6 sts, plus 1 for the foundation chain.

Step 1 (row 1) [2dc, ch1, 2dc] in 4th ch from hook.

Step 2 (row 1 cont.)
*Wdc2tog, [2dc, ch1, 2dc] in
next ch; rep from * to last 3ch,
Wdc2tog working last leg in
last ch, turn.

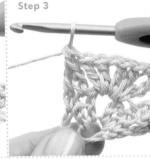

Step 3 (row 2) Ch3, skip 2 sts, 1dc in next dc, *[2dc, ch1, 2dc] in ch-1 sp, Wdc2tog; rep from * working last leg in tch, turn.

Step 4 Repeat Step 3.

Special stitch Wdc2tog (wide double crochet 2 together): *yo, insert hook in next st, yo, pull loop through, yo, pull through first 2 loops**, skip next 3 sts, rep from * to ** in next st, [yo, pull through 2 loops on hook] twice.

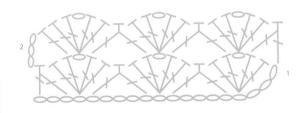

43 Peacock

Peacock stitch, sometimes known as Peacock Fan stitch, is a big stitch made from large clusters of treble crochet. It is constructed in a similar way to Open Scallop stitch (see stitch 42, left), but this stitch has a two-row repeat which helps to provide some stability to the fabric. Suitable for most yarn types, this stitch would look striking in a variegated or self-striping yarn.

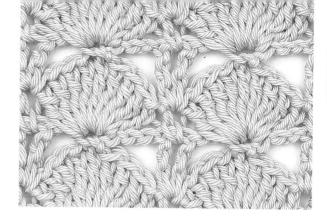

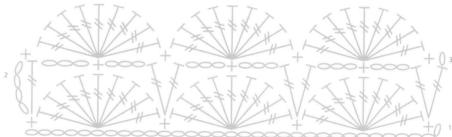

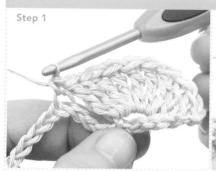

Step 2

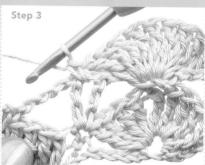

Multiple 10 sts + 1, plus 1 for the foundation chain.

Step 1 1sc in 2nd ch from hook, *skip 4ch, 9tr in next ch, skip 4ch, 1sc in next ch; rep from * to end, turn.

Step 2 Ch4, 1tr in first sc, *ch3, skip 4tr, 1sc in next tr (center tr of 9), ch3, skip 4tr, 2tr in next sc; rep from * ending 2tr in last sc, turn.

Step 3 Ch1, 1sc in sp between first 2tr, *skip 3ch, 9tr in next sc, skip 3ch, 1sc in the sp between 2tr; rep from * ending with 1sc in sp between last tr and tch, turn.

Step 4: Repeat Steps 2 and 3.

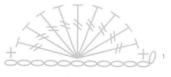

Step 1

Step 2

Step 3

44 Fantail

Fantail is an easily recognized stitch based on a four-row repeat. The pattern is built by offsetting rows of small and large fanlike clusters, held together by a framework of chain. This stitch would work well in a variety of yarns. The patterning could be further emphasized by working rows two and four in one color or type of yarn and then rows three and five in another. When worked over large areas, the stitch has good drape and would make a lovely bedspread.

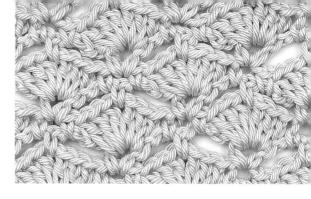

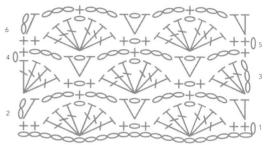

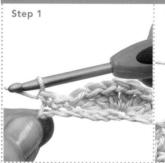

Step 1 1sc in 2nd ch from hook, 1sc in next ch, *skip 3ch, Fan in next ch, skip 3ch, 1sc in next ch, ch1, skip 1ch, 1sc in next ch; rep from * to last 9ch, skip 3ch, Fan in next ch, skip 3ch, 1sc in each of last 2ch, turn.

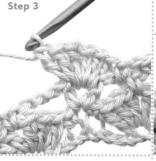

Step 2 Ch2 (counts as 1hdc), 1hdc in first st, *ch3, 1sc in ch sp at center of next Fan, ch3, [1hdc, ch1, 1hdc] in next ch-1 sp; rep from * to last 10 sts, skip next sc, ch3, 1sc in ch sp at center of last Fan, ch3, skip next sc, 2hdc in last sc, turn.

Step 3 Ch3, 3dc in first st, *1sc in next ch-3 arch, ch1, 1sc in next arch, Fan in ch-1 sp; rep from * to last 2 arches, 1sc in next arch, ch1, 1sc in next arch, skip last hdc, 4dc in tch, turn.

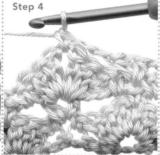

Step 4 Ch1, 1sc in first st, *ch3, [1hdc, ch1, 1hdc] in next ch-1 sp, ch3, 1sc in ch-1 sp at center of next Fan; rep from * to end of row, working last sc in tch, turn.

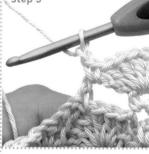

Step 5 Ch1, 1sc in first st, *1sc in next arch, Fan in ch-1 sp, 1sc in next arch, ch1; rep from * ending with 1sc in last arch and 1sc in last sc, turn.

Step 6 Repeat Steps 2–5.

Special stitch Fan: [3dc, 1ch, 3dc].

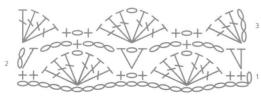

Steps 1-3

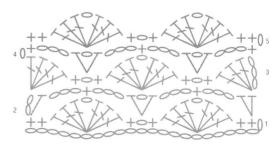

Steps 4-5

45 Dock Leaf

The fans in this highly stylized stitch are given extra emphasis by the three rows of chain that sit below each cluster of stitches. This is not a difficult stitch but it needs to be worked over a large enough area to accommodate the eight-row repeat. It would look beautiful worked in very fine yarn and hung at a window, or used as an overlay. Care should be taken to work into the correct point of the turning chain on every row in order to maintain an accurate stitch count and straight edges.

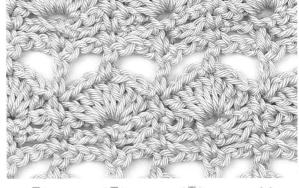

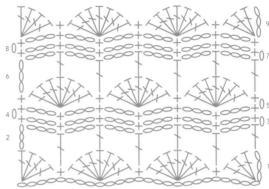

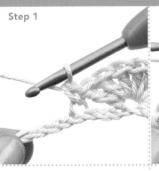

Multiple 8 sts + 4.

Step 1 (row 1) (RS) 3dc in 4th ch from hook, skip 3ch, 1sc in next ch, *skip 3ch, 7dc in next ch, skip 3ch, 1sc in next ch; rep from * to last 4ch, skip 3ch, work 4dc in last ch, turn.

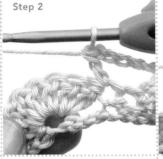

Step 2 (row 2) Ch6 (counts as 1dc, 3ch), 1dc in next sc, *ch3, skip next 3dc, 1dc in next dc, ch3, 1dc in next sc; rep from * to last 4 sts, ch3, 1dc in tch, turn.

Step 3 (row 3) Ch1, *1sc in next dc, ch3; rep from * to last st, 1sc in 3rd of ch-6, turn.

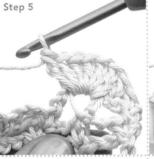

Step 4 (row 4) Ch1, 1sc in first sc, *ch3, 1sc in next sc; rep from * to end of row, turn.

Step 5 (row 5) Ch1, 1sc in first sc, *7dc in next sc, 1sc in next sc; rep from * to end of row, turn

Step 6 (row 6) Ch6 (counts as 1dc, ch3), skip 3dc, 1dc in next dc, *ch3, skip next 3dc, 1dc in next sc, ch3, 1dc in next dc, ch3,

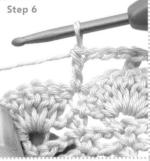

1dc in next sc; rep from * to end, turn.

Step 7 (rows 7–8) As Steps 3 and 4.

Step 8 (row 9) Ch3 (counts as 1dc) 3dc in first sc, 1sc in next sc, *7dc in next sc, 1sc in next sc; rep from * to last sc, 4dc in last sc, turn.

Step 9 Repeat Steps 2-8.

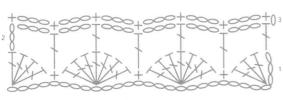

Steps 1-3

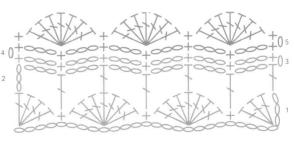

Steps 4-5

46 Picot Fan

Picot Fan stitch is made from extended fans of double crochet that are topped with little picot points. The result is an impressive-looking stitch based on a threerow repeat. It is important to maintain a fairly firm gauge, so that the patterning remains sharp and pleasing to look at. It is also a good idea to work the foundation chain in a slightly different way. Normally you would work through the top loop only of the chains. In this instance, it is better to take in the top loop and the bar that lies underneath. This will help you to avoid unnecessary loops forming along the foundation row at the base of the first set of arches. Due to the size of the fans and the intricate nature of the picots, this stitch is best worked in crisp cottons or silk-based yarns. However, it is suited to all colors depending on the purpose of the project.

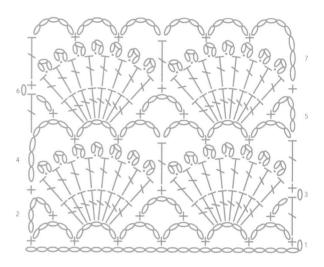

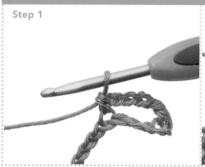

Multiple 12 sts + 1, plus 1 for the foundation chain.

Step 1 (RS) 1sc in 2nd ch from hook, *ch5, skip 3ch, 1sc in next ch; rep from * to end, turn.

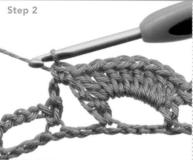

Step 2 Ch5 (counts as 1dc and 2ch), *1sc in next ch-5 arch, 8dc in next arch, 1sc in next arch, ch5; rep from * to last arch, 1sc in last arch, ch2, 1dc in last sc, turn.

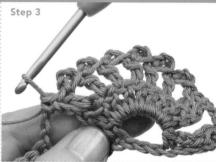

Step 3 Ch1, 1sc in first st, skip [2ch, 1sc], *make a Picot by working [1dc in next dc, 3ch, insert hook down through top of dc just made, sl st to close] 7 times, 1dc in next dc, 1sc in next arch; rep from * to end, turn.

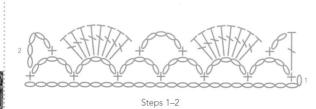

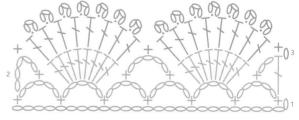

Step 3

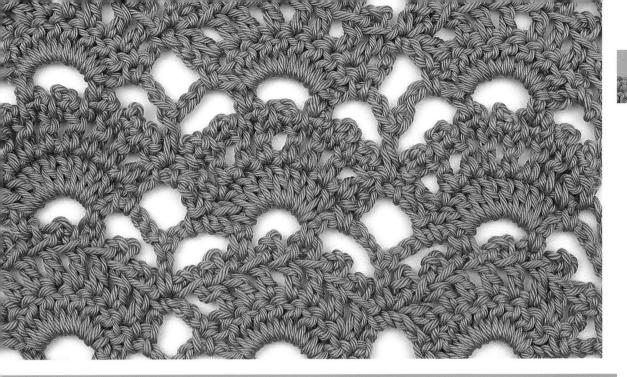

Step 4 Ch8 (counts as 1dc and 1 ch-5 arch), skip next 2 Picots, *1sc in next Picot, ch5, skip 1 Picot, 1sc in next Picot, ch5, skip 2 Picots, 1dc in next sc**, ch5, skip 2 Picots; rep from * ending last rep at **, turn.

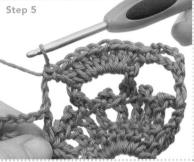

Step 5 Ch5 (counts as 1dc and 2ch), *1sc in next ch-5 arch, 8dc in next arch, 1sc in next arch, ch5; rep from * to last arch, 1sc in last arch, ch2, 1dc in 3rd of ch-8, turn.

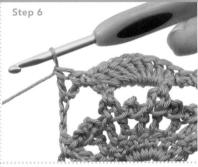

Step 6 Repeat Steps 3–5.

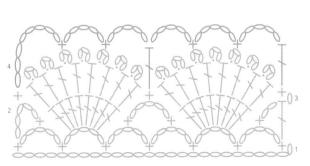

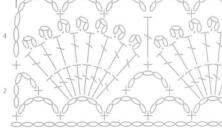

Step 4 Step 5

47 Open Shell and Picot

Open Shell and Picot is a pretty stitch combining double crochet shells and small picot shells. In this example the picot points have a less decorative purpose than they do in Picot Fan stitch. Here they are used to support the larger double crochet shells. So although the overall effect of the stitch is quite delicate, it is also quite strong and so could be used like a mesh stitch in projects like bags. This stitch is probably worked best in light-colored, mediumweight cotton yarn.

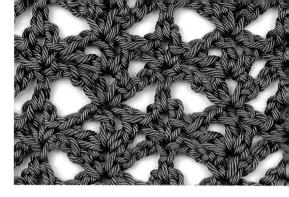

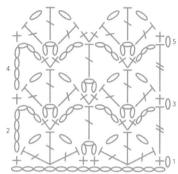

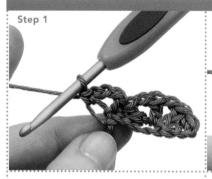

Multiple 7 sts, plus 1 for the foundation

Step 1 (RS) 1sc in 2nd ch from hook, *skip 2ch, [1dc, ch1, 1dc, ch1, 1dc] in next ch, skip 2ch, 1sc in next ch**, ch3, 1sc in next ch; rep from * ending last rep at **, turn.

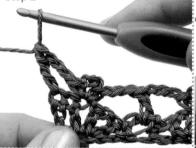

Step 2 Ch7 (counts as 1tr and 3ch), *work [1sc, ch3, 1sc] in center dc of Shell, ch3**, 1dc in next ch-3 arch, ch3; rep from * ending last rep at **, 1tr in last sc, turn.

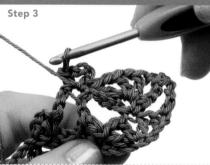

Step 3 Ch1, 1sc in tr, *skip next ch-3 sp, [1dc, ch1, 1dc, ch1, 1dc] in center of next Picot, skip next ch-3 sp** [1sc, 3ch, 1sc] in next dc; rep from * ending last rep at **, 1sc in 4th of ch-7, turn.

Step 4 Repeat Steps 2 and 3.

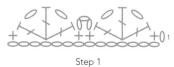

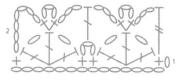

Step 2

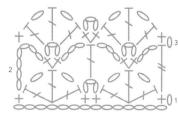

Step 3

48 Picot Ridge

Picot Ridge stitch uses picots to transform a block stitch into a shell shape. This is a fairly complex stitch combining several techniques, including wrapping stitches to add extra texture. This is achieved by wrapping the yarn around the hook and then inserting the hook from in front, and from right to left around the stem of the designated stitch, before completing the stitch in the usual way. This is referred to as a front raised double crochet stitch in the pattern. It is important to maintain a firm gauge while working this four-row pattern repeat. Medium-weight cotton yarns would suit the structure of this stitch.

Special stitch Frdc (front raised double crochet): yo, insert hook (from front) around stem of designated stitch from right to left and back to front, then complete the dc stitch in the usual way.

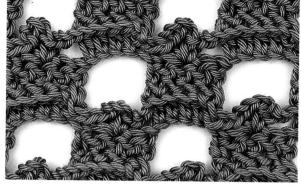

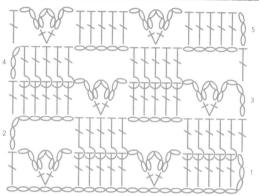

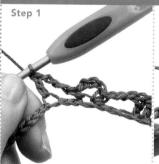

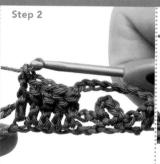

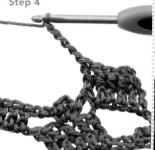

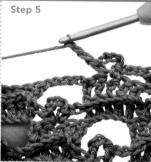

Multiple 10 sts + 2, plus 2 for the foundation chain.

Step 1 (RS) Skip 3ch (counts as 1dc), *1dc in each of next 5ch, ch3, skip 2ch, [1sc, ch4, 1sc] in next ch, ch3, skip 2ch; rep from * to last ch, 1dc in last ch, turn.

Step 2 Ch8 (counts as 1dc and 5ch), skip first dc and next 3 ch sp (arches), *1Frdc around each of next 5 sts, ch5, skip next 3 arches; rep from * to last 5 sts, 1Frdc around each of the next 5 sts, 1dc in tch, turn.

Step 3 Ch6, skip first 3 sts. *[1sc, ch4, 1sc] in next st, ch3, skip 2 sts, 1dc in each of next 5ch**, ch3, skip 2 sts; rep from * ending last rep at **, 1dc in 3rd of ch-8, turn.

Step 4 Ch3 (counts as 1dc), skip first dc *1Frdc around each of next 5 sts, ch5**, skip next

3 arches; rep from * ending last rep at **, skip next 2 arches, 1dc in arch made by tch, turn.

Step 5 Ch3 (counts as 1dc), skip first dc, *1dc in each of next 5ch. ch3, skip 2dc, [1sc, ch4, 1sc] in next st, ch3, skip 2dc; rep from * ending 1dc in tch turn.

Step 6 Repeat Steps 2-5.

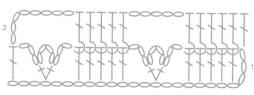

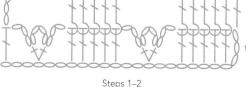

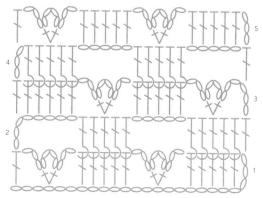

Steps 3-5

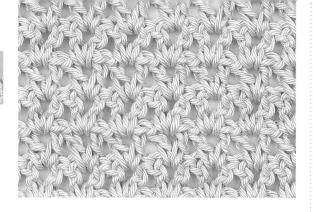

49 Rope

It would be easy to confuse Rope stitch with the Double V stitch that appears in the Basic Stitches section (see stitch 29, page 48). However, in this example the pairs of doubles also include a chain in the middle of them and more stitches are skipped between the pairs. This stitch would work well in a variety of yarns and has excellent drape.

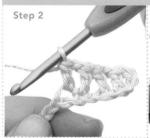

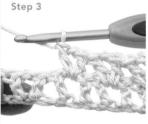

Multiple 3 sts + 2, plus 1 for the foundation chain.

Step 1 (row 1) 1dc in 4th ch from hook, ch1, 1dc in next ch.

Step 2 (row 1 cont.) *Skip 1ch, 1dc in next ch, ch1, 1dc in next ch; rep from * to last ch, 1dc in last ch, turn. **Step 3** (row 2) Ch3, skip first 2dc, *[1dc, ch1, 1dc] in ch-1 sp, skip 2dc; rep from * to last dc, skip last dc, 1dc in tch, turn.

Step 4 Repeat Step 3.

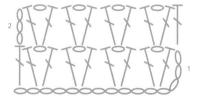

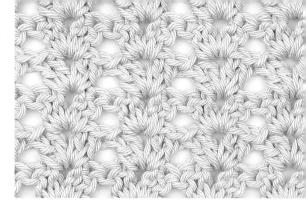

50 Iris

Iris stitch is an elegant stitch with lots of drape. It is similar in construction to Rope stitch (see stitch 49, left) but with two stitches sitting either side of the center chain there is increased stability. This makes the stitch suited to finer, lace-weight yarns Pastels and bright colors would show this stitch off to its best advantage.

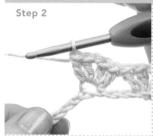

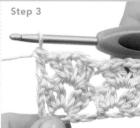

Multiple 4 sts + 1, plus 2 for the foundation chain.

Step 1 (row 1) [2dc, ch1, 2dc] in 5th ch from hook.

Step 2 (row 1 cont.) *Skip 3ch, [2dc, ch1, 2dc] in next ch; rep from * to last 2ch, skip 1ch, 1dc in last ch, turn. Step 3 (row 2) Ch3, skip first 3dc, *[2dc, ch1, 2dc] in ch-1 sp, skip next 4dc; rep from * to last 2dc, skip last 2dc, 1dc in tch, turn.

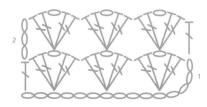

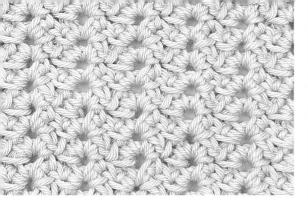

51 Sprig

Sprig stitch is one of the simplest stitches in this section. Worked entirely in chain and single crochet, it creates a much lirmer, denser pattern than is usually associated with fans and shells. It is a good stitch to use to break up large sections of the larger, less stable stitches.

Multiple 4 sts + 2, plus 1 for the foundation chain.

Step 1 (row 1) 2sc in 4th ch from hook, ch2, 2sc in next ch.

Step 2 (row 1 cont.) *Skip 2ch, 2sc in next ch, ch2, 2sc in next ch; rep from * to last 2ch, skip 1ch, 1sc in last ch, turn.

Step 3 (row 2) Ch3, [2sc, ch2, 2sc] in each ch-2 sp, ending 1sc in tch, turn.

Step 4 Repeat Step 3.

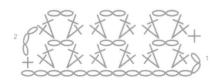

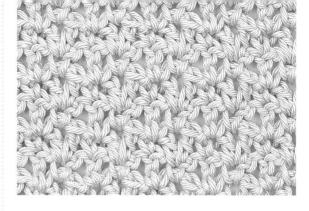

52 Blossom

Blossom stitch is another beautiful stitch combining columns of "V" stitches and chain spaces. It is a fairly dense pattern and so would work well not only in pale cotton-based yarns but also lace-weight yarns. This simple pattern is easy to shape and so very suitable for hats, scarves, and gloves.

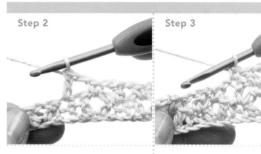

Multiple 4 sts + 1.

Step 1 [1dc, ch1, 1dc] in 3rd ch from hook, *skip 1ch, 1sc in next ch, skip 1ch, [1dc, ch1, 1dc] in next ch; rep from * to last 2ch, skip 1ch, 1sc in last ch, turn.

Step 2 Ch4, skip [first sc, 1dc], *1sc in ch-1 sp, ch1, skip 1dc, 1dc in next sc, ch1, skip 1dc; rep from * to last ch-1 sp and dc, 1sc in last ch-1 sp, ch1, 1dc in last dc, turn.

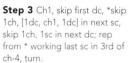

Step 4 Repeat Steps 2 and 3.

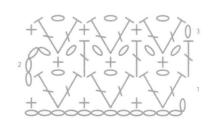

53 Strawberry Lace

I had to include this stitch because it is so pretty. Although it requires some experience, it is based on a four-row repeat, so once you have mastered that, it is simply a case of repeating the pattern of working that you have established. The pattern is built from columns of lacy fans alternating with narrower columns of "V"-type stitches. The "V" stitches help to give the fabric some stability, as well as maintaining its excellent drape. I would recommend working this stitch in a medium-weight yarn before attempting it in anything too fine.

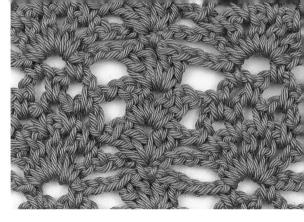

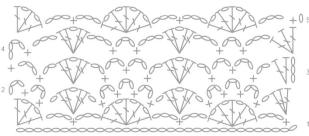

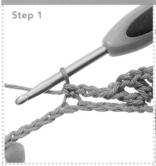

Step 2

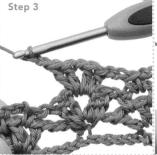

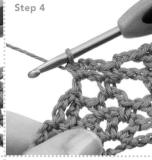

Multiple 12 sts + 8.

Step 1 1sc in 2nd ch from hook, *ch3, skip next 5ch, work [1dc (ch1, 1dc) 4 times] in next ch, ch3, skip 5ch, 1sc in next ch; rep from * to last 6ch, ch3, skip next 5ch, [1dc (ch1, 1dc) twice] in last ch, turn.

Step 2 [Ch3, 1sc in next ch sp] twice, *ch1, skip 3ch, [2dc, ch1, 2dc] in next sc, ch1, skip 3ch, 1sc in next ch sp, [ch3, 1sc in next sp] 3 times; rep from * ending ch1, skip 3ch, 3dc in last sc, turn.

Step 3 Ch3 (counts as 1dc), 2dc in first dc, *ch2, skip 1ch, 1sc in next ch-3 arch**, [ch3, 1sc in next arch] twice, ch2, skip next ch, [2dc, ch1, 2dc] in next ch sp; rep from * ending last rep at **, ch3, 1sc in tch, turn.

Step 4 Ch4, 1sc in next ch-3 arch, *ch3, skip 2ch, [2dc, ch1, 2dc] in next ch sp, ch3, skip 2ch, 1sc in next arch, ch3, 1sc in next arch; rep from * ending ch3, skip 2ch, 3dc in tch, turn.

Step 5 Ch1, 1sc in first dc, *ch3, skip next 3ch, work [1dc (ch1, 1dc) 4 times] in next ch-3 arch, ch3, skip 3ch, 1sc in next ch sp; rep from * to last 3ch, ch3, skip last 3ch, [1dc (ch1, 1dc) twice] in tch, turn.

Step 6 Repeat Steps 2-5.

Steps 1-2

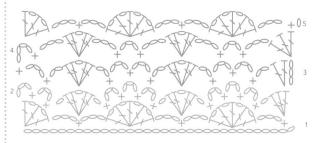

Steps 3-5

54 Crow's Foot Lattice

Crow's Foot Lattice is a distinctive and popular crochet stitch. It is built up over four rows of alternating "V" and fan stitches. The name is derived from the fans which have a treble at their center with a double either side and are separated by single chains. The effect is similar to the kind of print a bird's claw night make. This stitch has a good drape and therefore is suited to a variety of projects including garments and increasonies. It produces an overall pattern that is suited to a variety of weights and colors of yarn.

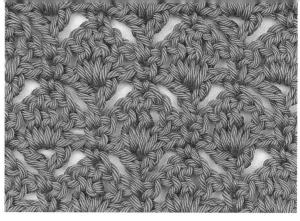

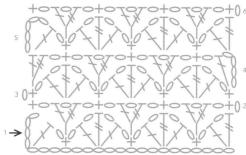

Step 4

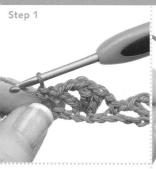

Multiple 4 sts, plus 4 for the foundation chain.

Step 1 (WS) Skip 4ch (counts as 1tr and 1ch), 1dc in 5th ch from hook, ch1, skip 2ch, 1sc in next ch, *ch1, skip 2ch, [1dc, ch1, 1tr, ch1, 1dc] in next ch, ch1, skip 2ch, 1sc in next ch; rep from * to last 3ch, ch1, skip 2ch, [1dc, ch1, 1tr] in last ch, turn.

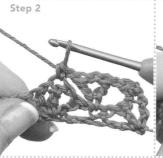

Step 2 Ch1, 1sc in tr, *ch1, 1tr in next sc, ch1, 1dc in 2 strands of lower side of tr just made, ch1, 1sc in next tr; rep from * working last sc in tch, turn.

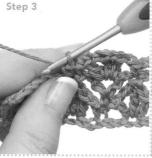

Step 3 Ch1, 1sc in first sc, *ch1, skip 1 sp, [1dc, ch1, 1tr, ch1, 1dc] in next sp, ch1, skip 1 sp, 1sc in next sc; rep from * to end, turn.

Step 4 Ch4 (counts as 1tr), 1dc in 4th ch from hook, *ch1, skip 2 sps, 1sc in next tr, ch1, 1tr in next sc**, ch1, 1dc in 2 strands of lower side of tr just made; rep from * ending last rep at **, 1dc in 2 strands of tr just made, turn.

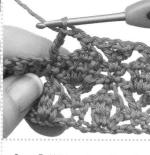

Step 5 Ch5 (counts as 1tr and 1ch), 1dc in first dc, ch1, skip 1 sp, 1sc in next sc, *ch1, skip 1 sp, [1dc, ch1, 1tr, ch1, 1dc] in next sp, ch1, skip next sp, 1sc in next sc; rep from * to last sp, ch1, [1dc, ch1, 1tr] in 4th of ch-4, turn.

Step 6 Repeat Steps 2-5.

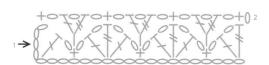

Steps 1-2

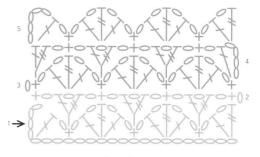

Steps 3-5

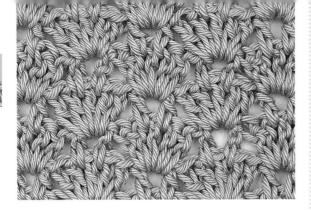

55 Linked Shell

Linked Shell stitch belongs to a group of fan-like stitches that are more grid-like in appearance. The pattern is built up over two rows, with clusters of doubles broken up by two straight stitches. The offsetting of the clusters helps to create a fan-like structure and brings stability to the fabric. It is advisable to work this stitch in crisp cotton or linen yarns to appreciate the full effect of the fans.

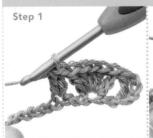

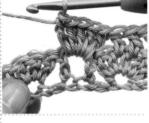

Multiple 7 sts + 2, plus 2 for the foundation chain.

Step 1 1dc in 4th ch from hook, *skip 2ch, 5dc all in next ch. Skip 2ch, 1dc in each of next 2ch; rep from * to end, turn.

Step 2 Ch3, 2dc in first dc, skip next 3dc, *1dc in each of the sps between 2nd and 3rd, and 3rd and 4th dc of 5dc group, skip 3dc, 5dc in sp between 2 vertical dc, skip

3dc; rep from * ending with 3dc in sp between last dc and tch, turn

Step 3 Ch3, 1dc between first 2dc, skip 3dc, 5dc in sp between 2 vertical dc, *skip 3dc, 1dc in each of the sps between 2nd and 3rd, and 3rd and 4th dc of 5dc group; rep from * ending with last dc in tch, turn.

Step 4 Repeat Steps 2 and 3.

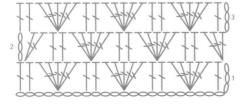

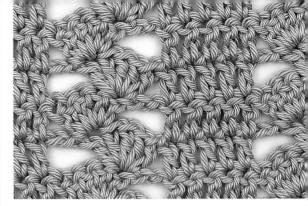

56 Block and Offset Shell

Block and Offset Shell stitch is similar in construction to Thistle (see stitch 129, pages 132–133), although this time one pattern row is repeated throughout. The fan-shape clusters appear more prominent in this example due to being worked either side of broad columns of double crochet. Further interest is added by each fan sitting at an angle to the one on the previous row.

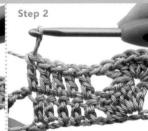

Multiple 11 sts + 5, plus 2 for the foundation chain.

Step 1 (RS) 1dc in 4th ch from hook (counts as first dc), 1dc in each of next 3ch, *skip 2ch, 5dc in next 6th, ch2, skip 3ch, 1dc in each of next 5ch; rep from * to end turn Step 2 Ch3 (counts as first dc), skip first dc, 1dc in each of next 4dc, *skip 2ch, skip next dc, 5dc in next dc, ch2, skip 3dc, 1dc in each of next 5dc; rep from * to end, turn.

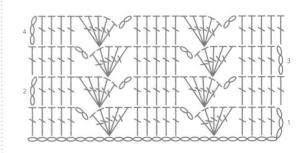

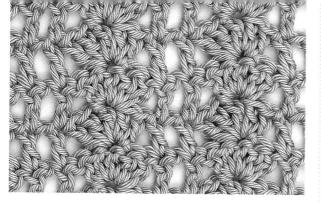

57 Shell Network

Shell Network has a more delicate appearance than the previous two stitches. This is partly due to smaller clusters and more open columns between the fans. This is a popular choice for baby clothes and accessories. It lends itself to being worked in pastel colors and is suited to cotton- and wool-mix yarns.

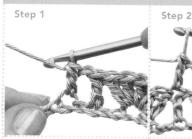

Multiple 8 sts + 3, plus 3 for the foundation chain.

Step 1 (RS) 1dc in 6th ch from hook, *skip 2ch, 5dc in next ch, skip 2ch, 1dc in next ch, ch1, skip 1ch, 1dc in next ch; rep from * to end, turn.

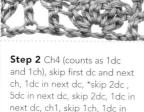

next dc; rep from * ending last

rep by working a dc in 2nd ch

of tch, turn. Step 3 Repeat Step 2.

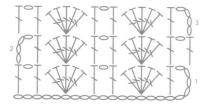

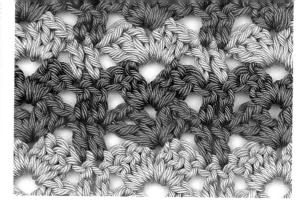

58 Rack

Rack stitch is similar in construction to Shell Network (see stitch 57, left), but overall has a much lacier appearance, due to the increased number of chains worked between the stitches. The pattern is built up over three rather than one row and so would be suited to slightly larger projects than Shell Network. This stitch looks particularly beautiful in a soft, neutral shade.

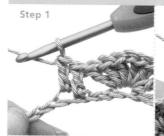

Step 1 1dc in 4th ch from hook, *skip 2ch, [3dc, ch1, 3dc] in next ch, skip 2ch, 1dc in each of next 2ch; rep from * to end, turn.

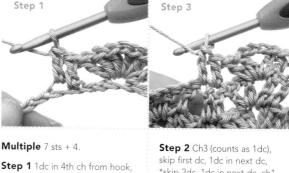

*skip 2dc, 1dc in next dc, ch1, [1dc, ch1, 1dc] in next ch sp, ch1, 1dc in next dc, skip 2dc. 1dc in each of next 2dc; rep from * and end by working last dc in tch, turn.

Step 3 Ch3, skip first dc, 1dc in next dc, *skip next ch sp, [2dc, ch3, 2dc] in next ch sp. skip [1dc, 1ch, 1dc], work 1dc in each of next 2dc; rep from * ending with last dc in tch, turn.

Step 4 Ch3 (counts as 1dc), 1dc in next dc, *[3dc, ch1, 3dc] in next ch-3 sp, skip 2dc, 1dc in each of next 2dc; rep from * ending with last dc in tch, turn.

Step 5 Repeat Steps 2-4.

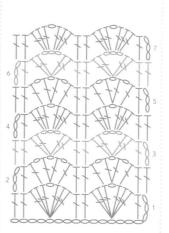

59 Open Fan

Open Fan is a beautiful open stitch that creates a very fluid-looking pattern. It is built up from a series of interlocking fans over a four-row repeat. Each fan is made in the same way by working (one treble, [two chain, one treble] four times) into the designated chain or stitch. The fabric retains some stability due to the fact that subsequent fans are anchored into some of the stitches and chain spaces of the row before. This stitch would suit many yarn types, but would look exceptionally pretty worked in a lace-weight or hand-dyed yarn.

Special stitch Fan: 1tr, [ch2, 1tr] 4 times.

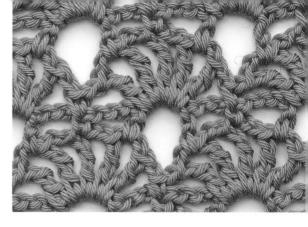

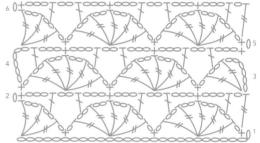

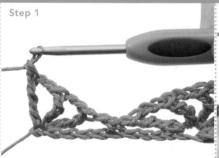

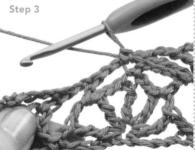

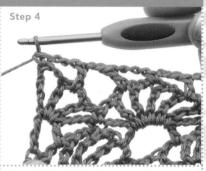

Multiple 10 sts + 7.

Step 1 (RS) 1sc in 2nd ch from hook, *ch1, skip 4ch, 1Fan in next ch, ch1, skip 4ch, 1sc in next ch; rep from * to last 5ch, ch1, skip 4ch, work [1tr, ch2, 1tr, ch2, 1tr] all in last ch, turn.

Step 2 Ch1, 1sc in first tr, *ch3, skip next ch-2 sp, 1dc in next sp**, ch2, skip next [tr, sc, tr] and work 1dc in first ch-2 sp of next Fan, ch-3, 1sc in center (3rd) dc of Fan; rep from * ending last rep at **, ch1, 1tr in last sc, turn.

Step 3 Ch6 (counts as 1tr and 1ch), skip first tr, work [1tr, ch2, 1tr] in next ch-1 sp, ch1, skip ch-3 sp, 1sc in next sc, *ch1, skip next ch-3 sp, 1Fan in next ch-2 sp, ch1, skip next ch-3 sp, 1sc in next sc; rep from * to end, turn.

Step 5 Ch1, *1sc in next sc, ch1, skip next ch-3 sp, 1Fan in next ch-2 sp, ch1, skip next ch-3 sp; rep from * to last sc and ch-3 sp, 1sc in last sc, ch1, skip ch-3 sp, work [1tr, ch2, 1tr, ch2, 1tr] in tch, turn.

Step 6 Repeat Steps 2-5.

Steps 2-3

Steps 4–5

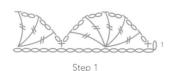

60 Interlocking Shell

nterlocking Shell stitch is an incredibly pleasing and relaxing stitch to work. As the swatch shows, it is best worked in at least two colors, so that the fans become apparent. When worked with two colors, you will end up with a two-sided fabric, with a different color dominant on each side. It is particularly suitable for projects like baby blankets and would look beautiful worked in a rainbow of pastel shades. The pattern is built up out of a two-row repeat, with alternating fans appearing to sit side by side. The effect of this is a denser fabric than some of the previous examples, probably better suited to being worked in light- to medium-weight yarns. You will need to break each color at the end of a row, so it is a good idea to get into the habit of crocheting over your ends.

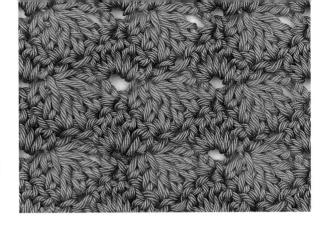

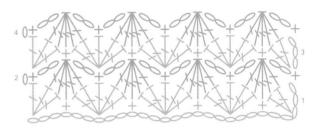

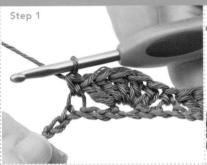

Step 2

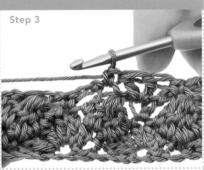

Multiple 6 sts + 1, plus 2 for the foundation chain.

Step 1 (RS) Skip 2ch (counts as 1dc), 2dc in next ch, skip 2ch, 1sc in next ch, *skip 2ch, 5dc in next ch, skip 2ch, 1sc in next ch; rep from * to last 3ch, skip 2ch, 3dc in last ch, turn.

Step 2 Ch1, 1sc in first dc, *ch2, dc5tog over next 5 sts, ch2, 1sc in next dc; rep from * and end by working last sc in tch, turn.

Step 3 Ch3 (counts as 1dc), 2dc in first sc, skip 2ch, *1sc in top of next Fan, skip 2ch, 5dc in next sc, skip 2ch; rep from * to last Fan, 1sc in top of Fan, skip 2ch, 3dc in last sc, turn.

Step 4 Repeat Steps 2 and 3.

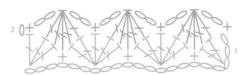

Steps 1-2

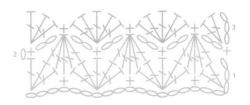

Step 3

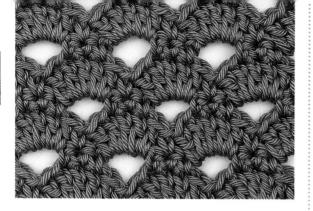

61 Arcade

Arcade stitch, sometimes known as Wheatsheaf stitch, produces one of those instantly recognizable crochet fabrics. It is an interesting stitch because the overall fabric looks as if sections have been cut away. This is achieved by offsetting clusters of doubles and linking them with a row of chains and single crochet. This has the effect of making each row touch, rather than stem from, the row below.

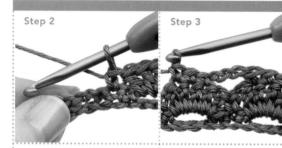

Multiple 6 sts + 1.

Step 1 1sc in 2nd ch from hook, *ch3, skip 3ch, 1sc in each of next 3ch; rep from * to last 5 sts, ch3, skip 3 ch, 1sc in each of last 2ch, turn.

Step 2 Ch1, skip first sc, *skip 1sc, 5dc in ch-3 sp, skip 1sc, 1sc in next sc (the 2nd of 3); rep from * ending 1sc in ch-1, turn.

Step 3 Ch3, skip [1sc, 1dc], *1sc in each of next 3dc (2nd, 3rd, 4th dc of 5dc), ch3, skip [1dc, 1sc, 1dc]; rep from * to

last group, 1sc in each of 3dc, ch2, skip 1dc, 1sc in ch-1, turn.

Step 4 Ch3, skip first sc, 2dc in ch-2 sp, *skip 1sc, 1sc in next sc (the 2nd of 3), skip 1sc, 5dc in ch-3 sp; rep from * ending 3dc under tch, turn.

Step 5 Ch1, skip first dc, 1sc in next dc, *ch3, skip [1dc, 1sc, 1dc], 1sc in each of next 3dc (2nd, 3rd, 4th dc of 5dc); rep from * ending 1sc in last dc, 1sc in tch, turn.

Step 6 Repeat Steps 2–5.

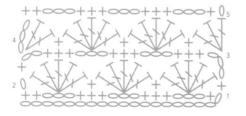

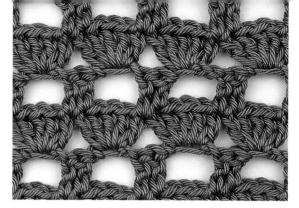

62 Boxed Shell

Boxed Shell stitch creates a striking network of stitches. Many fan and shell stitches are linked by working into the tops of stitches or into chain spaces. In this example, you will be working into the chain itself as the base of the stitch. It is a good idea to take in the bar underneath the chain and the top loop, in order to avoid untidy stitches.

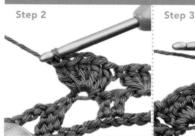

Multiple 5 sts + 2, plus 2 for the foundation chain.

Step 1 Skip 3ch (counts as 1dc), 1dc in next ch, *ch3, skip 3ch, 1dc in each of next 2ch; rep from * to end, turn.

Step 2 Ch3 (counts as 1dc), skip first st, *5dc in 2nd ch of next ch-3 arch; rep from * ending 1dc in tch, turn.

Step 3 Ch3 (counts as 1dc), skip first dc, *1dc in first of 5dc, ch3, skip 3dc, 1dc in last of 5dc, rep from * ending with 1dc in tch.

Step 4 Repeat Steps 2 and 3.

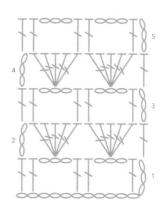

63 Acrobatic

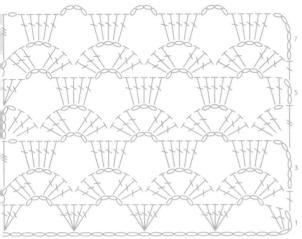

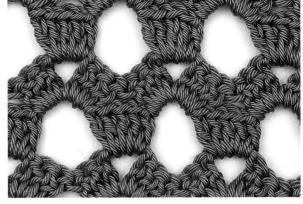

Acrobatic stitch is constructed in a very similar way to Arcade stitch (see stitch 61, left). Once again the rows appear to touch rather than support each other, but this time the spaces between the shells are deeper and wider. This is achieved by alternating two different fan shapes. One is built from a cluster of five doubles, the other from a cluster of six doubles with three chains at the center of the fan. Each cluster is worked into a chain space and it is the interlinking of rows that gives the fabric its stability. Each row needs to be clearly defined and so this stitch is best worked in medium- to slightly heavier-weight cotton yarns.

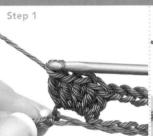

Multiple 6 sts +1, plus 2 for the foundation chain.

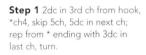

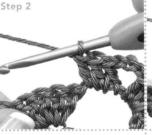

Step 2 Ch2 (counts as 1dc), skip first 3 sts, *[3dc, ch3, 3dc] in next ch-4 arch**, skip next 5dc; rep from * ending last rep at **, skip 2dc, 1dc in tch, turn.

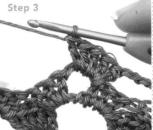

Step 3 Ch6 (counts as 1dtr and 1ch), *5dc in next ch-3 arch**, ch4; rep from * ending last rep at **, ch1, 1dtr in tch, turn.

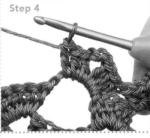

Step 4 Ch5 (counts as 1tr and 1ch), 3dc in next ch-1 sp, *skip 5dc, [3dc, ch3, 3dc] in next ch-4 arch; rep from * ending skip 5dc and working [3dc, ch1, 1tr] in tch, turn.

Step 5 Ch3 (counts as 1dc) 2dc in next ch-1 sp, *ch4, 5dc in next ch-3 arch; rep from * ending ch4, 3dc in tch, turn.

Step 6 Repeat Steps 2-5.

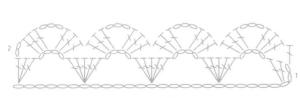

Steps 1-2

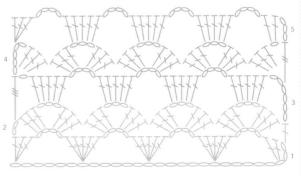

Steps 3-5

64 Tulip

Tulip stitch is a pretty stitch, with clusters of doubles offset against each other to produce quite a heavy pattern. It is quick and easy to work, with one row repeated throughout. This stitch is suited to larger projects like blankets and throws, and would look particularly effective worked in stripes of more than one color.

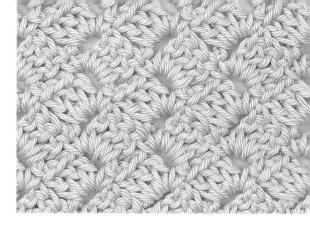

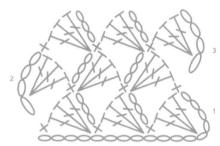

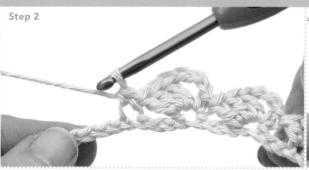

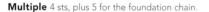

Step 1 (row 1) 3dc in 5th ch from hook, skip 3ch, 1sc in next ch.

Step 2 (row 1 cont.) *Ch3, 3dc in same ch as last sc, skip 3ch, 1sc in next ch; rep from * to end, turn.

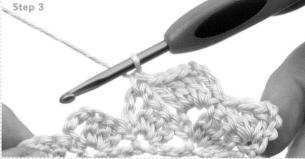

Step 3 (row 2) Ch4, 3dc in first of these ch-4, skip [1sc, 3dc], 1sc in ch-3 sp, *ch3, 3dc in same ch sp as last sc, skip [1sc, 3dc], 1sc in next ch-3 sp, rep from * working last sc under ch-4, turn.

Step 4 Repeat Step 3.

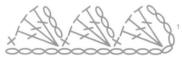

Steps 1-2

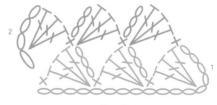

Step 3

65 Diagonal Shell

Diagonal Shell stitch is an extension of Tulip stitch (see stitch 64, left). It is made more intricate by the addition of paired stitches being worked into the tops of the shells and is worked over two rather than just one row. The shells are unusual in that they are not symmetrical like other examples. They are made up of a single crochet, three chains and four doubles, which enables them to sit on a diagonal. Pattern rows alternate with a row of single crochet and chain to stop the fabric from forming a bias.

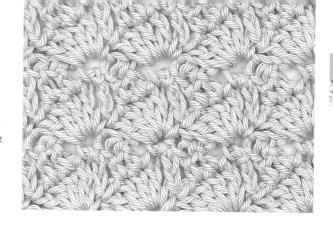

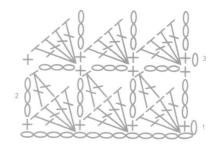

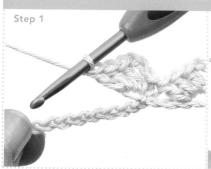

Multiple 4 sts + 1, plus 1 for the foundation chain.

Step 1 1Shell in 2nd ch from hook, *skip 3ch, 1Shell in next ch; rep from * to last 4ch, skip 3ch and work 1sc in last ch, turn.

Step 2 Ch3 (counts as 1dc), skip first st, *skip 1dc, dc2tog over next 2 sts, ch3, skip 1dc, 1sc in ch-3; rep from * to end, turn.

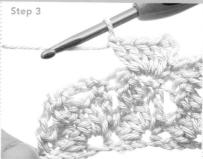

Step 3 Ch1, 1Shell in first st, *skip ch3 and next st, 1Shell in next sc; rep from * ending skip 3ch and sc, 1sc in tch, turn.

Step 4 Repeat Steps 2 and 3.

Special stitch Shell: [1sc, ch3, 4dc] all in the same st.

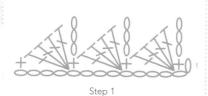

2

Step 2

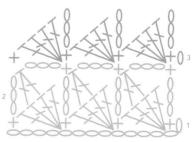

Step 3

66 Fan and V

Fan and V stitch is a densely patterned but very elegant stitch. Like so many examples in this section, it is made up of a series of interlinking shell and "V"-style stitches. However, the gaps are closed between the rows by working over the alternating rows of chain that separate the shells and "V" stitches. Another unusual feature of this stitch is that it has specific instructions for working the final row. Details can be found after step six. This stitch is suitable for working in a range of yarns and would look especially beautiful in silk or linen blends.

Special stitch V st: [1dc, ch1, 1dc].

Ending End with a Step 2 or 4 and replace the ch-5 between the V st with [ch2, sl st to 5th dc of group, ch2] in place of 5ch between the V sts.

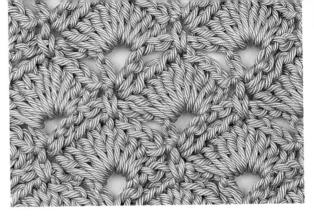

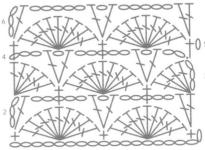

Step 1 1sc in 2nd ch from hook, *skip 3ch, 9dc in next ch, skip 3ch, 1sc in next ch; rep from * to end. turn.

Step 2 Ch3 (counts as 1dc), 1dc in first sc, *ch5, skip 9dc group, work a V st of [1dc, ch1, 1dc] in next sc; rep from * to last 9dc group, ch5, skip 9dc group and work 2dc in last sc, turn.

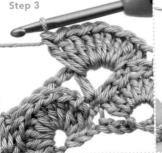

Step 3 Ch3 (counts as 1dc), 4dc in first st, *1sc in 5th dc of 9dc group in row below, taking care to enclose ch-5 that lie directly above the group**, 9dc in ch-1 sp at center of V st; rep from * and end last rep at **, 5dc in tch, turn.

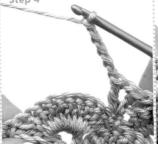

Step 4 Ch3 (counts as 1dc), skip 5dc, V st in next sc *ch5, skip 9dc group, V st in next sc; rep from *, ch2 ending sl st in tch, turn.

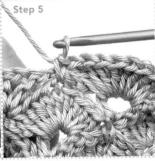

Step 5 Ch1, 1sc over sl st and in first dc in row below, *9dc in ch-1 sp at center of V st**, 1sc in 5th dc of 9dc group in row below, taking care to enclose ch-5 that lie directly above the group; rep from * and end the last rep at **, 1sc in first of ch-3, turn.

Step 6 Repeat Steps 2–5.

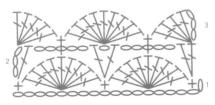

Steps 1-3

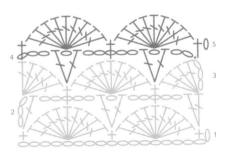

Steps 4-5

67 Starburst

Starburst stitch is similar in construction to Fan and V stitch usee stitch 66, left), but this time the diamond shapes are eplaced with circles. Starburst stitch also has a slightly more open texture since there is no overlapping of rows. The circles are created by working a cluster of nine stitches into one stitch on one row, and then reversing the process two rows later by working all nine stitches together. This formation is stabilized by intervening rows of chain and single crochet to provide a framework. This stitch would look very effective worked in allk-based yarns, as the luster of the silk content would emphasize the small circles at the center of each motif.

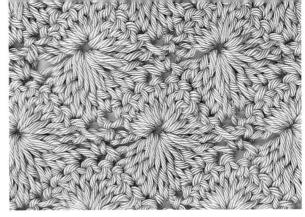

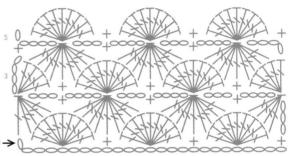

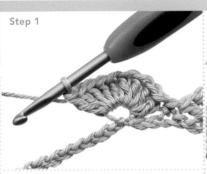

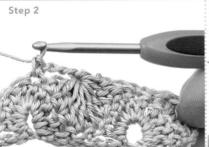

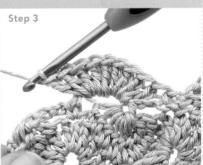

The multiple for the foundation chain is different from the pattern multiple of 10 + 1.

Multiple 8 sts, plus 1 for the foundation chain.

Step 1 Skip 4ch, *9dc in next ch, skip 3ch, 1sc in next ch, skip 3ch; rep from * to last ch, 1sc in last ch, turn. **Step 2** Ch3, skip first sc, dc4tog over next 4dc, *ch4, 1sc in next dc (5th of 9dc group), ch3, dc9tog over next [4dc, 1sc, 4dc]; rep from *, dc5tog over last 4dc and ch-1, turn.

Step 3 Ch4, 4dc in top of dc5tog at base of ch, *skip 3ch, 1sc in next sc, skip 4ch, 9dc in closing st of dc9tog; rep from * and end by working dc5tog in top dc4tog, turn.

Step 4 Ch4, skip first sc, dc9tog over next [4dc, 1sc, 4dc], ch4, 1sc in next dc (5th of 9dc group), ch3; rep from * to end, 1sc in tch, turn

Step 5 Ch1, skip first sc, *skip ch4, 9dc in closing st of the dc9tog, skip ch3, 1sc in next sc; rep from * working last sc in first of ch-4, turn.

Step 6 Repeat Steps 2-5.

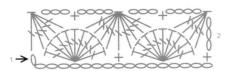

Steps 1-2

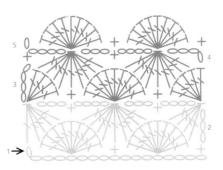

Steps 3-5

68 Petal

Petal stitch is another very pretty stitch based on interlocking groups of shells. It is slightly more complex than most of the stitches described so far and is worked over a six-row repeat. It is also a slightly more bulky stitch since each leg of the shell is made by working two double stitches together. A double two together is made by working one double into the designated stitch until the last yarn over hook is reached. Another double is then worked into the same stitch to the same point and then, with the final yarn over hook, the yarn is pulled through all three remaining stitches. The double two together clusters are balanced with two chains between each post. This helps the fabric from becoming too rigid. However, it is probably a good idea to use lighter-weight varns in order to highlight the gentle patterning. Further emphasis can be gained by alternating two or even three different colors every three rows. You will need to cut yarn after every color change and so it is a good idea to weave in any loose ends as you go, especially if you are working on a large project.

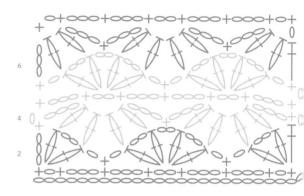

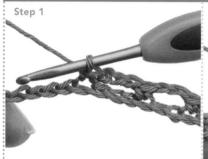

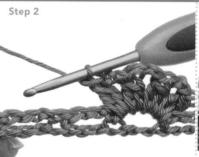

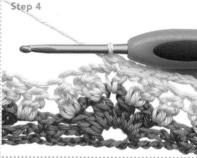

Multiple 11 sts, plus 3 for the foundation chain.

Step 1 (RS) 1sc in 2nd ch from hook, ch1, skip 1ch, 1sc in next ch, [ch3, skip 3ch, 1sc in next ch] twice, *ch2, skip 2ch, 1sc in next ch, [ch3, skip 3ch, 1sc in next ch] twice; rep from * to last 2ch, ch1, skip next ch, 1sc in last ch, turn.

Step 2 Ch3 (counts as 1dc), [dc2tog, ch2, dc2tog] in first ch sp, ch1, skip 1sc, 1sc in next sc, *ch1, skip ch-3 sp, dc2tog in next ch-2 sp, work [ch2, dc2tog] 3 times in same sp as last dc2tog, ch1, skip ch-3 sp, 1sc in next sc; rep from * to last 2 ch sps, ch1, skip ch-3 sp, work [dc2tog, ch2, dc2tog] in final ch sp, 1dc in last sc, turn.

Step 3 Ch1, 1sc in first dc, *ch3, dc2tog in top of each of next 4 dc2tog, ch3, 1sc in next ch-2 sp; rep from * to end working last sc in tch, turn.

Step 4 Ch1, 1sc in first sc, *ch3, 1sc in top of next dc2tog, ch2, skip next 2 dc2tog, 1sc in top of next dc2tog, ch3, 1sc in next sc; rep from * to end, turn.

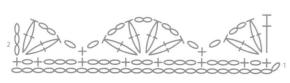

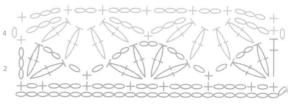

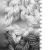

Steps 3-4

Step 5 Ch1, 1sc in first sc, *ch1, skip ch-3 sp, dc2tog in next ch-2 sp, work [2ch, dc2tog] 3 times in same sp as last dc2tog, ch1, skip ch-3 sp, 1sc in next sc; rep from *

to end, turn.

Step 6 Ch3, dc2tog in top of each of next 2 dc2tog, ch3, 1sc in next ch-2 sp, ch3, *dc2tog in top of each of next 4 dc2tog, ch3, 1sc in next ch-2 sp, ch3; rep from * to last 2 dc2tog, work 1 dc2tog in each of last 2 dc2tog, 1dc in last sc, turn.

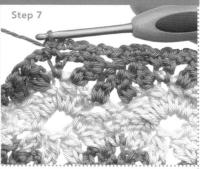

Step 7 Ch1, 1sc in first dc, ch1, skip 1 dc2tog, 1sc in top of next dc2tog, ch3, 1sc in next sc, ch3, *1sc in top of next dc2tog, ch2, 1sc in top of next dc2tog, ch3, 1sc in next sc, ch3; rep from * to last 2 dc2tog, 1sc in next dc2tog, ch1, skip last dc2tog, 1sc in tch, turn.

Step 8 Repeat Steps 2-7.

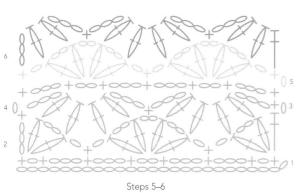

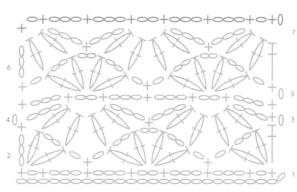

6 Step 7

69 Hexagon

Hexagon stitch is one of the most striking and certainly the most complex of all the stitches in this section. It uses the picot and cluster techniques in a very specific way. The cluster is worked by taking the yarn over the hook, inserting the hook into the designated stitch, taking yarn over hook again and then drawing the loop of yarn through quite loosely, over the directed number and position of stitches. The stitch is completed with a final yarn over hook and then drawing through all loops, and closed off by working one chain fairly tightly. The picot is created by making five chain stitches and then working a single crochet into the second chain from the hook and then one single crochet into each of the next three chain stitches. The trickiest part of the pattern is working into either side of the picot and it is probably a good idea to practice this using a medium-weight, light-colored cotton yarn before starting a project. Again, further emphasis could be given to this stitch by working every two rows in a different color as at right. It is important to use a smooth-running yarn for this stitch, since you are often handling a lot of stitches in one transaction.

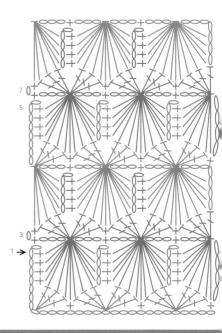

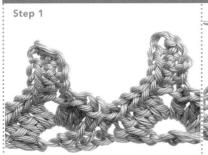

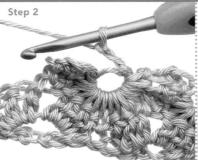

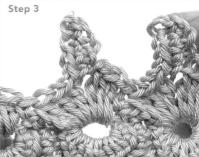

Multiple 8 sts + 4, plus 1 for the foundation chain.

Step 1 (WS) 1sc in 2nd ch from hook, 1sc in each of next 3ch (counts as a Picot), skip 3ch, 3dc in next ch, skip 3ch, 1sc in next ch, *skip 3ch, work [3dc, 1Picot, 3dc] in next ch, skip 3ch, 1sc in next ch; rep from * to end,

Step 2 Ch4 (counts as 1tr), 1Cl over each of first 8 sts, ch3, 1sc in top of Picot, *ch3, 1Cl over next 15 sts by inserting hook in bottom loop of 4ch of Picot, next 3dc, 1sc and 3dc and then 4sc of next Picot, ch3, 1sc in top of Picot: rep from * to end, turn.

Step 3 Ch1, 1sc in first sc, *skip 3ch, [3dc 1Picot, 3dc] in closing loop of Cl in row below, skip 3ch, 1sc in next sc; rep from * to last dc-8 Cl, skip 3ch, 4dc in loop that closes this part Cl, turn.

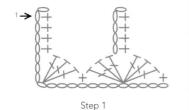

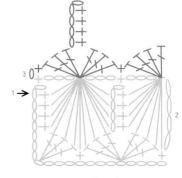

Step 2

Step 3

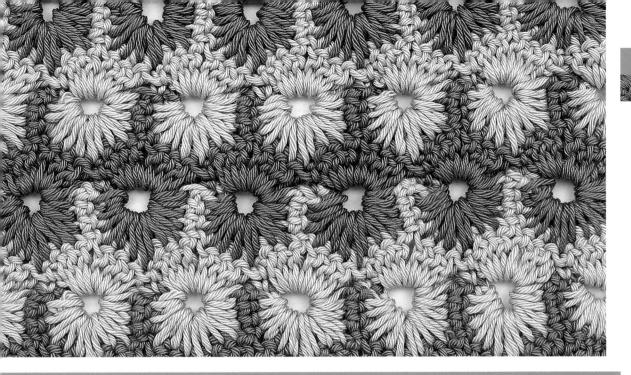

Step 4 Ch7 (counts as 1tr and 3ch), 1Cl over next 15 sts as in Step 2, starting with 5th ch from hook, *ch3, 1sc in top of Picot, ch3, 1Cl over next 15 sts; rep from * to last Picot, 1Cl over next 8 sts, turn.

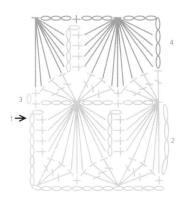

Step 4

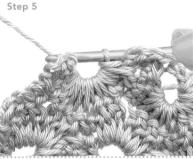

Step 5 Ch8, 1sc in 2nd ch from hook, 1sc in each of next 3ch (counts as 1dc, 1Picot), 3dc in first st, skip 3ch, 1sc in next sc *skip 3ch, [3dc, 1Picot, 3dc] in closing loop of Cl in row below, skip 3ch, 1sc in next sc; rep from * to end, working last sc in 4th of ch-7, turn.

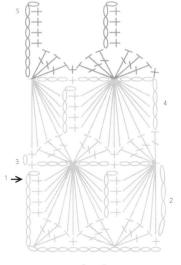

Step 5

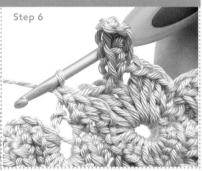

Step 6 Repeat Steps 2-5.

Special stitch CI (cluster): Work [yo, insert hook, yo, draw loop through loosely] over number and position of sts as indicated, ending yo, draw through all loops, ch to tightly to close the CI.

Special stitch Picot: ch5, 1sc in 2nd ch from hook, 1sc in each of next 3ch.

70 Catherine Wheel

Catherine Wheel is a really interesting stitch and certainly one that benefits from being worked in more than one color. It is similar in construction to Starburst stitch (see stitch 67, page 77), but this time the circles are broken up by rows and columns of single crochet between the fans and clusters. This difference becomes more apparent when the stitch is worked in two colors and helps to create the illusion of the circles spinning. As with Petal stitch (see stitch 68, pages 78-79), it will become necessary to break colors when they change and so weaving these in as you go will save lots of finishing at the end of your project. There is no reason why you should not use more than two colors as a repeating or random sequence. However, the original image will tend to be lost as the eye tries to read the color pattern, rather than the stitch pattern. Catherine wheel uses the cluster technique. This involves working (yarn over hook, insert hook into designated stitch, yarn over hook, draw loop through, yarn over hook, draw through two loops] over the directed number of stitches and is then completed by one final yarn over hook and drawing through all the loops on the hook.

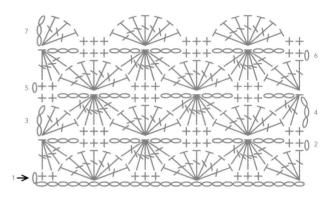

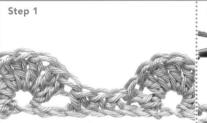

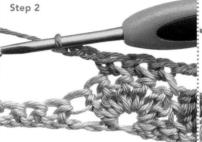

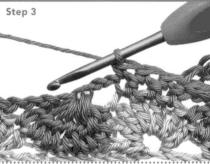

Multiple 10 sts + 6, plus 1 for the foundation chain.

Step 1 (WS) 1sc in 2nd ch from hook, 1sc in next ch, *skip 3ch, 7dc in next ch, skip 3ch, 1sc in each of next 3ch; rep from * to last 4ch, skip 3ch, 4dc in last ch, turn.

Step 2 Ch1, 1sc in each of first 2dc, *ch3, work 1Cl over next 7 sts, ch3, 1sc in each of next 3 sts; rep from * to last 4 sts, ch3, 1Cl over last 4 sts, turn.

Step 3 Ch3 (counts as 1dc), 3dc in first st, *skip 3ch, 1sc in each of next 3sc, skip 3ch, 7dc in loop that closed next Cl; rep from * and end by skipping 3ch and working 1sc in each of last 2sc. turn.

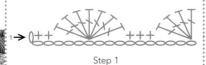

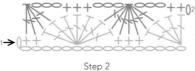

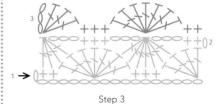

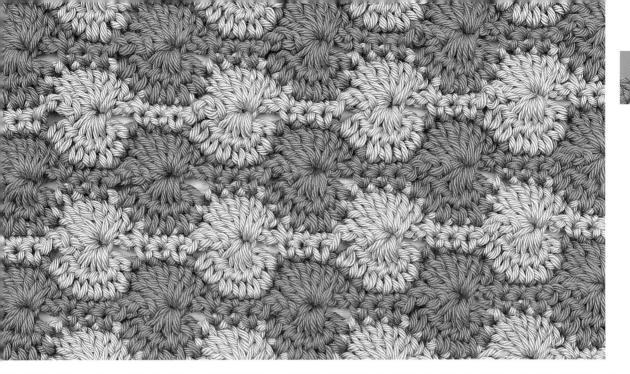

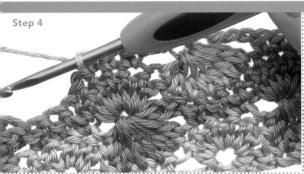

Step 4 Ch3 (counts as 1dc), skip first st, 1Cl over next 3 sts, *ch3, 1sc in each of next 3 sts, ch3, 1Cl over next 7 sts; rep from * to end, ch3, 1sc in last st, 1sc in tch, turn.

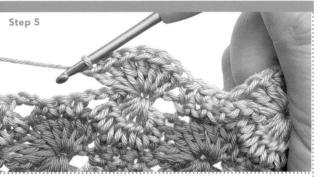

Step 5 Ch1, 1sc in each of next 2sc, *skip 3ch, 7dc in loop that closed next Cl, skip 3ch, 1sc in each of next 3sc; rep from * to end, skip 3ch, 4dc in tch, turn.

Step 6 Repeat Steps 2–5.

Special stitch CI (cluster): Work [yo, insert hook, yo, draw loop through, yo, draw through 2 loops] over the designated number of sts, yo, draw through all loops on hook.

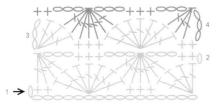

Step 4

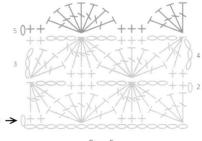

Step 5

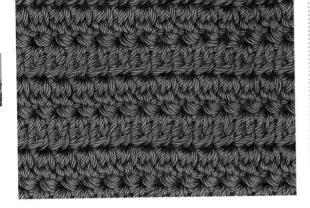

71 Aligned Double Clusters

This is the first and most basic of all the cluster stitches. Unlike most cluster stitches, this one is made of pairs of stitches that are joined at the top only. This produces a striped texture that works well across a range of yarns. It is important to maintain a firm gauge in order to retain the raised effect of the clusters. When working the foundation, you may want to use a size larger hook so that the chains are quite loose, making it easier for you to place two stitches into each chain.

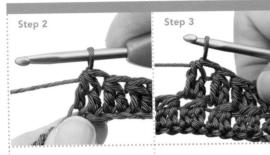

Multiple Any number of sts, noting that the first 3ch will count as the first dc.

Step 1 (row 1) 1dc in 4th ch from hook.

Step 2 (row 1 cont.) Dc2tog in each chain to end of row, turn.

Step 3 (row 2) Ch3, 1dc in first dc2tog, dc2tog in each dc2tog to end of row, turn.

Step 4 Repeat Step 3.

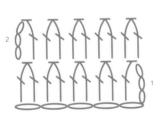

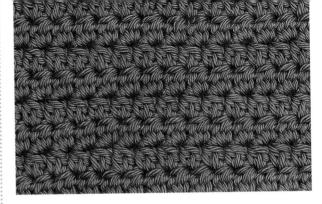

72 Pique

Pique stitch follows the same principles as Aligned Double Clusters (see stitch 71, left). The extra texture in this example is created through the combination of half doubles and doubles. The rows are balanced by doubles sitting on top of doubles so that a bias is not created. This stitch would suit a variety of yarn types.

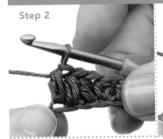

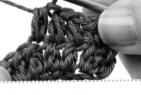

Multiple Any number of sts, noting that the first 3ch will count as the first dc.

Step 1 (row 1) 1hdc in 4th ch from hook.

Step 2 (row 1 cont.) 1Gp in each ch to end, turn.

Step 3 (row 2) Ch3, 1hdc in first Gp, 1Gp in each Gp, ending 1Gp in 1hdc, turn.

Step 4 Repeat Step 3.

Special stitch Gp (group): 1dc and 1hdc, worked together as: yo, insert hook in next st, yo, pull loop through, yo, pull loop through first 2 loops on hook, yo, insert hook in same st as before, yo, pull loop through, yo and pull through all 4 loops on hook.

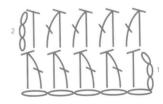

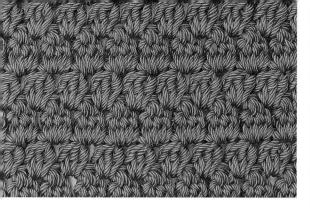

73 Alternate Double Clusters

Alternate Double Clusters illustrates the basic construction of cluster stitches extremely well. Each cluster is made up of three doubles that are joined together at the top and bottom. These clusters are held together by a mesh of single chain which helps to offset the clusters and make the fabric stable. When working the foundation chain, you may want to use a size larger hook, so that the chain is loose enough to take three stitches.

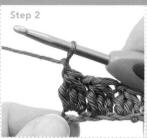

Multiple Any number of sts, noting that the first 3ch will count as the first dc.

Step 1 (row 1) Dc3tog in 4th ch from hook.

Step 2 (row 1 cont.) *Ch1, skip next ch, dc3tog in next ch; rep from * to end, turn.

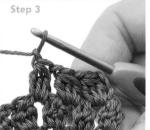

Step 3 (row 2) Ch3, skip first dc3tog, *dc3tog in next ch sp, ch1, skip next dc3tog; rep from * to last 3ch, work dc3tog under tch, turn.

Step 4 Repeat Step 3.

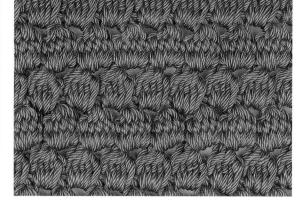

74 Large Clusters

Large Clusters could be described as a chunkier version of Alternate Double Clusters (see stitch 73, left). It is constructed in a similar way, with clusters being worked into alternating chain spaces. The difference lies in the size of the cluster, with five doubles taking the place of three and so producing a firmer fabric.

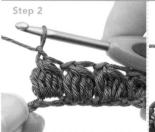

Multiple An even number of sts, plus 2 for the foundation chain.

Step 1 (row 1) 1Lc in 4th ch from

Step 2 (row 1 cont.) *Ch1, skip 1ch, 1Lc in next ch; rep from * to last ch, 1Lc in last ch, turn.

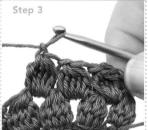

Step 3 (row 2) Ch3, skip first Lc, *1Lc in next ch sp, ch1, skip next Lc; rep from * ending 1Lc under ch-3, turn.

Step 4 Repeat Step 3.

Special stitch Lc (large cluster): [yo, insert hook as directed, yo, pull loop through, yo, pull through 2 loops] 5 times in same place, yo, pull through first 5 loops on hook, yo, pull through both loops on hook.

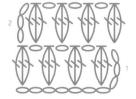

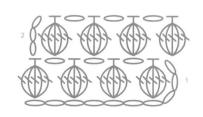

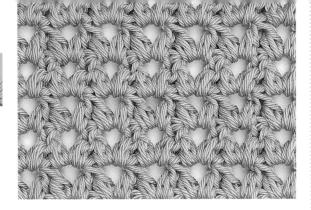

75 Forked Clusters

Forked Cluster stitch is a beautiful stitch where the focus of the cluster is used to outline spaces rather than a group of stitches. Forked Clusters are still joined at the top and bottom, but the base of the stitch is worked into two different stitches, while the top is drawn together in one stitch. This stitch works well with silk- and cotton-based yarns.

Step 3

Multiple 3 sts + 2, plus 3 for the foundation chain.

Step 1 (row 1) 1Fc in 5th and 7th ch from hook.

Step 2 (row 1 cont.) *Ch 2, 1Fc in next ch and following alt ch; rep from * to last ch, ch1, 1dc in last ch, turn.

Step 3 (row 2) Ch4, skip first dc, 1Fc in first and 2nd ch sps, *ch2, 1Fc in next ch, skip 1Fc then 1Fc in next ch sp; rep

from * ending last Fc under ch-4, ch1, 1dc under same ch-4, turn.

Step 4 Repeat Step 3.

Special stitch FC (forked cluster): *[yrh, insert hook at first position given, yrh, pull loop through] twice in same place, yrh, pull through first 4 loops on hook, repeat from * at second position given, yrh, pull through all 3 loops on hook.

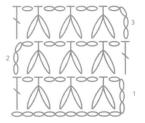

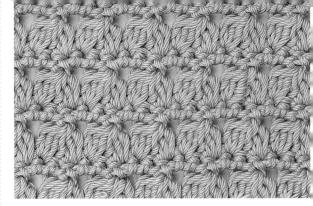

76 Twin Clusters

A couple of subtle differences make this forked stitch look completely different from the last one. The spacing of the pairings is similar, but each cluster is built from six rather than four stitches and the rows of clusters alternate with rows of single crochet. This helps to define the forked cluster as the focus and the spaces in-between are now much smaller.

Multiple 3 sts, plus 2 for the foundation chain.

Step 1 1sc in 2nd ch from hook, 1sc in every ch to end, turn.

Step 2 Ch4, skip 1st sc, *1Tc over next 3sc, ch2; rep from * to last 3sc, 1Tc over last 3sc, ch1, 1dc in ch-1, turn.

Step 3 Ch1, skip first dc, 1sc in ch-1 sp, *1sc in top of Tc, 2sc in ch-2 sp; rep from * ending 1sc in top of last Tc, 1sc under ch-4, 1sc in 3rd of these ch-4, turn.

Step 4 Repeat Steps 2 and 3.

Special stitch Tc (twin cluster): [yo, insert hook in next sc, yo, pull loop through, yo, pull through first 2 loops on hook] 3 times in same place, skip next sc, rep between [] 3 times in next sc, yo, pull through all 7 loops on hook.

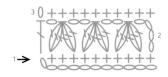

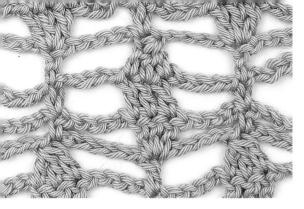

77 Extended Forked Cluster

This is an interesting and elegant stitch. I have described it as an extended forked cluster stitch because the overall impression is of a stitch that is closed at the top and the pottom. It differs from the previous two examples because he cluster is worked over three rows instead of one and held together by a mesh of chains. This stitch is probably best suited to smooth, lightweight yarns in pale colors. It is important to maintain an even gauge so that the chain sections enhance rather than detract from the clusters.

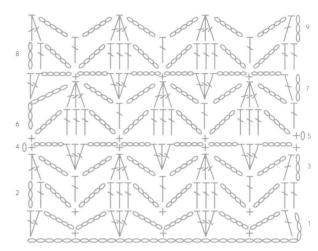

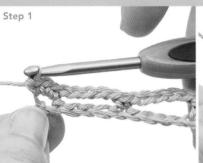

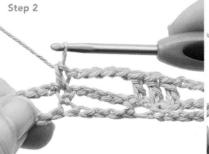

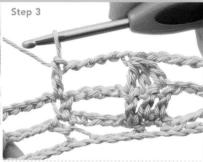

Multiple 10 sts, plus 4 for the foundation chain.

Step 1 1dc in 4th ch from hook, *ch5, skip 4ch, 1sc in next ch, ch5, skip next 4ch**, 3dc in next ch; rep from * ending last rep at **, 2dc in last ch, turn.

Step 2 Ch3 (counts as 1dc), skip 1dc, 1dc in next dc, *ch5, skip next ch-5 loop, 1sc in next sc, ch5, skip next ch-5 loop**, 1dc in each of next 3dc; rep from * and end last rep at **, 1dc in last dc, 1dc in tch, turn.

Step 3 Ch3 (counts as 1dc), skip first dc, 1dc in next dc, *ch5, skip next ch-5 loop, 1dc in next sc, ch5, skip next ch-5 loop**, dc3tog over next 3dc; rep from * and end last rep at **, dc2tog over last 2dc, turn.

Step 4 Ch1, 1sc in top of first cl, *ch5, skip next ch-5 loop, 3dc in next dc, ch5, skip next ch-5 loop, 1sc in top of next cl; rep from * placing last sc in tch, turn.

Step 5 Ch1, 1sc in first sc, *ch5, skip next ch-5 loop, 1dc in each of next 3dc, ch5, skip next ch-5 loop, 1sc in next sc; rep from * to end, turn.

Step 6 Ch8 (counts as 1dc and 5ch) *skip next ch-5 loop, dc3tog over next 3dc, ch5, skip next ch-5 sp, 1dc in next sc**, ch5; rep from * and end last rep at **, turn.

Step 7 Ch3 (counts as 1dc), 1dc in first dc, *ch5, skip next ch-5 sp, 1sc in top of next cl, ch5, skip next ch-5 sp**, 3dc in next dc; rep from * and end last rep at **, 2dc in 3rd of ch-3, turn.

Step 8 Repeat Steps 2–7.

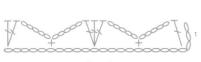

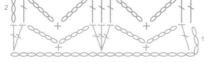

Step 2

Step 1

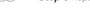

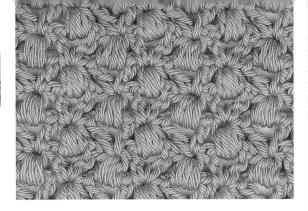

78 Lace Clusters

This is a pretty stitch combining clusters with the "V"-style construction we looked at in many of the stitches in the previous section. The more lacy effect is achieved by working clusters into the top of the two chain spaces at the top of each "V". The result is a fabric with good drape and particularly suited to finer-weight yarns.

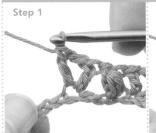

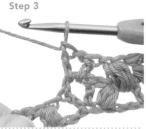

Multiple 6 sts + 2, plus 3 for the foundation chain.

Step 1 [1dc, ch2, 1dc] in 4th ch from hook, *skip 2ch, 1Hdcl in next ch, skip 2ch, [1dc, ch2, 1dc] in next ch; rep from * to last ch, 1dc in last ch, turn.

Step 2 Ch3, skip first 2dc, *1Hdcl in next ch-2 sp, skip next dc, [1dc, ch2, 1dc] in top of next cl, skip 1dc; rep from * to last ch-2 sp, 1Hdcl in last ch-2 sp, skip 1dc, 1dc in tch, turn. Step 3 Ch3, skip first dc,
*[1dc, ch2, 1dc] in top of next
cl, skip 1dc, 1Hdcl in next ch-2
sp, skip next dc; rep from * to
last cl, [1dc, ch2, 1dc] in top of
last cl, 1dc in 3rd of ch-3, turn.

Step 4 Repeat Steps 2 and 3.

Special stitch Hdcl (half double cluster): [yo, insert hook as directed, yo, pull loop through] 4 times in same place, yo, pull through all loops on hook, ch1 to close the cluster.

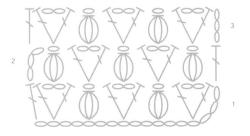

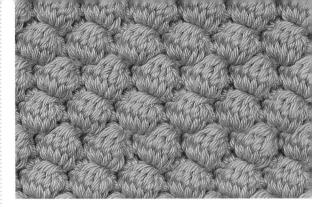

79 Honeycomb

Honeycomb stitch is a much denser and more highly textured stitch then our previous examples. It is typical of the way that clusters are worked into a firm background of single crochet. The clusters are made in the same way as those in Large Clusters (see stitch 74, page 85), but are more prominent in this instance because they are worked directly into the base fabric, rather than a chain space.

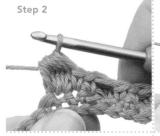

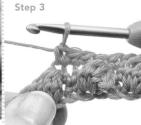

Multiple 3 sts, plus 1 for foundation chain.

Step 1 1sc in 2nd ch from hook, 1sc in every ch to end, turn.

Step 2 Ch1, 1sc in each of first 2sc, *dc5tog in next sc, 1sc in each of next 2sc; rep from * to last sc, dc5tog in last sc, turn.

Step 3 Ch1, *1sc in top of first cl, 1sc in each of next 2sc; rep from * to end of row, turn.

Step 4 Ch1, dc5tog in next sc, *1sc in each of next 2sc, dc5tog in next sc; rep from * to last 2sc, 1sc in each of last 2sc, turn.

Step 5 Ch1, 1sc in each of first 2sc * 1sc in top of first cl, 1sc in each of next 2sc; rep from * to last cl, 1sc in top of last cl, turn.

Step 6 Repeat Steps 2–5.

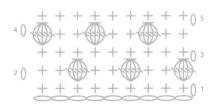

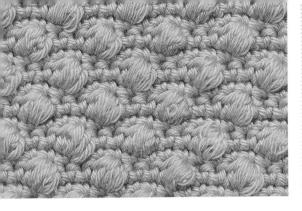

30 Ball

Ball stitch is a much gentler version of Honeycomb stitch see stitch 79, left). It uses half doubles instead of doubles, ne clusters are built from four, rather than five stitches, and ne space between the clusters is larger. This stitch will still produce a firm fabric and is therefore ideal for bags and momewares. This kind of stitch works particularly well in cotton yarns.

Step 3

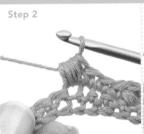

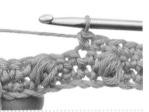

Multiple 4 sts, plus 3 for the foundation chain.

Step 1 1sc in 2nd ch from hook, 1sc in every ch to end, turn.

Step 2 Ch1, skip first sc, 1sc in each of next 2sc, *hdc4tog in next sc, 1sc in each of next 3sc; rep from * working last sc in tch, turn.

Step 3 Ch1, skip first sc, 1sc in each of next 2sc, *1sc in top of cl, 1sc in each of next 3sc; rep from * working last sc in tch, turn.

Step 4 Ch1, skip first sc, *hdc4tog in next sc, 1sc in each of next 3sc; rep from * to last sc, hdc4tog in last sc, 1sc in tch, turn.

Step 5 As Step 3.

Step 6 Repeat Steps 2-5.

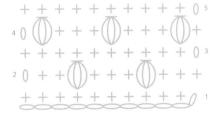

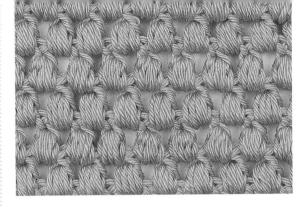

81 Pineapple Cluster

At first sight, you could be forgiven for thinking that this is not a cluster stitch at all, but rows of the groups of doubles that are seen in afghan squares and stripes. However, closer inspection will reveal that each group is made up of four half doubles joined at the top and bottom and worked into chain spaces in the same way as Alternate Double Cluster stitch (see stitch 73, page 85).

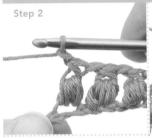

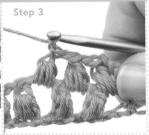

Multiple An even number of sts, plus 2 for the foundation chain.

Step 1 (row 1) 1Ps in 4th ch from hook, ch1.

Step 2 (row 1 cont.) *Skip 1ch, 1Ps in next ch, ch1; rep from * to last 2ch, skip 1ch, 1dc in last ch, turn.

Step 3 (row 2) Ch3, skip first dc, 1Ps in first ch sp, *ch1, skip 1Ps, 1Ps in next ch sp; rep from * to last Ps, ch1, skip last Ps, 1dc in tch, turn.

Step 4 Repeat Step 3.

Special stitch Ps (pineapple stitch): [yo, insert hook as directed, yo, draw a loop through] 4 times in same place, yo, draw through first 8 loops on hook, yo, draw through remaining 2 loops on hook.

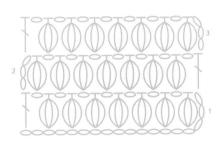

82 Raised Pineapple

Raised Pineapple stitch is very different in construction from Pineapple stitch (see stitch 81, page 89) and has more in common with Honeycomb stitch (see stitch 79, page 88). It is worked on a background of single crochet, but this time the cluster or bobble is worked as an extended stitch over three rows rather than one row. It is important to maintain an even tension when creating the loops on the hook so that the "pineapple" remains neat. This stitch would work best in medium- to heavyweight yarns and is best suited to larger projects. The raised pineapples could be given more prominence by working them in a contrasting colored yarn. They would also make a great border to a blanket.

Special stitch Rps (raised pineapple stitch): insert hook as given, yo, pull loop through, [yo, insert hook in same st 2 rows below, yo, pull loop through, yo, pull through first 2 loops on hook] 6 times, yo, pull through all 8 loops on hook.

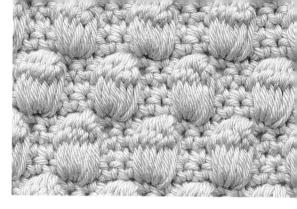

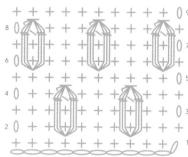

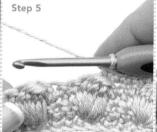

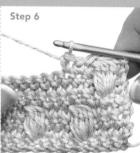

Multiple 4 sts, plus 3 for the foundation chain.

Step 1 (row 1) 1sc in 2nd ch from hook, 1sc in every ch to end of row, turn.

Step 2 (row 2) Ch1, 1sc in 2nd st from hook, 1sc in every st to end of row, 1sc in ch-1, turn.

Step 3 (row 3) As Step 2.

Step 4 (row 4) Ch1, skip first sc, 1sc in each of next 2sc, *1Rps in next sc, 1sc in each of next 3sc; rep from * to end, working last sc in ch-1, turn. **Step 5** (rows 5–7) As Step 2, 3 times.

Step 6 (row 8) Ch1, skip first sc, *1Rps in next sc, 1sc in each of next 3sc; rep from * to last sc, 1Rps in last sc, 1sc in ch-1, turn.

Step 7 (row 9) As Step 2.

Step 8 Repeat Steps 2–6.

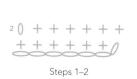

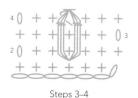

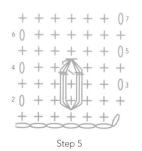

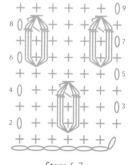

Steps 6-7

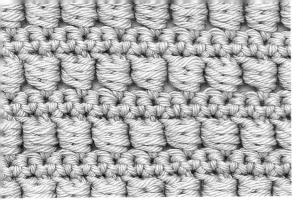

33 Bead

read stitch has the appearance of a stitch that has been prapped. This is achieved by working the stitch over two witches so that it slopes rather than forms a single cluster in ne place. The effect is very pretty and looks very effective in arns that catch the light. Unlike a lot of stitches in this section, his stitch would suit lightweight yarns and make lovely stoles and scarves.

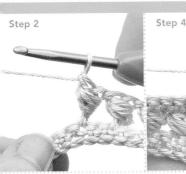

Step 3 Ch1, skip first dc, *1sc in Slcl, 1sc in next dc; rep from * to end, 1sc in tch, turn.

Step 4 Repeat Steps 2 and 3.

Step 2 Ch3, skip first sc, *1dc in next sc, 1Slcl, skip next sc; rep from * to end, 1dc in ch-1, turn.

Step 1 1sc in 2nd ch from

hook, 1sc in every ch to end,

Multiple 2 sts.

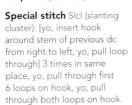

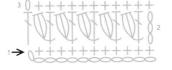

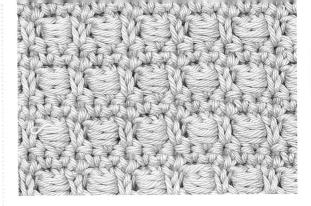

84 Boxed Beads

As the name suggests, Boxed Beads is a variation or extension on the basic Bead stitch (see stitch 83, left). The difference lies in the fact that each "bead" is enclosed within a box, created by working an extended single crochet (see page 24) after the bead. As this is a slightly more intricate stitch it is best worked in crisp 4ply cotton yarns in light colors.

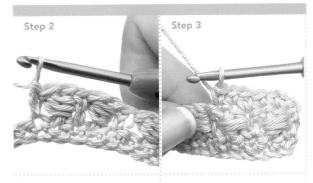

Multiple 3 sts + 1, plus 1 for the foundation chain.

Step 1 1sc in 3rd ch from hook, 1sc in next ch, *1exsc (see page 24) in next ch, 1sc in each of next 2ch; rep from * to last ch, 1exsc in last ch, turn.

Step 2 Ch2, skip first exsc, *1dc in next sc, 1Slcl, skip next sc, 1exsc in next exsc; rep from * ending last exsc in tch, turn. **Step 3** Ch2, skip first exsc, *1sc in Slcl, 1sc in next dc, 1exsc in next exsc, rep from * ending last exsc in tch, turn.

Step 4 Repeat Steps 2 and 3.

Special stitch SIcl (slanting cluster): [yo, insert hook around stem of previous dc from right to left, yo, pull loop through] 3 times in same place, yo, pull through first 6 loops on hook, yo, pull through both loops on hook.

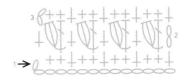

85 Bullion

Bullion stitch is different from other cluster and bobble stitches because it is the number of times that the yarn is wound over the hook initially that creates the cluster. In previous examples, we have seen how winding the yarn over the hook and pulling through a specified number of loops a number of times creates a cluster or bobble. Bullion stitch is very similar in appearance to embroidered versions of this stitch, where the thread is wound around a central post. It is much more softly textured than Honeycomb (see stitch 79, page 88) and Raised Pineapple (see stitch 82, page 90) and so should be worked in fine cotton yarns so that the stitch definition is not lost.

Special stitch Bs (bullion stitch): yo 7 times, insert hook, yo, pull loop through, yo, pull through all 9 loops on hook.

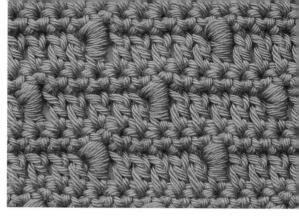

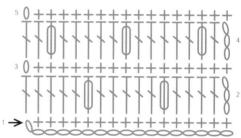

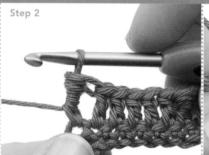

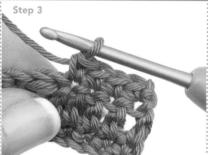

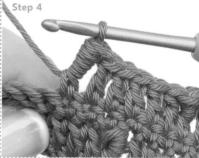

Multiple 6 sts, plus 5 for the foundation chain.

Step 1 1sc in 2nd ch from hook, 1sc in every ch to end, turn.

Step 2 Ch3, skip first sc, 1dc in each of next 4sc, *1Bs in next sc, 1dc in each of next 5sc; rep from * to end, 1dc in tch, turn.

Step 3 Ch1, skip first dc, 1sc in each of next 4dc, *1sc in Bs, 1sc in each of next 5dc; rep from * to end, ending 1sc in tch, turn.

Step 4 Ch3, skip first sc, 1dc in next sc, *1Bs in next sc, 1dc in each of next 5sc; rep from * to last 3 sts, 1Bs in next sc, 1dc in next sc, 1dc in tch, turn.

Step 5 Ch1, skip first dc, 1sc in next dc, *1sc in Bs, 1sc in each of next 5dc; rep from * to last dc, 1sc in last dc, 1sc in tch, turn.

Step 6 Repeat Steps 2-5.

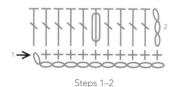

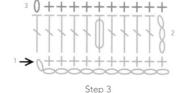

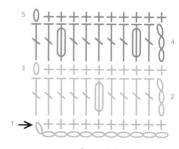

Steps 4–5

36 Spot

pot stitch is another cluster stitch that is worked over a ackground of single crochet. The bobble is created by orking five double crochet stitches together. This is achieved y working to the last yarn over of each stitch and then, at the nal yarn over, pulling the yarn through all six loops on the pok. The result is a well-formed bobble, held together firmly the top with the final pulling through of the yarn. It is apportant to work the single crochet that follows the cluster wite firmly so that the bobble sits proudly.

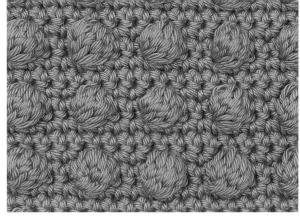

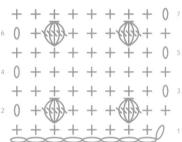

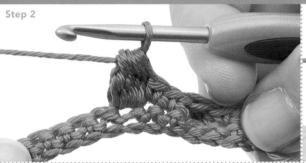

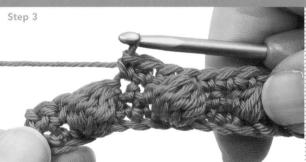

Multiple 4 sts + 1.

Step 1 (row 1) 1sc in 2nd ch from hook, 1sc in every ch to end, turn.

Step 2 (row 2) Ch1, skip first sc, 1sc in next sc, *dc5tog in next sc, 1sc in next 3sc; rep from * to last 2sc, dc5tog in next sc, 1sc in last sc, 1sc in ch-1, turn.

Step 3 (rows 3–5) [Ch1, skip first sc, 1sc in every st to end, turn] 3 times.

Step 4 Repeat Steps 2 and 3.

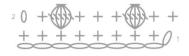

Steps 1-2

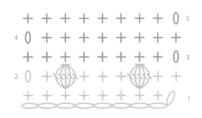

Step 3

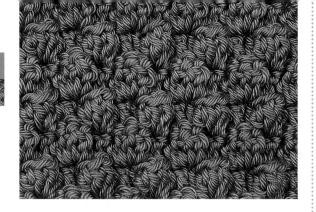

87 Alternate Popcorns

This stitch is a very good introduction to working popcorns. Popcorns are made by working a specified number of stitches into one place and then drawing them together by removing the hook from the work, reinserting it through the back loop only of the first of these stitches, catching the live loop and pulling it through the back loop of the first stitch to close the popcorn. This example also shows you how to work popcorns from both sides of the work.

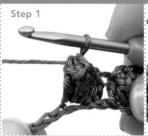

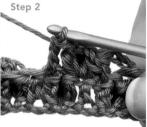

Multiple 4 sts, plus 3 for the foundation chain.

Step 1 1Rsp in 5th ch from hook, skip 1ch, 1dc in next ch, *skip 1ch, 1Rsp in next ch, skip 1ch, 1dc in next ch; rep from * to end, turn.

Step 2 Ch3, skip first dc, *1dc in Rsp, 1Wsp in next dc; rep from * to last Rsp, 1dc in last Rsp, 1dc in tch, turn.

Step 3 Ch3, skip first dc, *1Rsp in next dc, 1dc in Wsp; rep from * to last two sts, 1dc in last Wsp, 1dc in tch, turn.

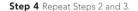

Special stitch Rsp (popcorn on right-side row): work 5dc all in next st, withdraw hook leaving a loop, reinsert hook under back loop only of first of these 5dc, catch empty loop and pull through to close the popcorn.

Special stitch Wsp (popcorn on wrong-side row): as Rsp, above, but to close, reinsert hook from top of first of 5dc, down under front loop only.

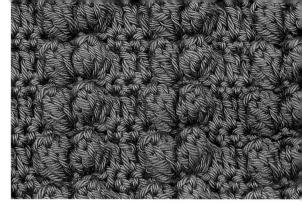

88 Paired Popcorns

As the name suggests, this stitch is based on building a network of paired popcorns linked by single chains and alternating with groups of double crochet. This produces a textured fabric with a distinct pattern that would work well for larger projects. This type of pattern also looks best in medium- to heavyweight yarns.

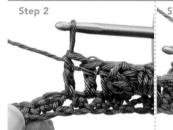

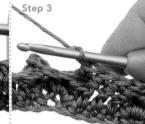

Multiple 6 sts + 1.

Step 1 (WS) 1sc in 2nd ch from hook, *ch1, skip 1ch, 2sc in next ch, ch1, skip 1ch, 1sc in each of next 3ch; rep from * to last 2ch, ending 1sc in each of last 2ch, turn.

Step 2 Ch3, skip first sc, 1dc in next sc, skip 1ch, 1Pc in next sc, ch1, 1Pc in next sc, skip 1ch, *1dc in each of next 3sc, 1Pc in next sc, ch1, 1Pc in next sc, skip 1ch; rep from * to last 2 sts, 1dc in 1ch, turn.

Step 3 Ch1, skip first dc, 1sc in next dc, ch1, skip 1Pc, 2sc in next ch-1 sp, ch1, *1sc in each of next 3dc, ch1, skip 1Pc, 2sc in next ch-1 sp, ch1; rep from * to last 2 sts, 1sc in next dc, 1sc in tch, turn.

Step 4 Repeat Steps 2 and 3.

Special stitch Pc (5dc popcorn): 5dc in same stitch, withdraw hook leaving a loop, reinsert hook under 2 threads at top of first of these 5dc, catch empty loop and pull it through to close popcorn.

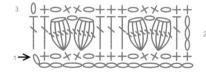

89 Raised Popcorns

This stitch shares some similarities with Raised Pineapple stitch (see stitch 82, page 90). Both are worked over a background of single crochet, but in this example the stitch is worked entirely into a single crochet two rows below the position of the stitch. Raised popcorns are made in the same way as regular popcorns, but are raised by lying above the single crochet fabric. The result is a distinct pattern with clearly defined texture. As with similar stitches it is best worked in mediumto heavyweight pure wool and cotton-based varns. It would be a suitable stitch to use in homewares projects like pillows, blankets, and throws.

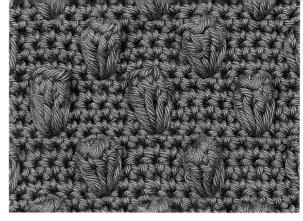

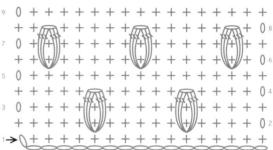

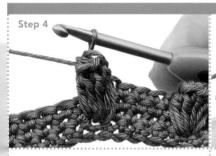

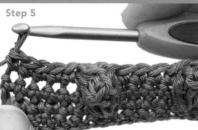

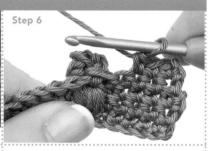

Multiple 6 sts + 5.

Step 1 (row 1) 1sc in 2nd ch from hook, 1sc in every ch to end, turn.

Step 2 (row 2) Ch1, skip first sc, 1sc in every sc to end, 1sc in ch-1, turn.

Step 3 (row 3) As Step 2.

Step 4 (row 4) Ch1, skip first sc, 1sc in each of next 4sc, *1Rp in sc 2 rows below next sc, 1sc in each of next 5sc; rep from * to end, working last sc in ch-1, turn.

Step 5 (rows 5-7) As Step 2, 3 times.

Step 6 (row 8) Ch1, skip first sc, 1sc in next sc, *1Rp in sc 2 rows below next sc, 1sc in each of next 5sc; rep from * to last 3sc, 1Rp in sc 2 rows below next sc, 1sc in next sc, 1sc in ch-1, turn.

Step 7 Repeat Steps 2-6.

Special stitch Rp (raised popcorn): ch1, 6dc all in sc 2 rows below next sc, withdraw hook leaving a loop, reinsert hook in ch worked before 6dc, catch empty loop and pull through to close popcorn.

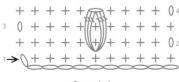

Steps 1-4

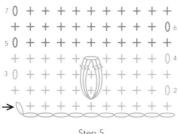

Step 5

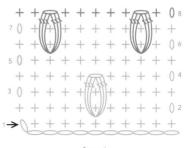

Step 6

90 Global Connection

Global Connection is one of the more delicate popcorn stitches. There are two reasons for this. The first is that there are only four doubles in each popcorn. The second is that each popcorn sits in-between a three-stitch fan. The overall effect is much lacier and less dense than other examples in this section. Consequently, it has a better drape than some of the more deeply textured stitches. It is important to maintain an even gauge when combining these two techniques and you may find it necessary to move down a hook size to achieve this. When completed, it is often a good idea to check the popcorns and pop them through from the back if they have got flattened while you have been working.

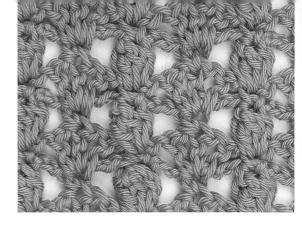

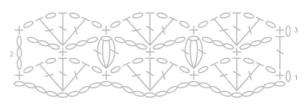

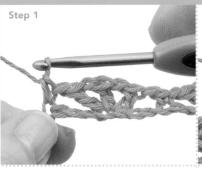

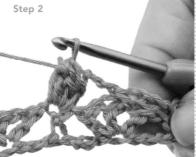

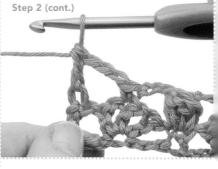

Multiple 8 sts + 2.

Step 1 (RS) 1sc in 2nd ch from hook. *ch1, skip 3ch, 1dc in next ch, ch1, work [1dc, ch1, 1dc] in same ch as last dc, ch1, skip 3ch, 1sc in next ch; rep from * to end, turn.

Step 2 Ch6 (counts as 1dc and 3ch), skip 1dc, 1sc in next dc, *ch3, 1Pc in next sc, ch3, skip 1dc, 1sc in next dc; rep from * to last sc, ch3, 1dc in last sc, turn.

Step 3 Ch1, 1sc in first dc, *ch1, 1dc in next sc, ch1, work [1dc, ch1, 1dc] in top of next sc, ch1, 1sc in top of Pc; rep from * ending 1sc in 3rd of ch-6, turn.

Step 4 Repeat Steps 2 and 3.

Special stitch Pc (4dc popcorn): 4dc in the next stitch, remove hook from loop, and reinsert (from front to back) in the top of the first of the 4dc, pick up the live loop and draw through the first dc, ch1 to secure popcorn.

Step 2

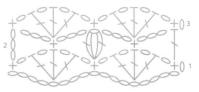

Step 3

91 Zig-zag Popcorn

Zig-zag Popcorn is another stitch that requires some aftercare to achieve the desired effect. One of the reasons for this is that you are making popcorns on every row. This means that sometimes the front of the doubles will show and sometimes the backs will. This in turn affects the appearance of the popcorn and so it becomes necessary to push the popcorns through from the back when you have finished creating your fabric. The popcorns are held together by a network of chains and single crochet, which makes this the least stable stitch in this collection. Choice of yarn is very important with a stitch like this and you may also find that you need to adjust the size of your hook to achieve a professional finish.

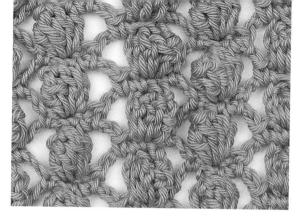

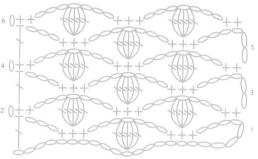

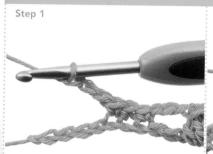

Step 2

Multiple 10 sts + 1, plus 4 for the foundation chain.

Step 1 1sc in 9th ch from hook, 1sc in each of next 2ch, *ch3, skip 3ch, 1Pc in next ch, ch3, skip 3ch, 1sc in each of next 3ch; rep from * to last 4ch, ch3, skip 3ch, 1dc in last ch, turn.

Step 2 Ch1, 1sc in first dc, *1sc in next ch-3 arch, ch3, 1Pc in 2nd of next 3sc, ch3**, 1sc in next ch-3 arch, 1sc in next Pc; rep from * ending last rep at **, 1sc in 6th and 7th of ch-9, turn.

Step 3 Ch6 (counts as 1dc and 3ch), *1sc in next ch-3 arch, 1sc in next Pc, 1sc in next ch-3 arch**, ch3, 1Pc in 2nd of next 3sc, ch3; rep from * ending last rep at **, ch3, 1dc in last sc, turn.

Step 4 Repeat Steps 2 and 3.

Special stitch Pc (5dc popcorn): 5dc in the next stitch, remove hook from loop, and reinsert (from front to back) in the top of the first of the 5dc, pick up the live loop and draw through the first dc, ch1 to secure popcorn.

Step 2

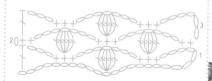

Step 3

92 Zig-zag Lozenge

Zig-zag Lozenge stitch is a very versatile and pleasing stitch to work. The pattern is based on a series of alternating rows of "V" stitches and clusters. The resulting fabric is more stable than Global Connection (see stitch 90, page 96) which combines popcorns and fans, because in this example the clusters are worked into the "V"s, rather than suspended between them. Further stability is gained by the offsetting of the pattern over four rows. Zig-zag Lozenge is a much less textured stitch than previous examples, but emphasis can be given to the clusters by working the pattern over a two- or even three-row stripe sequence. The stitch is suited to many different varn types and would also work in a variety of contexts from garments through to accessories.

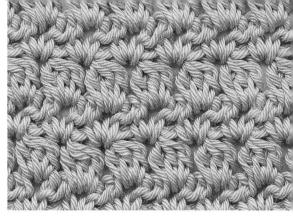

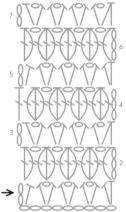

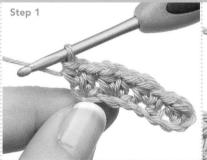

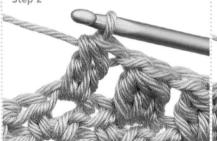

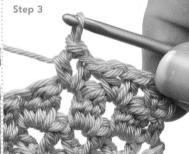

Multiple 2 sts + 1, plus 2 for the foundation chain.

Step 1 (WS) Skip 2ch (counts as 1hdc), 1hdc in 3rd ch from hook, *skip 1ch, [1hdc, ch1, 1hdc] in next ch; rep from * to last 2ch, skip 1ch, 2hdc in last ch, turn.

Step 2 Ch3, 1dc in first st (counts as dc2tog), *ch1, work dc3tog into next ch-sp; rep from * to last sp, ending ch1, dc2tog in top of tch.

Step 3 Ch2 (counts as 1hdc), skip first dc2tog, *[1hdc, ch1, 1hdc] in next ch sp; rep from * to end working 1hdc in tch, turn.

Step 4 Ch3 (counts as 1dc), *dc3tog in next ch-sp, ch1; rep from * to end working 1dc in tch, turn.

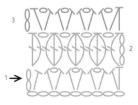

Step 4

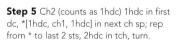

Step 6 Repeat Steps 2-6.

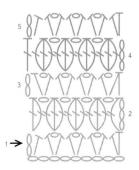

Steps 5-6

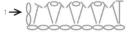

93 Crown Puff Lattice

Crown Puff Lattice is a beautiful but fairly complex stitch, combining "V" stitches, clusters, bobbles, and fans. The result is a bold pattern which needs to be worked over fairly large areas for the overall design to be appreciated. Despite the fact that there are distinct spaces in the fabric, it remains stable because the clusters are supported by the network of "V" stitches and fans. Once again, further stability is gained by the offsetting of the pattern over four rows. This stitch would work well in a variety of yarns, although it is limited to projects that do not require too much shaping.

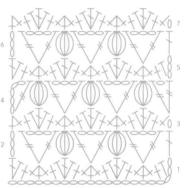

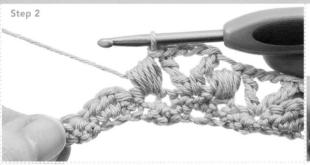

Multiple 6 sts + 1, plus 2 for the foundation chain.

Step 1 (RS) 1hdc in 3rd ch from hook, *1sc in next ch, sc3tog over next 3ch, 1sc in next ch, [1hdc, 1dc, 1hdc] in next ch; rep from * to end of row ending last rep with [1hdc, 1dc] in last ch, turn.

Step 2 Ch3 (counts as 1dc), skip first 3 sts, *[1tr, ch3, 1tr] in next sc cl, skip 2 sts**, hdc5tog in next dc; rep from * ending last rep at **, 1dc in tch, turn.

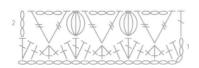

Steps 1-2

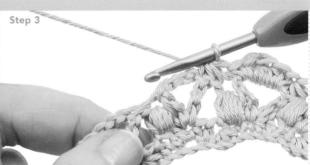

Step 3 Ch1, skip 1dc, 1sc in next tr (counts as 1Cl), *[1sc, 1hdc, 1dc, 1hdc, 1sc] in next ch-3 arch**, sc3tog over next 3 sts; rep from * ending last rep at **, sc2tog over last dc and tch, turn.

Step 4 Ch5 (counts as 1tr and 1ch), 1tr in first sc, *skip 2 sts, hdc5tog in next dc, skip 2 sts**, [1tr, ch3, 1tr] in next sc Cl; rep from * ending last rep at **, [1tr, ch1, 1tr] in tch, turn.

Step 5 Ch3 (counts as 1dc) 1hdc in first tr, 1sc in next ch, *sc3tog over next 3 sts**, [1sc, 1hdc, 1dc, 1hdc, 1sc] in next ch-3 arch; rep from * ending last rep at **, 1sc in 5th of ch-5, [1hdc, 1dc] in 4th of ch-5, turn.

Step 6 Repeat Steps 2-5.

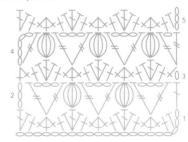

Steps 3-5

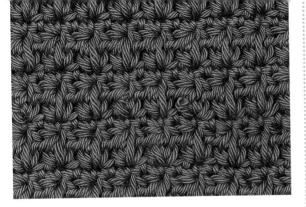

94 Mixed Cluster

Mixed Cluster stitch is a simple but highly effective stitch. It is described as mixed not because it combines different types of cluster, but because the beginning of one cluster starts at the same point as the end of the previous cluster and so the cluster becomes mixed.

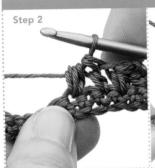

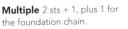

Step 1 (WS) Skip 2ch (counts as 1sc), 1sc in next and every ch to end of row, turn.

Step 2 Ch2 (counts as 1hdc), 1Mc in first sc, *ch1, 1Mc starting in same st as previous Mc; rep from * ending last rep in 2nd of ch-2, 1hdc also in tch, turn.

Step 3 Ch1, skip 1hdc, 1sc in next and every st to end of row, 1sc in tch, turn.

Step 4 Repeat Steps 2 and 3.

Special stitch Mc (mixed cluster): yo, insert hook in first of designated sts, yo, draw loop through, yo, draw through 2 loops, skip 1 st, [yo, insert hook in next st, yo, draw loop through] twice all in the same st, yo and draw through all 6 loops on hook.

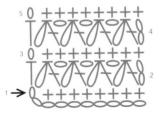

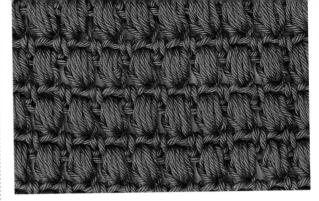

95 Aligned Puff

Aligned Puff stitch is a highly distinctive, yet easy stitch to work. The rows of single crochet and half double clusters result in a sturdy, textured fabric ideal for making bags and homewares. It would work well in a variety of yarns and greater emphasis could be given to the clusters by working them in a contrasting color to the single crochet rows.

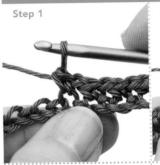

Multiple 2 sts + 1, plus 1 for the foundation chain.

Step 1 (RS) 1sc in 2nd ch from hook, *ch1, skip 1ch, 1sc in next ch; rep from * to end, turn.

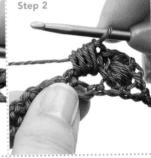

Step 2 Ch2 (counts as 1hdc), skip first sc, hdc4tog in next ch-sp, *ch1, hdc4tog in next ch-sp; rep from * to end working last hdc in last sc, turn.

Step 3 Ch1, 1sc in first hdc, *ch1, skip 1 st, 1sc in next ch-1 sp; rep from * to end, 1sc in 2nd of ch-2, turn.

Step 4 Repeat Steps 2 and 3.

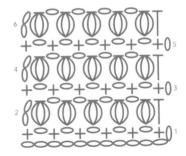

96 Blackberry Salad

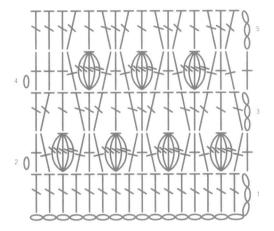

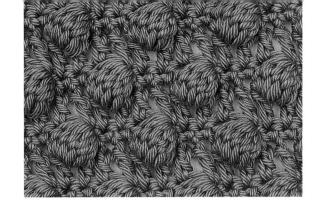

Blackberry Salad is a lovely cluster stitch that offers texture as well as excellent drape. Although the clusters are made from five doubles being worked together, this is balanced by the fact that these clusters alternate between rows of double crochet. The overall fabric remains surprisingly stable due to the clusters being worked into the double crochet in the row below. This would be a great stitch to use for a baby blanket and could be worked in a variety of weights and colors of varn. It would also make an effective border to other homewares projects.

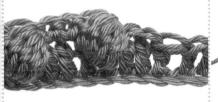

Step 3

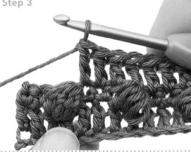

Step 4

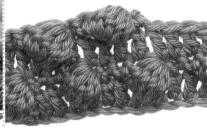

Step 4 Ch1, 1sc in each of first 4dc, *dc5tog

in next dc, 1sc in next 3dc; rep from * to end,

Multiple 4 sts + 1, plus 2 for the foundation chain.

Step 1 (RS) Skip 3ch (counts as 1dc), 1dc in every ch to end of row, turn.

Step 2 Ch1, 1sc in each of first 2 sts, *dc5tog in next dc, 1sc in each of next 3dc; rep from * to last 2dc, dc5tog in next dc, 1sc in last dc, 1sc in tch, turn.

Step 3 Ch3, skip first sc, 1dc in every st to end of row, turn.

Step 6 Repeat Steps 2-5.

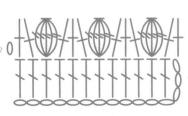

Steps 1-2

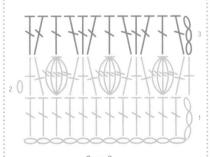

Step 3

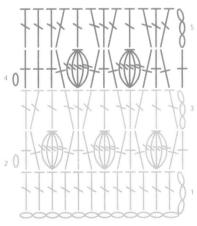

Steps 4-5

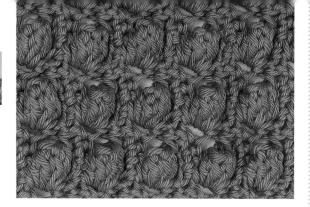

97 Popcorn Waffle

Popcorn Waffle is a highly textured stitch, but remains fairly simple as it is worked over two rows only. The popcorns are anchored on either side by a single crochet stitch, which helps to give the impression that they are lying on their side. The popcorns are further stabilized by the sequence of single crochet, half doubles and doubles in the intervening rows.

Step 3 Ch1, 1sc in next dc, *ch3, 1Pc in sc just worked, skip next 3 sts, 1sc in next dc; rep from * to end, 1sc in tch,

Step 1 (RS) 1sc in 2nd ch from hook, *ch3, 1Pc in sc just worked, skip 3ch, 1sc in next

Multiple 4 sts + 1, plus 1 for

the foundation chain.

Step 2 Ch3 (counts as 1dc), skip first sc, *1sc in each of next 2ch, 1hdc in 3rd ch, 1dc in next sc; rep from * to end of row, turn.

ch; rep from * to end, turn.

Step 4 Repeat Steps 2 and 3.

turn.

Special stitch Pc (5dc popcorn): 5dc in the next stitch, remove hook from loop, and reinsert (from front to back) in the top of first of 5dc, pick up the live loop and draw through the first dc, ch1 to secure the popcorn.

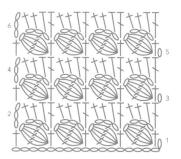

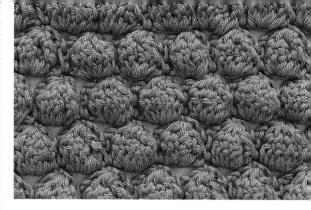

98 Pebble Lace

Pebble Lace is very similar in appearance to Popcorn Waffle (see stitch 97, left), but is constructed in a very different way. The depth and roundness of each cluster is created by working seven treble crochet stitches together. These clusters are suspended within a tight framework of chain and single crochet to gain stability. The result is a highly textured fabric, suitable for projects that need to be hard wearing, like rugs and mats.

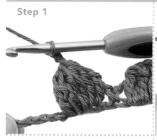

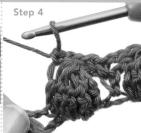

Multiple 4 sts + 3, plus 1 for the foundation chain.

Step 1 (WS) 1sc in 2nd ch from hook, *ch2, skip 1ch. tr7tog in next ch, ch2, skip 1ch, 1sc in next ch; rep from * to last 2ch, ch2, skip 1ch, 1hdc in last ch, turn.

Step 2 Ch1, 1sc in first hdc, *ch3, 1sc in next cl; rep from * to last sc, ch1, 1hdc in last sc, turn

Step 3 Ch4, skip first hdc and 1ch, 1sc in next sc, *ch2, tr7tog in 2nd of next ch-3, ch2,

1sc in next sc; rep from * to end, turn.

Step 4 Ch3, skip first st and 2ch, 1sc in next cl, *ch3, 1sc in next cl; rep from *, ch3, 1sc in 2nd of ch-4, turn.

Step 5 Ch1, 1sc in first sc, *ch2, tr7tog in 2nd of next ch-3, ch2, 1sc in next sc; rep from *, ch2, 1hdc in 2nd of ch-3, turn.

Step 6 Repeat Steps 2-5.

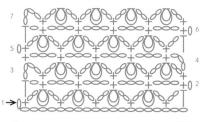

Where this symbols appears, work:

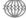

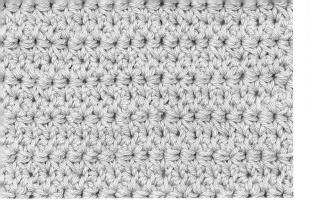

99 Marguerite

Marguerite stitch is probably the flattest of all the cluster-based stitches. It is included in this section because of the nature of ts construction. In this stitch the cluster is made up of spiked oops. These loops are so called because they spread out over several stitches before being drawn back together with a closing loop. The example below shows a Marguerite cluster with three spike loops, but your pattern will always advise as to now many spike loops to make.

Multiple An odd number of sts.

Step 1 1M3c picking up 1 loop in 2nd, 3rd, and 5th ch from hook, *ch1, 1M3c; rep from * to end, turn.

Step 2 Ch3, 1M3c picking up loops in 2nd and 3rd ch from hook and in loop that closed 2nd M3c on previous row, *ch1, 1M3c picking up first loop in loop that closed previous M3c, 2nd loop in same place as last spike of previous M3c and last loop in

ch that closed next M3c on previous row; rep from * to end, picking up final loop in 3rd of ch-3, turn.

Step 3 Repeat Step 2.

Special stitch M3c

(Marguerite cluster with 3 spike loops): yo and draw a loop through the loop that closed previous M3c, 2nd loop in same place as last spike of previous M3c, skip 1ch, last loop in next ch, yo and draw through all 5 loops.

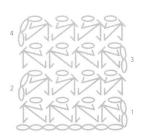

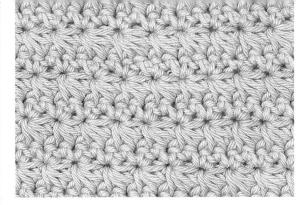

100 Five-Star Marguerite

Five-Star Marguerite stitch builds on the basic technique of the last stitch. As the name suggest, there are now five rather than three spike loops and so the fabric is much lacier in appearance. This is a very pretty stitch where the alternating rows of single crochet help the spiked loops to look like the heads of daisies.

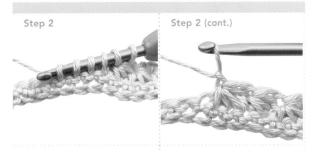

Multiple An even number of sts.

Step 1 (WS) 1sc in 2nd ch from hook, 1sc in every ch to end of row, turn.

Step 2 Ch3, 1M5c inserting hook in 2nd and 3rd ch from hook and then first 3 sts to pick up 5 spike loops, *ch1, 1M5c; rep from * to end, turn.

Step 3 Ch1, 1sc in loop that closed M5c, *1sc in next ch, 1sc in loop that closed last M5c; rep from * to end, 1sc in each of next 2ch, turn.

Step 4 Repeat Steps 2 and 3.

Special stitch M5c

(Marguerite cluster with 5 spike loops): pick up spike loops (yo and draw through) by inserting hook in loop that closed the previous M5c under 2 threads of last spike loop of same M5c, in same place that last spike loop of same M5c was worked in each of next 2 sts, yo and draw through all 6 loops on hook.

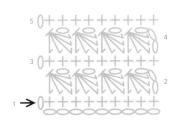

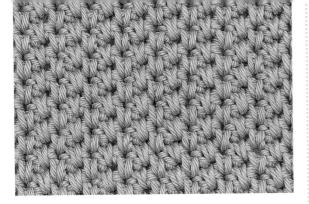

101 Alternate Spikes

Although this is one of the most basic stitches in this section, it is still very attractive. Spike stitches are made by inserting the hook into rows below the working row at designated points. The best way to ensure successful spike stitches is to draw this loop back up to the working row quite loosely. Alternate spikes are a great introduction to this technique.

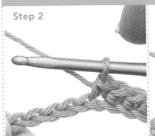

Multiple An even number of sts.

Step 1 (row 1) 1sc in 2nd ch from hook.

Step 2 (row 1 cont.) 1sc in every ch to end of row, turn.

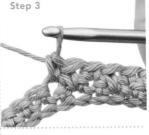

Step 3 (row 2) Ch1, *1sc in next sc, 1sc below next sc; rep from * to last st, 1sc in ch-1,

Step 4 Repeat Step 3.

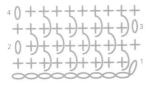

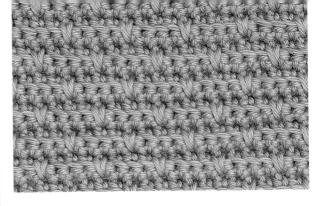

102 Basket

Basket stitch is similar in appearance and technique to Back Loop Single crochet (see stitch 3, page 35). In this example the rows of back loop single crochet are broken up by working a single crochet underneath the designated single crochet in the row below. The effect is of little "V"s lying across the ridges of back loop single crochet.

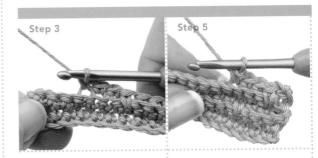

Multiple 4 sts, plus 3 for the foundation chain.

Step 1 1sc in 2nd ch from hook, 1sc in every ch to the end of the row, turn.

Step 2 Ch1, skip first sc, 1sc in back loop of every sc to the end of the row, 1sc in ch-1, turn.

Step 3 Ch1, skip first sc, 1sc in back loop of next 2sc, *1sc below the next sc, 1sc in back loop of next 3sc; rep from * to end of row working last sc in ch-1, turn.

Step 4 As Step 2.

Step 5 Ch1, skip first sc, *1sc below next sc, 1sc in back loop of next 3sc; rep from * to last sc, 1sc below last sc, 1sc in ch-1, turn.

Step 6 Repeat Steps 2–5.

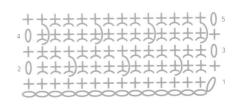

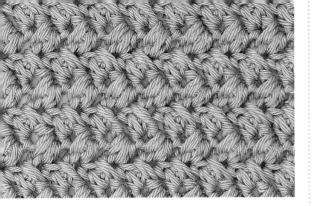

103 Spiked Boxes

Spiked Boxes is a really attractive stitch, combining the techniques of working spikes and clusters. It is much quicker to work than the previous examples (see left) because it is made up of doubles and worked into deeper chain spaces. The zig-zag effect is created by working two double stitches together over the spiked double and half double two together of the previous row.

Step 2

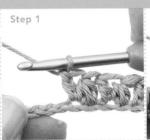

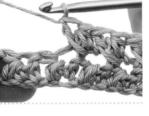

Multiple An odd number of sts.

Step 1 Hdc2tog over 4th and 5th ch from hook, *1dc in same ch as last st, hdc2tog over next 2ch; rep from * to end, turn.

Step 2 Ch3, hdc2tog over first hdc2tog and next dc, *15pike dc, hdc2tog over next 2 hdc2tog and following dc; rep from * to last hdc2tog, hdc2tog over last hdc2tog and tch, turn. **Step 3** Ch3, hdc2tog over first hdc2tog and next Spike dc, *1Spike dc, hdc2tog over next hdc2tog and next Spike dc; rep from * to last hdc2tog, hdc2tog over last hdc2tog and tch, turn.

Step 4 Repeat Step 3.

Special stitch Spike dc (spiked double crochet): work 1dc, inserting hook in row below in sp between 2 sts last worked into.

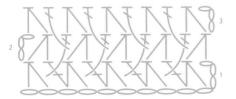

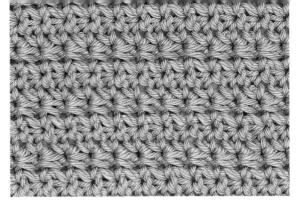

104 Small Daisy

Small Daisy is a fully reversible stitch with a distinctive pattern. In this example, the spiked stitches are worked across the row to draw the clusters together, rather than dipping down into the row below. Small Daisy is best worked in pale cotton yarns so that the subtlety of the patterning is not lost.

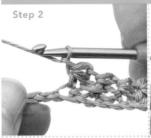

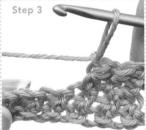

Multiple An odd number of sts.

Step 1 (row 1) 1Daisy cl from 2nd, 3rd, and 5th ch from hook.

Step 2 (row 1 cont.) *Ch1, 1Daisy cl; rep from * to end, turn.

Step 3 (row 2) Ch3, work first 2 legs of first Daisy cl; in 2nd and 3rd of these 3ch, skip [first Daisy cl, 1ch] and work 3rd leg of cl in st at top of next Daisy cl, *ch1, 1Daisy cl; rep from * to end, turn.

Step 4 Repeat Step 3.

Special stitch Daisy cl (daisy cluster): insert hook in st closing previous Daisy cl, yo, pull through a loop, insert hook in same place as last spike of previous Daisy cl, yo, pull through a loop, skip 1ch, insert hook in next st, yo, pull through a loop, yo, pull through 4 loops on hook.

105 Brick

Brick stitch is an unusual stitch where the spiked doubles help to create the illusion of movement across the pattern. This is achieved by working spiked doubles over alternating rows of front loop single crochet. In other words, the spiked doubles appear to "catch" the front loops of the single crochet. This stitch is best worked in medium- to heavyweight cottons which will help to accentuate the spiked doubles. The resulting fabric has good drape as well as remaining quite firm.

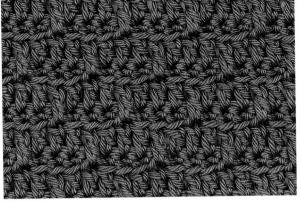

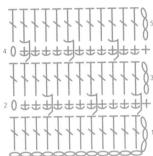

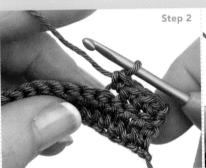

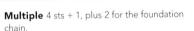

Step 1 1dc in 4th ch from hook, 1dc in every ch to end of row, turn.

Step 2 Ch1, skip first dc, 1sc in front loop of every dc to end of row, 1sc in tch, turn.

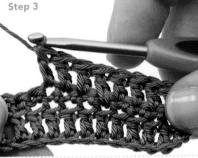

Step 3 Ch3, skip first sc, *1dc in front loop of dc in row below next sc, 1dc in each of next 3sc; rep from * to end, working last dc in top of ch-1, turn.

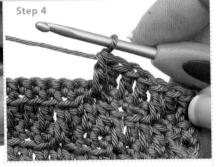

Step 4 As Step 2.

Step 5 Ch3, skip first sc, 1dc in each of next 2sc, *1dc in front loop of dc in row below next sc, 1dc in each of next 3sc; rep from * to last sc, 1dc in front loop of dc in row below last sc, work last dc in ch-1 below, turn.

Step 6 Repeat Steps 2-5.

Steps 1-2

Step 3

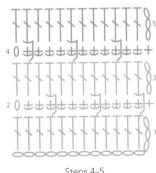

Steps 4-5

106 Brickwork

Brickwork is a quick and interesting stitch to work. If you are new to the stitch it is probably best to work it in two contrasting colors so that it is easier to see and count where the spiked stitches need to be worked. The overall design is based on the typical brickwork pattern of overlapping segments. In this example, groups of trebles are worked into the front loops of single crochet in the row below. This process is then alternated over a four-row pattern repeat. The resulting fabric is firm but still with relatively good drape and this makes it an ideal choice for homeware projects.

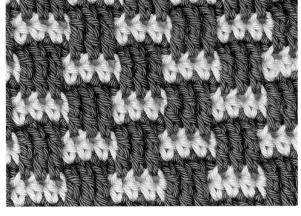

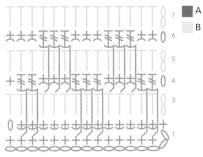

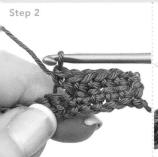

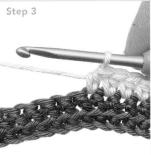

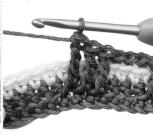

Step 4

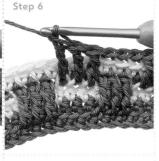

Multiple 6 sts + 3, plus 1 for the foundation chain.

Step 1 Work the required number of foundation chain in yarn A. 1sc in 3rd ch from hook, 1sc in every ch to end of row, turn.

Step 2 Ch1 (counts as 1sc), skip first sc, 1sc in front loop only of every sc to end of row, changing to yarn B at last yo of final sc, turn. Fasten off yarn A.

Step 3 In yarn B, ch2 (counts as first hdc), skip first st and then work a hdc, (under both loops) of every sc to end of row. Fasten off yarn B, but do not turn the work.

Step 4 Join yarn A to beginning of previous row, ch1 (counts as first sc), 1tr in front loop only of next 2sc 2 rows below, 1sc in back loop only of next 3hdc, *1tr in front loop only of next 3sc 2 rows below, 1sc in back loop only of next 3hdc; rep from * to last 3 sts, 1tr in front loop only of next 2sc in 3rd row below, 1sc in last sc. Fasten off yarn A, but do not turn the work.

Step 5 As Step 3 in yarn B.

Step 6 Join yarn A to beginning of previous row, ch1 (counts as first sc), 1sc in back loop only of next 2hdc, *1tr in front loop only of next 3sc 2 rows below, 1sc in back loop only of next 3hdc; rep from * to end. Fasten off yarn A, but do not turn the work.

Step 7 As Step 3.

Step 8 Repeat Steps 4-7.

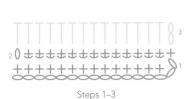

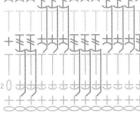

Steps 4-7

107 Outline Squares

Outline Squares is a highly distinctive and impressive stitch. Again, if you are new to this one, it is probably best to work in two contrasting colors to start with. This will help you to understand how the stitch is constructed and increase your ability and confidence to experiment with different color combinations and yarn textures. The "squares" are worked in back loop single crochet and are defined by working a quadruple single over the preceding four rows. Further definition is achieved by working every fourth row in the same color as the quadruple singles, thus completing the illusion of an outlined square. This beautiful textured stitch would make a lovely pillow cover.

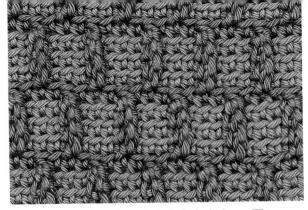

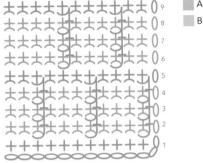

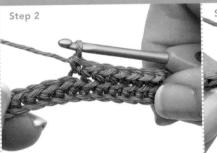

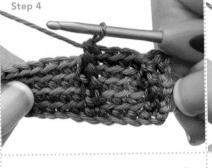

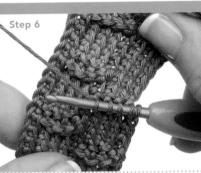

Multiple 4 sts, plus 1 for the foundation chain

Step 1 (row 1) Using yarn A, work 1sc in 3rd ch from hook, 1sc in every ch to end of row. Fasten off yarn A and do not turn the work.

Step 2 (row 2) Join yarn B to beginning of previous row, ch1 (counts as first sc), skip first st. 1sc in back loop only of every sc to end of row.

Step 3 (rows 3-4) As Step 2, twice. At the end of row 4, fasten off yarn B and do not turn the work.

Step 4 (row 5) Join yarn A to beginning of previous row, ch1 (counts as first sc), skip first sc, insert hook under front loop of next st, yo and pull loop through, [insert hook under front loop of st that lies below st just worked, yo and pull loop through] 3 times, [yo and pull loop through first 2 loops on hook] 4 times, (1Quad sc) *1sc in back loop of next 3 sts, 1 connected Quad sc in next st; rep from * to last 2 sts, 1sc in back loop of the last 2sc. Fasten off varn A and do not turn the work.

Step 5 (rows 6-8) As Step 2, 3 times.

Step 6 (row 9) Join yarn A to beginning of previous row, ch1 (counts as first sc), skip first sc, 1sc in back loop of next 2 sts, *1 connected Quad sc in next st, 1sc in back loop of next 3 sts; rep from * to last st, 1sc in back loop of last sc. Fasten off yarn A and do not turn the work.

Step 7 Repeat Steps 2-6.

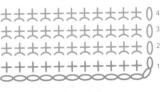

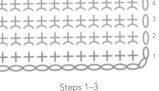

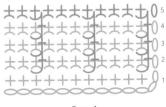

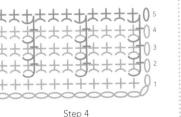

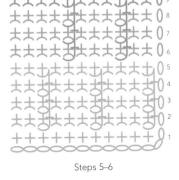

108 Double Crosses

This is a highly effective but relatively simple stitch to work. Like Small Daisy stitch (see stitch 104, page 105), the spiked element works across the row, rather than into the row or rows below the working one. The result is a fabric punctuated with double crochet crosses. Since these crosses alternate every two rows, the overall effect is of interlinking diamonds, similar to quilting. The structure is much looser than most of the previous stitches and so this stitch would work in a variety of weights and textures of yarns and in a variety of contexts. However, it may be a good idea to avoid very dark or fluffy yarns as the crosses may lose some of their definition.

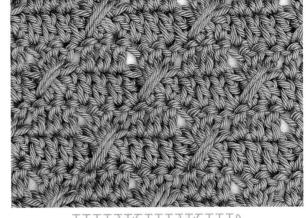

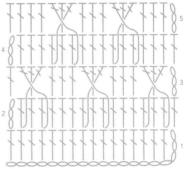

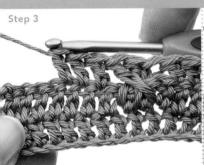

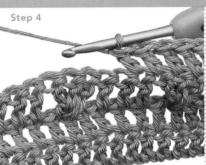

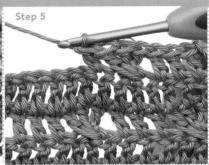

Multiple 6 sts + 5, plus 2 for the foundation chain

Step 1 1dc in 4th ch from hook, 1dc in every ch to end, turn.

Step 2 Ch3, skip first dc, 1dc in every dc to end of row, 1dc in tch, turn.

Step 3 Ch3, skip first dc, *skip next 2dc, 1dc at base of next dc, 1dc in 2nd of skipped dc, 1dc in base of first skipped dc, 1dc in each of next 3dc; rep from * to last 3dc, skip next 2dc, 1dc at base of next dc, 1dc in 2nd of skipped dc, 1dc in base of first skipped dc, 1dc in tch, turn.

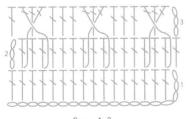

Steps 1–3

Step 4 As Step 2.

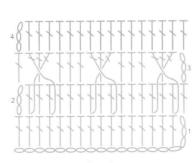

Step 4

Step 5 Ch3, skip first dc, *1dc in each of 3dc, skip next 2dc, 1dc at base of next dc, 1dc in 2nd of skipped dc, 1dc in base of first skipped dc; rep from * to last 3dc, 1dc in each of next 3dc, 1dc in tch, turn.

Step 6 Repeat Steps 2-5.

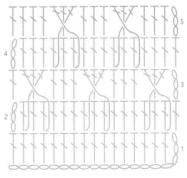

Step 5

110

109 Rake

This is a crochet stitch that seems to closely resemble a piece of woven fabric. As with previous examples, it is a good idea to work it in two contrasting colors while you become familiar with the technique, but there is no reason why yarns of different textures should not also be used in your own projects. It is also a good stitch for practicing changing and joining in new colors at the end of a row. I would recommend changing to a new color at the last yarn over of the last stitch in a row to ensure a neat edge and avoid any "jumps" in color. Yarns do not need to be cut at the end of rows and should simply be twisted up the side of the work.

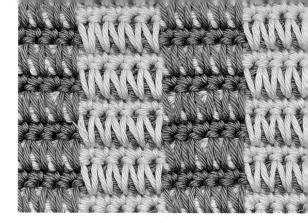

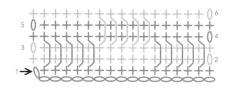

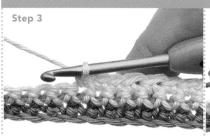

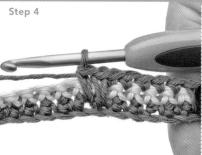

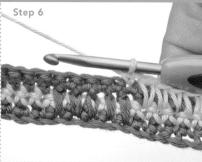

Multiple 10 sts + 7.

Step 1 (WS) In yarn A, work the required number of foundation ch, 1sc in 2nd ch from hook, 1sc in every ch, changing to yarn B (as above) at end of row, turn.

Step 2 In yarn B, ch1, skip first sc, 1sc in every sc to end, turn.

Step 3 As Step 2, changing to yarn A at end of row.

Step 4 In yarn A, ch1, skip first sc, *[1sc in corresponding sc in yarn A 2 rows below next sc] five times, 1sc in each of next 5sc; rep from * to last 6 sts, [1sc in corresponding sc in yarn A 2 rows below next sc] 5 times, 1sc in tch, turn.

Step 5 As Step 2, changing to yarn B at end of row.

Step 6 In yarn B, ch1, skip first sc, 1sc in each of next 5sc, *[1sc in corresponding sc in yarn B 2 rows below next sc] 5 times; rep from * to last 5 sts, 1sc in each of next 5sc, 1sc in tch, turn.

Step 7 Repeat Steps 3-6.

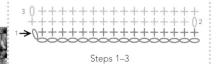

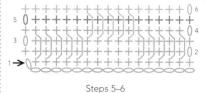

110 Eyelash

Eyelash stitch is very appropriately named, since the spike stitches are arranged in such a way as to resemble the lower lashes of the eye. Where two contrasting colors are used to work the pattern (as here), the lighter color will dominate and the "lashes" in the darker color will appear less defined. As with Rake stitch (see stitch 109, left), I would recommend changing to a new color at the last yarn over of the last stitch in a row to ensure a neat edge and avoid any "jumps" in color. Yarns do not need to be cut at the end of rows and should simply be twisted up the side of the work.

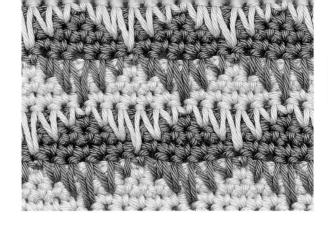

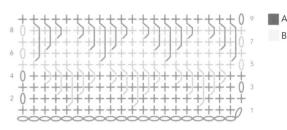

Step 5

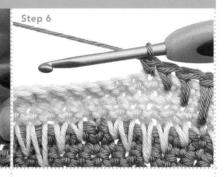

Multiple 6 sts + 3.

Step 1 (row 1) In yarn A, work the required number of foundation ch, 1sc in 2nd ch from hook, 1sc in every ch to end, turn.

Step 2 (row 2) Ch1, skip first sc, 1sc in every sc to end of row, turn.

Step 3 (rows 3-4) As Step 2, twice, changing to yarn B at end of 2nd rep

Step 4 (row 5) In yarn B, ch1, skip first sc, 1sc in next sc. *1sc in sc 1 row below next sc. 1sc in sc 2 rows below next sc. 1sc in sc 3 rows below next sc, 1sc in sc 2 rows below next sc, 1sc in sc 1 row below next sc, 1sc in next sc; rep from * to end, 1sc in tch, turn.

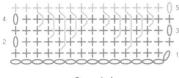

Steps 1-4

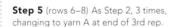

*1sc in sc 3 rows below next sc, 1sc in sc 2 rows below next sc, 1sc in sc 1 row below next sc, 1sc in next sc, 1sc in sc 1 row below next sc, 1sc in sc 2 rows below next sc; rep from * to last 2 sts, 1sc in sc 3 rows below next sc, 1sc in tch, turn.

Step 6 (row 9) In yarn A, ch1, skip first sc,

Step 7 Repeat Steps 2-6.

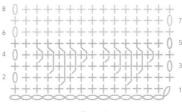

Step 5

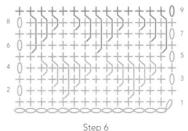

111 Birdsfoot Spike

Birdsfoot Spike is a very distinctive and aptly named stitch. The spikes are worked in contrasting colors (A and B), into the rows below and in different directions, to create the effect of a bird's footprint. It is better to join colors at the end of the row, by changing to the new color at the last yarn over of the last stitch of the previous row. There are a couple of things to be aware of when working this stitch. The first is accurate counting. Once the pattern is established, it is easier to see if you have made a mistake, but it is a good idea to keep a check on the first couple of repeats. The second concerns the length of the different spikes. It is important that the spikes are loose enough to reach the designated rows, but also tight enough to lie flat rather than become too loopy.

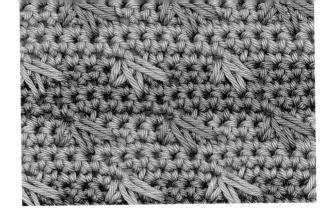

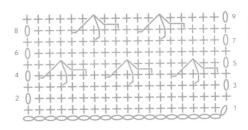

Step 6

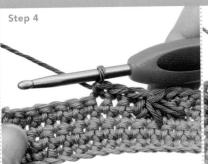

Multiple 6 sts, plus 1 for the foundation chain

Step 1 (row 1) In yarn A, work the appropriate number of foundation chain, 1sc in 2nd ch from hook, 1sc in every ch to end of row, turn

Step 2 (row 2) Ch1, skip first sc, 1sc in every sc to end of row, 1sc in tch, turn.

Step 3 (rows 3-4) As Step 2 twice, changing to yarn B at the end of the 2nd rep.

Step 4 (row 5) In yarn B, ch1, 1sc in each of next 2sc, *1Scl in place of next sc, 1sc in each of next 5sc; rep from * to last 2sc, 1sc in each of last 2sc, 1sc in tch, turn.

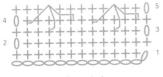

Steps 1-4

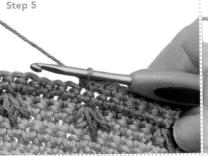

Step 5 (rows 6-8) As Step 2, 3 times, changing to yarn A as before at the end of the 3rd rep. Do not break yarn B.

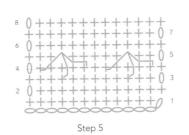

Step 6 (row 9) In yarn A, ch1, skip first sc. *1sc in each of next 5sc, 1Scl in place of next sc; rep from * to last 5 sts, 1sc in each of last 5sc, 1sc in tch, turn.

Step 7 Repeat Steps 2-6.

Special stitch Scl (Spike cluster): insert hook to right of sc 1 row below and 2 sts to right of next sc, yo, pull loop through, insert hook to right of sc 2 rows below next sc, yo, pull loop through, insert hook to right of sc 1 row below and 2 sts to left, yo and pull through all 4 loops on hook. It is important to lengthen these spiked sts so that the fabric continues to lie flat.

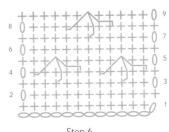

Step 6

112 Mirror

Mirror stitch is a relatively easy stitch to work but produces a surprisingly complex looking fabric. It differs from previous examples in two ways. The first is that the spikes are made using a tall stitch like a treble, rather than pulling through a long loop. The second is that the treble is worked into stitches that have been left empty or skipped in previous rows, rather than a designated space. The overall effect is of a strong interlocking pattern with good drape. This technique would work well in a variety of yarn weights and colors.

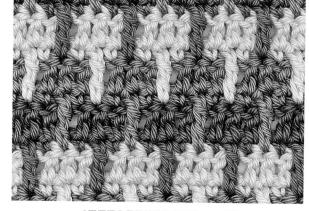

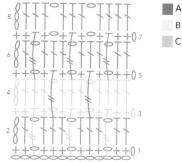

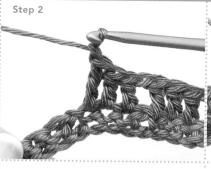

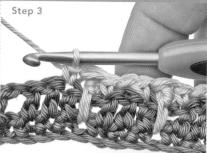

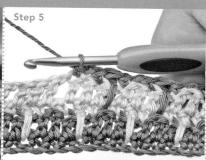

Step 4 Ch3, skip first sc, 1dc in each of next

3 sts, *ch1, skip 1ch, 1dc in each of next 3 sts;

changing to yarn C at last yo of last dc, turn.

2dc, *ch1, skip 1dc, 1sc in next dc, 1tr in next

skipped dc 3 rows below, 1sc in next dc; rep from * to last 2dc, ch1, skip 1dc, 1sc in next

Step 6 Ch3, skip first sc, 1dc in next sc, *ch1,

skip 1ch, 1dc in each of next 3 sts; rep from *

Step 5 In yarn C, ch1, 1sc in each of first

dc, 1sc in tch, turn.

rep from * to last sc, 1dc in last sc and

Multiple 4 sts, plus 2 for the foundation chain.

Step 1 (RS) Work the required number of foundation chain in yarn A, 1sc in 2nd ch from hook, 1sc in next ch, *ch1, skip 1ch, 1sc in each of next 3ch; rep from * to last 3ch. ch1, skip 1ch, 1sc in each of last 2ch, turn.

Step 2 Ch3, (counts as 1dc), skip first sc, 1dc in next sc, *ch1, skip 1ch, 1dc in each of next 3sc; rep from * to last 3sc, ch1, skip 1ch, 1dc in each of last 2sc and changing to yarn B at last yo of last dc, turn.

Step 3 In yarn B, ch-1 space, 1sc in each of first 2dc, 1tr in first skipped ch from row 1, *1sc in next dc, ch-1 space, skip 1dc, 1sc in next dc, 1tr in next skipped ch from row 1; rep from * to last dc, 1sc in next dc, 1sc in tch, turn.

1sc in next skipped dc 3 rows below, *1sc in next dc, 1tr in next skipped dc 3 rows below, 1sc in next dc; rep from * to last 2dc, 1sc in each of last 2dc, turn.

Step 8 As Step 4, but using yarn A.

Step 9 Repeat Steps 5–8, maintaining the 6-row stripe sequence of 2 rows in B, C, and A throughout.

Steps 1-2

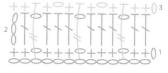

Step 3

113 Caterpillar Stripe

Caterpillar Stripe is sometimes known as Tooth Pattern. Both names are equally valid and what you decide to call the stitch may depend on whether you prefer to see a row of teeth or the legs and body of a caterpillar! Whatever your preference, the overall pattern is well balanced and much easier to work than some of the other spiked examples. The main reason for this is that you are not required to count and place stitches into rows below the working row. In this example the "spikes" are created by working taller stitches over the spaces that you have created on previous rows. This makes it easier to identify the two skipped stitches that you will need to place the treble stitches into. In other words, these "spikes" are worked in designated stitches rather than spaces. However, this still creates the illusion of covering existing stitches rather than simply filling in the gaps. The pattern is most effective when there is a strong contrast between yarn B with yarns A and C.

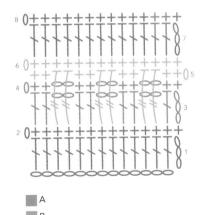

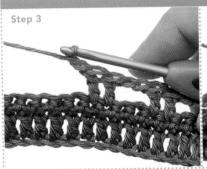

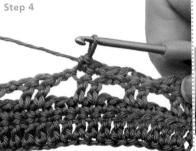

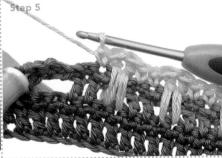

C

Multiple 4 sts, plus 4 for the foundation chain.

Step 1 (RS) Work the required number of foundation chain in yarn A. 1dc in 4th ch from hook, 1dc in every ch to end of row, turn.

Step 2 Ch1, 1sc in every dc to end of row, 1sc in 3rd of ch-3, changing to yarn B at last yo of row, turn.

Step 3 In yarn B, ch3 (counts as 1dc), skip first sc, 1dc in next sc, *ch2, skip 2sc, 1dc in each of next 2sc; rep from * to end, turn.

Step 4 Ch1, 1sc in each of first 2dc, *ch2, 1sc in each of next 2dc; rep from * to last dc, ch2, 1sc in last dc and 1sc in 3rd of ch-3, changing to yarn C at last yo of row, turn.

Step 5 In yarn C, ch1, 1sc in each of first 2sc, *1tr in each of 2 skipped sc lying 3 rows below, 1sc in each of next 2sc; rep from * to end, turn.

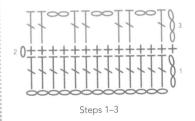

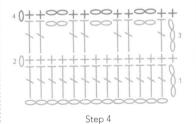

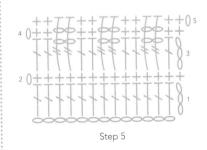

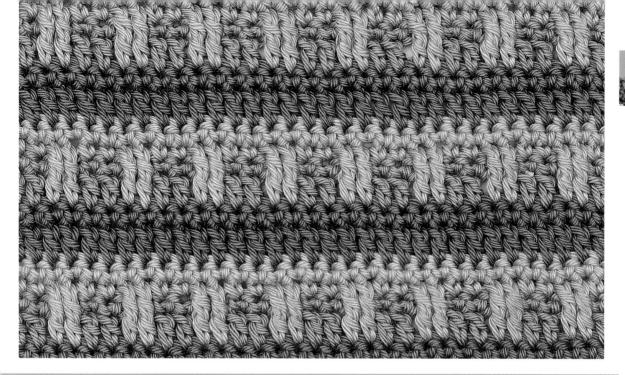

Step 6 Ch1, 1sc in every sc and tr to end of row, changing to yarn A at last yo of row, turn.

Step 7 In yarn A, ch3, skip first sc, 1dc in every sc to end of row, turn.

Step 8 Ch1, 1sc in every dc to end of row, 1sc in 3rd of ch-3, turn.

Step 9 Repeat Steps 3-8.

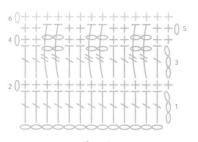

Step 6

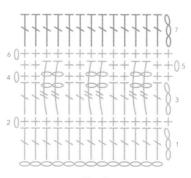

Step 7

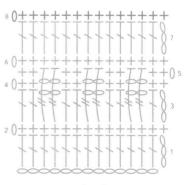

Step 8

114 Spiked Squares

Spiked Squares is a fairly simple stitch that relies on good use of color and accurate counting. It bears some similarities to Rake stitch (see stitch 109, page 110) where the regular alternation of squares of single crochet and spiked stitches produces a dense fabric that looks more like a weave than crochet. One of the impressive things about this stitch is that although it is based on repeating a six-row stripe sequence it appears much more complex than this. The regular two-row stripes are disrupted by spiked stitches. This creates the illusion that more than one color is being used in a row. So, where five single crochet in one color are followed by five spiked single crochet, the same color appears to drop down to the row below for this section.

An essential feature of this pattern is that the stitches are worked closely together. It is therefore probably best suited to medium- to heavyweight cotton and cotton-blend yarns. This will help to ensure that stitch definition is not lost and that an even gauge is maintained. The resulting fabric is strong and durable and would be ideal for many household projects.

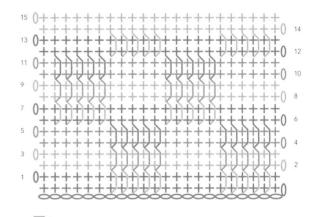

- A
- В
- C

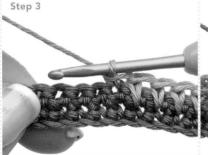

Step 4 (1st rep)

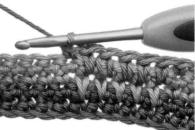

Step 4 (2nd rep)

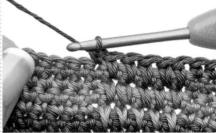

Multiple 10 sts + 2, plus 1 for the foundation chain.

Stripe sequence Work 2 rows in yarns A, B, and C throughout.

Step 1 (base row) (RS) Work the required number of foundation chain in yarn A. 1sc in 2nd ch from hook, 1sc in every ch to end of row, turn.

Step 2 (row 1) Ch1, 1sc in every st to end of row, turn.

Step 3 (row 2) Ch1, 1sc in first sc, *1Ssc in each of next 5 sts, 1sc in each of next 5sc; rep from * to last sc, 1sc in last sc, turn.

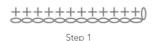

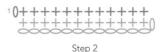

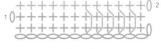

Step 3

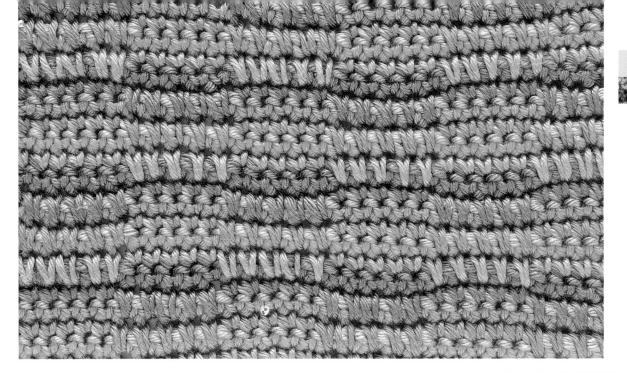

Step 4 (rows 3–6) Work as Steps 2 and 3, twice.

Step 5 (row 7) As Step 2.

Step 7 (1st rep)

Step 6 (row 8) Ch1, 1sc in first sc, *1sc in each of next 5sc, 1Ssc in each of next 5 sts; rep from * to last sc, 1sc in last sc, turn.

Step 7 (row 9–12) Work as Steps 5 and 6, twice.

Step 8 Repeat Steps 2-7.

Special stitch Ssc (spiked single crochet): insert hook one row below the next st, yo, draw loop through and up to the height of the working row, yo and draw through both loops on the hook.

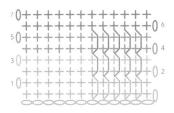

Steps 4–5

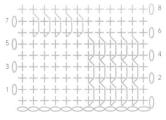

Step 6

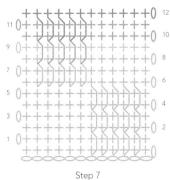

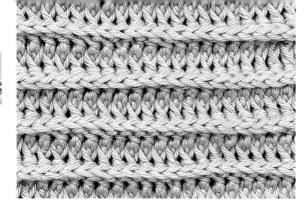

115 Front Raised Double

Front Raised Double is a good introduction to working raised or relief stitches, often called post stitches. Many stitches in this section are created by working around the stem or post of stitches in the row below, rather than through a chain. This technique will enable you to introduce lots of texture into your work. This first example is highly effective, yet based on a single-row repeat. This stitch is fully reversible.

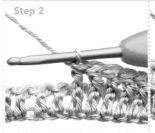

Multiple Any number of sts, plus 2 for the foundation chain.

Step 1 1dc in 4th ch from hook, 1dc in every ch to end of row, turn.

Step 2 Ch2, skip first dc, *1Frdc around next dc; rep from * to end of row, 1 Frdc around ch-3, turn.

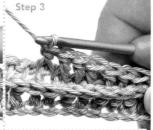

Step 3 As Step 2 to end of row, 1Frdc around ch-2, turn.

Step 4 Repeat Step 3.

Special stitch Frdc (front raised double crochet): yo, insert hook from the front around the stem of the dc in the row below from right to left, then complete st in the usual way.

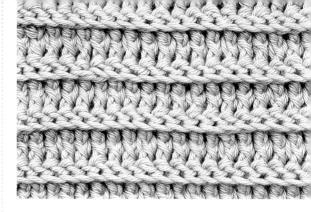

116 Back Raised Double

As the name suggests, Back Raised Double crochet is worked by inserting the hook from the back of the work and then around the stem of the stitch in the row below. However, it does look quite different from its partner (see stitch 115, left). The ridges are deeper, softer and slightly firmer. Again, it is fully reversible.

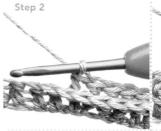

Multiple Any number of sts, plus 2 for the foundation chain.

Step 1 1dc in 4th ch from hook, 1dc in every ch to end of row, turn.

Step 2 Ch2, skip first dc, *1Brdc around next dc; rep from * to end of row, 1Brdc around ch-3, turn.

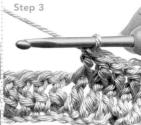

Step 3 As step 2 to end of row, 1Brdc around ch-2, turn.

Step 4 Repeat Step 3.

Special stitch Brdc (back raised double crochet): yo, insert hook from the back around the stem of the dc in the row below from right to left, then complete st in the usual way.

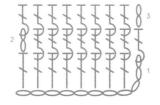

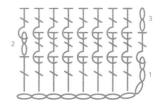

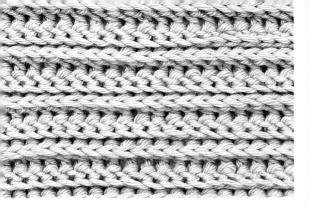

117 Raised Double Ridges

Raised Double Ridges produces a much tighter, but less extured fabric than the previous two stitches. This is achieved by working front raised double crochet on one row and then back raised double crochet on the next. There is now a definite ront and back to the work, with rows of double ridges on the ront and a smooth back. It is worth taking a look at the back of the work as it demonstrates very clearly how the raised stitches are worked.

Step 3

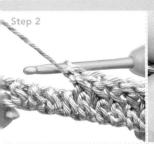

Multiple Any number of sts, plus 2 for the foundation chain.

Step 1 1dc in 4th ch from hook, 1dc in every ch to end of row, turn.

Step 2 Ch2, skip first dc, *1Frdc around next dc; rep from * to end of row, 1Frdc around ch-3, turn.

Step 3 Ch2, skip first dc, *1Brdc around next dc; rep from * to end of row, 1Brdc around ch-3, turn. **Step 4** As Step 2 to end of row, 1Frdc around ch-2, turn.

Step 5 Repeat Steps 3 and 4.

Special stitch Frdc (front raised double crochet): yo, insert hook from the front around the stem of the dc in the row below from right to left, then complete st in the usual way.

Special stitch Brdc (back raised double crochet): yo, insert hook from the back around the stem of the dc in the row below from right to left, then complete st in the usual way.

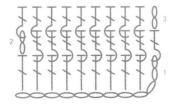

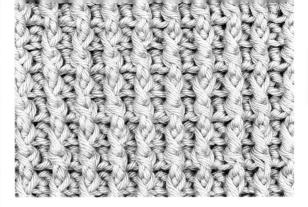

118 Raised Double Rib

Raised Double Rib is a highly textured, reversible stitch. It is worked in a similar way to Extended Half Double crochet (see stitch 14, page 40), except that this time you will be working front and back raised double crochets along the row. This stitch would suit many yarn types, but probably works best in lighter colors so that the stitch definition is not lost.

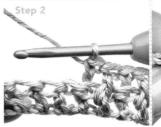

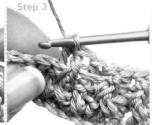

Multiple An even number of sts, plus 2 for the foundation chain.

Step 1 1dc in 4th ch from hook, 1dc in every ch to end of row, turn.

Step 2 Ch2, skip first dc, *1Frdc around next dc, 1Brdc around next dc; rep from * to end of row, 1Frdc around ch-3, turn. **Step 3** As Step 2 to end of row, 1Frdc around ch-2, turn.

Step 4 Repeat Step 3.

Special stitch Frdc (front raised double crochet): yo, insert hook from the front around the stem of the dc in the row below from right to left, then complete st in the usual way.

Special stitch Brdc (back raised double crochet): yo, insert hook from the back around the stem of the dc in the row below from right to left, then complete st in the usual way.

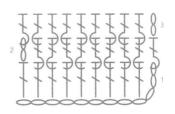

119 Basketweave

Basketweave is a solid and beautifully constructed stitch. The woven effect of the fabric is created by working groups of front and back raised double crochet along the row. The surprising thing about this stitch is that some groups appear to be worked vertically and others horizontally. This is simply an optical illusion and made possible by working different combinations of front and back raised double crochet over four rows. This stitch produces a fabric that is hard wearing and therefore suitable for bags, pillows, and even floor coverings. It would work successfully in many weights of yarn, including materials such as string and twine.

Special stitch Frdc (front raised double crochet): yo, insert hook from the front around the stem of the dc in the row below from right to left, then complete st in the usual way.

Special stitch Brdc (back raised double crochet): yo, insert hook from the back around the stem of the dc in the row below from right to left, then complete st in the usual way.

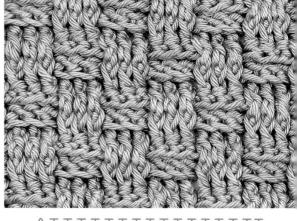

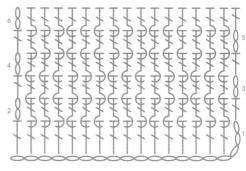

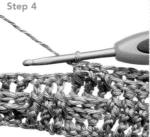

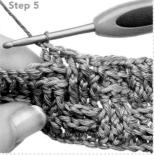

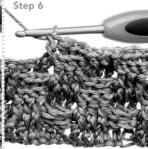

Multiple 6 sts + 5, plus 2 for the foundation chain

Step 1 1dc in 4th ch from hook, 1dc in every ch to end of row,

Step 2 Ch2, skip first dc, *1Frdc around each of next 3dc, 1Brdc around each of next 3dc; rep from * to last 3 sts. 1Frdc in each of last 3dc. 1dc in tch. turn.

Step 3 Ch2, skip first dc, *1Brdc around each of next 3Frdc, 1Frdc around each of next 3Brdc; rep from * to last 3 sts, 1Brdc in each of last 3Frdc, 1dc in tch, turn.

Step 4 Ch2, skip first dc, *1Brdc around each of next 3Brdc, 1Frdc around each of next 3Frdc; rep from * to last 3 sts, 1Brdc in each of last 3Brdc, 1dc in tch, turn.

Step 5 Ch2, skip first dc, *1Frdc around each of next 3Brdc, 1Brdc around each of next 3Frdc; rep from * to last 3 sts, 1Frdc in each of last 3Brdc, 1dc in tch, turn.

Step 6 Ch2, skip first dc, *1Frdc around each of next 3Frdc, 1Brdc around each of next 3Brdc; rep from * to last 3 sts, 1Frdc in each of last 3Frdc, 1dc in tch, turn.

Step 7 Repeat Steps 3-6.

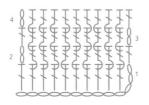

Steps 1-4

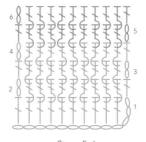

Steps 5-6

120 Diagonal Raised Double

Diagonal Raised Double is a similar stitch to Basketweave (see stitch 119, left), except that this example has a clear diagonal pattern, rather than alternating squares. It is based on a four-row pattern repeat, but this time the repeated blocks of stitches are moved along the row, by one stitch each time, so that regular rows and columns are forced onto the diagonal. It is important to keep a check on which row of the repeat you are on so that the pattern builds up successfully. The overall fabric is very robust and would be suitable for bags and homewares.

Special stitch Frdc (front raised double crochet): yo, insert hook from the front around the stem of the dc in the row below from right to left, then complete st in the usual way.

Special stitch Brdc (back raised double crochet): yo, insert hook from the back around the stem of the dc in the row below from right to left, then complete st in the usual way.

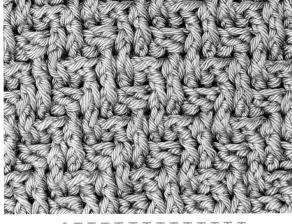

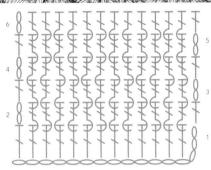

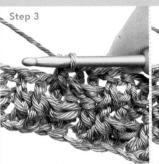

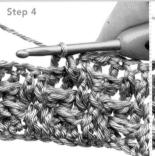

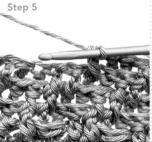

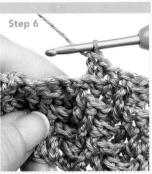

Multiple 4 sts + 2, plus 2 for the foundation chain

Step 1 1dc in 4th ch from hook, 1dc in every ch to end of row,

Step 2 Ch2, skip first dc, *1Frdc around each of next 2dc, 1Brdc around each of next 2dc; rep from * to end of row, 1dc in tch, turn.

Step 3 Ch2, skip first dc, 1Frdc around first Brdc, *1Brdc around each of next 2 sts, 1Frdc around next 2 sts; rep from * to last st, 1Frdc around last Frdc, 1dc in tch. turn.

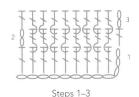

Step 4 Ch2, skip first dc, *1Brdc around each of next 2 sts, 1Frdc around each of next 2 sts; rep from * to end of row, 1dc in tch, turn.

Step 5 Ch2, skip first dc, 1Brdc around first Frdc, *1Frdc around each of next 2 sts, 1Brdc around each of next 2 sts; rep from * to last Brdc, 1Brdc in last Brdc, 1dc in tch, turn.

Step 6 As Step 2 to end of row, 1dc in 2nd of ch-2, turn.

Step 7 Repeat Steps 3-6.

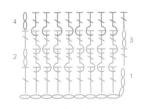

Step 4

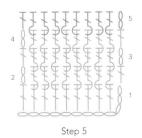

Step 6

121 Raised Ripple

Raised Ripple stitch is a beautifully balanced and textured stitch. It has a simple structure, with two out of every four rows worked in single crochet only. Front raised treble crochet is worked on the intervening rows, but only on every other stitch. The result is a much less chunky fabric than previous examples and one where the raised stitches appear to be embedded within the background fabric. This stitch would suit many yarn types and colors as well as a range of projects, from garments to accessories.

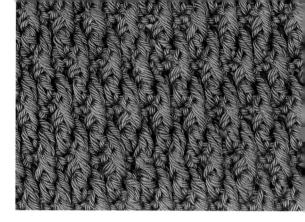

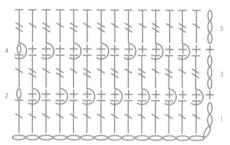

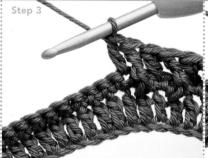

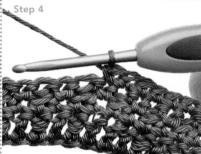

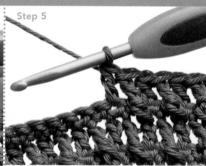

Multiple An odd number of sts, plus 2 for the foundation chain.

Step 1 1dc in 4th ch from hook, 1dc in every ch to end of row, turn.

Step 2 Ch1, skip first st, 1sc in every dc to end of row, 1sc in tch, turn.

Step 3 Ch3, skip first sc, *skip next sc and work 1Frtr around dc in row below skipped sc, 1dc in next sc; rep from * to end of row, 1dc in tch, turn.

Step 4 As Step 2.

Step 5 Ch3, skip first sc *1dc in next sc, 1Frtr around dc in row below skipped sc; rep from * to last dc, 1dc in next dc, 1Frtr in row below ch-1, turn

Step 6 Repeat Steps 2-5.

Special stitch Frtr (front raised treble): yo twice, insert hook from the front around the stem of the dc in the row below from right to left, then complete st in the usual way.

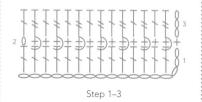

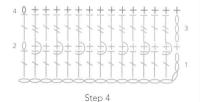

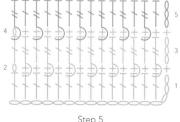

Step 5

122 Raised Brick

Raised Brick is a very tactile stitch, combining front and back raised doubles and introducing front raised trebles for extra texture. We have been used to seeing the impact of raised doubles, but in this example they are completely dominated by the trebles, which appear to mark the spaces between the "bricks." It is worth taking a look at the back of the work as you progress so that you can see how the raised trebles cover a space in the fabric. This prevents it from becoming too chunky and ensures that the fabric is still pliable enough to be used for a range of projects.

Special stitch Frdc (front raised double crochet): yo, insert hook from the front around the stem of the dc in the row below from right to left, then complete st in the usual way.

Special stitch Frtr (front raised treble): yo twice, insert hook from the front around the stem of the tr in the row below from right to left, then complete st in the usual way.

Special stitch Brdc (back raised double crochet): yo, insert hook from the back around the stem of the dc in the row below from right to left, then complete st in the usual way.

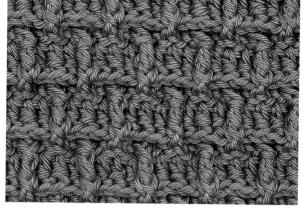

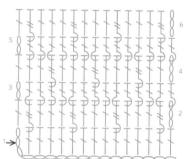

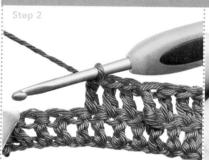

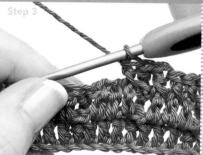

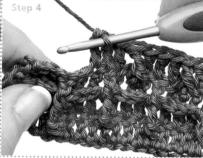

Multiple 4 sts + 3, plus 2 for the foundation chain.

Step 1 (WS) 1dc in 4th ch from hook, 1dc in every ch to end of row, turn.

Step 2 Ch3, skip first dc, *1Frtr around next dc, 1dc in each of next 3dc; rep from * to last dc, 1Frtr around last dc, 1dc in tch, turn.

Step 3 Ch2, skip first dc, *1Brdc around Frtr, 1Frdc around each of next 3dc; rep from * to last Frtr, 1Brdc around last Frtr, 1Frdc around tch, turn.

Step 4 Ch3, skip first Frdc, 1dc in each of next 2 sts, *1Frtr around next Frdc (2nd of 3), 1dc in each of next 3 sts; rep from * working last dc in tch, turn.

Step 5 Ch2, skip first dc, *1Frdc around each of next 2dc, *1Brdc around Frtr, 1Frdc around each of next 3dc; rep from * working last Frdc in ch-3, turn.

Step 6 Ch3, skip first Frdc, *1Frtr around next Frdc, 1dc in each of next 3 sts; rep from * to last 2 sts, 1Frtr around last Frdc, 1dc in 2nd of ch-2, turn.

Step 7 Repeat Steps 3-6.

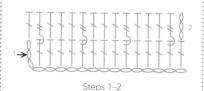

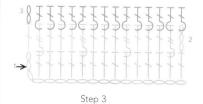

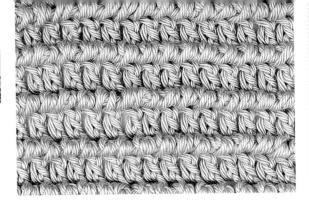

123 Corded Ridge

Corded Ridge is one of those stitches that you just want to reach out and touch. It is a simple, yet highly tactile stitch and unusual because all the rows are worked with the right side of the work facing. This means that instead of turning the work at the end of the row, you need to work wrong-side rows from left to right. Experiment with different yarns to see the effect they have on the ridges.

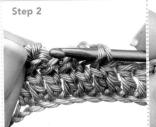

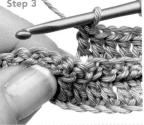

Multiple Any number of sts, plus 2 for the foundation chain.

Step 1 (RS) Skip 3ch (counts as 1dc), 1dc in next and every ch to end of row. Do not turn.

Step 2 Ch1, 1sc in front loop of last dc, *1sc in front loop of next dc to right; rep from * to end of row, sl st in 3rd of ch-3.

Step 3 Ch3 (counts as 1dc), skip 1sc, 1dc in back loop of each dc from row before last, to end of row. Do not turn.

Step 4 Repeat Steps 2 and 3.

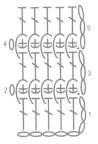

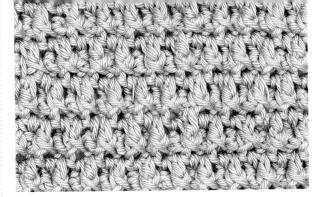

124 Crinkle

Crinkle is a very hard-wearing stitch, which produces a firm fabric with an attractive texture. The subtle patterning is created by alternating rows of pairs of raised single crochet worked into the front and back of the fabric. The extra sturdiness is gained through wrong-side rows being worked in half double crochet only. This would be a great stitch for bags and pillows.

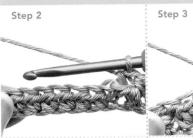

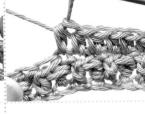

Multiple 2 sts, plus 1 for the foundation chain.

Step 1 (WS) Skip 2ch (counts as 1hdc), 1hdc in next and every ch to end of row, turn.

Step 2 Ch1, 1sc in first hdc, *1Frsc around stem of hdc in row below, 1Brsc around stem of hdc in row below; rep from * to end of row, 1sc in 2nd of ch-2, turn.

Step 3 Ch2, skip first sc, 1hdc in every st to end of row, turn.

Step 4 Ch1, 1sc in first hdc, 1Brsc around stem of next st, 1Frsc around stem of next st; rep from *

to end of row, 1sc in 2nd of ch-2, turn.

Step 5 As Step 3.

Step 6 Repeat Steps 2-5.

Special stitch Brsc (back raised single crochet): insert hook from the front around the stem of the hdc in the row below from right to left, then complete st in the usual way.

Special stitch Frsc (front raised single crochet): insert hook from the back around the stem of the hdc in the row below from right to left, then complete st in the usual way.

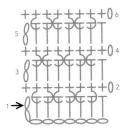

125 Crossed Ripple

Crossed Ripple is another hard-wearing stitch with a beautiful texture. It is also one of those stitches where the back is almost as interesting as the front. Crossed Ripple has two foundation rows. The first row of single crochet provides a base on which to build the pattern. The second row establishes the pairs of crossed stitches, known as a crossed pair. Once these crossed pairs are established, subsequent rows also include a front raised double crochet to amplify the texture. This is a two-row pattern with alternating rows worked in single crochet only.

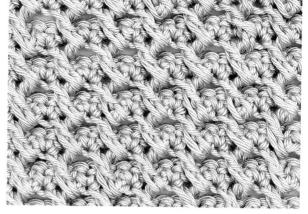

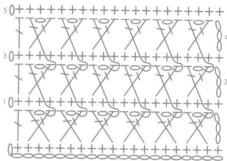

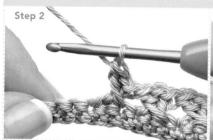

Multiple 3 sts + 2, plus 1 for the foundation chain.

Step 1 (base row 1) (WS) 1sc in 2nd ch from hook, 1sc in every ch to end of row, turn.

Step 2 (base row 2) Ch3 (counts as 1dc), skip first sc, *skip next 2 sts, 1dc in next st, ch1, 1dc back in first of 2 sts just skipped; rep from * to last sc, 1dc in last sc, turn.

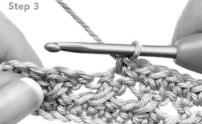

Step 3 (row 1) Ch1, 1sc in every st and every ch-sp to end of row, 1sc in tch, turn.

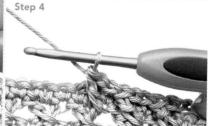

Step 4 (row 2) Ch3 (counts as 1dc), skip first sc, *skip next 2sc, 1dc, ch1, 1Frdc around dc below first of 2sc just skipped; rep from * to last sc, 1dc in last sc, turn.

Step 5 Repeat Steps 3 and 4.

Special stitch Frdc (front raised double crochet): yo, insert hook from the front around the stem of the dc in the row below from right to left, then complete st in the usual way.

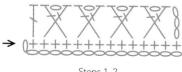

Steps 1-2

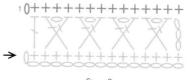

Step 3

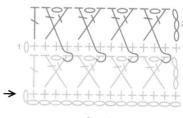

Step 4

126 Relief Arch

The principle of Relief Arch is similar to the idea of couching threads in embroidery, where strands appear to be caught at specified intervals to create a surface pattern. It is not a difficult stitch, but does require careful counting. It is also best suited to larger projects in order to fully appreciate the full potential of the patterning. Like Crossed Ripple (see stitch 125, page 125), it takes two rows to establish the pattern, which then follows a simple four-row repeat. This stitch works best in medium-weight, cotton-based yarns.

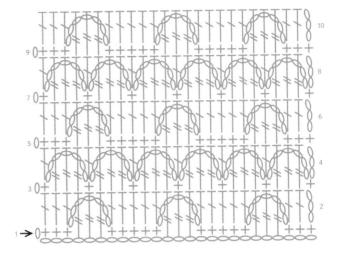

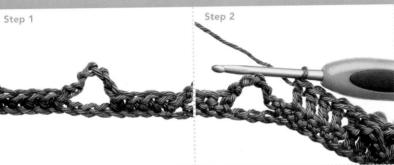

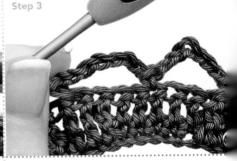

Multiple 8 sts + 1, plus 1 for the foundation chain.

Step 1 1sc in 2nd ch from hook, 1sc in each of next 2ch, *ch7, skip 3ch, 1sc in each of next 5ch; rep from * to last 6ch, ch7, skip 3ch, 1sc in each of last 3ch, turn.

Step 2 Ch3 (counts as 1dc), skip 1sc, 1dc in each of next 2sc, *work 1tr in each of next 3 base ch by working behind ch-7 loop**, 1dc in each of next 5sc; rep from * ending last rep at **, 1dc in each of last 3sc, turn.

Step 3 Ch1, 1sc in first dc, *ch7, skip 3 sts, 1sc in next st at same time as catching in 4th of ch-7 from 2 rows below, ch7, skip 3ch, 1sc in next st; rep from * to end, turn.

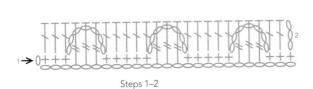

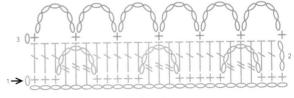

Step 3

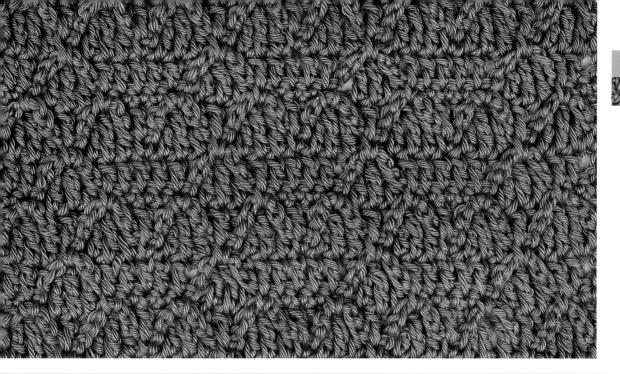

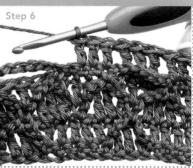

Step 4 Ch3 (counts as 1dc), skip 1 st, *work 1tr in each of next 3 sts from 2 rows below by working behind ch-7 loop, 1dc in next sc; rep from * to end of row, turn.

Step 5 Ch1, 1sc in each of first 2 sts, *1sc in next st at same time as catching in 4th of ch-7 from 2 rows below, ch7, skip 3 sts, 1sc in next st at same time as catching in 4th of ch-7 from 2 rows below**, 1sc in each of next 3 sts; rep from * ending last rep at **, 1sc in last tr, 1sc in top of ch-3, turn.

Step 6 Ch3 (counts as 1dc), skip 1sc, 1dc in each of next 2sc, *work 1tr in each of next 3 sts from 2 rows below by working behind ch-7 loop**, 1dc in each of next 5sc; rep from * ending last rep at **, 1dc in each of last 3sc, turn.

Step 7 Repeat steps 3-6.

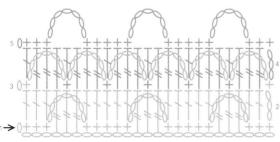

Steps 4-5

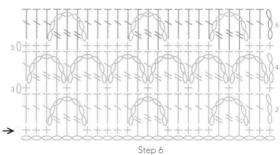

127 Dots and Diamonds

Dots and Diamonds is a fairly complex stitch combining a number of techniques. Once the foundation rows are established, the pattern is built up over a four-row repeat. This includes two pattern rows containing front raised trebles and picot single crochet and two plain rows of double crochet. The diamond patterning is created by the front raised trebles being worked over two stages or "legs." A picot single crochet is worked on the same rows and between the raised stitches to form a bobble at the center of the diamond. The resulting fabric is firm but surprisingly soft, making it an ideal choice for a range of projects. It would also suit a variety of yarn types, including tweeds and chunkier blends. Although Dots and Diamonds is most commonly used as an overall pattern, it would also be very effective as a border or edging to a garment or accessory.

Special stitch Psc (picot single crochet): insert hook, yo, draw loop through, [yo, draw through 1 loop] 3 times, yo, draw through both loops on hook. Draw Picot loops to RS of fabric.

Special stitch Frtr2tog (front raised treble two together): *yo twice, insert hook in designated st, yo, draw loop through, [yo, draw through 2 loops] twice.

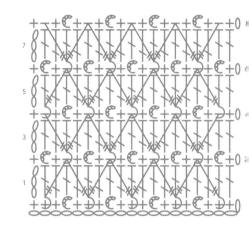

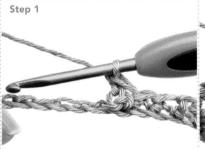

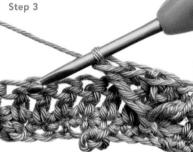

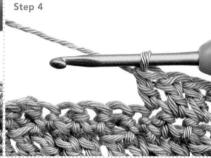

Multiple 4 sts + 3, plus 1 for the foundation chain.

Step 1 (base row) (RS) 1sc in 2nd ch from hook, 1sc in each of each of next 2ch, *1Psc in next ch, 1sc in each of next 3ch; rep from * to end, turn.

Step 2 (row 1) Ch3 (counts as 1dc), skip first st, 1dc in each st to end, turn.

Step 3 (row 2) Ch1, 1sc in first st, *1Psc in next st, 1sc in next st, 1Ftr2tog over next st inserting hook around 2nd sc in 2nd-to-last row for first leg and around following 4th sc for 2nd leg (skipping 3 sts in between), 1sc in next st; rep from * to last st, 1Psc in last st, 1sc in 3rd of ch-3, turn.

Step 4 (row 3) As Step 2.

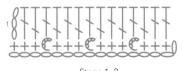

Steps 1–2

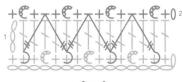

Step 3

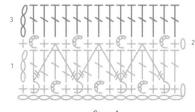

Step 4

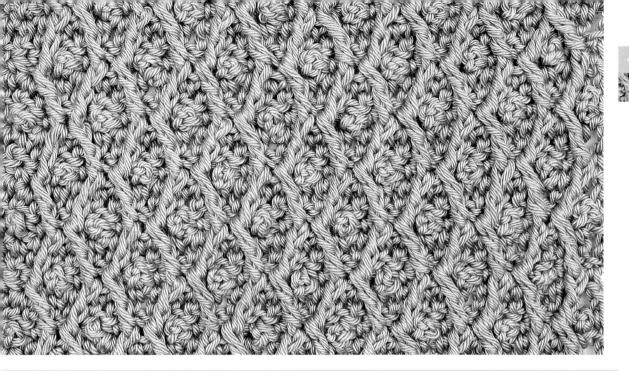

Step 5 (row 4) Ch1, 1sc in first st, 1Frtr (see page 122) around top of first raised Cl 2 rows below, *1sc in next st, 1Psc in next st, 1sc in next st**, 1Frtr2tog by inserting hook around same CI as last raised st for first leg and around top of next raised Cl for 2nd leg; rep from * ending last rep at **, 1Frtr in same Cl as last raised st, 1sc in 3rd of ch-3, turn.

Step 6

Step 6 (row 5) As Step 2.

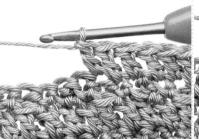

Step 7 (row 6) Ch1, 1sc in first st, *1Psc in next st, 1sc in next st, 1Frtr2tog by inserting hook around same CI as last raised st for first leg and around top of next raised CI for 2nd leg, 1sc in next st; rep from * to last st,

1Psc in last st, 1sc in 3rd of ch-3, turn.

Step 8 Repeat Steps 4-7.

Step 7

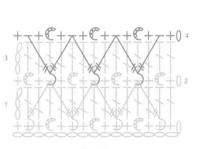

Step 5

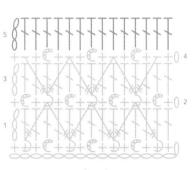

Step 6

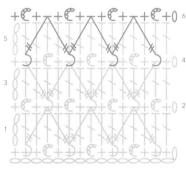

Step 7

128 Relief Squares

Relief Squares is a striking and intriguing stitch. It is also one of the best examples of how crochet can be used to create an optical illusion. The squares appear to be worked separately and then somehow joined together. The reality is, of course, that this pattern is built up over a series of rows. It is the clever use of stitches of different heights over a tenrow repeat that creates the pattern. This stitch also helps the crocheter to really appreciate the potential of raised stitches as a way of working over or embedding different areas to create shapes and patterns. The full effect of the stitch requires you to use three different-colored yarns, A, B, and C. This provides you with lots of opportunities to experiment with color combinations. For example, try reversing A and C to see what effect that has on the pattern. Try selecting a series of tones from the same palette for a subtle approach or combining different textures for dramatic impact. The possibilities are many, although it is probably best to avoid very light or very heavyweight yarns. This well-proportioned and sturdy stitch makes it an ideal choice for homewares projects.

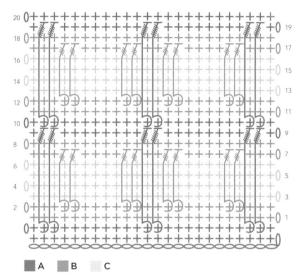

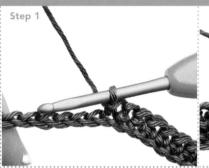

Step 3

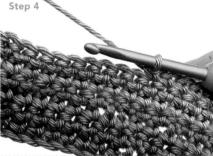

Multiple 10 sts + 4, plus 1 for the foundation chain.

Step 1 (base row 1) (RS) In yarn A, work the required number of chain. 1sc in 2nd ch from hook, 1sc in every ch to end of

Step 2 (base row 2) Ch1, 1sc in every sc to end of row, turn.

Step 3 (rows 1-2) Change to B and work step 2, twice more.

Step 4 (rows 3-6) Change to yarn C and work step 2, 4 times more.

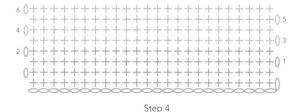

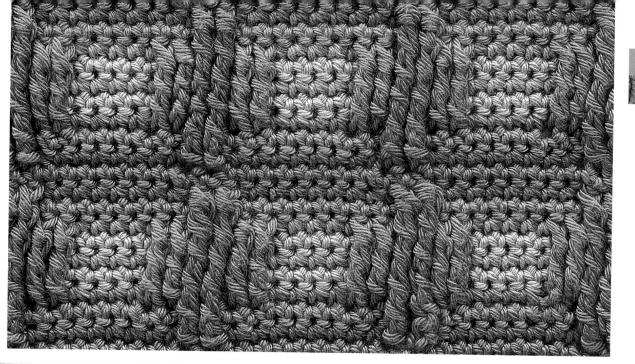

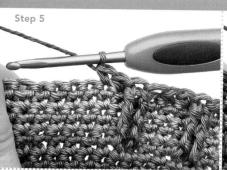

Step 5 (row 7) Change to yarn B, ch1, 1sc in each of the first 3sc, *[1Frdtr around next st that lies 5 rows below] twice, 1sc in each of next 4 sts, [1Frdtr around next st that lies 5 rows below] twice, 1sc in each of next 2 sts; rep from * ending with 1sc in last sc, turn.

Step 6 (row 8) As Step 2, in B.

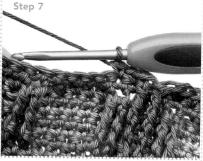

Step 7 (row 9) Change to yarn A, ch1, 1sc in first st, *[1Frquintr around next st that lies 9 rows below] twice, 1sc in each of next 8 sts; rep from * to last 3 sts, [1Frquintr around next st that lies 9 rows below,] twice, 1sc in last st, turn.

Step 8 (row 10) As Step 2, in A.

Step 9 Repeat steps 3-8.

Special stitch Frdtr (front raised double treble): yo 3 times, insert hook from in front and from right to left around the stem of the designated st and then complete the stitch in the usual way.

Special stitch Frquintr (front raised quintuple treble): yo 6 times, insert hook from in front and from right to left around the stem of the designated st and then complete the stitch in the usual way.

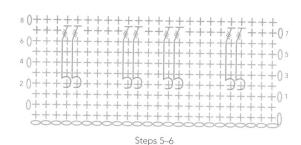

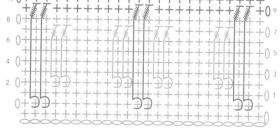

Steps 7–8

129 Thistle

Thistle pattern is a really interesting stitch that shows how a simple single crochet background can be transformed by incorporating some surface crochet techniques. It is important to note that the single turning chain is counted as a stitch throughout the pattern. This will help to maintain the stitch count and keep the edges of the work neat. The thistles are created using two different techniques. The stem and leaves are created by working three loops of ten chain stitches that are anchored to the work. This happens first by anchoring with a single crochet and is then later caught and kept in shape by catching the center of the loop and working that in with the corresponding stitch three rows later. The thistle at the top of the stem is made by working six doubles into one stitch, which has the effect of making it stand proud of the base fabric. Once you feel confident with this technique, try replacing the chains and doubles with different colors to make the thistles more prominent.

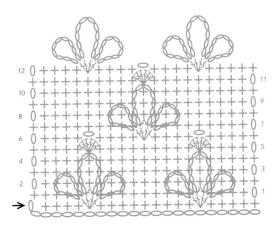

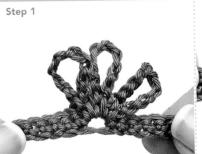

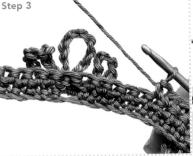

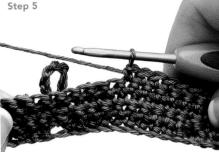

Multiple 10 sts + 1, plus 1 for the foundation chain.

Step 1 (base row) (WS) Skip 2ch (counts as 1sc), 1sc in each of next 4ch, *work a Thistle of 1sc [ch10, 1sc] 3 times**, 1sc in each of next 9 ch; rep from * ending last rep at **, 1sc in each of last 5ch, turn.

Step 2 (row 1) Ch1 (counts as 1sc), 1sc in each of next 4sc, *skip sc at top of Thistle, sc2tog over next 2sc, skip last sc at top of Thistle**, work 1sc in each of next 9sc; rep from * ending last rep at **, 1sc in each of last 4sc and 1sc in 2nd of ch-2, turn.

Step 3 (row 2) Ch1, 1sc in every st to end of row, turn.

Step 4 (row 3) Ch1, skip 1sc, 1sc in next sc, *catch first loop of Thistle in next sc, 1sc in each of next 5sc, skip center loop of Thistle, catch third loop of Thistle in next sc**, 1sc in each of next 3sc; rep from * ending last rep at **, 1sc in each of last 2 sts, turn.

Step 5 (row 4) As Step 3.

Steps 2-3

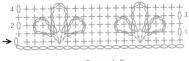

Steps 4-5

Step 6 (row 5) Ch1, skip 1sc, 1sc in each of next 4 sts, *6dc in next sc, at same time as catching center ch-10 loop**, 1sc in each of next 9sc; rep from * ending last rep at **, 1sc in each of last 5sc, turn.

Step 7 (row 6) Ch1, skip 1sc, 1sc in each of next 4sc, *ch1, skip 6dc, 1sc in each of next 4sc**, work a Thistle (see Step 1) in next sc, 1sc in each of next 4sc; rep from * ending last rep at **, 1sc in tch, turn.

Step 8 (row 7) Ch1, skip 1sc, 1sc in each of next 9sc, *sc2tog over center 2 of next 4sc, skip 1sc, 1sc in each of next 9sc; rep from *, 1sc in tch, turn.

Step 9 (row 8) As Step 3.

Step 10 (row 9) Ch1, skip 1sc, 1sc in each of next 6sc, *catch first loop of Thistle in next sc, 1sc in each of next 5sc, skip center loop of Thistle, catch 3rd loop of Thistle in next sc**, 1sc in each of next 3sc; rep from * ending last rep at **, 1sc in every st to end of row, turn.

Step 11 (row 10) As Step 3.

Step 12 (row 11) Ch1, skip 1sc, 1sc in each of next 9 sts, *6dc in next sc, at same time as catching center ch-10 loop, 1sc in each of next 9sc; rep from *, 1sc in tch, turn.

Step 13 (row 12) Ch1, skip 1 st, 1sc in each of next 4sc, *work a Thistle in next sc, 1sc in each of next 4sc**; skip 6dc, 1sc in each of next 4sc; rep from * ending last rep at **, 1sc in tch, turn.

Step 14 Repeat Steps 2-13.

Step 6

Step 7

130 Tulip Cable

Tulip Cable is an interesting stitch to work and one of the few examples where crochet strongly resembles knitting. You may be familiar with the way that stitches are crossed or twisted in knitting to produce cables. While not exactly the same, a similar effect can be achieved in crochet by working raised stitches as part of a cluster to give the illusion of stitches moving places. Bobbles are created in a very similar way to knitting, with several stitches being worked into one place and then closed off by returning to one stitch. One advantage that crochet has over knitting in this instance is that the raised stitches can be placed from both sides of the work, whereas knitted cables can only be worked on a right-side row. Panels of cable are often marked by columns of raised stitches to provide definition either side of the cabling. Instructions relate to the fifteen-stitch cable panel only.

Note Raised legs of these clusters will be worked at the front (rf) on RS rows and at back (rb) on WS rows-Fcl/rf, Fcl/rb, Bcl/rf, Bcl/rb

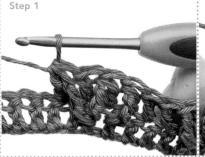

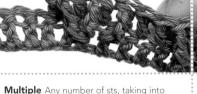

account that the cable panel is worked over

Step 1 Ch3, 1Frtr around next st, 1dc in

next 2 sts, [1Fcl/rf] twice, 1dc in next st, [1Bcl/rf] twice, 1dc in each of next 2 sts,

1Frtr around next st, 1dc in next st, 1Frtr

next st, 1Frtr around next st, 1dc in each of

15 sts. A row of doubles needs to be

worked before working step 1.

around next st, 1sc into tch.

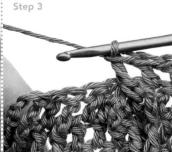

Step 2 Ch3, [1Brtr around next st, 1dc in next st] twice, [1Fcl/rb] twice, 1dc in each of next 3 sts, [1Bcl/rb] twice, [1dc in next st, 1Brtr around next st] twice, 1sc into tch.

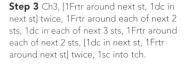

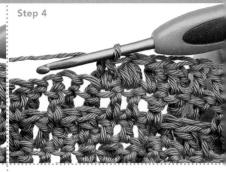

Step 4 Ch3, 1Brtr around next st, 1dc in next st, 1Brtr around next st, 1dc in each of next 2 sts, [1Bcl/rb] twice, 1Puff st of hdc5tog in next st, [1Fcl/rb] twice, 1dc in each of next 2 sts, 1Brtr around next st, 1dc in next st. 1Brtr around next st. 1sc into tch.

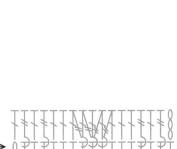

Step 1

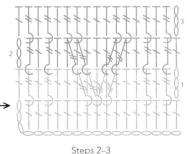

Step 4

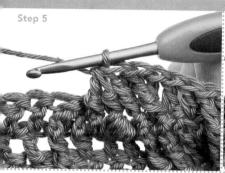

Step 5 Ch3, 1Frtr around next st, 1dc in next st, 1Frtr around next st, 1dc in each of next 3 sts, 1Bcl/rf, 1Tcl, 1Fcl/rf, 1dc in each of next 3 sts, 1Frtr in next st, 1dc in next st, 1Frtr around next st. 1sc into tch

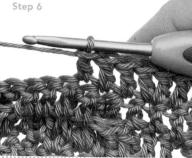

Step 6 Ch3, *1Brtr around next st, 1dc in next st, 1Brtr around next st**, 1dc in each of next 9 sts; rep from * ending last rep at **, 1sc into tch.

Step 7 Repeat Steps 1-6.

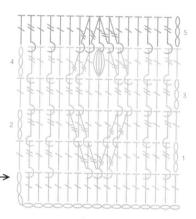

Step 5

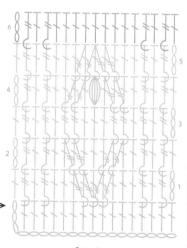

Step 6

Special stitch Fcl (forward cluster): leaving last loop on hook of each st on hook, work 1dc in next st and 1Frtr or Brtr around next st after that, yo and draw through all 3 loops on hook.

Special stitch Bcl (backward cluster): leaving last loop of each st on hook, work 1Frtr or Brtr around st below dc just made and 1dc in next st, yo and draw through all 3 loops on hook.

Special stitch Tcl (triple cluster): leaving last loop of each st on hook, work 1Frtr around st below dc just made, 1Frdc around next Puff st, 1Frtr around next st, yo and draw through all 4 loops on hook.

Special stitch Frtr (front raised treble): yo twice, insert hook from the front around the stem of the dc in the row below from right to left, then complete st in the usual way.

Special stitch Brtr (back raised treble): yo twice, insert hook from the back around the stem of the dc in the row below from right to left, then complete st in the usual way.

131 Chain Loop

Chain Loop is a relatively simple stitch, but one that creates a fantastic texture. It is impossible not to be instantly drawn to touching it. Although it is not complicated stitch, it takes quite a long time to work. This is because of the number of chains that need to be worked in-between each stitch and the fact that you are working back into the row below on alternate rows. This stitch would work well in a variety of yarns, from medium-weight cottons through to fine mohair. It is probably best to avoid highly textured yarns, since the stitch itself produces such a concentrated effect. It is important that the foundation chain is worked loosely and so it is a good idea to work this in a hook one size larger than required for the project.

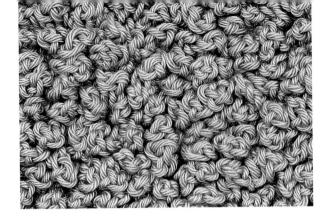

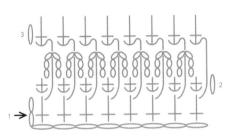

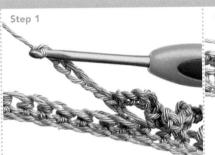

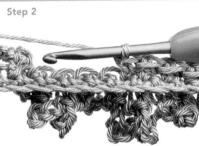

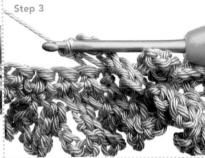

Multiple Any number of sts, plus 2 for the foundation chain.

Step 1 (WS) 1exsc (see page 24) in 3rd ch from hook, 1exsc in every ch to end of row, turn.

Step 2 Ch1, 1sc in front loop of first exsc, *ch6, 1sc in front loop of next exsc; rep from *, 1sc in front loop of last exsc, turn.

Step 3 Ch1, 1exsc in empty loop of first exsc 2 rows below, 1exsc in empty loop of every exsc 2 rows below to end of row, turn.

Step 4 Repeat Steps 2 and 3.

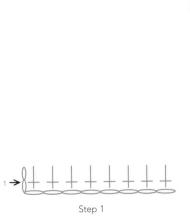

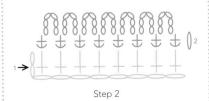

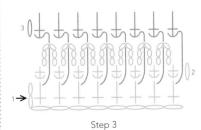

132 Loop

Loop stitch is sometimes known as Fur stitch. It is an unusual stitch because it can be left with stitches hanging in loops, or the loops may be cut to provide a different texture. This makes it a fairly versatile stitch since you also have the option of cutting some of the sections, while leaving others intact. Like Chain Loop stitch (see stitch 131, left), this would suit a variety of weights of yarn, but would probably be less successful in a highly textured fiber. If you find it difficult to control the loop size, try inserting a large knitting needle to gain consistency.

When loops are created, use the left hand to help you control the size of the loop. Start by inserting the hook into the chain, pick up both threads of the loop and pull these through, wrap yarn over the hook and draw through all the loops on the hook to finish.

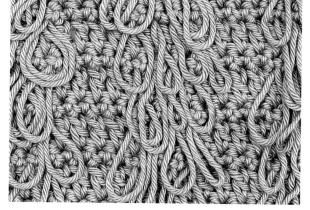

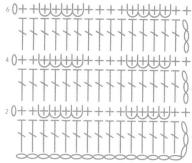

Step 4

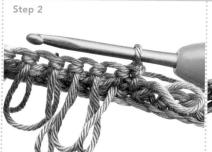

Multiple 8 sts, plus 2 for the foundation chain.

Step 1 (RS) 1dc in 4th ch from hook, 1dc in every ch to end of row, turn.

Step 2 Ch1, 1sc in each of first 2dc, *1Loop st in each of next 4 sts**, 1sc in each of next 4dc; rep from * ending last rep at **, 1sc in last dc, 1sc in tch, turn.

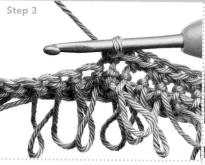

Step 3 Ch3 (counts as 1dc), skip first dc, 1dc in every st to end of row, turn.

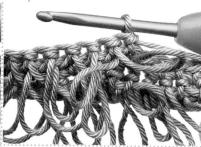

Step 4 Repeat Steps 2 and 3.

Special stitch Loop: Use the left hand to control the size of the loop. Insert the hook, pick up both threads of the loop and pull through, yo, draw through all loops on hook to finish.

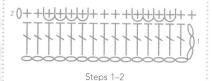

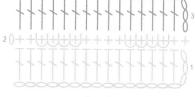

Step 3

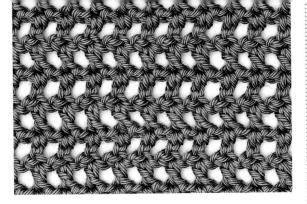

133 Small Mesh

This most basic of mesh patterns is a really useful introduction to the technique. Small Mesh is built on a grid of chains and double crochet. The result is surprisingly stable, although this will also depend on the kind of yarn you choose to work in. This stitch could be further enhanced by weaving contrasting colors and textures of yarn through the grid-like structure (see stitch 199, page 184).

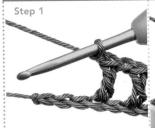

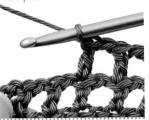

Multiple An odd number of sts, plus 3 for the foundation chain.

Step 1 1dc in 6th ch from hook, ch1, skip 1ch, 1dc in next ch; rep from * to end,

Step 2 Ch4, skip [first dc and 1ch], 1dc in next dc, ch1, skip 1ch; rep from * to last ch, 1dc in last ch, turn.

Step 3 Repeat Step 2.

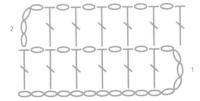

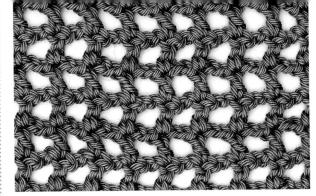

134 Large Mesh

As the name suggest, this is a larger example of the stitch that precedes it. Single chains are replaced with two chains which results in a looser, more flexible fabric although this will still depend to an extent on the type of yarn you choose to work in.

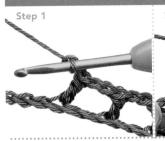

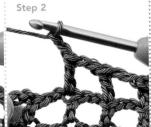

Multiple 3 sts + 1, plus 4 for the foundation chain.

Step 1 1dc in 8th ch from hook, *ch2, skip 2ch, 1dc in next ch; rep from * to end, turn.

Step 2 Ch5, skip [first dc and 2ch], *1dc in next dc, ch2, skip 2ch; rep from * to last ch, 1dc in last ch, turn.

Step 3 Repeat Step 2.

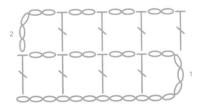

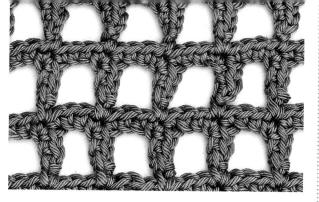

135 Firm Mesh

This is a firmer version of the very basic examples of this kind of stitch (see stitches 133 and 134, left). In Firm Mesh, the grid is created then strengthened by working a series of chains that are anchored by a slip stitch at designated points along the row, and reinforced with a round of single crochet stitches. This stitch would also serve as an ideal frame for weaving.

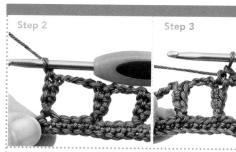

Multiple 4 sts + 1, plus 1 for the foundation chain.

Step 1 (WS) 1sc in 2nd ch from hook, 1sc in every ch to end of row, turn.

Step 2 Ch9, skip first 4sc, sl st in next sc, turn, 1sc in each of first 3sc, *ch6, skip next 3sc of previous row, sl st in next sc, 1sc in each of first 3ch; rep from * to end, turn.

Step 3 Ch1, 1sc in same ch as last sc of previous row, *1sc in each of next 3ch, 1sc in same ch as top sc of stem; rep from * working last sc in 3rd of ch-9, turn.

Step 4 Repeat Steps 2 and 3.

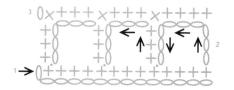

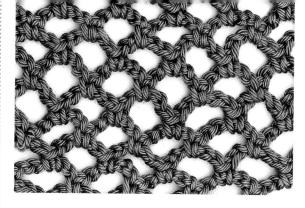

136 Arch Mesh

This is the first mesh stitch where we see the network of stitches being placed into chain spaces rather than the tops of stitches in the row below. This has the effect of creating a much looser fabric that works particularly well for scarves and shawls.

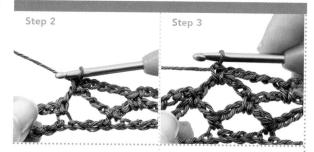

Multiple 4 sts + 1, plus 5 for the foundation chain.

Step 1 1sc in 10th ch from hook, *ch5, skip 3ch, 1sc in next ch; rep from * to end, turn.

Step 2 Ch6, *1sc in next ch sp, ch5; rep from * to last ch sp, 1sc in last ch sp, ch2, 1dc in 4th of ch-9, turn.

Step 3 Ch6, 1sc in first ch-5 sp, *ch5, 1sc in next ch-5 sp; rep from * to end, turn.

Step 4 As Step 2, ending 1dc in 4th of ch-6, turn.

Step 5 Repeat Steps 3 and 4.

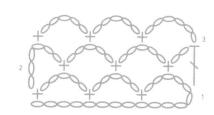

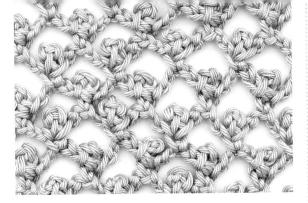

137 Picot Arch Mesh

Picot Arch Mesh is a popular and easy stitch to work. It is created by repeating rows of chain and simple picots made from three chains slip-stitched into a single crochet. The resulting fabric is delicate and might be worked in a variety of lace weight and luxury yarns.

Multiple 5 sts, plus 1 for the foundation chain.

Step 1 1sc in 8th ch from hook, ch3, join with a sl st to sc just worked, *ch5, skip 3ch, 1sc in next ch, ch3, join with a sl st to sc just worked; rep from * to last 4ch, ch5, 1sc in last ch, turn.

Step 2 Ch5, skip first sc, *1sc in 3rd of ch-5, ch3, join with a sl st to sc just worked, ch5, skip [next sc, Picot]; rep from * ending 1sc in 3rd of ch-7.

Step 3 Repeat Step 2 but ending 1sc in 3rd of ch-5.

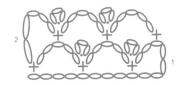

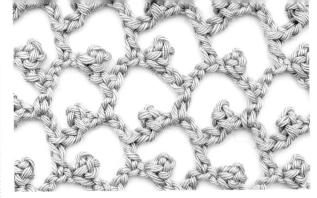

138 Crazy Picot Mesh

Crazy Picot Mesh works on a similar principle to Picot Arch Mesh (see stitch 137, left). The picot points are made from three chains, but this time they are joined with a slip stitch to a chain rather than a single crochet. This helps to create a lacier fabric than before and a diamond-like structure is achieved by working double crochet alternately along the row as well.

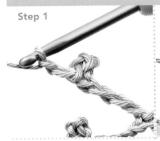

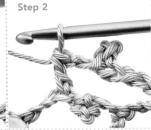

Multiple 7 sts.

Step 1 SI st in 6th ch from hook, ch2, 1dc in 10th ch from sI st, *ch7, sI st in 4th ch from hook, ch2, skip 4 of foundation ch, 1dc in next ch; rep from * to end of row, turn. Step 2 Ch10, sl st in 4th ch from hook, ch2, skip [first dc, ch2 and Picot], 1dc in 3rd ch before next dc, *ch7, sl st in 4th ch from hook, ch2, skip [ch2, 1dc, ch2 and 1Picot], 1dc in 3rd ch before next dc; rep from * to end of row, turn.

Step 3 Repeat Step 2.

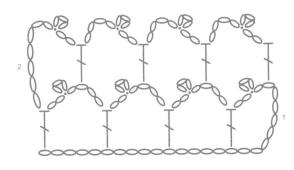

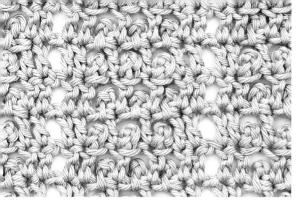

139 Fancy Picot

Fancy Picot stitch is based on a single-row repeat. The hree chain picot points are slip-stitched into the top of the preceding double stitch. Many picot stitches are organized to that they fall alternately as each row is added. This stitch has a much more formal appearance, with the picots worked three columns and sitting on top of each other. Extra definition is given to the columns by the intervening chain and double sections.

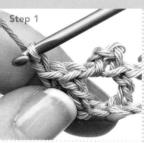

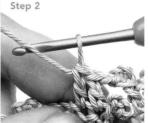

Multiple 10 sts + 1, plus 2 for the foundation chain.

Step 1 (RS) Skip first 3ch (counts as 1dc), *1dc in each of next 2ch, [ch3 and join with a sl st to top of dc just made, (1Picot)], [ch1, skip 1ch, 1dc in next ch, work a Picot] twice, ch1, skip 1ch, 1dc in each of next 2 ch**, ch1, skip 1ch; rep from * ending last rep at **, 1dc in last ch, turn.

Step 2 Ch3 (counts as 1dc), skip first dc, *1dc in next 2dc, [work a Picot, ch1, skip next ch and Picot, 1dc in next dc] 3 times, 1dc in next dc**, ch1, skip 1ch; rep from * ending last rep at **, 1dc in 3rd of ch-3, turn.

Step 3 Repeat Step 2.

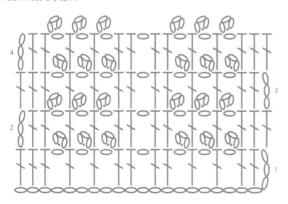

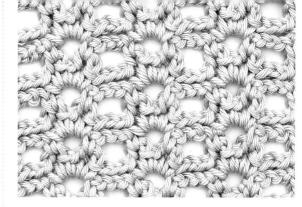

140 Single Picot String Network

Single String Picot Network is based on a two-row repeat, but like Fancy Picot (see stitch 139, left), the picot points are arranged so that they form columns rather than being offset. This combination of picots, single crochet, and chain is a good option if you want something decorative but not too lacy.

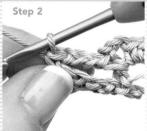

Multiple 6 sts + 5, plus 1 for the foundation chain.

Step 1 (WS) 1sc in 2nd ch from hook, ch3, skip 4ch, 1Picot in next ch, *ch3, skip 5ch, work a Picot in next ch; rep from * to last 5ch, ch3, skip 4ch, 1sc in last sc, turn.

Step 2 Ch1, 1sc in first sc, *ch3, skip 3ch, work 2Picots in next ch-3 arch; rep from * to last sc, ch3, skip 3ch, 1sc in last sc, turn.

Step 3 Ch6 (counts as 1dc and 3ch) skip 3ch, *[1sc in next Picot arch, ch3] twice, skip 3ch; rep from * to last sc, 1dc in last sc, turn.

Step 4 Repeat Steps 2 (ending 1sc in 3rd of ch-6) and 3.

Special stitch Picot: [1sc, ch3, 1sc] all in same st.

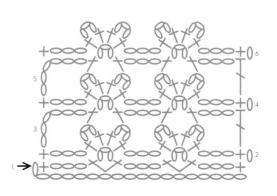

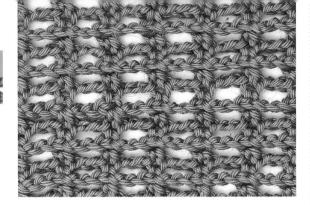

141 Ridged String Network

Ridged String Network is also based on a grid-like structure. It is different from the mesh-like structures because the chain spaces are wider than the height of the stitches. This example is made more interesting because the single crochet stitches are worked into the back loops only, which adds extra texture.

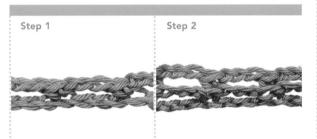

Multiple 4 sts + 1, plus 1 for the foundation chain.

Step 1 1sc in 2nd ch from hook, *ch3, skip 3ch, 1sc in next ch; rep from * to end, turn.

Step 2 Ch1, 1sc in back loop of first st, *ch3, skip 3ch, 1sc in back loop of next sc; rep from * to end, turn.

Step 3 Repeat Step 2.

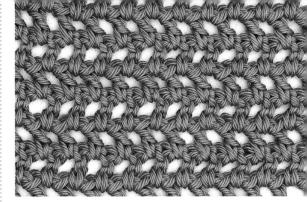

142 Offset Filet Net

Offset Filet Net differs from the previous example in two ways. In this example the net is created by the stitches being taller than they are wide and the stitches are worked into chain spaces rather than the top of stitches from the previous row. This has the effect of causing the double crochet stitches to lie at an angle, producing an attractive offset pattern.

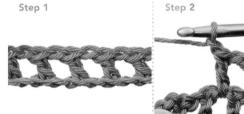

Multiple An even number of sts, plus 3 for the foundation chain.

Step 1 1dc in 5th ch from hook, *ch1, skip 1ch, 1dc in next ch; rep from * to end, turn.

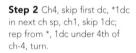

Step 3 Repeat Step 2.

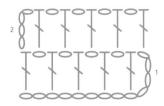

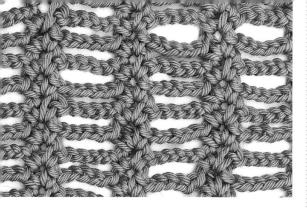

143 Ladder

adder stitch looks quite similar to Ridged String Network (see littch 141, left), but is created in quite a different way. In this xample the bars of chain are linked by two single crochet. The ncreased number of chain between the single crochet stitches reates a much less stable fabric, although one that would be very suitable for wraps and shawls.

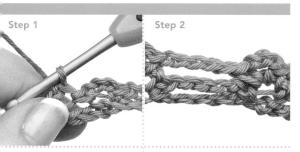

Multiple 6 sts + 1, plus 6 for the foundation chain.

Step 1 [1sc, ch3, 1sc] all in 13th ch from hook, *ch5, skip 5ch, [1sc, ch3, 1sc] in next ch; rep from * to last 6ch, ch5, skip 5ch, 1exsc (see page 24) in last ch, turn. **Step 2** Ch7, skip first exsc, *skip 5ch, [1sc, ch3, 1sc] in next ch-3 loop, ch5; rep from *, 1exsc in 5th of ch-13, turn.

Step 3 Repeat Step 2, ending each row by working 1 exsc in 2nd of ch-7, turn.

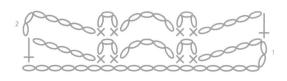

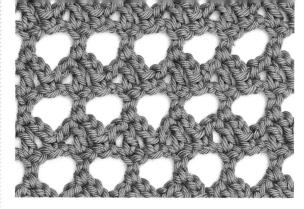

144 Bar and Lattice

Bar and Lattice is a very popular and pretty crochet stitch. It is still based on building up a grid using chains and double crochet. Further patterning is achieved by introducing alternating rows where additional chains are anchored with a single crochet at the center of each square to create the appearance of small triangles. The result is a fairly stable fabric which looks excellent worked in crisp cotton yarns.

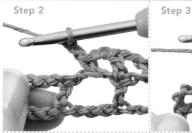

Multiple 4 sts + 1, plus 5 for the foundation chain.

Step 1 1dc in 10th ch from hook, *ch3, skip 3ch, 1dc in next ch; rep from * to end, turn.

Step 2 Ch5, skip [first dc and 1ch], 1sc in next ch, ch2, skip 1ch, *1dc in next dc, ch2, skip 1ch, 1sc in next ch, ch2, skip 1ch, 1sc in next ch, ch2, skip 1ch; rep from *, 1dc in 4th of ch-10, turn.

Step 3 Ch6, skip [first dc, 2ch, 1sc and 2ch], *1dc in next dc, ch3, skip [ch-2, 1sc, ch-2]; rep from * ending 1dc in 3rd of ch-5.

Step 4 Repeat Steps 2 and 3.

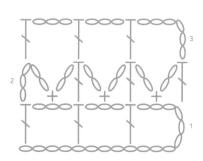

145 Triangle Mesh

Triangle Mesh is very similar in construction to Bar and Lattice stitch (see stitch 144, page 143). This time, every row is filled in with linked chains and single crochet and so the overall fabric looks more intricate. This stitch is quick to work and looks lovely in crisp, cotton yarns as well as fine lacy ones.

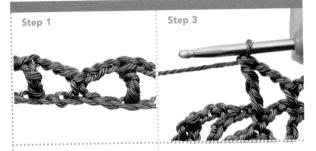

Multiple 6 sts + 1, plus 6 for the foundation chain.

Step 1 1sc in 10th ch from hook, *ch3, skip 2ch, 1tr in next ch, ch3, skip 2ch, 1sc in next ch; rep from * to last 3ch, ch3, skip 2ch, 1tr in last ch,

Step 2 Ch1, skip first tr, *ch2, skip 3ch, 1tr in next sc, ch2, skip 3ch, 1sc in next tr; rep from * to tch, skip 3ch, 1sc in next ch, turn.

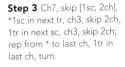

Step 4 Repeat Steps 2 and 3.

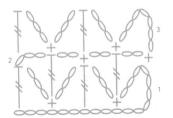

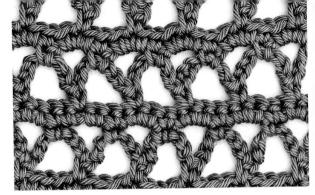

146 Ruled Lattice

Ruled Lattice is a very useful stitch if you want one that grows quickly and with good drape. It is an unusual stitch because it is made up of a three-row repeat and therefore has no right or wrong side after working the foundation row. Using a cotton yarn will help to maintain the zig-zag patterning within the rows.

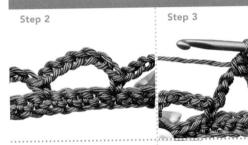

Multiple 4 sts + 1, plus 1 for the foundation chain.

Step 1 (RS) 1sc in 2nd ch from hook, 1sc in every ch to end of row, turn.

Step 2 Ch6, skip first 2 sts, 1sc in next sc, *ch7, skip 3sc, 1sc in next sc; rep from * to last 2sc, ch3, skip 1sc, 1dc in last sc, turn. **Step 3** Ch1, 1sc in first dc, *ch3, 1sc in next ch-7 arch; rep from * to end, turn.

Step 4 Ch1, 1sc in first sc, *3sc in next ch-3 arch, 1sc in next sc; rep from * to end, turn.

Step 5 Repeat Steps 2-4.

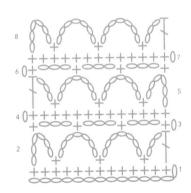

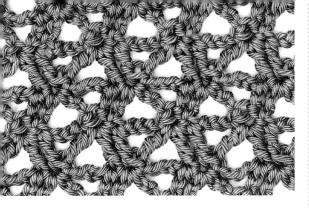

147 Doubled Lattice

Doubled Lattice stitch uses clusters as a way of building up a mesh or grid. Pairs of trebles are offset between groups of chain to create a diamond patterned trellis. The resulting fabric is surprisingly stable and would be a good choice for wraps and shawls.

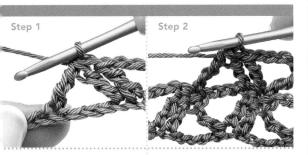

Multiple 6 sts + 2, plus 3 for the foundation chain.

Step 1 (RS) 1tr in 7th ch from hook (counts as 1edge Cl), ch4, 1tr in same ch as first tr, *tr2tog by working first leg in next ch, and 2nd leg in next 5th ch, (there will be 4ch between first and 2nd leg), ch4, 1tr in same ch as 2nd leg of Cl just made; rep from * to last 4ch, tr2tog by working first leg in next ch, and 2nd leg in last ch, (there will be 2ch between first and 2nd leg), turn.

Step 2 Ch6 (counts as 1tr and ch2), 1tr in first tr, *tr2tog by working in next tr for first leg and in top of next Cl for 2nd leg**, ch4, 1tr in same ch as 2nd leg of Cl just made; rep from * ending last rep at **, 2nd leg will be in edge Cl (described in Step 1), ch2, 1tr also in edge Cl, turn.

Step 3 Ch4, skip 2ch, 1tr in next Cl (counts as edge Cl), *ch4, 1tr in same place as tr just made**, tr2tog by working in next tr for 1st leg and in top of next cl for 2nd leg; rep from * ending last rep at **, tr2tog by working in next tr for first leg and in following 3rd ch for 2nd leg, turn.

Step 4 Repeat Steps 2 and 3.

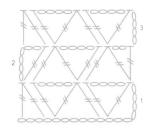

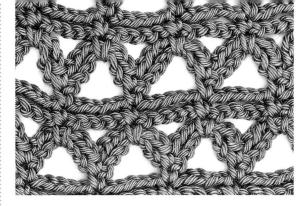

148 Zig-Zag Double String Network

This stitch appears to be a chunkier version of Doubled Lattice stitch (see stitch 147, left). However, it is constructed in a different way. Clusters are replaced with rows of chain that are bound together by working a single crochet underneath the chain sections. The stitch is simple to work, but requires accurate counting and neat chains to gain full effect.

Multiple 6 sts + 1, plus 1 for the foundation chain.

Step 1 (base row) (RS) 1sc in 2nd ch from hook, *ch5, skip 5ch, 1sc in next ch; rep from * to end, turn.

Step 2 (row 1) Ch1, 1sc in first sc, *ch5, skip 5ch, 1sc in next sc; rep from * to end, turn.

Step 3 (row 2) Ch1, 1sc in first sc, *ch7, skip 5ch, 1sc in next sc; rep from * to end, turn.

Step 4 (row 3) Ch1, 1sc in first sc, *ch7, skip 7ch, 1sc in next sc; rep from * to end, turn.

Step 5 (row 4) Ch5 (counts as 1dc and 2ch), work a sc by inserting hook under ch-7 arch made at Step 3, *ch5, 1sc under next ch-7 arch made at Step 3; rep from * to last sc, ch2, 1dc in last sc, turn.

Step 6 (row 5) Ch1, 1sc in first dc, ch2, skip 2ch, 1sc in next sc,

*ch5, skip 5ch, 1sc in next sc; rep from * to last 5ch, ch2, 1sc in 3rd of ch-5, turn.

Step 7 (row 6) Ch6, (counts as 1dc and 3ch), skip 2ch, 1sc in next sc, *ch7, skip 5ch, 1sc in next sc; rep from * to last 2ch, ch3, 1dc in last sc, turn.

Step 8 (row 7) Ch1, 1sc in first sc, ch3, skip 3ch, 1sc in next sc, *ch7, skip 7ch, 1sc in next sc; rep from * to last 6ch, ch3, 1sc in 3rd of ch-6, turn.

Step 9 (row 8) Ch1, 1sc in first sc, *ch5, 1sc under next ch-7 arch made at Step 7; rep from * to last sc, 1sc in last sc, turn.

Step 10 Repeat Steps 2-9.

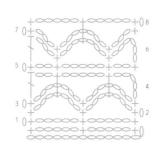

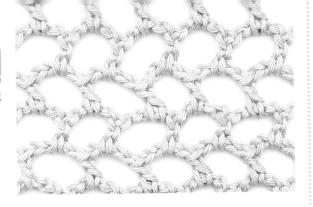

149 Honeycomb Mesh

Honeycomb Mesh is an extremely easy stitch. It relies on a one-row repeat combining chains and doubles. The very simplicity of this stitch means that it is suitable for working in all weights and colors of yarn. The finer the yarn, the more sophisticated it will look, although a thick yarn and large hook would make a cosy, cellular throw.

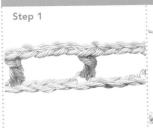

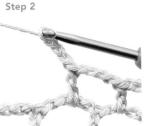

Multiple 4 sts + 3, plus 5 for the foundation chain.

Step 1 1dc in 8th ch from hook, *ch4, skip 3ch, 1dc in next ch; rep from * to end,

Step 2 Ch5, 1dc in first ch sp, *ch4, 1dc in next ch sp; rep from * to end, turn.

Step 3 Repeat Step 2.

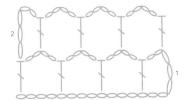

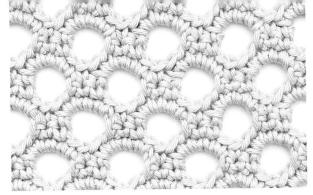

150 Honeycomb Trellis

Honeycomb Trellis is a much more sophisticated version of the mesh stitch. The pattern is built up over four rows and the chained arches are reinforced by a row of single crochet. This stitch works particularly well in crisp cotton yarns that will accentuate the highly defined pattern.

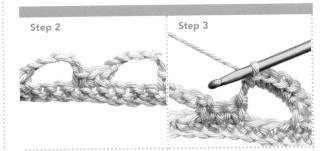

Multiple 5 sts + 2.

Step 1 (RS) 1sc in 2nd ch from hook, 1sc in every ch to end of row, turn.

Step 2 Ch1, 1sc in each of first 2sc, *ch5, skip 2sc, 1sc in each of next 3sc; rep from * to last 4sc, ch5, skip 2sc, 1sc in each of last 2sc, turn.

Step 3 Ch1, 1sc in first sc, *5sc in next ch-5 arch, skip 1sc, 1sc in next sc, skip 1sc; rep from * to last sc, 1sc in last sc, turn.

Step 4 Ch6 (counts as 1tr and 2ch), skip first 2sc, 1sc in each of next 3sc, *ch5, skip 3sc, 1sc in each of next 3sc; rep from * to last 2sc, ch2, 1tr in last sc, turn.

Step 5 Ch1, 1sc in first tr, 2sc in next ch-2 sp, skip 1sc, 1sc in next sc. *5sc in next ch-5 arch, skip 1sc, 1sc in next sc, skip 1sc; rep from * to last ch-2 sp, 2sc in last ch sp, 1sc in 4th of ch-6 at beginning of previous row, turn.

Step 6 Ch1, 1sc in each of first 2sc, *ch5, skip 3sc, 1sc in each of next 3sc; rep from * to last 5sc, ch5, skip 3sc, 1sc in each of next 2sc, turn.

Step 7 Repeat Steps 3-6.

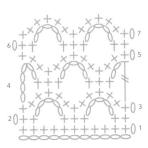

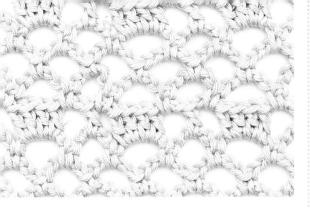

151 Block Trellis

Block Trellis is quite an unusual stitch in this section, created mainly from intersecting rows of chain and adding a group of doubles as a feature only once every four rows. This stitch needs to be worked in a medium- to heavyweight cotton yarn if is to retain any stability. It grows very quickly and is therefore in ideal stitch for those who are new to crochet.

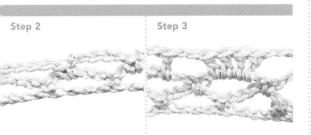

Multiple 8 sts + 5, plus 1 for the foundation chain.

Step 1 1sc in 2nd ch from hook, *ch5, skip 3ch, 1sc in next ch; rep from * to end, turn.

Step 2 *Ch5, 1sc in next ch-5 arch; rep from * to last arch, ch2, 1dc in last sc, turn.

Step 3 Ch3 (counts as 1dc), 1dc in first dc, ch2, 1dc in next ch-5 arch, *ch2, 4dc in next ch-5 arch, ch2, 1dc in next ch-5 arch; rep from * to end, turn.

Step 4 *Ch5, 1sc in next ch-2 sp; rep from * to last dc, ch2, 1dc in tch, turn.

Step 5 Ch1, 1sc in first dc, *ch5, 1sc in next ch-5 arch; rep from * to end, turn.

Step 6 Repeat Steps 2-5.

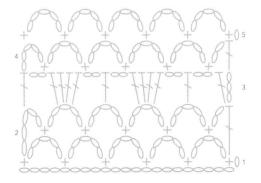

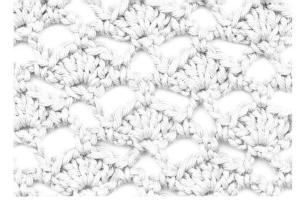

152 Shell Trellis

Shell Trellis stitch is another popular stitch combining chain arches and shell clusters. One of the reasons that this stitch retains its appeal is that it is well balanced and quick to work. It also looks good in a variety of contexts from a fine laceweight shawl to a heavy cotton picnic blanket.

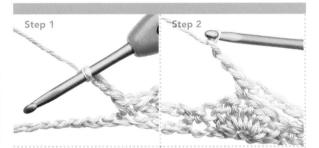

Multiple 12 sts + 1, plus 2 for the foundation chain.

Step 1 (RS) 2dc in 3rd ch from hook, *skip 2ch, 1sc in next ch, ch5, skip 5ch, 1sc in next ch, skip 2ch, 5dc in next ch; rep from * to end, working 3dc in last ch, turn.

Step 2 Ch1, 1sc in first dc, *ch5, 1sc in next ch-5 arch, ch5, 1sc in 3rd of next 5dc; rep from * to end, 1sc in 2nd of ch-2, turn.

Step 3 *Ch5, 1sc in next ch-5 arch, 5dc in next sc, 1sc in next ch-5 arch; rep from * to last sc, ch2, 1dc in last sc, turn.

Step 4 Ch1, 1sc in first dc, *ch5, 1sc in 3rd of next 5dc, ch5, 1sc in next ch-5 arch; rep from * to end, turn.

Step 5 Ch3 (counts as 1dc), 2dc in first sc, *1sc in next ch-5 arch, ch5, 1sc in next ch-5 arch, 5dc in next sc; rep from * to end, working 3dc in last sc, turn

Step 6 Repeat Steps 2–5.

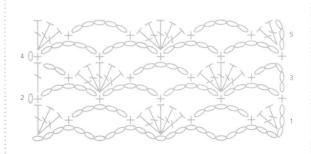

DIRECTORY OF STITCHES

153 Puff Cluster Trellis

Puff Cluster Trellis is an interesting stitch, combining several techniques. Once a series of arches has been established during the foundation row, all subsequent stitches are worked into the network of three-chain arches. This makes the rows quick to work and saves on lots of counting. The pattern is built up over four rows. The second and fourth rows are the same and single crochet is used to anchor the arches at the same points. On rows one and three, a cluster of three half doubles is used to bind the arches, which in turn adds detail and texture to the overall fabric.

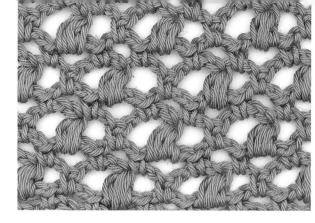

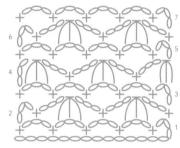

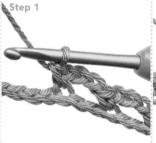

Multiple 6 sts + 2, plus 3 for the foundation chain.

Step 1 (RS) 1sc in 5th ch from hook, *ch3, skip 2ch, 1sc in next ch; rep from * to end, turn.

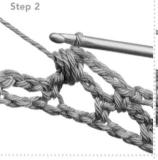

Step 2 Ch3, 1sc in next ch-3 arch, *ch3, hdc3tog in next arch, ch3, 1sc in next ch-3 arch; rep from * to end, turn.

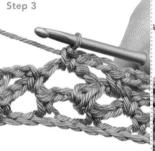

Step 3 *Ch3, 1sc in next ch-3 arch; rep from * to end, turn.

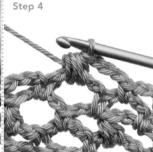

Step 4 *Ch3, hdc3tog in next ch-3 arch, ch3, 1sc in next ch-3 arch; rep from *, ch3, hdc3tog in tch arch, turn.

Step 5 As Step 3.

Step 6 Repeat Steps 2-5.

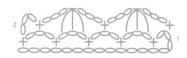

Steps 1-2

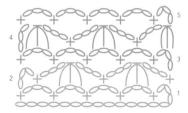

Steps 3–5

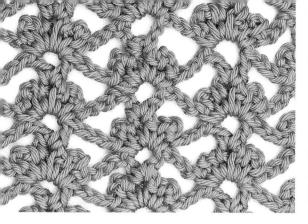

154 Triple Picot V

Friple Picot V is a really pretty stitch. It looks far more difficult than it is and so you may be surprised to learn that it is based on a one-row repeat. The extra detail comes from the fact that you will be working groups of picot stitches into the top of double crochet clusters as a means of anchoring the arch shapes. The result is an intricate-looking, lacy design that is suited to many different types of yarn weights and colors.

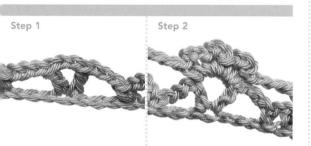

Multiple 11 sts + 7, plus 3 for the foundation chain.

Step 1 (RS) 1dc in 4th ch from hook, *ch3, skip 3ch, 1sc in next ch**, work a Picot of [ch3, 1sc in next ch] 3 times, ch3, skip 3ch, [1dc, ch2, 1dc] in next ch; rep from * and end last rep at **, ch3, 1sc in next ch, ch1, 1hdc in last ch, turn.

Step 2 Ch4 (counts as 1dc and 1ch), 1dc in first hdc, *ch3, skip 1Picot and 3ch**, work 1sc, [ch3, 1sc] 3 times in next ch-2 sp, ch3, skip 3ch and 1Picot, [1dc, ch2, 1dc] in next Picot; rep from * and end last rep at **, work [1sc, ch3, 1sc] in 4th of ch-4, ch1, 1hdc in 3rd of ch-4, turn.

Step 3 Repeat Step 2.

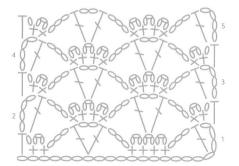

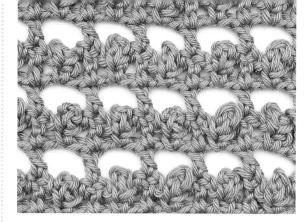

155 Picot Lattice

Picot Lattice is a much more stylized stitch than the previous one, reflecting a clear grid-like structure. It is softened by the picots that sit within each square. In this example, the picot is made up of three chains that are anchored into the single crochet just worked with a slip stitch. This stitch would make a beautiful throw and works with many different yarn weights.

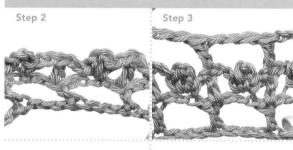

Multiple 4 sts + 1, plus 5 for the foundation chain.

Step 1 1dc in 10th ch from hook, *ch3, skip 3ch, 1dc in next ch; rep from * to end of row, turn.

Step 2 Ch5, skip [first dc and 1ch], 1sc in next ch, ch3, sl st in sc just made (counts as 1Picot), ch2, skip 1ch, *1dc in next dc, ch2, skip 1ch, 1sc in next ch, ch3, sl st in sc just made, ch2, skip 1ch; rep from * to last ch, 1dc in next ch, turn.

Step 3 Ch6, skip [first dc, 2ch, Picot, 2ch], *1dc in next dc, ch3, skip [2ch, Picot, 2ch]; rep from * to last ch, 1dc in last ch, turn.

Step 4 Repeat Steps 2 and 3.

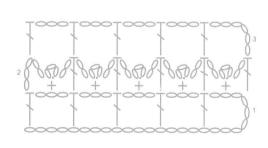

156 Solomon's Knot

Solomon's Knot is one of the most recognized and used crochet stitches. It is also known as the Love Knot, Lovers' Knot, True Lovers' Knot, or Hail Stone. Although it looks similar to other mesh-like structures, Solomon's Knot is constructed in an entirely different way. It is almost unique in that it does not start with a foundation chain. The work starts with a row of Solomon's Knot stitches (see page 31). These knots are best described as a lengthened chain stitch, locked into place with a single crochet through the back loop of the stitch.

You will start by working a chain and then lengthening it to about %in (15mm). (Edge Solomon's Knots are approximately %in [10mm] in length and worked on the foundation row and edges only.) Wrap the yarn over and pull this loop through keeping it to its normal size. At this stage you will need to keep the lengthened chain separate from the strand that leads to the new loop. This is the "bump" that can be found underneath the smooth V-shaped part of the chain. Insert the hook under this strand, wrap the yarn over and pull through the first loop. Take the yarn over for the last time and pull through both loops on the hook. Solomon's Knot has an extremely open and lacy structure which makes it ideal shawls and scarves.

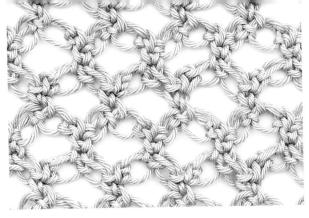

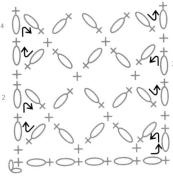

Step 2

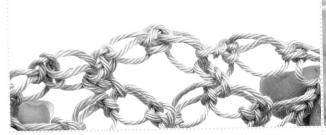

Multiple A multiple of 2Sk +1, plus 2 Sk for foundation chain

Step 1 (base row) Ch2, 1sc in 2nd ch from hook. Work a multiple of 2Esk to length required, ending with a normal height Msk.

Step 2 (row 1) 1sc in sc between 3rd and 4th loops from hook, *2Msk, skip 2 loops, 1sc in next sc; rep from * to end, turn.

Step 3 (row 2) 2Esk and 1Msk, 1sc in sc between 4th and 5th loops from hook, *2Msk, skip 2 loops, 1sc in next sc; rep from * to end, placing last sc in top of Esk, turn.

Step 4 Repeat Step 3.

Special stitch Sk (Solomon's knot): Draw up loop on hook to required length, ch1, insert hook under left-hand thread of 3 threads below hook, 1sc to close the knot (see page 31).

Esk (edge Solomon's knot): these form the foundation chain and edges of the fabric and are only $\frac{2}{3}$ the length of Msks.

 $\operatorname{\mathsf{Msk}}$ (Main Solomon's Knot): these form the main fabric and are half as long again as Esks.

Step 3

Steps 1-2

157 Solomon's Grid

Solomon's Grid is a variation on the traditional Solomon's Knot stitch (see stitch 156, left). In this instance, you will return to working a foundation chain followed by creating a grid-like structure from a series of doubles and Solomon's Knots. The result is still very lacy and the loops produced by the knots mean that it would not be suitable for projects requiring a very sturdy fabric.

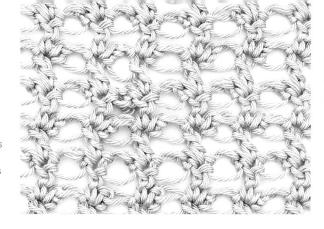

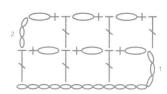

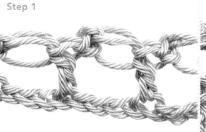

Step 2

Step 3

Multiple An odd number of sts equal to a multiple of 4 sts, plus 3 for the foundation

Step 1 1Sk, skip 6ch, 1dc in next ch, *1Sk, skip 3ch, 1dc in next ch; rep from * to end of row, turn.

Step 2 Ch3, skip first dc, *1Sk, skip 1Sk, 1dc in next dc; rep from * to end, working 1dc in 6th of ch-6, turn.

Step 3 Repeat Step 2 ending 1dc in 3rd of tch, turn.

Special stitch Sk (Solomon's knot): Draw up loop on hook to required length, ch1, insert hook under left-hand thread of 3 threads below hook. 1sc to close the knot (see page 31).

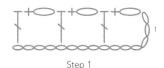

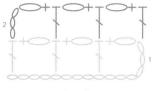

Step 2

158 Filet Squares

This stitch serves as a really good introduction to the filet technique. The term is derived from the French word, filet, meaning net. It has been adopted as a term to describe crochet patterns that are built up as a regular square mesh, with some sections filled in with double crochet to form patterns or motifs. Filet squares will help you to practice counting your stitches accurately and working from a chart. The three-row repeat means that the solid and empty squares alternate. In this example, we have provided written instructions as well as a chart. It is more usual for the pattern or motif to be presented in chart form and serves as a useful visual check. The empty squares on a chart represent spaces and the solid ones represent a block. These squares will need to be filled in differently, depending on the size of the mesh that you are working with. A pattern will always give you this information. Filet crochet is traditionally worked in fine cotton, white or pale-colored yarns. However, there is no reason why this technique should not be worked in darker colors and displayed against a light background.

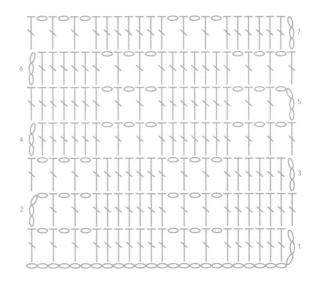

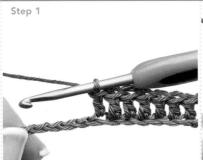

Multiple 12 sts + 1, plus 2 for the foundation chain.

Step 1 (row 1) 1dc in 4th ch from hook, 1dc in each of next 5ch, [ch1, skip 1ch, 1dc in next ch] 3 times, *1dc in each of next 6ch, [ch1, skip 1ch, 1dc in next ch] 3 times; rep from * to end of row, turn.

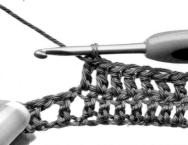

Step 2

Step 2 (row 2) Ch4, skip [first dc and 1ch], 1dc in next dc, [ch1, skip 1ch, 1dc in next ch] twice, 1dc in each of next 6dc *[ch1, skip 1ch, 1dc in next ch] 3 times, 1dc in each of next 6dc; rep from * to end of row working last dc in tch, turn.

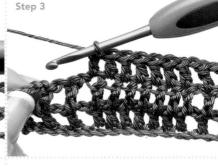

Step 3 (row 3) Ch3, skip first dc, *1dc in each of next 6dc, [ch1, skip 1ch, 1dc in next ch] 3 times; rep from * to end of row working last dc in 3rd of ch-4, turn.

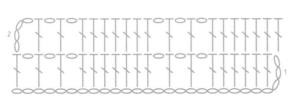

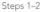

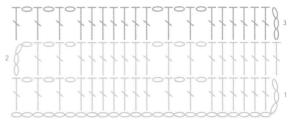

Step 3

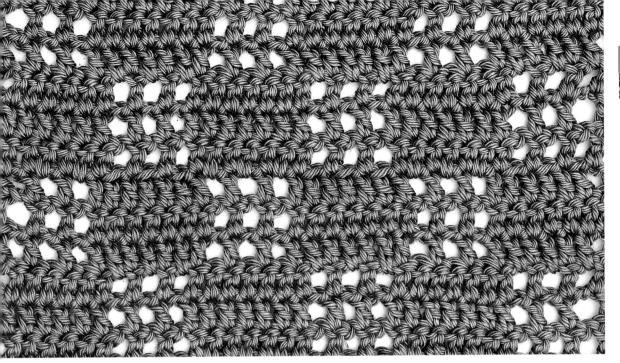

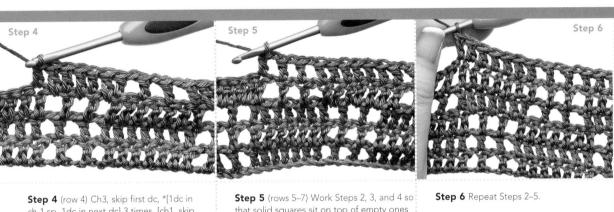

ch-1 sp, 1dc in next dc] 3 times, [ch1, skip 1dc, 1dc in next dc] 3 times; rep from * to end of row working last dc in tch, turn.

that solid squares sit on top of empty ones and vice versa.

Step 5

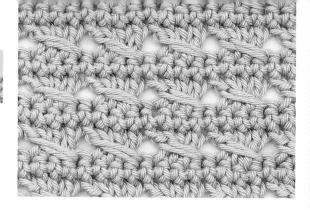

159 Cable

Cable stitch is a good introduction to the technique of crossing stitches. Rather like cables in knitting, the illusion of stitches changing places is created by working back across a group of stitches that you have already worked. The vertical columns of cables and alternating rows of single crochet prevent the fabric from forming a bias.

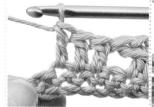

Multiple 4 sts + 2.

Step 1 (WS) 1sc in 2nd ch from hook, 1sc in every ch to end of row, turn.

Step 2 Ch3, skip first sc, *skip next sc, 1dc in each of next 3sc, 1Cable st; rep from *, 1dc in tch.

Step 3

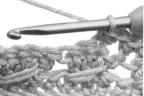

Step 3 Ch1, skip first dc, 1sc in every dc to end of row, 1sc in tch, turn.

Step 4 Repeat Steps 2–3.

Special stitch Cable st: work 1dc by inserting the hook 4 sts to the right and in the sc just skipped.

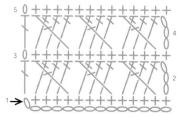

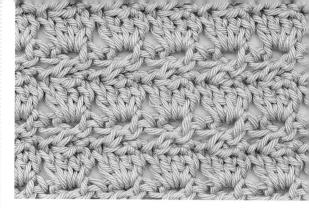

160 Cabbage Patch

There is something rather appealing about a stitch resembling a row of cabbages. This is a simple but clever stitch based on a two-row repeat. The crossed doubles in the first row have two chains in the middle of them. On the following row, four doubles are worked into this chain space. This helps to make the fabric sturdy as well as creating an interesting texture.

Step 2

Multiple 4 sts + 7.

Step 1 (RS) 4dc in 5th ch from hook, *skip 3ch, 4dc in next ch; rep from * to last 2ch, skip 1ch, 1dc in last ch, turn.

Step 2 Ch3 (counts as 1dc), skip first dc, *skip 3dc, 1dc in next dc, ch2, 1dc in first of skipped dc; rep from * to end, 1dc in tch, turn.

Step 3

Step 3 Ch3, 4dc in every ch-2 sp to end, 1dc in tch, turn.

Step 4 Repeat Steps 2 and 3.

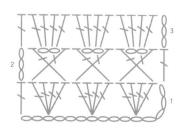

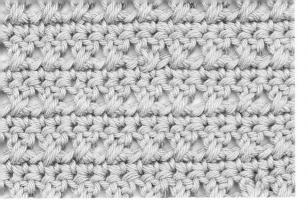

161 Crossed Double

Crossed Double is a simple but elegant stitch. It has a two-row epeat based on creating columns of crossed doubles. The esulting fabric is lacy but still quite firm because of the alternating rows of single crochet. This stitch works well in a variety of yarn types and is lovely for scarves and snoods.

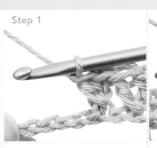

Step 2 Ch1 (counts as 1sc), skip 1 st, 1sc in next and every st to end of row, 1sc in tch,

Step 1 (RS) Skip 3ch (counts as 1dc) *skip 1ch, 1dc in next ch, 1dc in ch just skipped; rep from * to last ch, 1dc in last ch, turn.

Multiple 2 sts, plus 2 for the

foundation chain.

Step 3 Ch3 (counts as 1dc), *skip 1 st, 1dc in next st, 1dc in st just skipped, rep from *, 1dc in tch, turn.

Step 4 Repeat Steps 2 and 3.

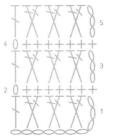

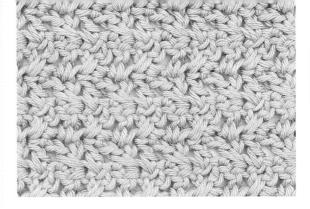

162 Crossbill

Crossbill stitch is a lacier version of Crossed Double stitch (see stitch 161, left). Although it is still a two-row repeat, the double stitches are crossed on every row. The result is an open textured fabric with diamond patterning. This stitch is also suited to a variety of yarn types and very much suited to scarves and snoods.

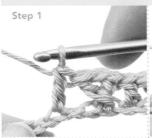

Multiple 4 sts + 1, plus 2 for the foundation chain.

Step 1 Skip 3ch, *2Cdc over next 3ch, 1dc in next ch; rep from * to end, turn.

Step 2 Ch3 (counts as 1dc), 1dc in first st, skip 1dc, *1dc in next ch-1 sp, 2Cdc over next 3dc; rep from * to last dc, 1dc in last ch-1 sp, skip last dc, 2dc in 3rd of ch-3, turn.

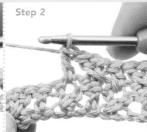

Step 3 Ch3 (counts as 1dc), skip 1dc, *2Cdc over next 3dc, 1dc in next ch-1 sp; rep from * to end, 1dc in 3rd of ch-3, turn.

Step 4 Repeat Steps 2 and 3.

Special stitch 2Cdc

(2 crossed double crochet): skip 2 sts, 1dc in next st, ch1, 1dc in first of 2 sts just skipped by working back over last dc made.

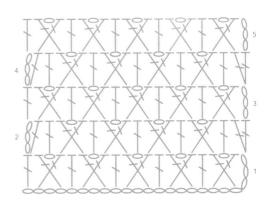

163 Crossed Lace Loop

Crossed Lace Loop is another elegant stitch, which always reminds me of cane work. It is based on a four-row repeat producing columns of crossed stitches equivalent in height to a treble, balanced by rows of equally spaced doubles. The technical skill in this stitch comes from being familiar with working a Solomon's Knot (see page 31)—in other words the cross is made by completing a series of loops which are picked up, crossed, and locked on the following row. This stitch will take a bit of practice and I would suggest working in a medium-weight cotton yarn to start with. This will help to avoid the yarn slipping when making the loops and make the strand at the back easier to identify. This would look magnificent in a lightweight silk yarn.

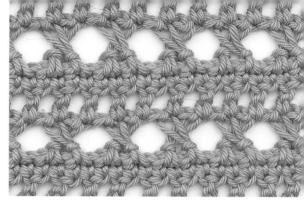

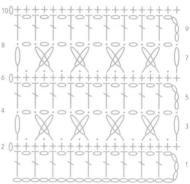

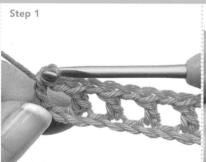

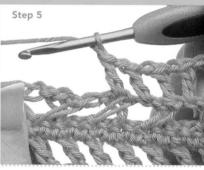

Multiple 4 sts + 3, plus 3 for the foundation chain

Step 1 (RS) 1dc in 6th ch from hook, *ch1, skip 1ch, 1dc in next ch; rep from * to end,

Step 2 Ch1, 1sc in first st, *1sc in next ch, 1sc in next dc; rep from *, 1sc in each of first 2ch of tch, turn.

Step 3 *Ch1, draw loop on hook up to the height of a tr. keeping the loop at this length, insert hook in next st, yo and pull loop through and up to height of tr, work a sl st in next st; rep from * to end, keeping all Lace loops on hook. Remove all Lace loops except the last 1, yo and insert hook under back thread and work a sl st to secure this last lace loop, turn.

Step 4 Skip first Lace loop, *ch1, skip 1Lace loop, sl st in top of next lace loop, ch1, bring skipped loop forward and work a sl st in top of it; rep from * to last loop crossing loops consistently, ch1, sl st in top of last loop, turn.

Step 5 Ch4 (counts as 1dc and 1ch), skip 1ch, 1dc in next sl st, *ch1, skip 1ch, 1dc in next sl st; rep from * to end, turn.

Step 6 Repeat Steps 2-5.

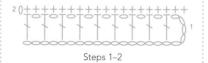

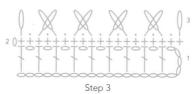

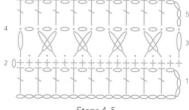

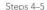

164 Hotcross Bun

Hotcross Bun stitch has several interesting features. It is based in a three-row repeat which makes it fully reversible and is nerefore a good choice for blankets and throws. Rows of rossed trebles mean that your project will grow quickly. hese deep crosses are balanced by intervening rows of louble clusters. This helps to add extra texture and interest to ne overall pattern. If you are new to this stitch it is probably sest to work it in a medium-weight, light-colored cotton yarn to start with. Once you are confident, this stitch may suit a lange of yarn types including some of the chunkier varieties.

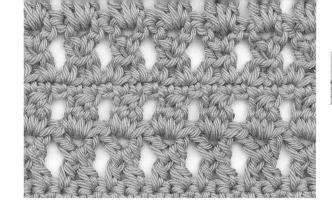

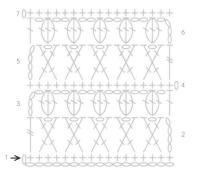

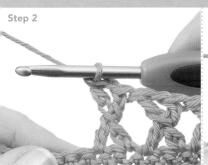

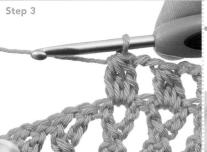

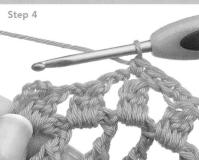

Multiple 3 sts + 2, plus 1 for the foundation chain.

Step 1 (WS) 1sc in 2nd ch from hook, 1sc in every ch to end of row, turn.

Step 2 Ch4 (counts as 1tr), skip first sc, *TrX over next 3 sts; rep from * to last st, 1tr in last sc, turn.

Step 3 Ch4 (counts as 1dc and 1ch), *dc3tog in next ch-1 sp**, ch2; rep from * ending last rep at **, ch1, 1dc in 4th of ch-4, turn.

Step 4 Ch1, 1sc in first st, 1sc in next ch, *1sc in next cl, 1sc in each of next 2ch; rep from * to end, turn.

Step 5 Repeat Steps 2-4.

Special stitch TrX (Treble "X" shape worked over 3 sts): yo twice, insert hook in next sc, yo, pull loop through, yo, pull loop through 2 loops, skip next sc, yo, insert hook in next sc, yo, pull loop through [yo, pull loop through 2 loops] 4 times, ch1, yo, insert hook halfway down st just made, yo, pull loop through, [yo, pull loop through 2 loops] twice.

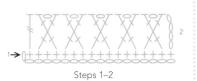

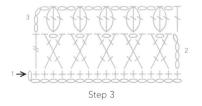

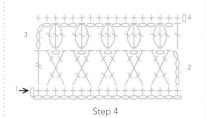

165 Zeros and Crosses

Zeros and Crosses is a very appropriately named stitch since the crossed doubles and chain spaces look exactly like the child's game. Like several stitches in this section, the stitch is based on a three-row repeat and so is fully reversible. This can be a really useful feature when making wraps and scarves. The top of the crossed stitch is narrower than the base and so care should be taken when positioning the two "legs" of the cross. This stitch would suit many different yarn types.

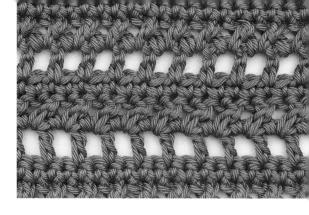

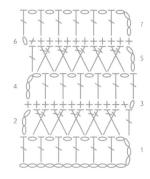

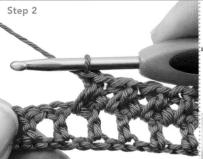

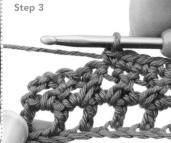

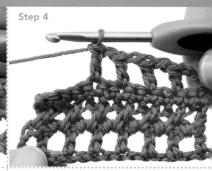

Multiple 2 sts + 1, plus 3 for the foundation chain.

Step 1 (RS) 1dc in 6th ch from hook, *ch1, skip 1ch, 1dc in next ch; rep from * to end, turn.

Step 2 Ch3, skip next ch sp, *1dc in next ch sp, insert hook from behind dc just worked in ch sp just skipped; rep from * to end working 1dc in 4th of ch-4 and 1dc in last ch, turn.

Step 3 Ch1, 1sc in first st, 1sc in next and every st to end of row ending with 1sc in tch, turn.

Step 4 Ch4 (counts as 1dc and 1ch), skip 2 sts, 1dc in next st, *ch1, skip 1 st, 1dc in next sc; rep from * to end, 1dc in tch, turn.

Step 5 Repeat Steps 2-4.

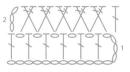

Steps 1–2

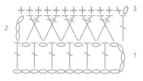

Step 3

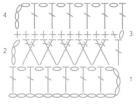

Step 4

166 Woven Shell

Voven Shell is a really solid example of a crossed crochet titch. It looks very similar to cabled stitches in knitting. Closer xamination shows that this is a two-row repeat, with stitches rossed on every row. Most crosses are worked across two titches. This version crosses six stitches, three on either side, nd it is this that gives the pattern its chunky texture. It is uitable for working in a variety of yarns, but a medium-weight otton will highlight the crosses as the light catches the stitches ving in different directions. However, this is one of the few rochet stitches that would also look effective in a tweedy r chunky yarn.

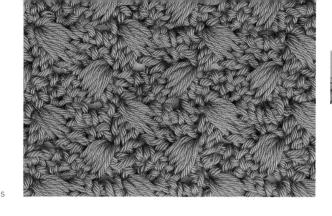

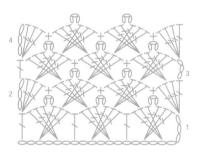

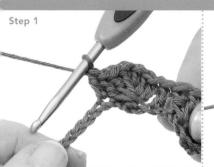

Step 2

Multiple 6 sts + 1, plus 2 for the foundation chain.

Step 1 Skip 3ch (counts as 1dc), *skip next 3ch, 3dc in next ch, ch3, work back over these 3dc by working 3dc in 2nd of 3ch just skipped, skip 1ch, 1dc in next ch; rep from * to end, turn.

Step 2 Ch3 (counts as 1dc), 3dc in first st, 1sc in next ch-3 arch, *1Cgr, 1sc in next ch-3 arch; rep from * to end, 4dc in tch, turn.

Step 3 Ch3 (counts as 1dc) skip 1 st, 1Cgr, *1sc in next ch-3 loop, 1Cgr; rep from * to end, 1dc in tch, turn.

Step 4 Repeat Steps 2 and 3.

Special stitch Cgr (crossed group): skip 3dc and next st, 3dc in 2nd of next 3dc, ch3, 3dc in 2nd of 3dc just skipped.

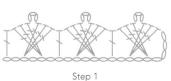

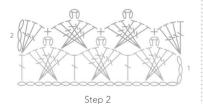

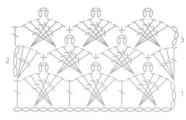

Step 3

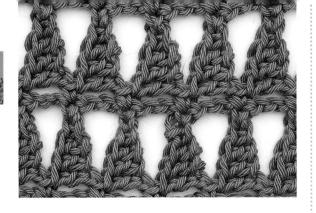

167 Little Pyramid

Little Pyramid is an unusual stitch although it is easy to see how it got its name. Each pyramid is worked individually across the row by working stitches of different heights into a length of chain. Although the concept is simple, it will take a little practice to ensure that all the pyramids look alike.

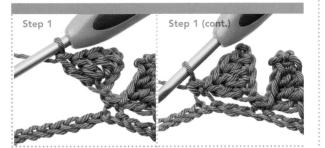

Multiple 4 sts + 1, plus 1 for the foundation chain.

Step 1 (RS) 1sc in 2nd ch from hook, *1Pyramid, skip 3ch, 1sc in next ch; rep from * to end, turn.

Step 2 Ch6 (counts as 1dtr and 1ch), 1sc in ch at top of next Pyramid, ch3; rep from * to last Pyramid, 1sc in ch at top of Pyramid, ch1, 1dtr in last sc, turn.

Step 3 Ch10, skip 1ch, 1sc in next sc, *1Pyramid, skip 3ch, 1sc in next sc; rep from * to last ch, ch5, skip 6th of ch-6, 1dtr in 5th of ch-6, turn.

Step 4 Ch1, 1sc in first st, *ch3, 1sc in ch at top of last Pyramid; rep from * to 10 tch, 1sc in 5th of ch-10, turn.

Step 5 Ch1, 1sc in first st, *1Pyramid, skip 3ch, 1sc in next sc; rep from * to end, turn.

Step 6 Repeat Steps 2-5.

Special stitch Pyramid: Ch6, 1sc in 3rd ch from hook, 1dc in each of next 3ch.

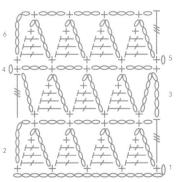

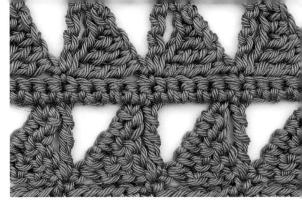

168 Inverted Triangles

Inverted Triangles is similar in construction to Little Pyramids (see stitch 167, left), although the triangles are now wider and worked in two directions. This is achieved by working a series of longer stitches away from the chain length as well as adding a double treble between each triangle. The pattern is built on a three-row repeat and so is fully reversible.

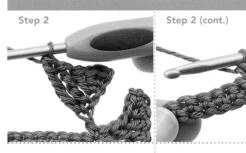

Multiple 6 sts + 2.

Step 1 (RS) 1sc in 2nd ch from hook, 1sc in every ch to end of row, turn.

Step 2 Ch1, 1sc in first sc, *ch6, 1sc in 2nd ch from hook, 1hdc in 3rd ch from hook, 1dc in 4th ch from hook, 1tr in 5th ch from hook, 1dtr in 6th ch from hook, skip 5sc (from previous row), 1sc in next sc; rep from * to end, turn. **Step 3** Ch5 (counts as 1dtr), *1sc in ch at top of next triangle, ch4, 1dtr in next sc; rep from * to end, turn.

Step 4 Ch1, 1sc in each [dtr, ch, and sc] group to end of row, working final sc in 5th of ch-5 at beginning of previous row, turn.

Step 5 Repeat Steps 2-4.

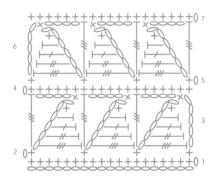

169 Crosshatch

Crosshatch is a very useful stitch and is based on a single-row repeat. This makes it very versatile and fully reversible. It works on the principle of working stitches of the same height out of a chain length. By repeating the same sequence on every row, the stitches will lie in the adjacent direction on every following row. This stitch looks effective when worked in a single pale color, but can be made more interesting by working three or more colors in a stripe sequence as shown here. Care should be taken to use an appropriate-sized hook to yarn weight to maintain an even gauge and prevent any gaps appearing.

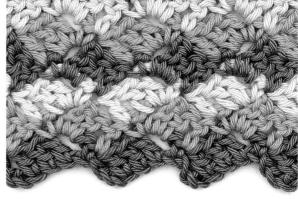

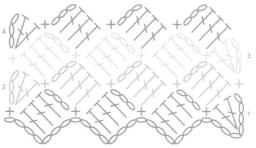

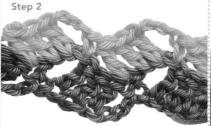

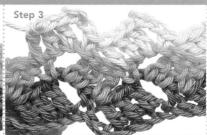

Multiple 7 sts + 5, plus 3 for the foundation chain.

Step 1 Skip 3ch (counts as 1dc), 2dc in next ch, *skip 3ch, 1sc in next ch, ch3, 1dc in next 3ch; rep from * to last 4ch, skip 3ch, 1sc in last ch, turn.

Step 2 Ch3 (counts as 1dc), 2dc in first sc, *skip 3dc, 1sc in first of ch-3, ch3, 1dc in next 2ch, 1dc in next sc; rep from * to last 2dc, skip 2dc, 1sc in tch, turn.

Step 3 Repeat Step 2.

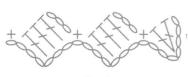

Step 1

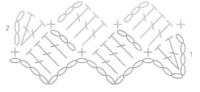

Step 2

170 Flying Shell

Flying Shell is an attractive stitch that combines the technique of interlocking stitches along with the traditional "V" stitch. It is worked over a four-row repeat so that the Flying Shells are offset against each other on alternate rows. This creates a firm fabric with an interesting texture. This stitch probably works best in light colors so that the detail in the patterning is not lost, but bands of darker colors could be introduced to add interest. Flying Shell would make a superb blanket or throw because of its lack of bias and good drape.

Special stitch Fs (flying shell): [1sc, ch3, 3dc] in the designated ch or st. Special stitch V st: 1dc, ch1, 1dc.

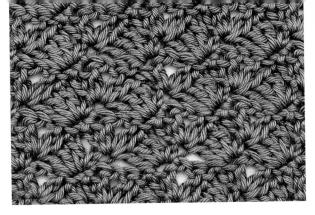

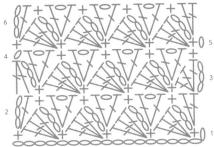

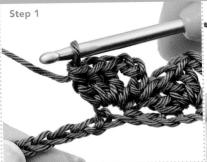

Multiple 4 sts + 1, plus 1 for the foundation chain.

Step 1 1Fs in 2nd ch from hook, *skip 3ch, 1Fs in next ch; rep from * to last 4ch, skip 3ch, 1sc in last ch, turn.

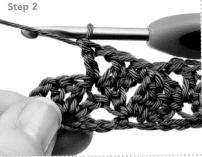

Step 2 Ch3, 1dc in first st, *skip 3 sts, 1sc in top of ch-3**, 1V st in next sc; rep from * ending last rep at **, 2dc in last sc, turn.

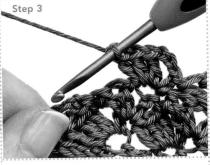

Step 3 Ch3, 3dc in first st, skip next st, *1Fs in next sc, skip next V st; rep from * to last 2 sts, 1sc in last sc, ch3, dc2tog over last dc and tch, turn.

Step 4 Ch1, *V st in next sc, skip 3 sts, 1sc in top of ch-3; rep from * to end,

Step 5 Ch1, 1Fs in first st, *skip next V st, 1Fs in next sc; rep from * to last V st, skip last V st, 1sc in tch, turn.

Step 6 Repeat Steps 2-5.

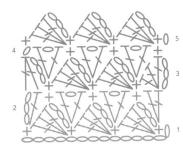

Steps 3-5

Step 1

Step 2

171 Wedge

Wedge stitch has a more fragile construction than some of the other examples in this section. The overall pattern looks like a series of ivy leaves strung together. It is this loose connection between the rows that gives the stitch its delicacy. This is achieved by working a series of different-sized stitches either side of a length of chain. The wedges are held together by he single crochet stitches at the corner of the wedge shapes. The stitch works well in several different yarn types and extra interest can be added by working in a two-row stripe sequence. The effect of this on the pattern is to give it the appearance of intersecting diamonds

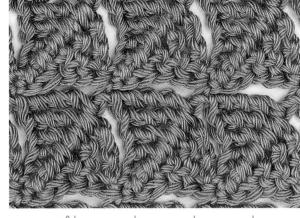

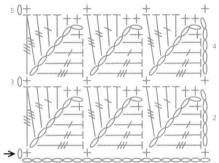

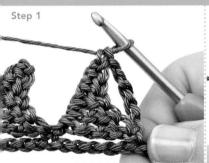

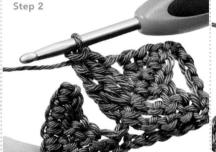

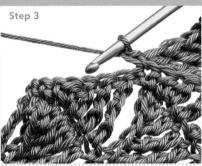

Multiple 6 sts + 1, plus 1 for the foundation chain

Step 1 (WS) 1sc in 2nd ch from hook, *1Wp, skip 5ch, 1sc in next ch; rep from * to end, turn.

Step 2 Ch5 (counts as 1dtr), *1sc in top of Wp, working in ch at base of Wp place 1sc in next ch, 1hc in next ch, 1dc in next ch, 1tr in next ch, 1dtr in next ch, skip next sc; rep from * omitting last dtr when 2 sts remain, **{[yo] 3 times, insert hook in last ch along base of Wp, yo and pull a loop through, [yo and pull through 2 loops] 3 times}; rep from ** in next sc, yo and pull through all 3 loops on hook, turn.

Step 3 Ch1, 1sc in first st, *1Wp, skip next 5 sts, 1sc in next st; rep from * to end, 1sc in tch, turn.

Step 4 Repeat Steps 2 and 3.

Special stitch Wp (wedge picot): ch6, 1sc in 2nd ch from hook, 1hdc in next ch, 1dc in next ch, 1tr in next ch, 1dtr in next ch.

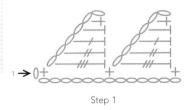

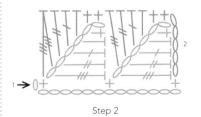

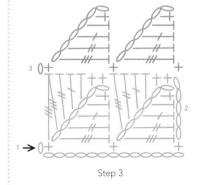

172 Sidesaddle Cluster

Sidesaddle Cluster stitch is another loosely connected stitch, but much firmer than the wedge picots in the previous example (see stitch 171, page 163). This is due to the fact that the solid sections are worked as clusters rather than a series of tall stitches off a chain length. Further stability is gained from each cluster being worked into the three-chain arch on the row below. Sidesaddle Cluster is another stitch that looks best worked in pale colors so that the definition of each cluster is not lost. This would be a great stitch to use when making baskets or large tote bags.

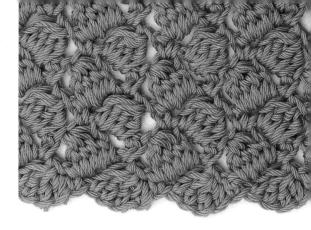

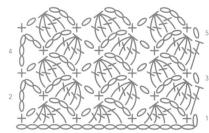

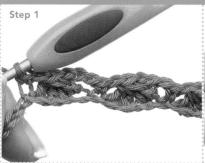

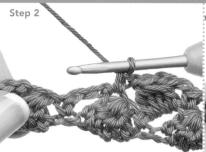

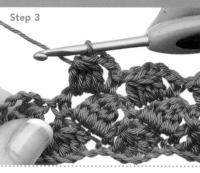

Multiple 5 sts + 1, plus 1 for the foundation chain.

Step 1 1sc in 2nd ch from hook, *ch3, dc4tog over next 4ch, ch1, 1sc in next ch; rep from * to end, turn.

Step 2 Ch5, 1sc in next Cl; *ch3, dc4tog in ch-3 arch, ch1, 1sc in next Cl; rep from * to last ch-3 arch, ch3, dc4tog all in last ch-3 arch, 1dc in last sc, turn.

Step 3 Ch1, skip 1 st, 1sc in next Cl, *ch3, dc4tog in ch-3 arch, ch1, 1sc in next Cl; rep from * ending last sc in tch, turn.

Step 4 Repeat Steps 2 and 3.

Step 1

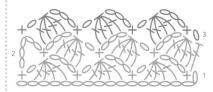

Step 2

Step 3

173 Sidesaddle Shell

Sidesaddle Shell is one of the more complex stitches in this section. It is similar in construction to Sidesaddle Cluster (see stitch 172, left), but this time each block is made up of a shell and a cluster, that are worked much more closely together. In the previous example, the blocks appeared to fall either side of a central chain. In this version, the proximity of the blocks gives the impression of small, intersecting diamond shapes. Sidesaddle Shell is quite a "busy" stitch and benefits from being worked in cool, crisp, or pale colors. Lightweight cotton varns would ensure that no stitch definition was lost.

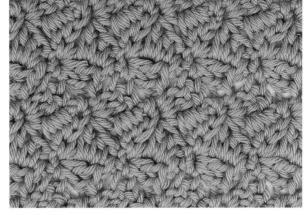

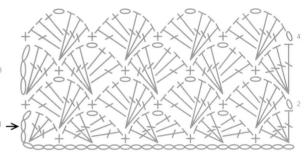

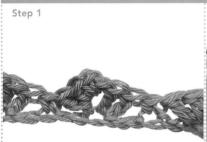

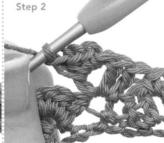

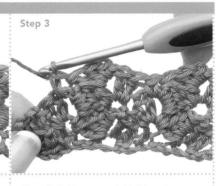

Multiple 6 sts + 1, plus 3 for the foundation chain.

Step 1 (WS) Skip 3ch (counts as 1dc), 3dc in next ch, skip 2ch, 1sc in next ch, *skip 2ch, 1Shell in next ch, skip 2ch, 1sc in next ch; rep from * to last 3ch, skip 2ch, 4dc in last ch,

Step 2 Ch1 (counts as 1sc), skip 1 st, *skip next 3 sts, 1Shell in next sc, skip 3 sts, 1sc in next ch-sp; rep from * to end working last sc in tch, turn.

Step 3 Ch3 (counts as 1dc), 3dc in first st, skip 3 sts, 1sc in next ch-sp, *skip 3 sts, 1Shell in next sc, skip 3 sts, 1sc in next ch-sp; rep from * to last 3 sts, skip 3 sts, 4dc in tch, turn.

Step 4 Repeat Steps 2 and 3.

Special stitch Shell: 3dc, ch1, [1sc, 1hdc, 1dc] all in side of last 3dc just made.

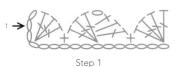

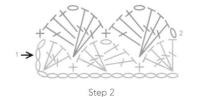

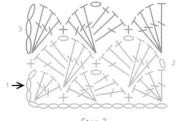

Step 3

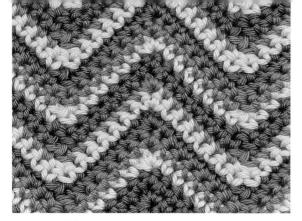

174 Chevron

The Chevron is probably the most iconic of all the crochet stitches. It is ever popular and ever capable of reinventing itself from the 1930s through to the runways of the twenty-first century. One reason that it has lasted is probably because it is based on the simple principle of peaks and troughs. This simple pattern can be variously interpreted and there are infinite opportunities to create patterns using different colors for each row.

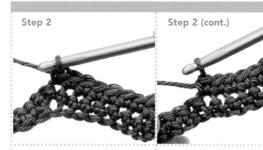

Multiple 16 sts + 2.

Step 1 (RS) 2sc in 2nd ch from hook, *1sc in each of next 7ch, skip 1ch, 1sc in each of next 7ch, 3sc in next ch; rep from * to last ch ending last rep with 2sc in last ch, turn.

Step 2 Ch1, 2sc in first sc, *1sc in each of next 7sc, skip 2sc, 1sc in each of next 7sc, 3sc in next sc; rep from * to last sc working 2sc in last sc,

Step 3 Repeat Step 2.

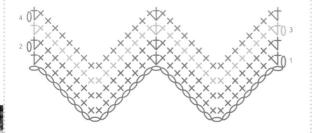

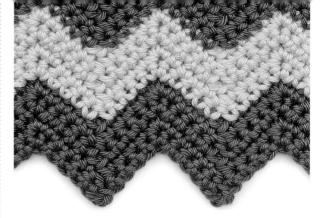

175 Close Chevron

Close Chevron is a shallower version of the first stitch in this section (see stitch 174, left). The increases are made by working three single crochet stitches into a stitch to form a peak. Decreases are made by skipping two stitches. The increases and decreases are equally spaced and the stitch count is maintained by an equal number of increases to decreases.

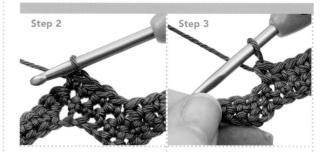

Multiple 11 sts + 1, plus 1 for the foundation chain.

Step 1 (RS) 2sc in 2nd ch from hook, *1sc in each of next 4ch, skip 2ch, 1sc in each of next 4ch, 3sc in next ch; rep from * to last ch working 2sc in last ch, turn.

Step 2 Ch1, 2sc in first sc, *1sc in each of next 4sc, skip 2sc, 1sc in each of next 4sc, 3sc in next sc; rep from * ending last rep with 2sc in last sc, turn.

Step 3 Repeat Step 2.

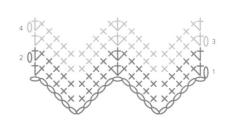

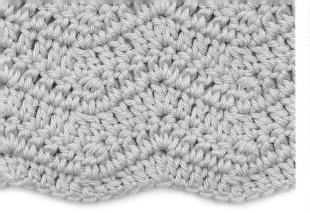

176 Simple Chevron

Simple Chevron follows the same basic principle of creating peaks and troughs. This time the decreases are made by working three stitches together in the same place, to compensate for the two extra stitches made. This chevron also appears gentler because it is worked in double rather than single crochet stitches.

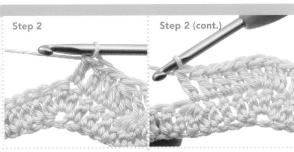

Multiple 10 sts + 1, plus 3 for the foundation chain.

Step 1 Skip 3ch (counts as 1dc), 1dc in next ch, *1dc in each of next 3ch, dc3tog over next 3ch, 1dc in each of next 3ch**, 3dc in next ch; rep from * to end, ending last rep at **, 2dc in last ch, turn.

Step 2 Ch3 (counts as 1dc), 1dc in next dc, *1dc in each of next 3dc, dc3tog over next 3dc, 1dc in each of next 3dc, 3dc in next dc; rep from * ending last rep with 2dc in tch, turn.

Step 3 Repeat Step 2.

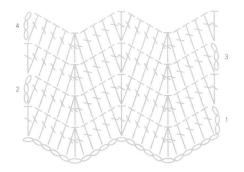

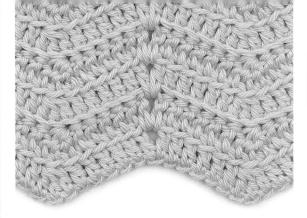

177 Wide Chevrons

Wide Chevron stitch illustrates another way of creating a peak. The decreases are made as before, by working three stitches together, but the increases are made by working two stitches and a chain into the chain space created by the preceding row. The result is a looser fabric, although the width can be altered by the number of doubles worked in-between the increases and decreases. Extra texture is achieved by working alternate rows into the front or back loops only of the double crochet.

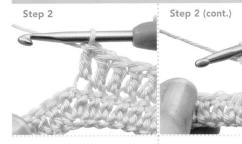

Multiple 14 sts + 1, plus 3 for the foundation chain.

Step 1 1dc in 4th ch from hook, *1dc in each of next 5ch, dc3tog over next 3ch, 1dc in each of next 5ch, [1dc, ch1, 1dc in next ch; rep from * ending last rep with 2dc in last ch, turn. Step 2 Ch3 (counts as 1dc), 1dc in front loop of first dc, *1dc in front loop of each of next 5dc, dc3tog by working in front loops only of next 3dc, 1dc in front loop of each of next 5dc, [1dc, ch1, 1dc] in next ch-1 sp; rep from * ending last rep with 2dc in 3rd of ch-3, turn.

Step 3 As Step 2, but working in back loops of dc.

Step 4 Repeat Steps 2-3.

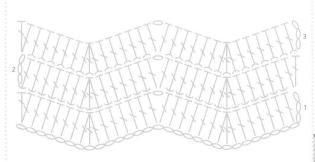

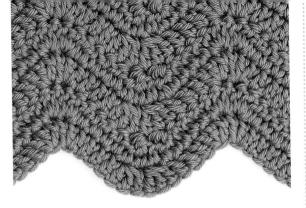

178 Sharp Chevron

As the name implies, the zig-zag patterning is much steeper in this stitch than the previous examples. This is achieved by working double increases and decreases either side of the sections of double crochet. Although the sides of the zig-zags are steeper, the peaks and troughs have smoother, more rounded points than we have seen in the other examples.

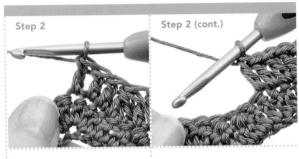

Multiple 14 sts, plus 3 for the foundation chain.

Step 1 Skip 3ch (counts as 1dc), 2dc in next ch, 1dc in each of next 3ch, [dc3tog over next 3ch] twice, *1dc in each of next 3ch, [3dc in next ch] twice, 1dc in each of next 3ch, [dc3tog over next 3ch] twice; rep from * to last 4ch, 1dc in each of next 3ch, 3dc in last ch, turn.

Step 2 Ch3 (counts as 1dc), 2dc in first dc, *1dc in each of next 3dc, [dc3tog] twice, 1dc in each of next 3dc, [3dc in next dc] twice; rep from * ending last rep with 3dc in tch, turn.

Step 3 Repeat Step 2.

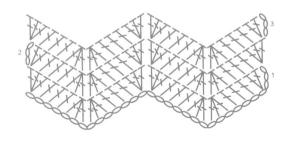

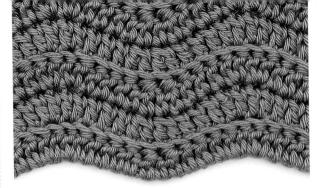

179 Ridged Chevron

Ridged Chevron is part of the group of very simple chevron stiches. It is different from the others because it is the horizontal lines of the pattern that are emphasized rather than the peaks and troughs. This is achieved by working the double crochet stitches into the back loops only of the stitches and helps to add texture to the overall patterning.

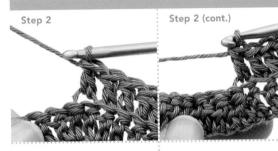

Multiple 12 sts, plus 3 for the foundation chain.

Step 1 Ch3 (counts as 1dc), 1dc in next ch, *1dc in each of next 3ch, [dc2tog over next 2dc] twice, 1dc in each of next 3ch, [2dc in next ch] twice; rep from * ending last rep with 2dc in last ch, turn. Step 2 Remember to work in back loops only of all sts. Ch3 (counts as 1dc), 1dc in next ch, *1dc in each of next 3dc, [dc2tog over next 2dc] twice, 1dc in each of next 3dc, [2dc in next dc] twice; rep from * ending last rep with 2dc in tch, turn.

Step 3 Repeat Step 2.

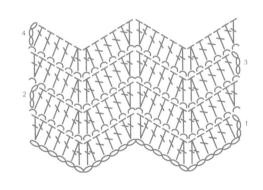

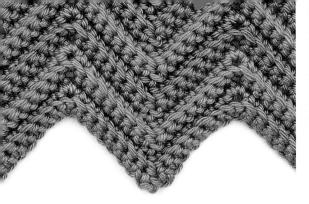

180 Ribbed Chevron

Ribbed Chevron is a sharply defined stitch, producing a tightly constructed fabric. It grows quite slowly, but clever use of color and the resulting texture make it very worthwhile. Extra interest can be achieved by working in more than two colors, and this stitch is suited to a variety of yarn types.

Multiple 16 sts + 2.

Step 1 (RS) 2sc in 2nd ch from hook, *1sc in each of next 7ch, skip next ch, 1sc in next 7ch, 3sc in next ch; rep from * ending last rep with 2sc in last ch, turn. Step 2 Ch1, 2sc in back loop of first sc, 1sc in back loop of each of next 7sc, skip next 2 sc, 1sc in back loop of each of next 7sc, 3sc in back loop of next sc; rep from * ending last rep with 2sc in back loop of last sc, turn.

Step 3 Repeat Step 2.

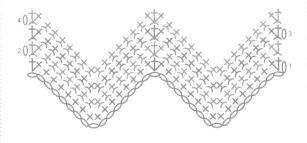

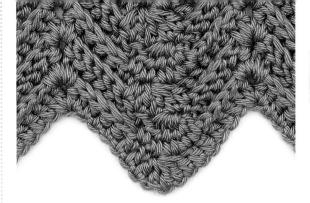

181 Raised Chevron

Raised Chevron is a more complex stitch than the examples we have seen so far in this section, because it uses the technique of working around the post of a previous stitch. This results in a sturdier, more textured version of the now familiar chevron patterning. The stitches that are raised to the front tend to dominate those that are raised to the back.

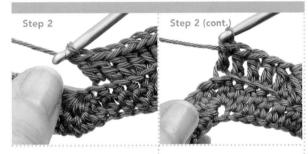

Multiple 16 sts + 1, plus 2 for the foundation chain.

Step 1 (RS) Skip 3ch, dc2tog over next 2ch (counts as dc3tog), *1dc in each of next 5ch, [2dc, ch1, 2dc] in next ch, 1dc in each of next 5ch**, dc5tog over next 5ch; rep from * ending last rep at **, dc3tog over last 3ch, turn.

Step 2 Ch3, skip first st, Brdc2tog over next 2 sts (all counts as Brdc3tog), *1Frdc around each of next 5 sts, [2dc, ch1, 2dc] in next ch sp, 1Frdc around each of next 5 sts**, Brdc5tog over next 5 sts; rep from * ending last rep at **, Brdc3tog over last 3 sts, turn. Step 3 Ch3, skip first st, Frdc2tog over next 2dc (counts as Frdc3tog), *1Brdc around next 5dc, [2dc, ch1, 2dc] in next ch sp, 1Brdc around each of next 5dc**, Frdc5tog over next 5dc; rep from * ending last rep at **, Frdc3tog over last 3dc, turn.

Step 4 Repeat Steps 2 and 3.

Special stitch Frdc (front raised double crochet): see page 118.

Special stitch Brdc (back raised double crochet): see page 118.

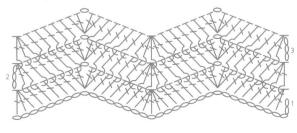

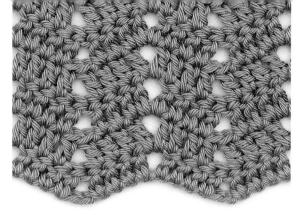

182 Peephole Chevron

Peephole chevron is a more delicate and less obvious chevron stitch. The peaks and troughs are less obvious in this example because they are created by adding chain spaces and working over chain spaces. This creates a lacier fabric, ideal for scarves and wraps.

Step 1

Multiple 10 sts, plus 3 for the foundation chain.

Step 1 Skip 3ch (counts as 1dc), 1dc in each of next 4ch, *skip 2ch, 1dc in each of next 4ch, ch2, 1dc in each of next 4ch; rep from * to last 6ch, skip 2ch, 1dc in each of next 3ch, 2dc in last ch, turn.

Step 2 Ch3 (counts as 1dc), 1dc in st at base of tch, 1dc in each of next 3dc, *skip 2dc, 1dc in each of next 3dc, [1dc, ch2, 1dc] in ch-2 sp, 1dc in next 3dc; rep from * to last 6 sts, skip 2dc, 1dc in each of next 3dc, 2dc in 3rd of ch-3,

Step 3 Repeat Step 2.

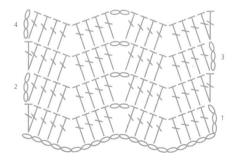

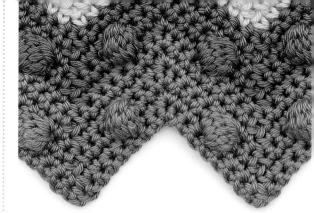

183 Bobble Chevron

Bobble chevron is an interesting stitch and a good example illustrating how the basic chevron pattern can be adapted to display different techniques. This stitch could be worked in one color so that the focus is on the texture. I would recommend a medium-weight cotton yarn in a light color for this. Alternatively, you could work bands of different colors to add extra interest. Bobbles are worked on wrong-side rows only. You can make a bobble by working five trebles to the last yarn over in the same stitch, yarn over, and pull through all six loops on the hook.

Step 2

Multiple 16 sts, plus 2 for the foundation chain.

Step 1 (row 1) (WS) 2sc in 2nd ch from hook, *1sc in each of next 7ch, skip next ch, 1sc in each of next 7ch. 3sc in next ch: rep from * ending 2sc in last ch,

Step 2 (row 2) Ch1, 2sc in first sc, *1sc in each of next 7sc, skip next 2sc, 1sc in each of next 7sc. 3sc in next sc; rep from * working 2sc in last sc, turn.

Step 3 (row 3) Ch1, 2sc in first sc, *1sc in each of next 3sc, Mb. 1sc in each of next 3sc. skip next 2sc, 1sc in each of next 3sc, Mb, 1sc in each of next 3sc, 3sc in next sc; rep from * working 2sc in last sc, turn.

Step 4 (rows 4-5) As Step 2,

Step 5 Repeat Steps 2-4.

Special stitch Mb (make bobble): work dc5tog in same st.

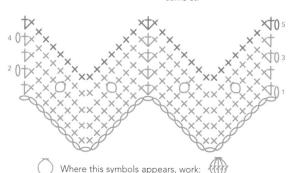

184 Granny Chevron

There is always something very appealing about granny squares and this chevron version is no exception. It is simple to work and will allow you to use up all your odds and ends to create your own unique project. Try to use yarns of a similar weight in order to maintain an even gauge.

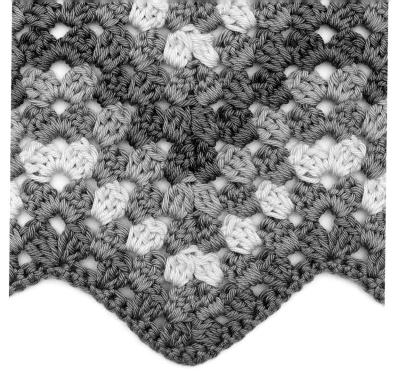

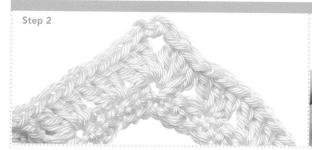

Multiple 35 sts +1, plus 12 for the foundation chain.

 $\mbox{\bf Step 1}$ (RS) 1sc in 2nd ch from hook, 1sc in every ch to end of row, turn.

Step 2 Ch3, skip first 3sc, [3dc in next sc, skip next 2sc] 3 times, [3dc, ch3, 3dc] in next sc, *[skip next 2sc, 3dc in next sc] twice, skip next 2sc, dc3tog in next sc, skip next 4sc, dc3tog in next sc, [skip next 2sc, 3dc in next sc] twice, skip next 2sc, [3dc, ch3, 3dc] in next sc; rep from * to last 12sc, skip next 2sc, [3dc in next sc, skip next 2sc] 3 times, 1dc in last sc, turn.

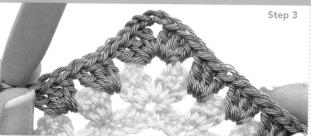

Step 3 Ch3, skip sp between tch and next dc3 group, 3dc in each of next 3 sps, [3dc, ch3, 3dc] in next ch-3 sp, *3dc in each of next 2 sps, dc3tog in next sp, skip sp between dc3tog clusters, dc3tog in next sp, 3dc in each of next 2 sps, [3dc, ch3, 3dc] in next ch-3 sp; rep from * to last 4 sps, 3dc in each of next 3 sps, 1dc in sp between last 3dc group and tch, turn.

Step 4 Repeat Step 3.

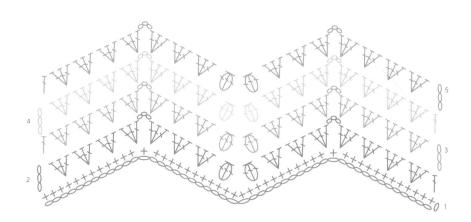

185 Puff Stitch Wave

Puff Stitch Wave is a very gentle pattern that produces a close, textured fabric. In theory it is a chevron stitch, but the increases and decreases are so shallow that it has more of the appearance of a wave stitch. The sharpness of the zig-zags is further broken by the alternating rows of puff stitches that help to smooth over the peaks of the arches. Like Bobble Chevron (see stitch 183, page 170), this would look great worked in a pale cotton yarn, but further emphasis can be given to the puff stitch clusters by working regular stripes or bands of different colors and textures.

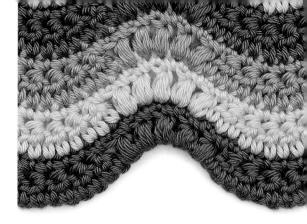

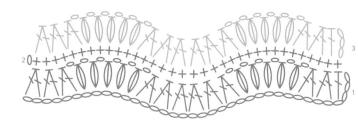

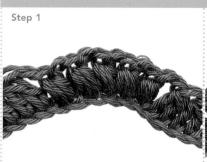

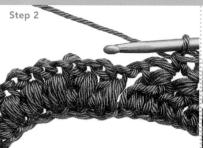

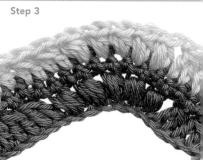

Multiple 17 sts, plus 2 for the foundation chain.

Step 1 (RS) 1dc in 4th ch from hook, [dc2tog over next 2ch] twice, *[ch1, hdc3tog in next ch] 5 times, ch1**, [dc2tog over next 2ch] 6 times, rep from * ending last rep at **, [dc2tog over next 2ch] 3 times, turn.

Step 2 Ch1, 1sc in first st and every st and ch-1 sp to end of row, turn.

Step 3 Ch3, skip first st, 1dc in next st, [dc2tog over next 2ch] twice, *[ch1, hdc3tog in next ch] 5 times, ch1**, [dc2tog over next 2ch] 6 times, rep from * ending last rep at **, [dc2tog over next 2ch] 3 times, skip ch-3, turn.

Step 4 Repeat Steps 2 and 3.

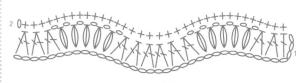

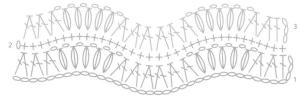

Steps 1-2

Step 3

186 Smooth Wave

Smooth Wave is a good introduction to creating wavy patterns in crochet. Wave patterns differ from chevrons because there is no increasing and decreasing to create peaks and troughs. In these examples, a sense of movement is created by working groups of stitches of different heights in the same row. In Smooth Wave, groups of doubles and single crochet alternate every two rows to maintain balance. It is important to work in two different colors, two rows in yarn A, two rows in yarn B, and extra interest could be added by working in contrasting textures of yarn.

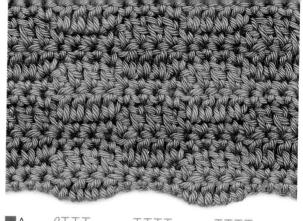

В

Step 1

Step 2

Step 4

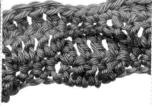

Multiple 8 sts + 4, plus 1 for the foundation chain.

Step 1 (RS) In varn A, skip 2ch (counts as 1sc), 1sc in each of next 3ch, *1dc in each of next 4ch, 1sc in each of next 4ch; rep from * to end, turn.

Step 2 Ch1 (counts as 1sc), skip 1sc, 1sc in each of next 3sc, *1dc in each of next 4dc, 1sc in each of next 4sc; rep from * to end. working last sc in tch, turn.

Step 3 In yarn B, ch3 (counts as 1dc), skip first sc, 1dc in each of next 3sc, *1sc in each of next 4dc, 1dc in each of next 4sc; rep from * to end, working last dc in tch, turn.

Step 4 Ch3, skip first dc, 1dc in next 3dc, *1sc in each of next 4sc, 1dc in each of next 4dc; rep from * to end working last dc in tch, turn.

Step 5 In yarn A, ch1 (counts as 1sc), skip 1dc, 1sc in each of next 3dc, *1dc in each of next 4sc, 1sc in each of next 4dc; rep from * to end working last sc in tch, turn.

Step 6 As Step 2 working last sc in tch.

Step 7 Repeat Steps 3-6.

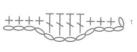

Step 1

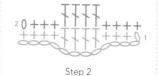

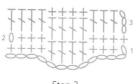

Step 3

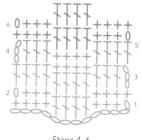

Steps 4-6

187 Long Wave

Long Wave stitch works on the same principle as Smooth Wave (see stitch 186, page 173). Greater movement is achieved by working three different heights of stitches in one row. This is then counter-balanced by working the reverse order of these stitches in the following alternate row. The rows in-between the pattern rows are worked in single crochet. This helps to stabilize the fabric, but would also allow you to introduce a third color if you wanted to. Once you are familiar with the four-row repeat, you will find this is a simple and relaxing stitch to work.

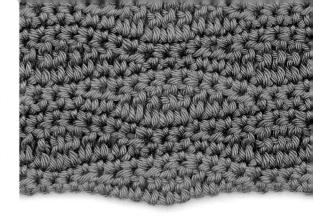

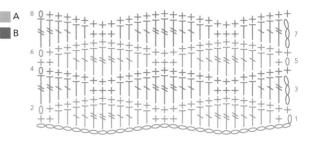

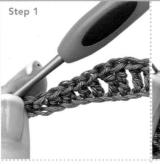

Multiple 14 sts + 1, plus 1 for the foundation chain.

Step 1 (RS) In yarn A, skip 2ch (counts as 1sc), *1sc in next st, 1hdc in each of next 2 sts, 1dc in each of next 2 sts, 1tr in each of next 3 sts, 1dc in each of next 3 sts, 1dc in each of next 3 sts, 1hdc in each of next 2 sts, 1sc in each of next 2 sts (Group); rep from * to end, turn.

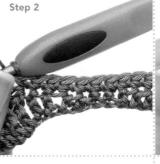

Step 2 Ch1, 1sc in every st to end of row, turn.

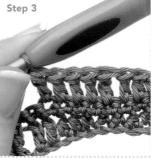

Step 3 In yarn B, ch3 (counts as 1tr), skip first st, *1tr in next st, 1dc in each of next 2 sts, 1hdc in each of next 2 sts, 1sc in each of next 3 sts, 1hdc in each of next 2 sts, 1dc in each of next 2 sts, 1dc in each of next 2 sts, 1tr in each of next 2 sts, 1tr in each of next 2 sts (Reverse Group); rep from * to end, working last st in tch, turn.

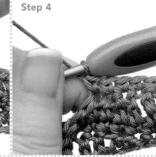

Step 4 As Step 2.

Step 5 In yarn A, ch1, skip first st, *1Group over next 14 sts; rep from * to end, working last st in tch, turn.

Step 6 As Step 2.

Step 7 Repeat Steps 3-6.

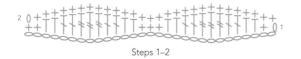

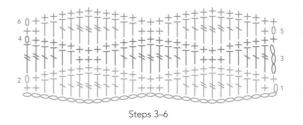

188 Textured Wave

Fextured Wave is a really interesting stitch that combines several techniques. It has a similar structure to Long Wave stitch (see stitch 187, left), but in this example the four-row pattern is extended to eight, with two rows of single crochet being worked between the patterned ows. Extra texture within the "waves" is created by working pairs of crossed doubles. This echnique involves skipping a stitch, working a double into the next stitch and then working a double into the stitch you have just skipped. The pattern is usually worked in two colors, but you could explore introducing more colors and extures.

Special stitch 2Cdc (2 crossed double crochet): skip next st, 1dc in next st, 1dc in skipped st by working over previous dc.

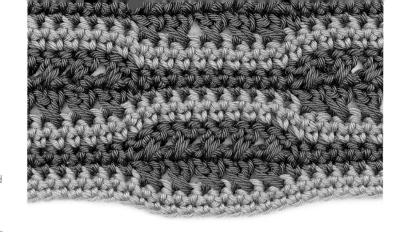

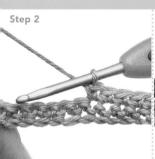

Multiple 20 sts, plus 1 for the foundation chain.

Step 1 (base row 1) (RS) In yarn A, skip 2ch (counts as 1sc), 1sc in next and every ch to end of row, turn.

Step 2 (base row 2) Ch1 (counts as 1sc), 1sc in next and every st to end of row, 1sc in tch, turn.

Step 3 (row 1) In yarn B, ch3 (counts as 1dc), skip 1 st, [2Cdc] twice over next 4 sts, *1sc in each of next 10 sts, [2Cdc] 5 times over next 10 sts; rep from * to last 15 sts, 1sc in each of next 10 sts, [2Cdc] twice over next 4 sts, 1dc in tch, turn.

Step 4 (row 2) As Step 3.

Step 5 (row 3–4) In yarn A, work as Step 2, twice.

Step 6 (row 5) In yarn B, ch1 (counts as 1sc), skip 1 st, 1sc in each of next 4 sts, *[2Cdc] 5 times over next 10 sts, 1sc in each of next 10 sts; rep from * to last 15 sts, [2Cdc] 5 times over next 10 sts, 1sc in each of next 4 sts, 1sc in tch, turn.

Step 7 (row 6) As Step 6.

Step 8 (rows 7–8) In yarn A, work as Step 2, twice.

Step 9 Repeat Steps 3-8.

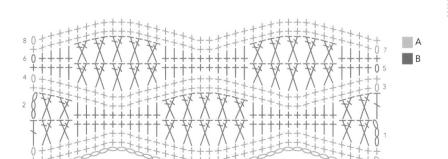

176

189 Wave and Chevron

This section ends with a stitch that combines the two techniques we have been focusing on. One of the really clever things about crochet is the opportunity it provides for mixing different types of stitches, while still being able to maintain balance and stitch count. Wave and Chevron stitch is built on a six-row repeat. The base row and the first row establish the wave shape in one color. Rows two and three are worked in a second color and demonstrate the chevron. Row four is worked in a third color and the tall stitches in row one are balanced out by shorter ones, and the short stitches by taller ones.

Two rows of single crochet complete the sequence. The patterning appears quite detailed and the colors used in this design (A, B, C, and D) are shown on the chart to the right next to their corresponding rows; for a less complicated look, you could use fewer than four colors. Where you choose to place your colors will also have an impact on where the emphasis falls within the pattern. Remember that lighter colors will always dominate. This stitch would suit many different yarn types and would also work equally successfully as a border as well as an overall pattern.

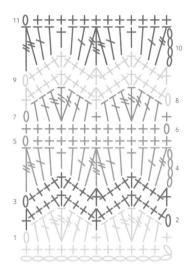

Step 2

Step 3

Step 5

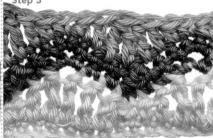

Multiple 6 sts + 1, plus 1 for the foundation chain.

Step 1 (base row) (RS) In yarn A, skip 2ch and work 1sc in next and every ch to end of row, turn.

Step 2 (row 1) Ch1 (counts as 1sc), skip 1sc, *1hdc in next st, 1dc in next st, 3tr in next st, 1dc in next st, 1sc in next st, rep from * to end, turn.

Step 3 (row 2) In yarn B, ch1, skip 1 st, 1sc in next st (counts as sc2tog) 1sc in each of next 2 sts, *3sc in next st, 1sc in each of next 2 sts, sc3tog over next 3 sts, 1sc in each of next 2 sts; rep from * to last 5 sts, 3sc in next st, 1sc in each of next 2 sts, sc2tog over next 2 sts, turn.

Step 4 (row 3) As Step 3.

Step 5 (row 4) In yarn C, ch4, skip 1 st, 1tr in next st (counts as tr2tog), *1dc in next st, 1hdc in next st, 1sc in next st, 1hdc in next st, 1dc in next st*, tr3tog over next 3 sts; rep from * ending last rep at **, tr2tog over last 2 sts, turn.

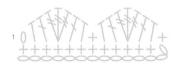

Steps 1-2

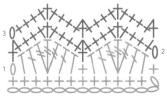

Steps 3-4

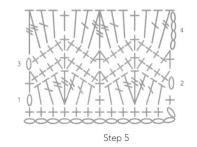

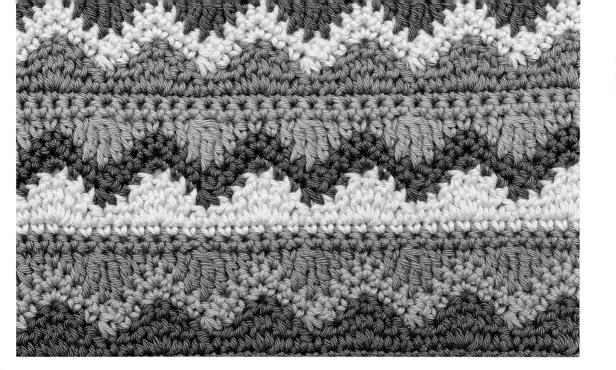

Step 6 (row 5) Ch1 (counts as 1sc) skip 1 st, 1sc in next and every st to end of row, turn.

Step 7 (row 6) In yarn D, work as Step 6.

Step 8 Repeat Steps 2–7.

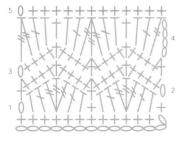

Step 6

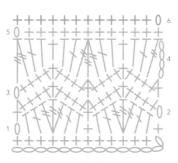

Step 7

190 Beaded Single Crochet

Adding beads to your crochet can turn the most basic of stitches into something really beautiful and tactile. This is a very simple technique which is quick to work once your yarn has been prepared. Start by threading the required number of beads onto your yarn. Remember that if you are using more than one color to create a pattern, you will need to thread up in reverse of the sequence, since the last bead you thread onto your yarn will be the first bead that you work.

If you are planning your own design, it is also important to remember that beads can be placed only on a wrong-side row, so that they show on the right side of the work. This prevents you from creating patterns where beads need to sit very closely to each other. Round beads are the most commonly available, but square and triangular ones also help to create an interesting texture. It is advisable to work at least three rows of single crochet before starting to place your beads.

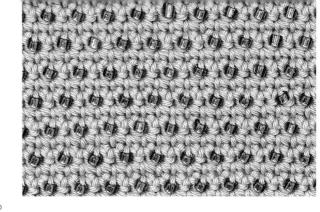

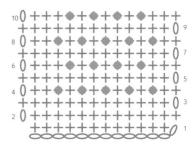

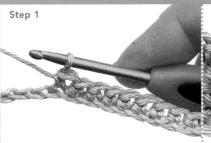

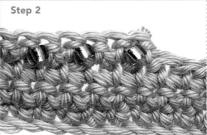

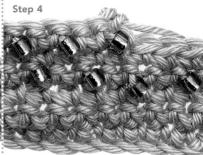

Multiple 3 sts + 1.

Step 1 (RS) 1sc in 2nd ch from hook, 1sc in every ch to end of row, turn.

Step 2 Ch1, 1sc in every st to end of row working last sc in tch, turn.

Step 3 As Step 2.

Step 4 Ch1, skip first st, 1sc in each of next 2sc, *1Bsc in next sc, 1sc in next sc; rep from * to end, 1sc in tch, turn.

Step 5 As Step 2.

Step 6 Ch1, skip first st, 1sc in each of next 3sc, *1Bsc in next sc, 1sc in next sc; rep from * to last 2 sts, 1sc in each of last 2sc, 1sc in tch, turn.

Step 7 Repeat Steps 3–6.

Special stitch Bsc (beaded single crochet): insert hook as directed, yo, pull loop through, slide bead up yarn close to work, yo (catching yarn beyond bead), pull through both loops on hook.

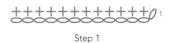

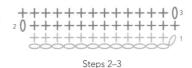

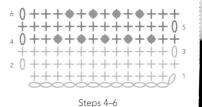

191 Sequinned Single Crochet

Sequins can be used in the same way as beads. You will need to start by threading the sequins onto the yarn first. This can be a little fiddly, but well worth the effort. Take care to choose the right size of sequin. If the sequin is too small for the weight of the yarn it will not lie flat and so it is a good idea to test this before starting on a project.

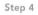

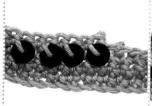

Step 6

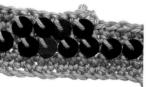

Multiple 3 sts + 1.

Step 1 (RS) 1sc in 2nd ch from hook, 1sc in every ch to end of row, turn.

Step 2 Ch1, 1sc in every st to end of row working last sc in tch, turn.

Step 3 As Step 2.

Step 4 Ch1, skip first st, 1sc in each of next 2sc, *1Sqsc in next sc, 1sc in next sc; rep from * to end, 1sc in tch, turn.

Step 5 As Step 2.

Step 6 Ch1, skip first st, 1sc in each of next 3sc, *1Sqsc in next sc, 1sc in next sc; rep from * to last 2 sts, 1sc in each of last 2 sts, 1sc in tch turn.

Step 7 Repeat Steps 3-6.

Special stitch Sqsc

(sequinned single crochet): insert hook as directed, yo, pull loop through, slide sequin up yarn close to work, yo (catching yarn beyond sequin), pull through both loops on hook.

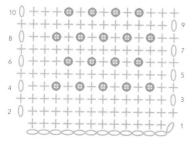

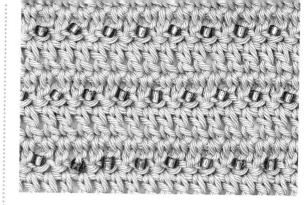

192 Beaded Doubles

There is no reason why you need to limit beading to single crochet. The beading technique can be applied to various stitches, but the point at which the bead is placed changes. When working beaded double crochet, you will need to work a double in the usual manner, and place the bead just before the last yarn over is worked. This allows the bead to sit higher up the stitch than in single crochet.

Multiple 3 sts + 2.

Step 1 (RS) 1dc in 4th ch from hook, 1dc in every ch to end of row, turn.

Step 2 Ch3, skip 1dc, 1dc in every st to end of row, 1dc in tch, turn.

Step 3 As Step 2.

Step 4 Ch3, skip first dc, 1dc in next dc, *1Bdc in next dc, 1dc in

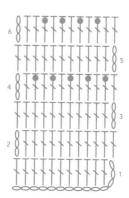

next dc; rep from * to end of row working last dc in tch, turn.

Step 5 As Step 2.

Step 6 Ch3 (counts as 1dc), skip 1dc, 1dc in each of next 2dc, *1Bdc in next dc, 1dc in next dc; rep from * to last st, 1dc in tch, turn.

Step 7 Repeat Steps 3-6.

Special stitch Bdc (beaded double crochet): yo, insert hook as directed, yo, pull loop through, yo, pull through 2 loops, slide bead up yarn close to work, yo (catching yarn beyond bead), pull through both loops on hook.

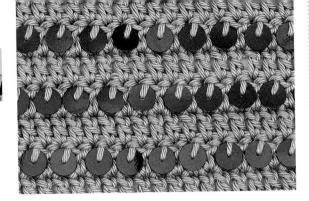

193 Sequinned Doubles

Sequins can be used across a range of stitches. Remember that when working double crochet the point at which the bead is placed changes. As with beaded double crochet, you will need to work a double in the usual manner, and then place the sequin just before the last yarn over is worked. This not only allows the sequin to sit higher up the stitch, but also enables you to use different-shaped sequins, as there will be a longer drop between rows.

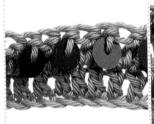

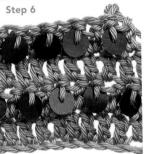

Multiple 3 sts + 2.

Step 1 (RS) 1dc in 4th ch from hook, 1dc in every ch to end of row, turn.

Step 2 Ch3, skip 1dc, 1dc in every st to end of row, 1dc in tch. turn.

Step 3 As Step 2

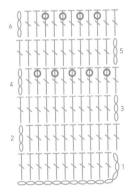

Step 4 Ch3, skip first dc, 1dc in next dc, *1Sqdc in next dc, 1dc in next dc; rep from * to end of row working last dc in tch, turn.

Step 5 As Step 2.

Step 6 Ch3 (counts as 1dc), skip 1dc, 1dc in each of next 2dc, *1Sqdc in next dc, 1dc in next dc; rep from * to end, 1dc in tch, turn.

Step 7 Repeat Steps 3-6.

Special stitch Sqdc (sequinned double crochet): yo, insert hook as directed, yo, pull loop through, yo, pull through 2 loops, slide sequin up yarn close to work, yo (catching yarn beyond sequin), pull through both loops on hook.

194 Beaded Groups

The beading technique can be extended to include groups of beads. Depending on the size of the bead and weight of the yarn, you may want to place groups of between three and seven beads. If you are planning to use more than one color of bead in these sequences, remember to thread them on in reverse order of use.

Step 4

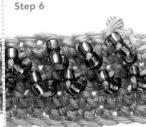

Multiple 3 sts + 1.

Step 1 (RS) 1sc in 2nd ch from hook, 1sc in every ch to end of row, turn.

Step 2 Ch1, 1sc in every st to end of row, turn.

Step 3 As Step 2.

Step 4 Ch1, 1sc in each of next 2sc, *1Bgp in next sc, 1sc in next sc; rep from * to last sc, 1sc in last sc, turn. Step 5 As Step 2.

Step 6 Ch1, 1sc in each of next 3sc, *1Bgp in next sc, 1sc in next sc; rep from * to last 2 sts, 1sc in each of last 2 sts, turn.

Step 7 Repeat Steps 3-6.

Special stitch Bgp (beaded group): insert hook as directed, yo, pull loop through, slide desired number of beads up yarn close to work, yo (catching yarn beyond group of beads), pull through both loops on hook.

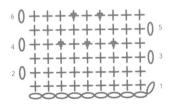

195 Beaded Loop

Beaded Loop stitch illustrates another way in which beads can be added to existing stitches to make them even more interesting. In this example, the loops are accentuated by the contrasting texture and sparkle of the beads, resulting in a very attractive fabric. This stitch is quite labor-intensive so you may vish to use it as stripe or border within a project. The beaded loops are made by sliding a bead down the yarn and then wrapping the yarn around the left index finger to make a loop. At this stage, make sure that one bead is in the loop, insert look into the next stitch, pull through the stitch and both hreads of the loop, take the yarn over again and pull hrough all loops.

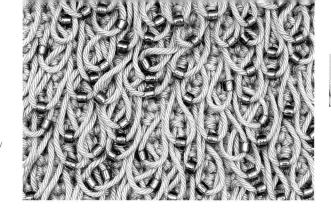

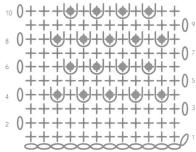

Step 6

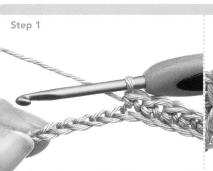

Multiple 3 sts + 1.

Step 1 (RS) 1sc in 2nd ch from hook, 1sc in every ch to end of row, turn.

Step 2 Ch1, 1sc in every st to end of row, turn.

Step 3 As Step 2.

Step 4 Ch1, 1sc in each of next 2sc, *1Blp in next sc, 1sc in next sc; rep from * end, turn.

Step 5 As Step 2.

Step 6 Ch1, 1sc in each of next 3sc, *1Blp in next sc, 1sc in next sc; rep from * to last 2 sts, 1sc in each of last 2 sts, turn.

Step 7 Repeat Steps 3-6.

Special stitch Blp (beaded loop): Slide bead down yarn, wrap yarn around finger to make a loop, insert hook in next st, pull through st and both threads of loop, yo, pull through all loops.

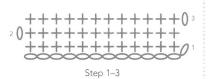

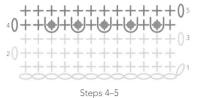

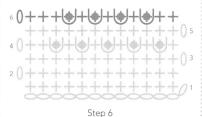

196 Sequinned Loop

Adding sequins to a basic loop stitch creates an eye-catching piece of crochet. As with Beaded Loop stitch (see stitch 195, page 181), this technique is quite labor-intensive and so once again you may wish to use it as a stripe or border within a project. The sequinned loops are made by sliding a sequin down the yarn and then wrapping the yarn around the left index finger to make a loop. At this stage, make sure that one sequin is in the loop, insert hook into the next stitch, pull through the stitch and both threads of the loop, take the yarn over again and pull through all loops. Some sequins are cupped rather than flat and need to be threaded from the back to the front so that they sit the correct way around on the work.

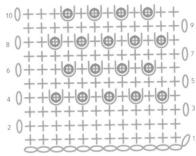

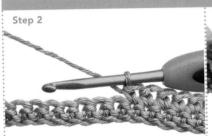

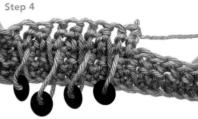

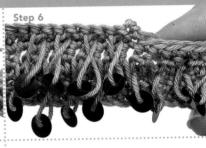

Multiple 3 sts + 1.

Step 1 (RS) 1sc in 2nd ch from hook, 1sc in every ch to end of row, turn.

Step 2 Ch1, 1sc in every st to end of row, turn

Step 3 As Step 2.

Step 4 Ch1, 1sc in each of next 2sc, *1Sqlp in next sc, 1sc in next sc; rep from * end, turn.

Step 5 As Step 2.

Step 6 Ch1, 1sc in each of next 3sc, *1Sqlp in next sc, 1sc in next sc; rep from * to last sc, 1sc in last sc, turn.

Step 7 Repeat Steps 3-6.

Special stitch Sqlp (sequinned loop): Slide sequin down yarn, wrap yarn around finger to make a loop, insert hook in next st, pull through st and both threads of loop, yo, pull through all loops.

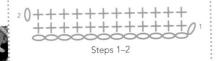

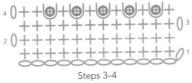

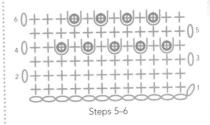

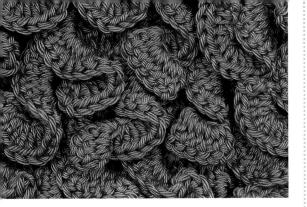

197 Large Ruffles

Ruffles are another way of adding texture to a double crochet background. In the example below, the ruffles are worked over ten chains, but the length of the ruffle can be adjusted depending on the project. Ruffles are made by working a series of chains and then working a multiple of stitches into each chain. The chain is forced to twist because of this rapid increase in stitches.

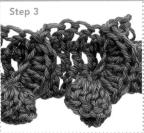

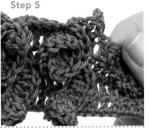

Multiple 5 sts + 4, plus 3 for the foundation chain.

Step 1 1dc in 4th ch from hook, 1dc in every ch to end of row, turn.

Step 2 Ch3 (counts as 1dc), 1dc in every dc to end of row, turn.

Step 3 Ch3 (counts as 1dc), 1dc in each of next 4dc, *ch10, 2dc in 4th ch from hook, 3dc in each of next 6ch, sl st in last dc worked in main fabric, 1dc in each of next 5dc; rep from * to end working last dc in tch, turn.

Step 4 As Step 2.

Step 5 Ch3 (counts as 1dc), 1dc in each of next 2dc, *ch10, 2dc in 4th ch from hook, 3dc in each of next 6ch, sl st in last dc worked in main fabric, 1dc in each of next 5dc; rep from * to last dc, ch10, 2dc in 4th ch from hook, 3dc in each of next 6ch, sl st in last dc worked in main fabric, 1dc in last st, 1dc in tch, turn.

Step 6 Repeat Steps 2-5.

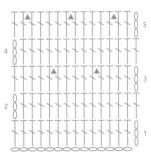

▲ Where this symbols appears, work:

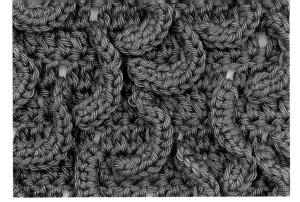

198 Small Ruffles

Ruffles can be worked in different sizes to create different effects. These smaller ruffles are made from six chain and worked in single crochet. The effect is much gentler and could be made even more delicate by increasing the number of plain rows and stitches worked in-between ruffles. Even though the chain is shorter the ruffle is still forced to twist because of the rapid increase in stitches.

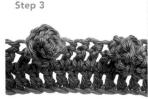

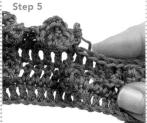

Multiple 5 sts + 4, plus 3 for the foundation chain.

Step 1 1dc in 4th ch from hook, 1dc in every ch to end of row, turn.

Step 2 Ch3 (counts as 1dc), 1dc in every dc to end of row, turn.

Step 3 Ch3 (counts as 1dc), 1dc in each of next 4dc, *ch6, 2sc in 2nd ch from hook, 3sc in each of next 4ch, sl st in last dc worked in main fabric, 1dc in each of next 5dc; rep from * to end working last dc in tch, turn.

Step 4 As Step 2.

Step 5 Ch3 (counts as 1dc), 1dc in next 2dc, *ch6, 2sc in 2nd ch from hook, 3sc in each of next 4ch, sl st in last dc worked in main fabric, 1dc in each of next 5dc; rep from * to last dc, chó, 2sc in 2nd ch from hook, 3sc in each of next 4ch, sl st in last dc worked in main fabric, 1dc in last st, 1dc in tch, turn.

Step 6 Repeat Steps 2-5.

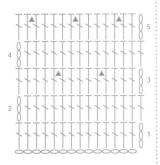

Where this symbols appears, work:

199 Surface Crochet over Small Mesh

Surface crochet describes the technique of working a continuous line of slip stitches into a crocheted background. This technique is most commonly used over a plain mesh. In the example below, it is easy to see how this technique might be mistaken for embroidery, since the slip stitches so closely resemble chain stitches.

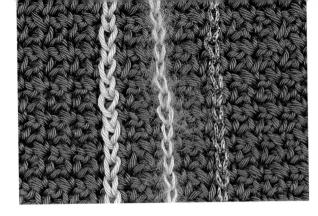

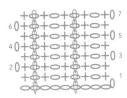

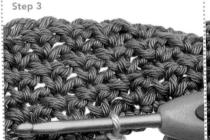

Step 1 (RS) 1sc in 2nd ch from hook, *ch1, skip next ch, 1sc in next ch; rep from * to end, turn.

Step 2 Ch1, 1sc in first sc, *ch1, 1sc in next sc; rep from * to end, turn. Work as this step until you have worked a piece of fabric to the size required.

Step 3 To work the surface crochet, use your chosen yarn and attach to the lower edge of the mesh with a sl st.

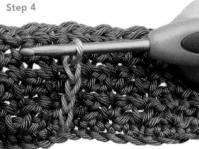

Step 4 *Keep the yarn behind the mesh and pull a loop through the next hole in the mesh and through the loop on the hook to complete a sl st; rep from * to top of row.

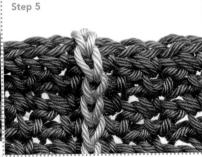

Step 5 To finish, break yarn and pull through the last st to make it secure.

200 Surface Crochet over Large Mesh

Surface crochet can be worked over different sizes of plain mesh. A larger mesh will give you more chances to experiment with the basic technique. Try adding yarns of different weights and textures or working more than one row of crochet through a mesh to create interesting stripes.

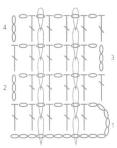

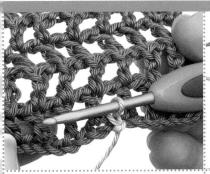

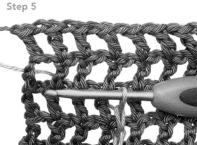

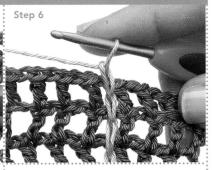

Multiple 2 sts + 2.

Step 1 (RS) 1dc in 6th ch from hook, *ch1, skip next ch, 1dc in next ch; rep from * to end, turn.

Step 2 Ch4 (counts as 1dc and 1ch), *1dc in next dc, ch1; rep from * ending 1dc in 2nd of ch-4, turn.

Step 3 Ch4 (counts as 1dc and 1ch), *1dc in next dc, ch1; rep from * to end, 1dc in tch, turn. Work as this step until you have worked a piece of fabric to the size required.

Step 4 To work the surface crochet, use your chosen yarn and attach to the lower edge of the mesh with a sl st.

Step 5 *Keep the yarn behind the mesh and pull a loop through the next hole in the mesh and through the loop on the hook to complete a sl st; rep from * to top of row.

Step 6 To finish, break yarn and pull through last st to make it secure.

Symbols and abbreviations

These are the abbreviations and symbols used in this book. There is no worldwide standard, so, in other publications, you may find different abbreviations and symbols. Throughout this book, abbreviations for basic stitches appear in lower-case letters. Special stitches begin with a captial leter.

Basic stitches, abbreviations and symbols

Additional symbols

American crochet terms are used throughout this book, abbreviated as shown. For detailed methods of working,

	see pages 23	–25.			
Stitch	Abbreviation	Symbol	Description	Abbreviation	Symbol
chain	ch	0	direction of working	-	< ₽
slip stitch	sl st	•	stitch worked in front loop only	-	4]
single crochet	sc	+ † †	stitch worked in back loop only	-	≠ Ţ
extended single crochet	exsc	1	beaded single crochet	Bsc	•
half double	hdc	ŢŢ	beaded double	Bdc	•
double	dc	 	sequinned single crochet	Sqsc	•
treble	tr	1 * * * * *	sequinned double	Sqdc	▼
double treble	dtr	*			s how a stitch pattern r much resemblance
quintuple treble	quintr	Ţ	to the actual ap	pearance of the f	inished stitch. Always ether with the chart.

Special stitches

In addition, various stitch patterns use special stitch constructions and, where these occur in this book, the abbreviation is indicated in the Special Stitch instructions for that pattern. Sometimes abbreviations may be combined, e.g., Scl means spike cluster; Psc means Picot single crochet. Always refer to Special Stitch instructions where they occur. Any published pattern should include a list of all the abbreviations and symbols used, which may differ from those below.

Stitch	Abbreviation	Symbol	Stitch	Abbreviation	Symbol
front raised single crochet	Frsc	5	extended half double	EXhdc	Ţ
back raised single crochet	Brsc	ţ	marguerite cluster	M3c, M5c	K
front raised double (left); back raised double (right)	Frdc, Brdc	} }	spike cluster	Scl	\wedge
front raised treble	Frtr	3	pineapple	Ps	\bigcirc
front raised double treble	Frdtr	\\\\\\\\\\\\\\\\\\\\\\\\\\\\\\\\\\\\\	raised pineapple	Rps	
front raised quintuple treble	Frquintr		puff stitch	-	
spiked single crochet	Ssc	†	popcorn	Рс	•
quadruple single crochet	Quad sc	#1,11,7	bullion stitch	Bs	•
Solomon's knot (edge and main)	Esk, Msk	Ţ	loop stitch	-	U
group	Gp	A	surface crochet	-	0

	Arrangement of sy	mbols
Description	Symbol	Explanation
symbols joined at top	** #	A group of symbols may be joined at the top, indicating that these stitches should be worked together as a cluster, as page 28.
symbols joined at base	₹	Symbols joined at the base should all be worked into the same stitch below, as page 27.
symbols joined at top and bottom		Sometimes a group of stitches is joined at both top and bottom, making a puff, bobble, or popcorn, as pages 28–29.
symbols on a curve		Sometimes symbols are drawn along a curve, depending on the construction of the stitch pattern.
distorted symbols	ノ	Some symbols may be lengthened, curved, or spiked to indicate where the hook is inserted below, as for spike stitches, page 26.

eeninen as	breviations
Term	Abbreviation
stitch(es)	st(s)
chain space	ch sp
turning chain	tch
together	tog
yarn over	yo
right side	RS
wrong side	WS

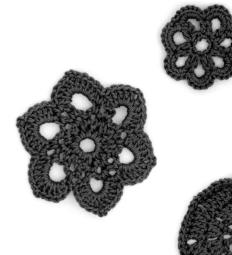

American/English equivalent terms

Some English terms differ from the American system, as shown below: patterns you may encounter that are published using English terminology can be very confusing unless you understand the difference.

American	English	English Abbreviation	Symbol
single crochet	double crochet	dc	+
extended single crochet	extended double corchet	exdc	1
half double	half treble	htr	T
double	treble	tr	7
treble	double treble	dtr	\
double treble	triple treble	ttr	
quintuple treble	sextuple treble	sextr	

A
abbreviations 186, 187
American/English
equivalent terms 189
common abbreviations 18
accessories 16
Acrobatic 73
Aligned Double Clusters 84
Aligned Puff 100
Alternate 40
Alternate Double Clusters 85
Alternate Popcorns 94
Alternate Single Crochet 36
Alternate Spikes 104
Arcade 72
arches
Arch Mesh 139
Picot Arch Mesh 140
Poliof Arch 126-7

В Back Loop Single Crochet 35 Back Raised Double 118 Back Raised Double Crochet (Brdc) 27 Ball 89 Bar and Lattice 143 basic skills crochet aftercare 22 fastening off and weaving in ends 19 foundation chains 18 holding the hook 17 holding the yarn 17 joining yarn 20 left-handed crocheters 17 making a slip knot 17 measuring gauge 22 seams 21 tips 19 turning chains 19 working in rows 18 basic stitches 23-25 abbreviations and symbols 186 stitch variations 26-31 tips 25 Racket 104 Basketweave 120 Bead 91 Beaded Doubles 179 Beaded Groups 180 Beaded Loop 181 Beaded Single Crochet 178 Birdsfoot Spike 112 Blackberry Salad 101 Block and Offset Shell 68 Block Trellis 147 blocking 22 Blossom 65 Bobble 29 Bobble Chevron 170 Boxed Beads 91 Boxed Shell 72 Boxes, Spiked 105 Brick 106 Brickwork 107

Raised Brick 123

Bullion (Bs) 30, 92

Cabbage Patch 154 Cable 154 Caterpillar Stripe 114-115 Catherine Wheel 82-83 Chain Loop 136 chain stitch (ch) 23 Chevron 166 Bobble Chevron 170 Close Chevron 166 Granny Chevron 171 Peephole Chevron 170 Raised Chevron 169 Ribbed Chevron 169 Ridged Chevron 168 Sharp Chevron 168 Simple Chevron 167 Wave and Chevron 176-177 Wide Chevron 167 Close Chevron 166 Close Scallops 56 Cluster (CI) 28 Aligned Double Clusters 84 Alternate Double Clusters 85 Extended Forked Cluster 87 Forked Clusters 86 Lace Clusters 88 Large Clusters 85 Mixed Cluster 100 Pineapple Cluster 89 Puff Cluster Trellis 148 Sidesaddle Cluster 164 Twin Clusters 86 Corded Ridge 124 Crazy Picot Mesh 140 Crinkle 124 crochet aftercare 22 Crossbill 155 Crossed Double 155

\Box

Diagonal Raised Double 121 Diagonal Shell 75 Diagonal Trip 55 Dock Leaf 59 Dots and Diamonds 128-129 Double Crochet (dc) 25, 37 Back Raised Double Crochet (Brdc) 27 Beaded Doubles 179 Front Raised Double Crochet (Frdc) 27 Herringbone Double 52 Sequinned Doubles 180 Staggered Double Crochet Pairs 39 Double Crosses 109 double foundation chain 31 Double V 48 Doubled Lattice 145

Crossed Lace Loop 156

Crow's Foot Lattice 67

Crown Puff Lattice 99

Crossed Ripple 125

Crosshatch 161

Crunch 44

equipment 14-16 Even Berry 46 Extended Forked Cluster 87 Extended Half Double 40 Extended Single Crochet (exsc) 24 Evelash 111

F

Fancy Picot 141 fans 27 Fan and V 76 Fantail 58 Open Fan 70 fastening off 19 Filet Squares 152-153 Offset Filet Net 142 Firm Mesh 139 Five-Star Marguerite 103 Floret 44 Flying Shell 162 Forked Clusters 86 foundation chains 18 double foundation chain 31 tips 23 Front and Back Loop Single Crochet 35 Front Loop Single Crochet 34 Front Raised Double 118 Front Raised Double Crochet (Frdc) 27 Fur Stitch 30

G

Global Connection 96 Granny Chevron 171 Granule 54 Grit 45

Half Double Crochet (hdc) 24, 36 Extended Half Double 40 Half Double V 48 Herringbone Half Double 52 Linked Half Double 53 Paired Half Double 38 Staggered Half Double Pairs Herringbone Double 52 Herringbone Half Double 52 Hexagon 80-81 Honeycomb 88 Honeycomb Mesh 146 Honeycomb Trellis 146 holding the hook 17 hook sizes 14 Hotcross Bun 157

inserting between stitches 26 Interlocking Shell 71 Inverted Triangles 160 Iris 64

J

joining yarn 20 changing color mid-row 20 joining new yarn in double crochet 20

joining new yarn in single crochet 20 joining new yarn using slip stitch

L

lace Crossed Lace Loop 156 Lace Clusters 88 Pehble Lace 102 Strawberry Lace 66 Ladder 143 Large Clusters 85 Large Mesh 138 Large Ruffles 183 lattice Bar and Lattice 143 Crow's Foot Lattice 67 Crown Puff Lattice 99 Doubled Lattice 145 Picot Lattice 149 Ruled Lattice 144 left-handed crocheters 17 Linked Half Double 53 Linked Shell 68

Little Pyramid 160 Long Wave 174 Loop 137 Beaded Loop 181 Chain Loop 136 Crossed Lace Loop 156 Loop Stitch 30 Sequinned Loop 182

M Marguerite 103

measuring gauge 22 mesh Firm Mesh 139 Honeycomb Mesh 146 Large Mesh 138 Small Mesh 138 Surface Crochet over Large Mesh 185 Surface Crochet over Small Mesh 184 Triangle Mesh 144 Mirror 113

Five-Star Marguerite 103

Mixed Cluster 100 Moss 46

needles, tapestry 16 net Offset Filet Net 142

Ridged String Network 142 Shell Network 69 Single Picot String Network 141 Zig-zag Double String

Network 145

0

Offset Filet Net 142 Open Fan 70 Open Scallop 56 Open Shell and Picot 62 Outline Squares 108

Paired Half Double 38 Paired Popcorns 94 Paired Single 38 Peacock 57 Pebble Lace 102 Peephole Chevron 170 Petal 78-79 Picot 30 Fancy Picot 141 Open Shell and Picot 62 Picot Arch Mesh 140 Picot Fan 60-61 Picot Lattice 149 Picot Ridge 63 Single Picot String Network 141 Triple Picot V 149 Pike 50 Pineapple Cluster 89 Raised Pineapple 90 pins, large-headed 16 Pique 84 Popcorn (Pc) 29 Alternate Popcorns 94 Paired Popcorns 94 Popcorn Waffle 102 Raised Popcorns 95 Zig-zag Popcorn 97 Puff 28 Aligned Puff 100 Crown Puff Lattice 99 Puff Cluster Trellis 148 Puff Stitch Wave 172 R Rack 69 raised stitches 27 Raised Brick 123 Raised Chevron 169 Raised Double Rib 119 Raised Double Ridges 119 Raised Pineapple 90 Raised Popcorns 95 Raised Ripple 122 Rake 110 Relief Arch 126-127 Relief Squares 130-131 Ribbed Chevron 169 ridges Corded Ridge 124 Picot Ridge 63 Raised Double Ridges 119 Ridged Chevron 168 Ridged String Network 142 ripples Crossed Ripple 125 Raised Ripple 122 Rope 64 Ruffles 183 Ruled Lattice 144 S Scallops 56 scissors 16 seams 21

back stitch seam 21

slip stitch seam 21 woven seam 21

double crochet seam 21

Sedge 43
Sequinned Doubles 180
Sequinned Loop 182
Sequinned Single Crochet 179
Sharp Chevron 168
shells 27
Block and Offset Shell 68
Boxed Shell 72
Diagonal Shell 75
Flying Shell 162
Interlocking Shell 71
Open Shell and Picot 62
Shell Network 69
Shell Trellis 147
Sidesaddle Shell 165
Woven Shell 159
Sidesaddle Cluster 164
Sidesaddle Shell 165
Sieve 45
Silt 53
Simple Chevron 167
Single Crochet (sc) 23, 34
Alternate Single Crochet 36
Back Loop Single
Crochet 35
Beaded Single Crochet 178
Extended Single
Crochet (exsc) 24
Front and Back Loop
Single Crochet 35
Front Loop Single
Crochet 34
Paired Single 38
Sequinned Single Crochet 179
Single Picot String Network 141
slip knots 17
slip stitch (sl st) 23
slip stitch (sl st) 23
slip stitch (sl st) 23 Small Daisy 105
slip stitch (sl st) 23 Small Daisy 105 Small Mesh 138
slip stitch (sl st) 23 Small Daisy 105 Small Mesh 138 Small Ruffles 183
slip stitch (sl st) 23 Small Daisy 105 Small Mesh 138
slip stitch (sl st) 23 Small Daisy 105 Small Mesh 138 Small Ruffles 183 Smooth Wave 173
slip stitch (sl st) 23 Small Daisy 105 Small Mesh 138 Small Ruffles 183 Smooth Wave 173 Solomon's Grid 151
slip stitch (sl st) 23 Small Daisy 105 Small Mesh 138 Small Ruffles 183 Smooth Wave 173 Solomon's Grid 151 Solomon's Knot (Sk) 31, 150
slip stitch (sl st) 23 Small Daisy 105 Small Mesh 138 Small Ruffles 183 Smooth Wave 173 Solomon's Grid 151 Solomon's Knot (Sk) 31, 150 special formations 30-31
slip stitch (sl st) 23 Small Daisy 105 Small Mesh 138 Small Ruffles 183 Smooth Wave 173 Solomon's Grid 151 Solomon's Knot (Sk) 31, 150
slip stitch (sl st) 23 Small Daisy 105 Small Mesh 138 Small Ruffles 183 Smooth Wave 173 Solomon's Grid 151 Solomon's Knot (Sk) 31, 150 special formations 30–31 Spider 42
slip stitch (sl st) 23 Small Daisy 105 Small Mesh 138 Small Ruffles 183 Smooth Wave 173 Solomon's Grid 151 Solomon's Knot (Sk) 31, 150 special formations 30–31 Spider 42 spike stitches 26
slip stitch (sl st) 23 Small Daisy 105 Small Mesh 138 Small Ruffles 183 Smooth Wave 173 Solomon's Grid 151 Solomon's Knot (Sk) 31, 150 special formations 30–31 Spider 42 spike stitches 26 Alternate Spikes 104
slip stitch (sl st) 23 Small Daisy 105 Small Mesh 138 Small Ruffles 183 Smooth Wave 173 Solomon's Grid 151 Solomon's Knot (Sk) 31, 150 special formations 30-31 Spider 42 spike stitches 26 Alternate Spikes 104 Birdsfoot Spike 112
slip stitch (sl st) 23 Small Daisy 105 Small Mesh 138 Small Ruffles 183 Smooth Wave 173 Solomon's Grid 151 Solomon's Knot (Sk) 31, 150 special formations 30–31 Spider 42 spike stitches 26 Alternate Spikes 104
slip stitch (sl st) 23 Small Daisy 105 Small Mesh 138 Small Ruffles 183 Smooth Wave 173 Solomon's Grid 151 Solomon's Knot (Sk) 31, 150 special formations 30–31 Spider 42 spike stitches 26 Alternate Spikes 104 Birdsfoot Spike 112 Spiked Boxes 105
slip stitch (sl st) 23 Small Daisy 105 Small Mesh 138 Small Ruffles 183 Smooth Wave 173 Solomon's Grid 151 Solomon's Knot (sk) 31, 150 special formations 30–31 Spider 42 spike stitches 26 Alternate Spikes 104 Birdsfoot Spike 112 Spiked Boxes 105 Spiked Squares 116–117
slip stitch (sl st) 23 Small Daisy 105 Small Mesh 138 Small Ruffles 183 Smooth Wave 173 Solomon's Grid 151 Solomon's Knot (Sk) 31, 150 special formations 30–31 Spider 42 spike stitches 26 Alternate Spikes 104 Birdsfoot Spike 112 Spiked Boxes 105 Spiked Squares 116–117 split-ring markers 16
slip stitch (sl st) 23 Small Daisy 105 Small Mesh 138 Small Ruffles 183 Smooth Wave 173 Solomon's Grid 151 Solomon's Knot (Sk) 31, 150 special formations 30–31 Spider 42 spike stitches 26 Alternate Spikes 104 Birdsfoot Spike 112 Spiked Boxes 105 Spiked Squares 116–117 split-ring markers 16 Spot 93
slip stitch (sl st) 23 Small Daisy 105 Small Mesh 138 Small Ruffles 183 Smooth Wave 173 Solomon's Grid 151 Solomon's Knot (Sk) 31, 150 special formations 30–31 Spider 42 spike stitches 26 Alternate Spikes 104 Birdsfoot Spike 112 Spiked Boxes 105 Spiked Squares 116–117 split-ring markers 16
slip stitch (sl st) 23 Small Daisy 105 Small Mesh 138 Small Ruffles 183 Smooth Wave 173 Solomon's Grid 151 Solomon's Knot (Sk) 31, 150 special formations 30-31 Spider 42 spike stitches 26 Alternate Spikes 104 Birdsfoot Spike 112 Spiked Boxes 105 Spiked Squares 116-117 split-ring markers 16 Spot 93 Sprig 65
slip stitch (sl st) 23 Small Daisy 105 Small Mesh 138 Small Ruffles 183 Smooth Wave 173 Solomon's Grid 151 Solomon's Grid 151 Solomon's Knot (Sk) 31, 150 special formations 30–31 Spider 42 spike stitches 26 Alternate Spikes 104 Birdsfoot Spike 112 Spiked Boxes 105 Spiked Boxes 105 Spiked Squares 116–117 split-ring markers 16 Spot 93 Sprig 65 squares
slip stitch (sl st) 23 Small Daisy 105 Small Mesh 138 Small Ruffles 183 Smooth Wave 173 Solomon's Grid 151 Solomon's Knot (Sk) 31, 150 special formations 30–31 Spider 42 spike stitches 26 Alternate Spikes 104 Birdsfoot Spike 112 Spiked Boxes 105 Spiked Squares 116–117 split-ring markers 16 Spot 93 Sprig 65 squares Filet Squares 152–153
slip stitch (sl st) 23 Small Daisy 105 Small Mesh 138 Small Ruffles 183 Smooth Wave 173 Solomon's Grid 151 Solomon's Knot (Sk) 31, 150 special formations 30–31 Spider 42 spike stitches 26 Alternate Spikes 104 Birdsfoot Spike 112 Spiked Boxes 105 Spiked Squares 116–117 split-ring markers 16 Spot 93 Sprig 65 squares Filet Squares 152–153 Outline Squares 108
slip stitch (sl st) 23 Small Daisy 105 Small Mesh 138 Small Ruffles 183 Smooth Wave 173 Solomon's Grid 151 Solomon's Knot (Sk) 31, 150 special formations 30–31 Spider 42 spike stitches 26 Alternate Spikes 104 Birdsfoot Spike 112 Spiked Boxes 105 Spiked Squares 116–117 split-ring markers 16 Spot 93 Sprig 65 squares Filet Squares 152–153
slip stitch (sl st) 23 Small Daísy 105 Small Mesh 138 Small Ruffles 183 Smooth Wave 173 Solomon's Grid 151 Solomon's Knot (Sk) 31, 150 special formations 30–31 Spider 42 spike stitches 26 Alternate Spikes 104 Birdsfoot Spike 112 Spiked Boxes 105 Spiked Boxes 105 Spiked Squares 116–117 split-ring markers 16 Spot 93 Sprig 65 squares Filet Squares 152–153 Outline Squares 108 Relief Squares 130–131
slip stitch (sl st) 23 Small Daisy 105 Small Mesh 138 Small Ruffles 183 Smooth Wave 173 Solomon's Grid 151 Solomon's Knot (Sk) 31, 150 special formations 30-31 Spider 42 spike stitches 26 Alternate Spikes 104 Birdsfoot Spike 112 Spiked Boxes 105 Spiked Squares 116-117 split-ring markers 16 Spot 93 Sprig 65 squares Filet Squares 152-153 Outline Squares 108 Relief Squares 130-131 Spiked Squares 116-117
slip stitch (sl st) 23 Small Daisy 105 Small Mesh 138 Small Ruffles 183 Smooth Wave 173 Solomon's Grid 151 Solomon's Knot (sk) 31, 150 special formations 30–31 Spider 42 spike stitches 26 Alternate Spikes 104 Birdsfoot Spike 112 Spiked Boxes 105 Spiked Squares 116–117 split-ring markers 16 Spot 93 Sprig 65 squares Filet Squares 152–153 Outline Squares 108 Relief Squares 108 Relief Squares 116–117 Staggered Double Crochet Pairs
slip stitch (sl st) 23 Small Daisy 105 Small Mesh 138 Small Ruffles 183 Smooth Wave 173 Solomon's Grid 151 Solomon's Knot (Sk) 31, 150 special formations 30–31 Spider 42 spike stitches 26 Alternate Spikes 104 Birdsfoot Spike 112 Spiked Boxes 105 Spiked Squares 116–117 split-ring markers 16 Spot 93 Sprig 65 squares Filet Squares 152–153 Outline Squares 108 Relief Squares 130–131 Spiked Squares 116–117 Staggered Double Crochet Pairs 39
slip stitch (sl st) 23 Small Daisy 105 Small Mesh 138 Small Ruffles 183 Smooth Wave 173 Solomon's Grid 151 Solomon's Knot (sk) 31, 150 special formations 30–31 Spider 42 spike stitches 26 Alternate Spikes 104 Birdsfoot Spike 112 Spiked Boxes 105 Spiked Squares 116–117 split-ring markers 16 Spot 93 Sprig 65 squares Filet Squares 152–153 Outline Squares 108 Relief Squares 108 Relief Squares 116–117 Staggered Double Crochet Pairs
slip stitch (sl st) 23 Small Daisy 105 Small Mesh 138 Small Ruffles 183 Smooth Wave 173 Solomon's Grid 151 Solomon's Knot (Sk) 31, 150 special formations 30–31 Spider 42 spike stitches 26 Alternate Spikes 104 Birdsfoot Spike 112 Spiked Boxes 105 Spiked Squares 116–117 split-ring markers 16 Spot 93 Sprig 65 squares Filet Squares 152–153 Outline Squares 108 Relief Squares 130–131 Spiked Squares 116–117 Staggered Double Crochet Pairs 39
slip stitch (sl st) 23 Small Daisy 105 Small Mesh 138 Small Ruffles 183 Smooth Wave 173 Solomon's Grid 151 Solomon's Knot (Sk) 31, 150 special formations 30–31 Spider 42 spike stitches 26 Alternate Spikes 104 Birdsfoot Spike 112 Spiked Boxes 105 Spiked Squares 116–117 split-ring markers 16 Spot 93 Sprig 65 squares Filet Squares 152–153 Outline Squares 108 Relief Squares 130–131 Spiked Squares 116–117 Staggered Double Crochet Pairs 39 Staggered Half Double Pairs 39 Starburst 77
slip stitch (sl st) 23 Small Daisy 105 Small Mesh 138 Small Ruffles 183 Smooth Wave 173 Solomon's Grid 151 Solomon's Grid 151 Solomon's Knot (sk) 31, 150 special formations 30–31 Spider 42 spike stitches 26 Alternate Spikes 104 Birdsfoot Spike 112 Spiked Boxes 105 Spiked Squares 116–117 split-ring markers 16 Spot 93 Sprig 65 squares Filet Squares 152–153 Outline Squares 108 Relief Squares 108 Relief Squares 116–117 Staggered Double Crochet Pairs 39 Staggered Half Double Pairs 39 Starburst 77 Strawberry Lace 66
slip stitch (sl st) 23 Small Daisy 105 Small Mesh 138 Small Ruffles 183 Smooth Wave 173 Solomon's Grid 151 Solomon's Knot (Sk) 31, 150 special formations 30–31 Spider 42 spike stitches 26 Alternate Spikes 104 Birdsfoot Spike 112 Spiked Boxes 105 Spiked Squares 116–117 split-ring markers 16 Spot 93 Sprig 65 squares Filet Squares 152–153 Outline Squares 108 Relief Squares 130–131 Spiked Squares 116–117 Staggered Double Crochet Pairs 39 Staggered Half Double Pairs 39 Starburst 77 Strawberry Lace 66 Surface Crochet over
slip stitch (sl st) 23 Small Daisy 105 Small Mesh 138 Small Ruffles 183 Smooth Wave 173 Solomon's Grid 151 Solomon's Knot (Sk) 31, 150 special formations 30–31 Spider 42 spike stitches 26 Alternate Spikes 104 Birdsfoot Spike 112 Spiked Boxes 105 Spiked Squares 116–117 split-ring markers 16 Spot 93 Sprig 65 squares Filet Squares 152–153 Outline Squares 108 Relief Squares 130–131 Spiked Squares 116–117 Staggered Double Crochet Pairs 39 Staggered Half Double Pairs 39 Starburst 77 Strawberry Lace 66 Surface Crochet over Large Mesh 185
slip stitch (sl st) 23 Small Daisy 105 Small Mesh 138 Small Ruffles 183 Smooth Wave 173 Solomon's Grid 151 Solomon's Knot (Sk) 31, 150 special formations 30–31 Spider 42 spike stitches 26 Alternate Spikes 104 Birdsfoot Spike 112 Spiked Boxes 105 Spiked Squares 116–117 split-ring markers 16 Spot 93 Sprig 65 squares Filet Squares 152–153 Outline Squares 108 Relief Squares 130–131 Spiked Squares 116–117 Staggered Double Crochet Pairs 39 Staggered Half Double Pairs 39 Starburst 77 Strawberry Lace 66 Surface Crochet over
slip stitch (sl st) 23 Small Daisy 105 Small Mesh 138 Small Ruffles 183 Smooth Wave 173 Solomon's Grid 151 Solomon's Knot (Sk) 31, 150 special formations 30–31 Spider 42 spike stitches 26 Alternate Spikes 104 Birdsfoot Spike 112 Spiked Boxes 105 Spiked Squares 116–117 split-ring markers 16 Spot 93 Sprig 65 squares Filet Squares 152–153 Outline Squares 108 Relief Squares 130–131 Spiked Squares 116–117 Staggered Double Crochet Pairs 39 Staggered Half Double Pairs 39 Starburst 77 Strawberry Lace 66 Surface Crochet over Large Mesh 185 Surface Crochet over Small Mesh
slip stitch (sl st) 23 Small Daisy 105 Small Mesh 138 Small Ruffles 183 Smooth Wave 173 Solomon's Grid 151 Solomon's Grid 151 Solomon's Knot (sk) 31, 150 Special formations 30–31 Spider 42 Spike stitches 26 Alternate Spikes 104 Birdsfoot Spike 112 Spiked Boxes 105 Spiked Squares 116–117 Split-ring markers 16 Spot 93 Sprig 65 Squares Filet Squares 152–153 Outline Squares 108 Relief Squares 108 Relief Squares 116–117 Staggered Double Crochet Pairs 39 Staggered Half Double Pairs 39 Starburst 77 Strawberry Lace 66 Surface Crochet over Small Mesh 184
slip stitch (sl st) 23 Small Daisy 105 Small Mesh 138 Small Ruffles 183 Smooth Wave 173 Solomon's Grid 151 Solomon's Knot (Sk) 31, 150 special formations 30–31 Spider 42 spike stitches 26 Alternate Spikes 104 Birdsfoot Spike 112 Spiked Boxes 105 Spiked Squares 116–117 split-ring markers 16 Spot 93 Sprig 65 squares Filet Squares 152–153 Outline Squares 108 Relief Squares 108 Relief Squares 116–117 Staggered Double Crochet Pairs 39 Staggered Half Double Pairs 39 Starburst 77 Strawberry Lace 66 Surface Crochet over Large Mesh 185 Surface Crochet over Small Mesh 184 symbols 186, 187
slip stitch (sl st) 23 Small Daisy 105 Small Mesh 138 Smolth Wave 173 Solomon's Grid 151 Solomon's Knot (Sk) 31, 150 special formations 30–31 Spider 42 spike stitches 26 Alternate Spikes 104 Birdsfoot Spike 112 Spiked Boxes 105 Spiked Squares 116–117 split-ring markers 16 Spot 93 Sprig 65 squares Filet Squares 152–153 Outline Squares 108 Relief Squares 100 Relief Squares 116–117 Staggered Double Crochet Pairs 39 Staggered Half Double Pairs 39 Starburst 77 Strawberry Lace 66 Surface Crochet over Large Mesh 185 Surface Crochet over Small Mesh 184 symbols 186, 187 American/English
slip stitch (sl st) 23 Small Daisy 105 Small Mesh 138 Small Ruffles 183 Smooth Wave 173 Solomon's Grid 151 Solomon's Knot (Sk) 31, 150 special formations 30–31 Spider 42 spike stitches 26 Alternate Spikes 104 Birdsfoot Spike 112 Spiked Boxes 105 Spiked Squares 116–117 split-ring markers 16 Spot 93 Sprig 65 squares Filet Squares 152–153 Outline Squares 108 Relief Squares 108 Relief Squares 116–117 Staggered Double Crochet Pairs 39 Staggered Half Double Pairs 39 Starburst 77 Strawberry Lace 66 Surface Crochet over Large Mesh 185 Surface Crochet over Small Mesh 184 symbols 186, 187
slip stitch (sl st) 23 Small Daisy 105 Small Mesh 138 Smolth Wave 173 Solomon's Grid 151 Solomon's Knot (Sk) 31, 150 special formations 30–31 Spider 42 spike stitches 26 Alternate Spikes 104 Birdsfoot Spike 112 Spiked Boxes 105 Spiked Squares 116–117 split-ring markers 16 Spot 93 Sprig 65 squares Filet Squares 152–153 Outline Squares 108 Relief Squares 100 Relief Squares 116–117 Staggered Double Crochet Pairs 39 Staggered Half Double Pairs 39 Starburst 77 Strawberry Lace 66 Surface Crochet over Large Mesh 185 Surface Crochet over Small Mesh 184 symbols 186, 187 American/English

tape measures 16 Textured Wave 175 Thistle 132-133 Three and Two 49 Treble Crochet (tr) 25, 37 trellis Block Trellis 147 Honeycomb Trellis 146 Puff Cluster Trellis 148 Shell Trellis 147 triangles Inverted Triangles 160 Little Pyramid 160 Triangle Mesh 144 Trinity 51 Triple Picot V 149 Tulip 74 Tulip Cable 134-135 turning chains 19 Twin Clusters 86 Twin V 49 U Uneven Berry 47 Up and Down 41 W Waffle 43 Wattle 41 waves Long Wave 174 Puff Stitch Wave 172 Smooth Wave 173 Textured Wave 175 Wave and Chevron 176-177 weaving in yarn 19 Wedge 163 Wide Checkers 50 Wide Chevron 167 working in rows 18 turning the work 18 working into a chain space 26 working into one loop 26 working several stitches in the same place 27 fans and shells 27 working several stitches together Woven 42 Woven Shell 159 Y yarns 15 holding the yarn 17 joining yarn 20

Z Zeros and Crosses 158 Zig-zag Double String Network 145 Zig-zag Lozenge 98 Zig-zag Popcorn 97

tips 15, 22

weaving in yarn 19

Credits

Quarto are grateful to ROWAN YARNS who supplied all the yarns used in this book.

Thanks also to Black Sheep Wools and Janie Crow who supplied the tools for photography.

The author wishes to thank Amanda Golland, Fiona Winning, Jools Yeo, and Sophia Reed for helping to create the crochet swatches.

All photographs and illustrations are the copyright of Quarto Publishing plc. While every effort has been made to credit contributors, Quarto would like to apologize should there have been any omissions or errors—and would be pleased to make the appropriate correction for future editions of the book.

Dedication: For my beautiful daughter Phoebe—published on her 16th birthday!

ALSO AVAILABLE FROM INTERWEAVE